Praise for

Religion Across Me

MW00823786

"The contemporary discourse on media and religion is significantly strengthened by this book, which overturns a number of unproductive conventions such as eclipsing history, dematerializing the study of media, foregrounding new media, and privileging the modern West. Clearly written and marshaling evidence no less than theory, the essays will contribute to the classroom as well as to research."

—*David Morgan, Department of Religion, Duke University*

"This landmark collection starts from the fundamental premise that both media and religion are material practices of communication. The result is to open up a fascinating set of reflections on media's role in the making of religious form and authority across a breathtaking historical landscape of two thousand years. Highly recommended."

—*Nick Couldry, Goldsmiths, University of London*

"This volume brings together leading scholars to explore the intersections of media and religion across cultures and societies. It breaks new ground in this interdisciplinary field, which is rapidly assuming greater scholarly significance as questions about global religion and their mediation become more pressing. Starting from the premise that religious practices are practices of mediation, the book argues, cogently, that media are central to our understanding of religious transformations today."

—*Marie Gillespie, Professor of Sociology, The Open University*

Religion Across Media

This book is part of the Peter Lang Media and Communication list.
Every volume is peer reviewed and meets
the highest quality standards for content and production.

PETER LANG
New York • Washington, D.C./Baltimore • Bern
Frankfurt • Berlin • Brussels • Vienna • Oxford

Religion Across Media

From Early Antiquity to Late Modernity

Knut Lundby, EDITOR

PETER LANG
New York • Washington, D.C./Baltimore • Bern
Frankfurt • Berlin • Brussels • Vienna • Oxford

Library of Congress Cataloging-in-Publication Data

Religion across media: from early antiquity to late modernity /
edited by Knut Lundby.
pages cm
Includes bibliographical references and index.
1. Mass media in religion. 2. Mass media—Religious aspects.
I. Lundby, Knut, editor of compilation.
BL638.R445 201'.7—dc23 2013007662
ISBN 978-1-4331-2078-7 (hardcover)
ISBN 978-1-4331-2077-0 (paperback)
ISBN 978-1-4539-1085-6 (e-book)

Bibliographic information published by **Die Deutsche Nationalbibliothek.**
Die Deutsche Nationalbibliothek lists this publication in the "Deutsche
Nationalbibliografie"; detailed bibliographic data is available
on the Internet at http://dnb.d-nb.de/.

The paper in this book meets the guidelines for permanence and durability
of the Committee on Production Guidelines for Book Longevity
of the Council of Library Resources.

Contents

Acknowledgments vii

Introduction: Religion Across Media xi
Knut Lundby

1. Material Mediations and Religious Practices of World-Making 1
 Birgit Meyer

2. Media of Ancient Hebrew Religion 20
 Terje Stordalen

3. The Ecology of Writing and the Shaping of Early Christianity 37
 Peter Horsfield

4. Manuscript Culture and the Myth of Golden Beginnings 54
 Liv Ingeborg Lied

5. Contested Ritual Mediation: Brahmin Temple Priests in South India 71
 Ute Hüsken

6. On Digital Eloquence and Other Rhetorical Pathways to Thinking
 About Religion and Media 87
 Peter Simonson

7. Religion, Space, and Contemporary Media 105
 Kim Knott

8. Mediating Gypsiness Through the Holy Spirit: Pentecostalism and
 Social Mobilization Among European Roma 121
 David Thurfjell

9. Taming the West: Mediations of Muslim Modernities 137
 Nabil Echchaibi

10. New Media, Religion, and Gender: Young Swedish Female Bloggers 153
 Mia Lövheim

11. Evolving Religion in the Digital Media 169
 Stewart M. Hoover

12. Media and Transformations of Religion 185
 Knut Lundby

 Contributors 203

 Index 209

Acknowledgments

The story of this book started at Sigtunastiftelsen, which claims to be a 'meeting place with an extra dimension.'[1] This modern monastery-like hotel in Sigtuna, said to be Sweden's oldest city, had been the site of several reflexive workshops on media and religion. The Director Alf Linderman had, in 1993, been a key organizer behind the first conference on media, religion, and culture in nearby Uppsala (Hoover & Lundby, 1997, p. ix). In October 2010 he was hosting the last in a five-year series of seminars in the Nordic research network on the mediatization of religion and culture (Hjarvard & Lövheim, 2012), funded by NordForsk, a research body under the Nordic Council of Ministers. Stig Hjarvard had coordinated the first part of the programme, Mia Lövheim the latter.

At this particular seminar in 2010, Peter Horsfield, Nabil Echchaibi, and David Thurfjell were presenting as keynote speakers, coming in from Australia, the United States, and the capital of Stockholm, respectively. Terje Stordalen was an invited participant. He was at that time director of the interdisciplinary programme on 'Religion in Pluralist Societies' (PluRel) at the University of Oslo. He was so inspired by the Sigtuna seminar that he wanted to initiate a follow-up event within the frames of PluRel.

This eventually took place in February 2012 in Oslo as the 'Religion Across Media' conference. Terje Stordalen had by then left as chair of PluRel, to be replaced by Oddbjørn Leirvik. Into the preparation committee came Inger Furseth, director of the Nordic research programme on 'The Role of Religion in the Public

Sphere' (NOREL). PluRel and NOREL together hosted the conference, which was financially covered by PluRel (who has also covered some of the costs associated with this book). I chaired the planning group, greatly supported by the PluRel secretary Randi Wærdahl, succeeded by Beate Solli.

I suggested Birgit Meyer as the keynote speaker for the 'Religion Across Media' conference. Peter Horsfield came over from Australia again and David Thurfjell and Mia Lövheim from Sweden. Kim Knott travelled in from the UK to present at the seminar. Ute Hüsken joined as a scholar within the PluRel constituency in Oslo, and Terje Stordalen was there. Liv Ingeborg Lied was called upon from a neighbouring institution in Oslo and Stewart M. Hoover from the United States.

Hoover directs the eminent Center for Media, Religion, and Culture, University of Colorado at Boulder, which became a partner in this book project. Two of its other connected scholars joined the list of contributors, Nabil Echchaibi, the deputy director, and Peter Simonson, part of their Ford-funded project on 'Finding Religion in the Media.' His chapter emerges out of a presentation at the University of Hyderabad, India, August 2011, within one of the 'Global Seminars on Media, Religion, and Culture,' funded by the Porticus Stiftung and chaired by Stewart Hoover and Birgit Meyer.

All eleven authors in this book besides myself were then identified. They have, with enthusiasm, contributed to the outcome, making this book a collaborative effort. Steinar Skarpnes, a former master student, took on the task as editorial assistant and has done a great job. Mary Savigar has been our supportive, kind, and professional editor at Peter Lang Publishing in New York. Her anonymous reviewer has contributed encouragement as well as constructive criticism. And the production team at Peter Lang has brought this volume through with efficiency.

It is hoped that the volume will inspire continued interdisciplinary work on religion across media. It already has a kind of afterlife, having inspired a further cooperation between the biblical scholar Terje Stordalen and the religious studies anthropologist Birgit Meyer. Stordalen will direct a programme on 'Local Dynamics of Globalization in the Pre-modern Levant' in 2014/2015 at the Centre for Advanced Study at the Norwegian Academy of Science and Letters, with Meyer as one of the participating researchers. Perspectives of materiality and mediation laid out in this book will continue to inform their joint work. The contributions in this volume should have the potential to stimulate interest in religion across media from early antiquity to late modernity.

—*Knut Lundby*
Oslo, 17 January 2013

Notes

1. According to its website www.sigtunastiftelsen.se/index_hk.asp/id/15

References

Hjarvard, S., & Lövheim, M. (Eds.). (2012). *Mediatization and religion. Nordic perspectives.* Gothenburg: NORDICOM.

Hoover, S. M., & Lundby, K. (1997). *Rethinking media, religion, and culture.* Thousand Oaks, CA: Sage.

Religion Across Media

KNUT LUNDBY

This book challenges the understanding of 'media' in media and communication studies as well as of 'religion' in religious studies. The book aims to study the interplay of media and religion

- across religious traditions with a focus on the mediation of religious practices
- across historical media forms with a wide concept of 'media.'

The span is from the performative media of early antiquity to the digital media of late modernity.

The study of 'religion and media' and 'the significance of their interplay for social, cultural and, political change in contemporary societies' (Herbert & Gillespie, 2011, p. 601) is a cross-disciplinary field with contributions from sociology, anthropology, cultural studies, religious studies, biblical studies, and media and communication studies. As the academic apprehension of religion and media is maturing, there is a significant potential for interdisciplinary exchange between this field and further strands of sociological, cultural, and intercultural—as well as historical—study of religion. This book attempts to address issues of religion and media precisely through establishing a widely cross-disciplinary scholarly dialogue on religion across media.

Across Disciplines

The volume is an interdisciplinary encounter beyond the rubrics of media and communication studies on the one hand and religious studies on the other. The authors cover a wide range of competences. For details, see the list of contributors; they are introduced briefly here in the order they appear in the book:

Birgit Meyer lays out a framework for the volume from her anthropological and religious studies perspective on religion. Terje Stordalen applies his background in biblical studies (Hebrew Bible/Old Testament). Peter Horsfield is a scholar of writing and communication. Liv Ingeborg Lied has her background in religious studies. Ute Hüsken is professor of Sanskrit and trained in cultural anthropology. Peter Simonson is a communication scholar. Kim Knott is professor of religious and secular studies. David Thurfjell is a religious studies scholar. Nabil Echchaibi teaches journalism and communication. Mia Lövheim is professor in sociology of religion with competence in media and communication studies. Stewart M. Hoover has a scholarly background in media studies and in religious studies. Knut Lundby works in media and communication studies but also has a degree in sociology of religion.

Religion as a Practice of Mediation

Religion has to be viewed as a practice of mediation. That is the groundbreaking observation by Birgit Meyer and her fellow scholars in the anthropology of religion. Religion 'cannot be analyzed outside the forms and practices of mediation that define it,' she argues with Annelies Moors (Meyer & Moors, 2006, p. 7).[1] This turn from conceptions of 'religion *and* media' to 'religion *as* media' (Stolow, 2005), that is, to understand religion through its forms of mediation, is immensely important.

Media, then, are taken 'as intrinsic, rather than opposed, to religion' (Meyer, 2011, p. 23). Actually, this has always been the case as all religion is to be shared, communicated by media within the community of adherents. Essentialist notions, however, have invited us to see religion as something given that could be disseminated. Such a view overlooks how the modes of mediation are part of the religion's configuration.

It's mediation as a process that matters, favouring certain symbolic forms before others, with given or selected media. Oral mediation invites other expressions of religion than written mediation or printed mediation. Electronic and digital forms of mediation create further options for the reconfiguration of religious practices.

Introduction of a new media technology does not directly change religious practices. But new media technologies invite new mediation practices and new mediation forms, like when radio sermons were introduced as supplement to services in

the church or when online religious expressions add to those offline, inferring on people's habits. New mediation forms will be present along former ones and old media forms may appear in a 're-mediation' of new ones (Bolter & Grusin, 1998).

The point for Meyer and Moors (2006) is to explore how the transition from one mode of mediation to another 'reconfigures a particular practice of religious mediation' (p. 7). This 'transition' becomes a transformation of the actual religious practice. The two authors relate to 'new mass media technologies' but their general argument is valid for small-scale digital media as well as for non-technological media according to the broad definition in this book.

On 'Religion'

The authors in this book regard 'religion' primarily as a set of practices, although this also involves ideas or meanings. *What* is being mediated still matters, although the focus in this book is on how the mediation forms play back into the religious traditions and shape the practices. The contributors take their examples from various traditions but focus on interaction and rituals, rather than beliefs or dogma. The authors deal with a variety of religious practices, from institutional 'world religions' to individual forms of spirituality and, also, secular forms of sacred expressions.

Terje Stordalen goes back to ancient Hebrew religion, Peter Horsfield to early Christianity, and Liv Ingeborg Lied to Christian Syriac monastic culture. Ute Hüsken refers to Brahman priests in Hinduism. Birgit Meyer and David Thurfjell look to contemporary forms of Pentecostalism. Nabil Echchaibi discusses modern dilemmas of Muslims. Kim Knott focuses on media representations of Islam, Christianity, and Sikhism. She reminds us that the contemporary religious field is an arena of struggle and also consists of anti-religious criticism and expressions of secularism. Religion and the sacred may have been synonymous in former historical periods but they are no longer necessarily so in late modernity. There are also, today, forms of the sacred secular, as Kim Knott (in press) is showing.

Peter Simonson, in his discussion of rhetoric across cultures, takes examples from the whole span covered by this book. They range from the ancient Hebrew tradition to present 'digital eloquence' on religion. Mia Lövheim analyses everyday ethical-religious expressions and practices in a late-modern blogosphere. Stewart Hoover takes his discussion to evolving new forms and systems of religious practice in digital media. Knut Lundby does not cover specific religious traditions but, rather, discusses how religious practices may be formed and transformed by the media they cater to.

The baseline through the volume is to understand religion through its forms of mediation. This is the challenge to religious studies. Any study of religion that does

not take the mediation forms and practices into account will limit the understanding of the phenomenon. All religion is to be communicated. The mediation in such communication is part of religion as a phenomenon. There is no religion that is not mediated. The media that are used are part of religion as practice. Religion has to be understood 'as a practice of mediation' (Meyer, 2009, p. 2). Birgit Meyer expands on this perspective and argument in the opening keynote chapter of this book. The thread she lays out is taken up in the chapters that follow.

Anthropology offers tools to grasp these forms of mediation, as demonstrated by Birgit Meyer. So may media and communication studies, working on mediated communication. However, the latter concentrate on communication with modern media. Could analytical insights from media and communication studies be brought to bear on religion in ancient media such as musical performance, ritual, or early manuscript culture? This is explored in the present volume.

On 'Media'

The book opens up a wide concept of 'media.' This is the challenge to media and communication studies as media scholars tend to limit themselves to technical media, from the printing press onwards. Liv Ingeborg Lied teases media researchers who think that Gutenberg's invention constitutes year zero in media history. This is 'the myth of golden beginnings,' she says.

Birgit Meyer is invited to set the definition of media through her understanding of mediation. Mediations, to her, are *material* mediations where a variety of material intermediaries—'or, in short, media' operate in the complex cultural 'transmission,' or communication (see Chapter 1, p. 4). The range of material media is wide, from the body of a person through various artefacts or objects to different technological media.

John B. Thompson, in *Media and Modernity* (1995), holds that 'All processes of symbolic exchange involve a technical medium of some kind. Even the exchange of utterances in face-to-face interaction presupposes some material elements' (p. 18). Yes, this is the key argument on material mediations. However, I regard Thompson's examples of the larynx and vocal cord, air waves, ears and hearing drums, etc., as *material* but not *technical*. I connect the term 'technical,' to modern, 'disembedded' media. Let me explain.

To Anthony Giddens (1991) 'disembeddedness' of time and space is a key characteristic of the modern experience. This disembeddedness is provided by the technical media from the printing press onwards that made it possible to share ideas and inspire practices on a broad scale beyond the moment and location they were issued. This does not re-create the 'myth of golden beginnings' as I am well aware

of the 'embedded' media that dominated before the advent of the modern mass media. The handwritten manuscripts that Lied is concerned with are to some extent disembedded media as they could be copied in a few examples and they could be carried from place to place. But basically these manuscripts were embedded in the monastery culture. The body is an 'embedded medium' and so are objects and instruments that are used on location. Instruments and tools may be inventions and result of innovation processes and as such work as technologies in social use. However, I reserve the concept of 'technical' for the construction principles behind disembedded media.

Embedded and disembedded media are both material media, in Meyer's sense. Embedded media employ place-based elements and technologies in immediate use while disembedded media have the technical qualities to transcend space and time in the mediations.

Stewart Hoover, Mia Lövheim, Nabil Echchaibi, and Peter Simonson, in the main part of his chapter, discuss religious practices in digital media. These are disembedded media spanning across space and time through Internet and mobile networks, based in the complex binary codes of computers (Bratteteig, 2008). The user interface may be so seamless that these digital media seem embedded, but actually they are not.

Other contributors to the book concentrate on old embedded media. Terje Stordalen explores performative media as dance and music. Peter Horsfield and Liv Ingeborg Lied work with handwritten manuscripts. For Ute Hüsken the Brahmin priests in their role function as media in the Hindu temples.

Some of the authors present cases where disembedded mass media and digital media are combined with embedded media, as we see in Birgit Meyer's examples from Pentecostals in Ghana, David Thurfjell's research among Pentecostal Roma people in Europe, and Kim Knott's cases on the location of religion in secular contexts.

Whether mass media, new digital media, bodily or performative media, Stordalen reminds us that 'All media rely on some symbolic or semantic system of signification to produce symbolic representations of the subject matter at hand' (Chapter 2, p. 23). This observation makes it obvious to focus on the processes of mediation rather than on the media as such. A medium gets its function and wider cultural and social meaning in the processes of communication and interaction of which it is part. The Latin American communication scholar Jesús Martín-Barbero led this move 'From the Media to Mediations,' as the subtitle of his book on *Communication, Culture and Hegemony* (1993) indicates. John B. Thompson (1995) elaborated the symbolic circulation that the modern technological media intensified. *His* history starts with the advent of printing. The present book goes beyond this moment of 'golden beginnings,' in Lied's words, way back to media in early antiquity.

Stordalen's challenge is that 'ancient Hebrew religion had a number of media whose symbolizations are lost'—namely, any symbolization 'that could not be contained in the scriptural or archaeological record' (Chapter 2, p. 25). Insights from reconstructions of religious practices in ancient media or in early manuscript culture could contribute to the study of current media and religion a strengthened awareness of continuities and discontinuities between the late modern and earlier ages. When Stordalen speaks of the 'sensational filtering provided by the medium' (Chapter 2, p. 23) this biblical scholar lines nicely up with Marshall McLuhan, the media theorist (Peters, 2011, p. 233).

Stordalen, in Chapter 2, follows Meyer, defining media as any device that facilitates communication—including technological, social, and other characteristics of that medium. Media give form to a given culture's memory and are vital to the writing of cultural history. Without claiming to do a 'media archaeology' in his sense I share Jussi Parikka's (2012) approach to the role of media in 'cultures of memory' to study old and new mediation forms in parallel and go from 'the entanglement of past and present, and accept the complexity this decision brings with it to any analysis of modern media culture' (p. 5).

Across Time

The historical span of this book is considerable. The ambitious time frame from early antiquity to late modernity is covered through chapters with concrete cases and not in theoretical discussions on how to label the periods.

When Terje Stordalen explores the media of ancient Hebrew religion, he researches a period between the late Iron Age and the end of the Hellenistic period, that is, from around 800 to 146 Before the Common Era (BCE). Peter Simonson reminds us that the Greek word for rhetoric dates back to Athens in the fourth century BCE. However, Simonson identifies 'rhetorical pathways to thinking about religion and media' back to the ancient Hebrew tradition and up to digital expressions in contemporary late modernity. Peter Horsfield looks at the first centuries of Christianity, when the oral movement was collected into a handwritten canon of texts, from around 150 to 380 CE. The Syriac manuscript culture that Liv Ingeborg Lied researches dates back to the Middle Ages, between the twelfth and fourteenth centuries.

Ute Hüsken's first example of criticism toward Brahmin temple priests is possibly from the second century CE, maybe earlier. Her second example is from a colonial context in the nineteenth/twentieth century, and the third example is from the early twenty-first century, or, to be more precise, from 2006 until today. Kim Knott also stays with her reflections on religion, space, and media at the end of the twen-

tieth century and the beginning of the twenty-first, as is the case with David Thur-fjell in his exploration of the Roma.

Birgit Meyer's example of the devotion to the *Sacred Heart of Jesus* relates to traditions from the seventeenth and eighteenth centuries, but, played out in Ghana, we are into the contemporary. This is definitely so with Nabil Echchaibi's contribution on how young Muslims today negotiate their relation to modernity through the disembedded media, with the Arab Spring in 2011 and the YouTube video on the *Innocence of Muslims* from 2012 as two of his points of reference. Mia Lövheim's case studies of top female bloggers also build on contemporary material. The same applies to Stewart Hoover's chapter, which even looks into developments in the foreseeable future.

Across Space

The contributions to this book also cover wide geographical areas, although much centres on the Mediterranean as a cradle of world religions. Terje Stordalen searches the Eastern part of the Mediterranean, the 'Levant,' which encompasses present-day Lebanon, Israel, Palestine, Jordan, and parts of Syria and Egypt. Peter Horsfield moves across the Mediterranean, between Rome and the other side of that empire, to Alexandria, Carthage, and Hippo in North Africa. This is the area where Nabil Echchaibi recently observed the Arab Spring. The Monastery of the Syrians from where Liv Ingeborg Lied gathers most of her old manuscript material was located in the desert in the Northern part of Egypt. Peter Simonson looks to sources of rhetoric in Athens and elsewhere around the Mediterranean but takes his explorations beyond. Ute Hüsken goes to Southern India, to the state of Tamil Nadu in the southernmost part of the country. Birgit Meyer takes the reader to Ghana, Africa, when she exemplifies her thinking on mediation, materiality, and transformation of religion. The Romani groups researched by David Thurfjell have previously lived as nomads within Europe without a specific locality of their own. His interviewees live in Finland and Sweden. Mia Lövheim finds her bloggers in Sweden, while the United States is Stewart Hoover's prime location for explorations into evolving religion in the contemporary digital realm.

While sticking to contemporary, well-known mass media, Kim Knott expands the understanding of space beyond geographical localities. She takes a spatial approach to religion and media. Her 'interpretive spatial methodology' opens new avenues for the understanding of material mediations. While Birgit Meyer regards the body or an object as media, Kim Knott sees them as spatial entities alongside a place or a community. Knott's concept of media is about technical media. Her interest is 'the location of religion in secular contexts, including the media.' She ap-

plies her spatial approach to analyse religion in contemporary mass media representations as well as in new digital media spaces. Knott regards texts as discursive spaces and, thus, has a critical grasp on coverage of religion in the mass media and on the Internet. A key point in her spatial approach is that all spaces are infused with power and conflicting ideologies. She studies discursive struggles over texts on religion and secularity in media debates. Knott also applies her approach to examine how a religious group, young British Sikhs, exploits the spatiality of webpages and social networking sites on the Internet in the mediation of their religious beliefs, values, and practices (see Chapter 7).

The Chapters

Chapter 1 is the keynote to the book. Here Birgit Meyer lays out the key concepts of mediation, materiality, and transformation to be picked up by other contributors throughout the volume. Religion has to be understood through its material mediations. The study of religion, then, is anchored in bodies, things, pictures, and texts. The mediation processes with these 'media' are central to grasping the transformations of religion, she argues. Religious practices are practices of mediation. They are 'practices of world-making' where religion is taken for real and experienced as immediate.

In Chapter 2, Terje Stordalen drafts a multimedial setting for ancient Hebrew religion and argues that a wider perception of media practices is necessary to provide an adequate historical interpretation of biblical texts. One also needs to be aware of the social field in which a given medium operated and also, he holds, of the aesthetic qualities of various media. Ancient Hebrew religion used a number of media and music and dance are among these. Religious symbolization in such media is now only indirectly available, if at all, in the textual and archaeological records. By way of comparison with African music and dancing, Stordalen argues that ancient Hebrew musical dancing expressed ways of being in the world that are filtered out in the textual record. Still, music and rhythm have a 'transcoded' presence in the written medium, for instance, in Psalm 136 in the Hebrew Bible/Old Testament.

In Chapter 3, Peter Horsfield explores the nature of religion as a mediated phenomenon through a study of changes in the mediation of early Christianity. This was a diverse movement, with a number of significant streams of interpretation and media practices emerging through the imaginative adaptation of the message of Jesus to different cultural contexts. By the end of the fourth century, one of those streams had become dominant and domineering, structured hierarchically under the control of male bishops, represented and enforced politically as the only true and acceptable representation. This chapter explores the important role of

(hand)written media in the success of this particular cultural interpretation over the others. Factors considered include the ability to build and master public opinion in support of the dominant positions through the hegemonic branding of this particular version of Christianity as 'catholic' or 'universal'; using the liberties of the action of writing to construct the opinions of others as deviant or heretical; and by excluding others from participation in written discourse through suppression and destruction of their writings. The enforcement of written Latin as the universal language of western civilization and religion was instrumental in this hegemony that was eventually challenged through the promotion of vernacular languages by the technologies and commerce of printing.

This is the 'golden beginnings' of print that Liv Ingeborg Lied criticises in Chapter 4. She finds that studies of religion and media tend to define the 1450s as a discursive and analytical 'year zero'; the story of the interrelationship between religion and media thus starts with a reference to the invention of the printing press. While there is certainly good reason to underscore the importance of print culture to the development of modern religious forms, Lied argues that the discursive use of the 1450s as a turning point of mythical proportions tends to block historical imagination and leave the centuries before 1450 in the dark. Toward this, she takes an example of religion and/as mediation in the context of twelfth- to fourteenth-century Syriac monasticism. She argues that closer studies of pre-1450 media cultures can stimulate further awareness of continuities and similarities between earlier and modern societies, and benefit the further development of analytical approaches to contemporary media culture (cf. Riepl (1913) on media of antiquity).

Ute Hüsken, in Chapter 5, looks closely at conflicts and contestations related to authority and agency of media in South Indian Hindu culture, highlighting issues that remain implicit when not contested. Her focus is on Brahmin temple priests, who act as mediators between the divine and the human realm but also between human individuals and interest groups. These Brahmin priests are at the centre of the redistributive process in the temple and are, therefore, powerful agents whose power at the same time needs to be controlled. During rituals, they are identified with the god but, paradoxically, they have a rather low position among the diverse Brahmin sub-castes. Throughout history, they faced and still face repeated challenges to their ritual authority and exclusiveness. Some of these challenges are discussed in the chapter to show the centrality of ritual practice on the one hand and, also, to disclose that authorization processes are closely connected to power struggles in society at large.

In Chapter 6, Peter Simonson makes a case for rhetoric as a theoretical and meta-theoretical vocabulary for thinking about religion across media, cultures, and time. Casting rhetoric as at once a conceptually reflective intellectual tradition, an energizing feature of all addressed discourse, and a practical art, he takes a broadly

historical, cross-cultural, and hermeneutic stance. He begins with consideration of the fact that, since its formal birth in ancient Greece, the Western intellectual tradition of rhetoric has often flourished in culturally unsettled moments marked by change in media environments and religious orientations—of which ours is certainly one. He argues that other civilizations and cultures have analogous languages and concepts for talking about addressed discourse and, thus, provide culturally immanent interpretive concepts and critical tools. He illustrates the potential fruitfulness of rhetorical vocabularies by extending Birgit Meyer's (2009) concept of aesthetic formations through the idea of 'digital eloquence', a rhetorical experience actualized through particular audience members, specific moments in time, and new media.

In Chapter 7, Kim Knott uses the spatial approach to examine those areas where religion and media interact. Her objectives are to consider the spatiality of intersections between religion and media (in relation to both the mediation of religion and media representations of religion). She introduces some ideas about the spatial nature of discourse about religion, and how religious and other ideological exponents mediate their positions by defining themselves and excluding others, with reference to spatial language and practices. She suggests that the formation of religious categories and standpoints is achieved with reference to parts of space, to open and closed containers, insides and outsides, inclusion and exclusion, left and right, to boundaries, territories, and forces, to inversion, opposition, centres, and peripheries, to intersections, engagements, and interactions. Thinking spatially draws attention, she argues, to how the media locate and represent religions, and how religious people use the media to position themselves and others, and to communicate within and across boundaries.

David Thurfjell, in Chapter 8, throws light on the charismatic Christian revival that has swept through the Romani communities of Europe since the early 1950s. Today, although there are many exceptions, Pentecostalism could be said to be the foremost religious orientation among Roma in Europe and beyond. Intimately connected to this revival is political activism for the human rights of Roma and the construction of ethnic coherence within this group. Through the means of revivalist meetings, educational campaigns, novels, journals, pamphlets, broadcast sermons, and organizational mobilization, ministers, human rights activists, and bureaucrats have managed to create not only greater awareness of the hardships of Europe's Roma but also a new way to perceive of Romani ethnicity among Roma themselves. Thurfjell argues that the gain of political empowerment is ambiguous since, while leading to human rights and political acknowledgment, it does so in ways that are defined by non-Roma. The position of Pentecostalism becomes pivotal here because it creates a platform that enables the Roma to maintain cultural integrity in their empowerment.

In Chapter 9, Nabil Echchaibi explores how some of the new media personalities in Islamic satellite television and on the Web enter a complex dialectic with various conceptions of modernity, in communication with a young generation of Muslims facing urban living and commercial culture. One of the most enduring consequences of the Arab Spring in 2011 might be the emergence of a new wave of cultural and political Islamism. The remarkable surge of support for Islamists, Echchaibi argues, represents a paradigmatic shift, as a new generation of Muslims seeks alternative frames of political and cultural identification beyond the exclusionary binaries of modern–traditional, Western–non-Western, or even the religious–secular. It is not an aversion but rather a strong proximity to modernity that has prompted this important rethinking of Muslim Arab identity. Islamic media, both broadcast and digital, have recently served as a prime stage for this critical reflexivity between Islam and modernity. The chapter examines the complex mediation of this dialectic with modernity through an analysis of the work of two prominent tele-Islamists in Egypt.

Mia Lövheim, in Chapter 10, observes that the presence of both new media and religion in contemporary society questions previous understandings of what is considered public and private. Furthermore, she observes that gender is often at the heart of these debates. Starting from an understanding of the relation between new, digital media and religion, the chapter discusses how digital media enable new media actors to express their personal experiences and concerns, but also how such mediated self-expressions become part of and contribute to contemporary public discussions of religious, existential, and ethical issues. Drawing on insights from contemporary research on new media and gender, the chapter illustrates how young women through personal blogs act in the positions of male, formally trained, and appointed religious authorities, but also how these possibilities are structured by social, cultural, and religious gender conventions and norms as expressed in the interaction with their readers. Young women's blogs thus form performative spaces in which the meaning of religion in contemporary society is negotiated, along with the question about whether mediated religion contributes to privatization or a new public role for religion.

In Chapter 11, Stewart M. Hoover demonstrates how evolving relations between religion and the media continue to challenge scholarly description. Much progress has been made in the nearly two decades of the international discourse on media, religion, and culture, he holds. The once-separate spheres of media and religion are converging. Technological change has played its part, but these questions are best addressed through attention to evolving social and cultural forces and practices rather than through determinist views of technology. Things have taken new turns with the emergence of the digital media. These new media encourage practices that imagine new forms of autonomy in reception, consumption, and circulation. Audi-

ences today are hailed into subjectivities that suggest active production, curation, and remediation. In the re-thinking of the digitally religious, new analytical and interpretive frames are required. Hoover calls for a new paradigm, one that is called the 'Third Spaces of Digital Religion' (Hoover & Echchaibi, 2012). These are in-between a range of other dimensions, including private/public and formally religious/informally religious, with an emphasis on the acting subjective person.

In Chapter 12, Knut Lundby focuses on the transformations of religion in the triangle of mediation, materiality, and transformation that Birgit Meyer laid out in Chapter 1. All contributors to this volume directly or indirectly discuss how the various media that are applied do not just transmit religious messages but actually change or transform the religious practices. This final chapter discusses the various ways this take place across the spans of time and of space that are covered in the book. What does this transformation of religion imply? An encounter between the concepts of mediation and mediatization is central to this discussion. While the former is the basic concept in understanding religious practices with a broad variety of material media, it is argued that 'mediatization' may be the most suitable concept with which to grasp transformations that are moulded by disembedded media.

Notes

1. Other scholars have taken part in this reorientation, among them Hent de Vries, Jeremy Stolow, Angela Zito, William Mazzarella, and Charles Hirschkind.

References

Bolter, J. D., & Grusin, R. (1998). *Remediation. Understanding new media.* Cambridge, MA: MIT Press.

Bratteteig, T. (2008). Does it matter that it is digital? In K. Lundby (Ed.), *Digital storytelling, mediatized stories: Self-representations in new media.* New York: Peter Lang.

Giddens, A. (1991). *Modernity and self-identity. Self and society in late modern age.* Cambridge: Polity Press.

Herbert, D., & Gillespie, M. (2011). Editorial [to Special Issue on Religion, Media and Social Change]. *Europoean Journal of Cultural Studies, 16*(6), 601–609.

Hoover, S. M., & Echchaibi, N. (2012). The third spaces of digital religion. In S. M. Hoover & N. Echchaibi (Eds.), *Finding religion in the media: Case studies of the 'third spaces' of digital religion.* Boulder, CO: Center for Media, Religion, and Culture, University of Colorado.

Knott, K. (in press). The secular sacred: In-between or both/and? In A. Day, C. Cotter, & G. Vincett (Eds.), *Social identities between the sacred and the secular.* Farnham, Surrey: Ashgate.

Martín-Barbero, J. (1993). *Communication, culture and hegemony: From the media to the mediations.* London: Sage.

Meyer, B. (2009). From imagined communities to aesthetic formations: Religious mediations, sensational forms, and styles of binding. In B. Meyer (Ed.), *Aesthetic formations. Media, religion, and the senses* (pp. 1–28). New York: Palgrave Macmillan.

Meyer, B. (2011). Mediation and immediacy: Sensational forms, semiotic ideologies and the questions of the medium. *Social Anthropology, 19*(1), 23–39.

Meyer, B., & Moors, A. (2006). Introduction. In B. Meyer & A. Moors (Eds.), *Religion, media, and the public sphere* (pp. 1–25). Bloomington, IN: Indiana University Press.

Parikka, J. (2012). *What is media archaeology?* Cambridge: Polity.

Peters, J. D. (2011). McLuhan's grammatical theology. *Canadian Journal of Communication, 36*, 227–242.

Riepl, W. (1913). *Das Nachrichtenwesen des Altertums, mit besonderer Rücksicht auf die Römer.* [The News Communications of the Ancient World with Special Reference to the Romans]. Leipsiz: B. G. Teubner.

Stolow, J. (2005). Religion and/as media. *Theory, Culture & Society, 22*(4), 119–145.

Thompson, J. B. (1995). *The media and modernity.* Oxford: Polity Press.

Material Mediations and Religious Practices of World-Making

Birgit Meyer

Over the past 20 years, scholars have been challenged to come to terms with the dazzling presence of religion in its various, often unexpected shapes. A number of fundamental presuppositions that underpinned the modern study of religion have been subject to substantial critique. There is a growing awareness of a mismatch between established theoretical notions and approaches, on the one hand, and the empirical level on which religion "happens" in the world, on the other. This calls for "grounded theory." At stake is the reconfiguration of the study of religion itself in the face of its changing subject. Many scholars agree that we need to move our inquiries beyond a mere focus on the West (long taken as a model to be followed by the "Rest") so as to truly globalize the study of religion. Moreover, as religion takes so many forms and shapes, moving out of—or refusing to be confined to—a separate sphere and playing a marked role in politics, education, healthcare, the arts, advertisement, and entertainment, there is need to situate our inquiries and debates in sustained cross-disciplinary collaborations that involve media scholars, journalists, theologians, historians, religious studies scholars, sociologists, political philosophers, and anthropologists so as to include all the relevant discipline-grounded expertise.

Pondering developments in the study of religion over the past 20 years, in my view three key terms stand out that are central to the reconfiguration of the study of religion in general, and the trans-disciplinary conversation envisioned by the editor of this volume: *transformation*, *materiality*, and *mediation*. First, secularization the-

ory with its inbuilt teleology gave way to an understanding of religion as being in constant *transformation* into multiple directions. The question of how (and why) religion transforms is at the core of much current research, yielding a strong emphasis on detailed case studies that place religion in broader social-cultural settings. Importantly, awareness of religion (and what we mean by it) as transforming entails a historical perspective. After all, the point is not just to state what is new, but to grasp how the present—and future—of religion and of its study are indebted to and shaped by its past. Exploring "the future of our religious past" (De Vries, 2008, p. xiv) requires that we think through the historical legacies of our analytical concepts.

This takes me straight to the second point, the question of the definition—and definability—of religion. Approaches that regard religion as first and foremost a matter of the mind—foregrounding belief, meaning, inner religiosity—were critiqued for being indebted to a typically Protestant, and hence historically situated, take on religion (e.g., Asad, 1993, pp. 27–54). This critique called not only for paying due attention to religious practices (understood not in a limited way as opposed to ideas, but as encompassing them) but also to deconstruct the hierarchy of *inward* belief over *outward* forms and practices. This hierarchy long underpinned theorizing about religion at large, as well as public opinion and policies that take the private inner self as the proper location of religion in modernity. Realizing the limitations of understandings of religion that foreground the level of the mind, scholars signaled the need to pay urgent attention to actual religious practices of engaging with things, words, pictures, and other religious forms. *Materiality* became a key term. Far from designating simply the empirical study of religious material culture from a practice perspective, the point is to "re-materialize" our conceptual approaches of religion (Meyer & Houtman, 2012; Morgan, 2010). This requires a critical engagement with the post-Enlightenment romanticist Protestant bias that still haunts the modern study of religion (Meyer, 2010a) as well as openness toward the spheres of the everyday level of "lived religion," asking how religion becomes tangible in "the world."

Third, and particularly important here, is the field of religion and media. Born out of an initial puzzlement about the rise of popular phenomena such as televangelism in the 1980s, research on religion and media soon established that the relation between these terms was far more complicated than the initial somewhat technical idea of the former "meeting" the latter suggested (Hoover & Lundby, 1997). Taking media as not opposed but intrinsic to religion brought about an understanding of religion as *mediation* (De Vries, 2001; Meyer, 2009, pp. 11–17; Stolow, 2005). Especially in the context of the Nordic Network on the Mediatization of Religion and Culture, there have been debates on how mediation relates to the notion of mediatization (e.g., Hjarvard, 2008, 2011; Lövheim & Lynch, 2011; Lundby, 2009). In the conclusion I will briefly address this question.

My main concern here is to outline why a focus on mediation as a material process—expressed in the term *material mediations,* which I took as the main title of this essay—is central to grasping the transformation of religion, both empirically and conceptually.

Media and Mediation

In anthropology a sustained interest in mass media arose only when globalization became a problematic empirical and conceptual issue (Ginsburg, 1991; Ginsburg, Abu-Lughod, & Larkin, 2002).[1] Initially, the scenario was one in which media were found to "impact" on a hitherto pre-mediated world. Local cultures were held to be prone to be deformed by global media that threatened to alienate people from their life worlds. A view of media as foreign imposers of a new logic of the trivial and banal is at the flipside of a romanticist view of culture. In the face of everyday practices, such a view proved untenable, both empirically and conceptually.[2] The dualism of authenticity and alienation was deconstructed as a symptom of a deeply problematic understanding of culture and a limited, ill-conceived media theory. The dualism expresses a longing for "the real thing" that has long underpinned the Western fascination with "other cultures"—a desire for a state that was held to be lost with the rise of modernity. As a symptom, this dualism requires our utmost attention, certainly because it is mobilized in line with the current commodification of culture—*Ethnicity Inc.* (Comaroff & Comaroff, 2009)—so as to attract global tourism. But analytically it is useless.

I myself came to study "media" because the entrance of video technology and its deployment into a spectacular and much-discussed local video-film industry in Ghana captured my attention. This prompted me to reflect on and correct my at the time limited, ill-reflected idea of media, as well as develop a dynamic understanding of culture (in terms of performance) as being simultaneously affected by and shaping "globalization" on the ground (Meyer, 2004). Venturing into the study of globalization, and by implication bumping into "mass media," was important for anthropology because it yielded a sustained critique of the notion of culture (Appadurai, 1996; Meyer & Geschiere, 1998).[3] Moving out of the pitfall that regards "culture as pre-mediated and harmonious," and mass media as artificial agents of alienation and individualization, anthropologists like myself adopted a broader understanding of media that includes, but is not confined to, mass media and that places media—and media shifts—in a long-term historical framework. Rather than "meeting" for the first time in the era of globalization (as if they were two separate entities), "media" are implied in "culture" (Mazzarella, 2004)—as well as in "religion," as I will argue below—and vice versa across time.

Let me sketch, in a nutshell, my understanding of media and mediation. My starting point is that humans relate to themselves, each other, and the "world" not in a direct way as one might intuitively expect, but through mediation.[4] Mediation rests on complex processes of transmission.[5] Transmission requires intermediaries—or, in short, media—that transmit messages between "senders" and "receivers." Note that this is not a substantive but a formal understanding of media according to which in principle anything can be made to operate as a medium. Media do not simply transport messages neutrally but shape them by virtue of their technological, social, and aesthetic properties and propensities, through specific formats and forms ("mediators" in Latour's sense [2005, pp. 39–40]). Transmission of messages organizes communication. This occurs along particular lines of social exchange, deploying specific modes of address that constitute audiences and shape forms to carry "content," raising sensibilities by appealing to particular senses and carrying particular meanings and values.

There are intriguing resonances between anthropological and philosophical understandings of mediation. Both reject the idea of an initially unmediated state of bliss and harmony—be it a genuine "culture" or a true "dialogue"—that is mischievously "disturbed" by media. In her compelling media theory,[6] the German philosopher Sybille Krämer (2008) moves away from an either strictly instrumentalist view of media as neutral means to express a message or a demiurgic view that vests media with ultimate power, as is the case with technological determinism. Embedded in practices of communication, media transmit what they are made to express, like a messenger, but at the same time shape the message by virtue of their affordances. Understanding between people does not occur out of the blue by a spiritual click—as a romanticist idea of dialogue in which the communicants blend into each other might suggest—but necessarily requires media. Krämer understands media as a "third party"—a messenger in the literal sense (*Bote*)—that engages in acts of "putting across." The German term used by Krämer, *Übertragung*, can also be rendered as "translation" from one language into another and as "broadcasting" across long distances via mass media. What people share, the "social," their "culture," is produced through practices of transmission in which media are made to bridge, but by the same token affirm, the distance and difference between those involved in communication. Note that in this perspective, there is no fundamental difference between face-to-face and distant communication. Media are the condition for the transmission and exchange of messages that make up communication. As communication cannot occur by immediate intuition (as a romanticist view would suggest), but necessarily depends on *external* media—language being the prime medium on which all others are modulated—we need to analyse communication as a concrete and material process.

Similarly, anthropologists (like myself) argue that the reproduction of what we call culture depends on a specific dynamic of transmission for which media are a sine qua non (Mazzarella, 2004; Meyer, 2011b).[7] The basic idea of "culture—and religion—as mediation" is that cultural communication is organized along horizontal and vertical axes, among people, and between people and the sacred via particular media. Therefore, if we want to understand social processes of sharing imaginaries, meanings, and values, of binding, bonding, and collaboration, we need to turn to media. They are in the middle, bridging the unavoidable differences that exist not only between "senders" and "receivers" but also between a mass of anonymous audiences, drawing them into an "imagined community" (Anderson, 1991) or, as I would put it, an "aesthetic formation" (Meyer, 2009, pp. 6–11), characterized by common ideas, values, and practices that emerge and are sustained through sharing media.

In sum, mediation captures a fundamental aspect of our relation to the "world." Rejecting the assumption of an *originally unmediated state* into which media enter with their alienating logic, and insisting on *mediation as generating communication and culture,* does not imply that our world is merely a construction, in the sense of being artificial. Mediation is the process through which our social world—"culture," if you wish—is made. This is a process that produces a shared world to be inhabited, taken for "real" and experienced as "immediate." In other words, mediation is at the core of practices of world-making that engender shared worlds of lived experience. Rather than deconstructing the rise of such worlds as mere artificial constructions, as a scholar in anthropology and religious studies I take it as my main aim to grasp how such worlds are constituted and experienced as real and immediate by their inhabitants. In short, immediacy is not prior to but rather an effect of mediation. From this perspective, immediacy is not taken at face value, but as a historically constituted romanticist desire (closely linked to the striving for authenticity) the occurrence of which requires deeper analysis.[8]

How do experiences of immediacy arise through mediation? In transmitting messages, media tend to become "invisible." This is so because the media on which communication, and hence the organization of a social world, depends are prone to be vested with taken-for-grantedness. As Patrick Eisenlohr (2009) put it, "for their habitual users they (media, BM) recede in the background, to the point of vanishing almost entirely in the face of what they mediate" (p. 9). As a result, what is mediated has the lure of immediacy. This lure emerges through routine and repetition, creating a "common sense" through which a social-cultural construction is perceived as a seemingly natural order. While media, and mediation at large, become taken-for-granted and "invisible" for insiders participating in communication, outsiders can more easily identify media and practices of mediation at work. Ultimately the point of anthropological analysis is to combine both levels, show-

ing how cultural mediation *re-produces* an everyday shared world through the work of communication, the effects of which subsequently tend to be *taken-for-granted* and only occasionally are subject to internal reflection in everyday life (Van de Port, 2011, 2012).

Obviously, from the perspective of mediation, entirely different questions arise about the "impact" of mass media on local cultures in the course of globalization. New global media (the messages they transmit and the communicative contexts in which they operate) are analysed by asking how they interfere with existing practices of mediation and modes of communication, how they relate to established forms of re-producing a "local" shared world. What is particularly compelling about the global circulation of electronic media is that they operate as both "infrastructural means" for and "privileged signs" of globalization (Mazzarella, 2004, p. 348). As signs, they convey a vision of new possibilities for connection and mobility, which they help bring about by virtue of their technology.

Take an example from Ghana, where a mobile phone advertisement states confidently, "Your world is about to change," implying that the advertized product is both a sign and harbinger of that change. Transcending boundaries of space so as to make possible ear-to-ear communication with people far away, these media clearly play into a strong desire for bridging distance and generating immediacy in an era of high mobility and dispersal. A Vodafone advertisement even promises "crystal clear sounds" and "immediate connections." This is a fine example of how a medium is vested with the promise of real dialogue and an illusion of simultaneity—a world we all share. This sharing is prefigured in that whole villages are painted in the color of a mobile phone brand, be it red, yellow, or green: a metonymic act of inscribing the local into the global.

The mobile phone advertisement uses a logic of what Bolter and Grusin (1999) call re-mediation. Looking at the promise of new media to improve communication—such as the mobile phone, which is regarded as offering direct contact, at all times and "live," among people—Bolter and Grusin argue that throughout history, new media devices have been embedded in discourses of authenticity and immediacy. They point out that remediation thrives on a "double logic": that of "transparent immediacy" and of "hypermediacy". The logic of transparent immediacy implies that media technologies are erased from the representations that they produce, making it seem as if these representations offer immediate access to reality in a raw and unmediated sense. In other words, the medium itself is rendered entirely transparent and invisible, like a window, and creates the illusion of the representation as an "authentic" presence. Hypermediacy, on the other hand, asserts multiple acts of representation—as in the case of Microsoft's Windows—and acknowledges that technology itself is "real", in that it is gradually becoming our second nature, and claims to offer ever more direct, authentic experience. In this postmodern logic,

reality is not supposed to lie beyond representation, but to be constituted by it (Van de Port, 2011). This is what is captured by the term *mediation*.

I find this perspective on (re)mediation extremely intriguing because it highlights the paradox that immediacy and authenticity, though at first sight held to be unmediated, are produced by highly technological and rapidly changing media.[9] Positioning a new medium in relation to a previous one, remediation—temporarily—cracks the taken-for-grantedness to which mediation owes its reality effect. Exactly for this reason, moments of the introduction of new media are fruitful entry points to study cultural transformation in our globalizing age. As life-worlds are constantly reproduced through mediation, with immediacy being an effect rather than a starting point, the question is: How do new media intervene in an established practice of mediation, characterized by the use of particular media, modes of transmission, and systems of communication? How does this change normalized transmission and communication?

Posing these questions is even more intriguing with regard to religion, which has long been held to be the ultimate zone for immediate, deeply existential encounters with the sacred. How do the notions of mediation and re-mediation transform our understanding of religion "as we know it" and help us grasp the role of new media in transforming religion?

Religious Mediation

Being critical of projects that aim at defining religion on a universal level, as highlighted in the introduction to this chapter, does not imply that the term *religion* would have no meaning at all. For me, religion involves a sense of "going beyond the ordinary"—call it the divine, spiritual, supernatural, invisible, or transcendent—that requires special forms of behavior, techniques of getting in touch and *extra*-ordinary sensibilities on the part of humans (Meyer, 2008, p. 705; Meyer, 2012, pp. 23–24). However, instead of taking the divine as self-revealing—as is claimed, especially, in Protestant ideas about God as the Wholly Other (as in the work of Rudolf Otto and Karl Barth)—I focus on the immanent as the location from where the "beyond" is invoked and approached through actual, empirically observable practices. As Robert Orsi (2012) put it evocatively: "Religion is the practice of making the invisible visible.... Once made material, the invisible can be negotiated and bargained with, touched and kissed, made to bear human anger and disappointment.... But the question remains: how does this happen?" The answer is, as Orsi puts it, by offering "multiple media for materializing the sacred" (p. 147).

Taking media as bridging distance through transmitting, I see no fundamental difference between religious and other mediations. As explained in a number of my

publications, I understand religion as a practice of mediation between humans and the professed transcendent that necessarily requires specific material media, that is, authorized forms through which the transcendent is being generated and becomes somehow tangible. Just as with culture and communication, religion is not a province that originally stood apart from media, as the initial puzzlement that promoted pioneering work on "religion and media" suggests. This puzzlement itself betrays a romanticist stance that suspects media to alienate people from the "real" encounter with the "living" God. However, there is no pre-mediated origin of religion. Religion rather is a hotbed for the development of religious theories about media and mediation practices (see also Schüttpelz, in press). Catholic—or, better, post-Catholic—media theory, as expressed by Orsi (2012), grasps this quite well. Authorized and authenticated in the context of incarnation and transubstantiation, media such as pictures and relics, the human body and rituals, are found to be indispensable to make the sacred *materialize*. But there are many other examples "across" religions at various times and places, as this volume also spotlights. Indeed, religion is the field par excellence to examine the deployment, authorization, and use of media in practices of religious mediation in a long-term historical perspective.

Indeed, imagining a "beyond" that demands a special mode of access and special acts, religion itself may well be characterized as a "medium of absence" (Weibel, 2011, p. 33) that effects some kind of presence of the transcendent. It renders present what is not "there" in an ordinary manner by employing multiple media (defined in a broad sense, from spirit mediums and pictures, from stones and bones, to books and computers) that train and activate the special sensibilities required for the kind of communication with a religious otherworld. From this perspective, media are understood as taking part in *effecting the transcendent* toward which humans reach out, with and about which they seek to communicate and which they strive to manipulate.

To stress the multi-sensorial channels through which media address and shape religious subjects, I have coined the notion "sensational form" (Meyer, 2008, pp. 707–710; Meyer, 2012, pp. 26–31). Negotiated and authorized within religious traditions, these forms embed media into a distinct set of practices of mediation that is characteristic for a particular religious tradition. Sensational forms are central to generating religious sensations through which what is not "there" and "present" in an ordinary way can be experienced, over and over again, as available and accessible. Evolving around sensational forms, religions entail their own modalities of make-believe that produce belief. I use form not in opposition to content, but as the necessary condition for expressing it, as well as a modality for repetition.[10] These forms, I argue, need to be at the center of the study of religion, rather than being bypassed in favour of content and meaning alone.

Sensational forms, to return to Orsi's (2012) expression, materialize the sacred. As the editors of *Material Religion* (including myself) stated recently:

Materializing the study of religion means asking how religion happens materially, which is not to be confused with asking the much less helpful question of how religion is expressed in material form. A materialized study of religion begins with the assumption that things, their use, their valuation, and their appeal are not something added to a religion, but rather inextricable from it. (Meyer, Morgan, Paine, & Plate, 2010, p. 209)

The notion of sensational form is intended as heuristic, stressing a material take on mediation so as to establish in our research that religion is reaching out to a "beyond," by way of practices that are by themselves not extraordinary. The point is to grasp how practices of religious mediation affect the perceived presence of the transcendent in the world through bodily sensations, texts, buildings, pictures, objects, and other material forms.

I would like to stress the importance of the body as a material medium. Techniques of the body (gestures, disciplines) form and train the senses so as to be able to feel the "extra"-ordinary. The way in which this occurred in my own research field, Pentecostalism in Ghana, prompted me to develop the notion of sensational form so as to be able to account for the importance of the body as a religiously constituted medium for "going beyond the ordinary" *and* as the sensorial and material ground of experience. In this understanding, experience is both personal *and* social. In other words, personal experience is shaped through particular, religiously transmitted, and embodied filters of perception.

Many scholars note that in our current "Erlebnisgesellschaft" (Aupers & Houtman, 2010; Schulze, 1993), personal experience is much sought after and regarded as ultimate proof for truth. Experience and emotions are what renders ideas and beliefs plausible. As the strong reference to the body and experience in, for instance, advertisement spotlights, there is a market that promises to fulfill—and reproduces—this quest. This mobilization of the body also is prominent in Western religiosities—in evangelical and Pentecostal churches, Islamic reform movements, as well as more individualized strivings for spirituality. They share a strong and explicit quest for experience, sensation, and embodiment (e.g., Luhrmann, 2012). As the prime site for religious experience to come about, the body is authorized as an index of divine presence—"I feel God is (in) here."

In the face of this, scholars of religion and media theorists have re-discovered the body. Not too long ago, new media were still understood as "virtual" and as overcoming the body—instigating a new immaterial Second Life. Now the body—and, more broadly, materiality—is back. The same holds for the study of religion, where the critique of narrowing down religion to belief and the level of doctrines and the subsequent turn to "lived religion" yielded an explosive interest in the body (see also Lövheim, 2011). It seems to me that this appraisal of the feel-

ing body speaks to a broader longing for a felt authentic grounding in a world that is found to be deceptive—"nothing is what it seems"—and lacking meaning (Van de Port, 2012). In my view, it is this longing for the "authentic" and "pure" that informs the transformation of religion, certainly in Northern Europe, where a new market emerged for spiritual resources, both within churches and outside, that go along with intense bodily experiences, including discipline and pleasure (Riis & Woodhead, 2010). However, instead of celebrating the appraisal of the body as a return to what really matters—life!—and dismissing language and other semiotic forms as secondary to that, it needs to be stressed that the body itself is formed through mediation: a medium that indexes its immediacy through personal and yet socially shaped experiences.

Religion Across Media

"Religion Across Media," the title of the conference on which this volume is based, signals a different set of questions than the old formula of "religion and media." Extending our inquiries not only across media but also across religions in various times and places opens up a new, exciting research field. It helps to overcome a lingering presentism that is limited to modern mass media (as is still the case in a great deal of mass communication studies) or takes the invention of print in the fifteenth century as decisive watershed (see Lied in this volume). Indeed, as Terje Stordalen shows in his study of music as a performative medium in Ancient Hebrew religion, a media perspective is able to reveal aspects of Hebrew religiosity that remain invisible within the confines of the "textual gaze" that has long been dominant in this field (Chapter 2, see also Stordalen, 2012). Extending the historical scope allows for comparative research on the use and authorization of media in practices of religious mediation and modes of world-making. Moreover, the availability of new media technologies at a given historical moment can be taken as an entry point to explore religious change. As pointed out, media are crucial factors for the formation and transformation of religion, both internally (regarding relations between leaders and followers) and externally (regarding religion's position in society). From the perspective of mediation, the incorporation of a new medium into established, longstanding religious sensational forms is not a simple transfer. My point here is that what a medium is and does is not fixed, but subject to negotiation and incorporation within a religious tradition, both on the level of theology and actual religious practice. What a medium is and does is constituted socially. Therefore, as researchers, we need to explore debates about media—media "talk"—that are articulated especially explicitly with the rise and accessibility of new technologies and media formats, but not limited to these particular moments.

The history of early Christianity (Horsfield, Chapter 3) may well be analyzed from a media perspective, examining debates about the implications of the adoption of writing into a hitherto oral setting for the organization of the church, communication among Christians, and the content of the message. The iconoclash in the aftermath of the (Calvinist) Reformation is another example. Bringing about a shift from devotional practices involving pictures and relics to bible reading, it is a prime case of a new religious media theory: a fierce critique of a previous medium in the name of a new one held to be closer to the essence of Christianity. Claiming to bring about a sense of immediacy and "live" communication, the emphasis on reading and text implies in this case a deliberate discrediting of another practice of mediation. Dismissed as "idol worship," a devotional practice with regard to pictures needs to be *de*-mediated as entirely unsuitable, replaced by a new re-mediation that promises immediate contact with the divine. Along with the spread of Protestant missions, the fierce rejection of "idols" and "fetishes" became an integral part of Protestant identity vis-à-vis "heathens" and Catholics. A trajectory of iconophobic practices has been influential in many Protestant and Pentecostal traditions, and it still is powerful, emphasizing bible reading, prayer, and increasingly embodiment as alternative forms that are sharply distinguished from other, more thing-friendly religions, be it Catholicism or indigenous religious traditions (Meyer, 2010b, pp. 107–113). At the same time, at the level of "lived religion" harsh iconophobia loses its sharpness. Also among Protestants, pictures may still play an important and possibly increasing role in personal practices of piety (Morgan, 1998). We therefore need to be alert to cleavages between religious theories of media ("media talk") and actual practices of mediation on the level of religious practitioners.

Tracing the (sought after) break with existing media and the incorporation of new media, which are subsequently transformed into suitable religious mediators, is one way to study religion across media: Media shifts may well be conceived as "technology dramas" (Beck, 2009) that articulate a new practice of religious mediation. By using the term *new* I do not want to suggest a total break; rather, I think of new practices of mediation as *re*mediations that "transcode" earlier and other media and the possibilities for sensation and experience to which they give rise (see Stordalen in this volume). Another possibility is to take one religious motif and follow its deployment *across* different media that take it *across* time and space. I would like to end this chapter with a case of such a deployment.

Recently, in the context of a larger research project on the global circulation of art and religious images,[11] I started to study, together with anthropologist Rhoda Woets (in press), the circulation of the image of the Sacred Heart of Jesus in Ghana. The rise and spread of the Sacred Heart offers an intriguing case of religion across media. Though devotions to the heart of Jesus go back into the Middle Ages, the beginning of the current devotion was the mystical encounter with Jesus experienced by the

French nun Margaret Mary Alacoque (1647–1690). She had a heavily visceral experience and trance-like vision of Jesus holding his bleeding heart in front of her (Morgan, 2012, pp. 112–120). Her own body was the medium through which she felt a deep encounter with Jesus. Her experiences, which she described in a set of letters toward the end of her life, became reworked into a spiritual guide that circulated as a booklet, fueling a revival of the devotional practice of the Sacred Heart (and at the same time contested within the Catholic Church). Alacoque's experience spoke to the popular Catholic imagination. This yielded a number of visual representations. Pompeo Batoni's *Sacred Heart of Jesus* painting (1767), placed in the Jesuit Il Gesu Church in Rome, became the prime pictorial model around which this devotion spread (Morgan, 2012, p. 119). Recycled in numerous versions, it circulated and still circulates via prints, posters, tattoos, and, recently, devotional websites and online shops. It is a sensational form that is now mass-produced in China and spreads via lines that are no longer controlled by the Catholic Church.

Interestingly, in the Ghanaian setting the Sacred Heart of Jesus picture emerges in several shapes, including mass-produced calendars, framed mass-produced pictures, stickers, and paintings. The Sacred Heart is central to Catholic piety with its authorized devotion to the Sacred Heart, but it also is popular outside of Catholic circles. On the level of everyday religious practice, Protestants—in Africa and elsewhere—prove to be less iconophobic than strict Calvinist reformation theology might suggest. In actual practice, for Ghanaian Protestants the picture of Jesus is an important material item, placed at the center of a domestic prayer site. While people insist that they do not "worship" the picture (that this argument needs to be made over and over again shows how powerful the nineteenth-century missionary discourse on "idol worship" still is), many attribute it with power: to remind you of what is good when you have something bad in mind, but also the power to prevent others from doing evil, protecting those who put the Jesus picture into their house against robbery and other attacks. Often people stress that the power imbued in the picture is due to the look of Jesus: his eyes and that of the beholders meet in a chiastic relation of seeing and being seen. At the same time, some people contest the pictures as dangerous "idols." The key problem for these opponents lies in Jesus's penetrating gaze. They claim that his familiar and dear face is just a façade behind which devilish power operates in secret (Meyer, 2010b, p. 119ff). The Devil, people say, is a master of deception who uses a picture of Jesus as the perfect mask. Nothing is what it seems, and nice appearances are particularly deceptive, and this is why one has to "be vigilant."

Exploring the Sacred Heart as a religious motif that circulates and assumes form across media, two issues are particularly intriguing. One concerns the extension of an originally Catholic pictorial item across other religions (Protestantism and also indigenous cults). From the perspective of mediation, as advocated here, the ques-

tion is how the picture is transferred from one practice of mediation (Catholic, with a specific take on pictorial devotion) into a more loosely defined popular Christian religiosity that still rejects "idol worship" but at the same time accommodates the picture into practices of prayer and of assuring oneself of divine protection. More research is needed, but in my view it can already be stated that the fascination with the picture pinpoints a shared emotional religiosity of the heart, which is generated through an intimate, sensorial encounter with the Jesus picture.

The second issue concerns mass mediation. Clearly, the fact that the pictures are mass-produced and reach Ghana through opaque global circuits (uncontrolled by Rome) does not prevent people from engaging with the picture in an intimate way. Through long-term devotional use and prayer, the picture becomes more and more personal—difficult to be done away with even when it gets old and bleak. The encounter with the picture is both visual and visceral, resonating intriguingly with the origin of the picture in Alacoque's trance-like experience. This runs counter to a simple idea of technologies of mass reproduction as disenchanting forces that destroy the "aura" of the original (as a simple reading of Walter Benjamin would have it). Through appropriation and devotional practice a picture of Jesus *becomes* an "original" resource. It is singled out and personal, yet other reproductions are shared by many others at the same time. Originality and mass-production do not contradict each other but rather interlock, enhancing the picture's power. Ending up in the format of the calendar poster does not necessarily disenchant the picture but rather incorporates it in a heavily experience-centered religiosity that engages with the picture through an animated exchange (Meyer, 2011a).

So far, in our research we have only been able to explore the circulation and emplacement of the picture in the Ghanaian setting. The Sacred Heart flourishes on a global scale—including in the "West"—and this would warrant more attention (Napolitano, 2007). I regard the Sacred Heart as a fascinating case for studying the circulation of a religious motif across media that, by virtue of technological mass-production, seem to fuel the concomitant reproduction *and* transformation of religion via the embracement of new media technologies. If, from the outset, Christianity was instigated to be a "world religion"—"spreading the word" across the world—the case of the Sacred Heart shows that mass-production need not put an end to, but may rather further, this process.

Epilogue

Mediation, as I tried to explain in this chapter, is not a theory but an epistemological starting point from which the formative role of media—including, but not limited to, mass media—as a constitutive part of religion can be acknowledged theoretically and

rendered fruitful with regard to diverse research fields in the study of religion. The shift from the initial opposition of "religion and media" to the study of "religious mediations" in a broad historical-comparative framework signals a new theoretical standpoint. As this volume testifies, the turn to mediation facilitates the study of religion *across* media, *across* time and space, and *across* disciplinary boundaries. This has far-reaching and promising implications for the study of religion at large.

As I argued, one reason the "religion and media" opposition is problematic for the study of religion is that it transports a hidden "media theory" according to which media are held to be secondary to immediate encounters with the transcendent. By contrast, taking mediation as a starting point allows us to explore how immediacy turns out to be a product of mediation, rather than an original state. What intrigues me in studying changes in religious mediations, be they radical breaks between one medium and another or the embrace of new media to contain and transcode a motif such as the Sacred Heart across time, is the question of how reality is effected through mediation. In other words, how are religious life worlds construed and at the same time vested with an aura of truth through which religious beliefs and practices become plausible? In my view, this is a key question with regard to the transformation of religion on a global scale. Religion, in various shapes and forms, is called upon to produce emotionally grounded experiences that offer some kind of security and certainty in a world in which "all that is solid melts into air"—capital included. In this sense, religion may well be analysed as a longed for "messenger" (or medium) of "the real" (Van de Port, 2012) that is an important resource for credible world-making. The "real" that is longed for remains situated in a limbo between desire and promised fulfillment. There can be no stable, ultimately satisfying answers and solutions, as religion is subject to the same processes of transformation that make people call for the "real."

Although attention to media has been central in my work over the past decade, the questions I raise from my disciplinary background in anthropology and religious studies are quite different from those addressed in the context of scholarship on mediatization. I would agree with those championing mediatization that within all spheres of social life in contemporary Western societies—and indeed throughout the world—mass media and social media play a central role in organizing communication (with the latter allowing for new forms and formats of political mobilization). Clearly, media formats and aesthetic conventions and modes of address shape politics, the economy, or religion. This is an intriguing process, and I acknowledge that work inspired by the mediatization thesis can be helpful in analysing these recent transformations.

What worries me, however, is the partly explicit, partly implicit teleology implied in "mediatization," suggesting a shift in late modern societies as a result of which "the media" becomes the key institution that imposes its media-logic on

other institutions, including religion. This is particularly pronounced in Stig Hjarvard's theory of mediatization, which regards "media as agents of religious change" (2008; see also 2011). Though I am certainly prepared to look at media as "actors" that operate in a particular social field (as proposed by Latour's Actor Network Theory; see Clark, 2011), I am suspicious of any invocation of "the media" as prime movers of society and culture. Acknowledging that media may operate as "actors" is not the same as a reificatory approach of media. What media are and do is constituted socially and needs to be uncovered through our analysis. This kind of analysis, that looks at media as both constituted by and constitutive of transmission and communication, is what a practice-centered approach as the one advocated in this chapter can contribute.

Mediatization, Hjarvard (2008) argues, produces a particular type of ("banal") religiosity emerging in Northern Europe in the slipstream of secularization (p. 10, 12). As explained in the introduction, like many scholars studying religion I am not convinced of the explanatory power of secularization, certainly on a global level.[12] Since mediatization theory was developed in response to a specific dynamic of differentiation in late modern Western societies, the question is whether "mediatization" can at all be fruitfully extended into a broader, historical, and global theory of the transformation of religion through "media." Hjarvard's (2011) point that mediatization refers to a specific development in modern societies (p. 124) would contradict the general applicability of this notion to earlier periods and other places where the processes of system differentiation described by Hjarvard with regard to Scandinavian societies did or do not (yet?) take place. Therefore, mediatization remains a limited, though to some extent useful, concept.

While mediation and mediatization converge in placing emphasis on media,[13] this convergence may also be deceptive, in that media mean different things and hence lead into different, partly discipline-specific universes of discourse. Clearly, to achieve fruitful discussion and enhance our understanding, it is necessary to explicate the "media theories" and larger questions that underpin our interest in and thinking about "media." This is one of the main concerns of this volume and with this chapter I hope to make a constructive contribution to establishing a truly interdisciplinary forum.

Acknowledgments

I would like to thank Knut Lundby, Terje Stordalen, and the members of the Focus Group "Media, Arts, Aesthetics" (Department of Religious Studies and Theology, Utrecht University) for stimulating comments on earlier versions of this chapter. Funding for the research on which this chapter is based was provided by the

Netherlands Foundation for Social Science Research (NWO) and HERA, in the context of the Cultural Dynamics Schemes.

Notes

1. That is, in media recognised as such. There is a lot of work on orality and literacy (e.g., by Walter Ong and Jack Goody) that was, however, not identified as "media" research. The same argument could be made regarding prime "media" such as language and the body.

2. It yielded a somewhat celebratory stance toward audiences that credited them with the capacity to interpret media messages in entirely different ways than intended. This stance is still indebted to the dualism described above, according to which audiences are regarded as resisting dominant media messages in the name of their local, cultural understandings.

3. That this occurred at a time in which "culture" was found by other disciplines—including media studies—and common sense in global parlance is an irony that cannot be further addressed here.

4. I would like to acknowledge that the fact that it still seems important to stress "not in a direct way" betrays an underlying expectation that immediacy and immersion would be the default position. Our thinking about media appears to be informed by a romanticist idea of immediacy and authenticity (Van de Port, 2012, pp. 864–866). I would like to stress that in emphasizing mediation, I do not intend to end up with the claim that our world is "merely" a construction (this would still indirectly reflect the romanticism that I reject). Instead I take construction literally as a tangible productive process. Exactly for this reason I use the expression *material* media. See below.

5. I do not have in mind here a technical model of communication between sender and receiver, involving processes of en-coding and de-coding. Stressing the mediated character of communication, my point is rather epistemological. As Johannes Fabian (2001) put it: "Mediated means that experiences (and our understandings) are made, shared, and transmitted by means (lit. things in the middle, media) that include language (in the broadest sense of the term), practices of communication and representation, and material objects....Culture is a discourse on mediations and practices" (p. 7876).

6. Her theory is grounded in the thinking of Walter Benjamin, Jean Luc Nancy, Michel Serres, Regis Debray, and John Durham Peters.

7. Therefore culture can best be analysed as a practice of mediation through which, as William Mazzarella (2004) puts it, "a given social dispensation produces and reproduces itself in and through a particular set of media" (p. 346).

8. Moreover, as Mattijs van de Port (2012, see also 2004) points out, the "cultural construction of the real" may also tap into other registers than the romanticist concern with authenticity and immediacy, including Camp and the Baroque.

9. Nonetheless I still have a problem with Bolter and Grusin (1999). They represent remediation as an unbounded process of absorption. This is quite typical for a lot of work in media studies that tends to view media as the central actors. I think that we need to transcend such a media-centric perspective and acknowledge that remediation is shaped and governed by established mediation practices, and hence subject to power relations (Meyer, 2005).

10. Indeed, religion is defined by structures of repetition that require particular forms (Groys, 2011, p. 25).

11. This project takes place in the Creativity and Innovation in a World of Movement (CIM) programme (directed by Maruska Svasek in the context of the HERA cultural dynamics funding scheme). See http://www.qub.ac.uk/sites/CreativityandInnovationinaWorld ofMovement/

12. Indeed, the whole point of the shift from the notion of "secularization" to the "transformation of religion" is the acknowledgment that actually on a global level religion does not develop in line with—and hence does not confirm—theories of modernization (and by implication secularization).

13. In my conference presentation I asked: Would it be possible to incorporate the theory of mediatization into a broader epistemology of mediation? What would mediatization theory say about the dynamics of world-making that stand central in this lecture? Is "banal religion" suitable as a term to capture the urge for immediacy and authenticity that fuels (re)mediation as I understand it?

References

Anderson, B. (1991). *Imagined communities: Reflections on the origin and spread of nationalism* (rev. ed.). London: Verso, 1991.

Appadurai, A. (1996). *Modernity at large. Cultural dimensions of globalization.* Minneapolis: University of Minnesota Press.

Asad, T. (1993). *Genealogies of religion: Discipline and reasons of power in Christianity and Islam.* Baltimore and London: Johns Hopkins University Press.

Aupers, S., & Houtman, D. (Eds.). (2010). *Religions of modernity: Relocating the sacred to the self and the digital.* Leiden: Brill.

Beck, K. (2009). Technological dramas in the Islamic reshaping of the Sudan. Paper presented at AEGIS conference, Leipzig, July.

Bolter, J. D., & Grusin, R. (1999). *Remediation: Understanding new media.* Cambridge, MA: MIT Press.

Clark, S. L. (2011). Considering religion and mediatization through a case study of J+K's big day (The J K wedding entrance dance): A response to Stig Hjarvard. *Culture and Religion: An Interdisciplinary Journal, 12*(2), 167–184.

Comaroff, J., & Comaroff, J. (2009). *Ethnicity, Inc.* Chicago: University of Chicago Press.

De Vries, H. (2001). In media res: Global religion, public spheres, and the task of contemporary religious studies. In H. de Vries & S. Weber (Eds.), *Religion and media* (pp. 3–42). Stanford, CA: Stanford University Press.

De Vries, H. (Ed.). (2008). *Religion: Beyond a concept.* New York: Fordham University Press.

Eisenlohr, P. (2009). What is a medium? The anthropology of media and the question of ethnic and religious pluralism. Inaugural lecture. Utrecht University, May 26.

Fabian, J. (2001). Interpretation in anthropology. In N. J. Smelser & P. B. Baltes (Eds.), *International encyclopedia of the social & behavioral sciences* (pp. 7874–7878). Amsterdam: Elsevier.

Ginsburg, F. (1991). Indigenous media. Faustian contract or global village. *Cultural Anthropology,* 6(1), 92–112.

Ginsburg, F., Abu-Lughod, L., & Larkin, B. (Eds.). (2002). *Media worlds: Anthropology on new terrain.* Berkeley, CA: University of California Press.

Groys, B. (2011). Religion in the age of mechanical reproduction. In B. Groys & P. Weibel (Eds.). *Medium religion. Faith. Geopolitics. Art.* (pp. 22–29). Köln: Walther König.

Hjarvard, S. (2008). The mediatization of religion. A theory of the media as agents of religious change. *Northern Lights, 6,* 9–26.

Hjarvard, S. (2011). The mediatization of religion: Theorising religion, media and social change. *Culture and Religion: An Interdisciplinary Journal, 12*(2), 119–135.

Hoover, S. M., & Lundby, K. (Eds.). (1997). *Rethinking media, religion, and culture.* London. Sage.

Krämer, S. (2008). *Medium, Bote, Übertragung. Kleine Metaphysik der Medialität.* Frankfurt am Main: Suhrkamp.

Latour, B. (2005). *Reassembling the social. An introduction to actor-network-theory.* Oxford: Oxford University Press.

Lövheim, M. (2011). Mediatization of religion: A critical appraisal. *Culture and Religion: An Interdisciplinary Journal 12*(2), 153–166.

Lövheim, M., & Lynch, G. (2011). The mediatization of religion debate: An introduction. *Culture and Religion: An Interdisciplinary Journal 12*(2), 111–117.

Luhrmann, T. M. (2012). *When God talks back: Understanding the American evangelical relationship with prayer.* New York: Knopf.

Lundby, K. (2009). Introduction: "Mediatization" as a key. In K. Lundby (Ed.), *Mediatization: Concept, changes, consequences* (pp. 1–18). New York: Peter Lang.

Mazzarella, W. (2004). Culture, globalization, mediation. *Annual Review of Anthropology, 33,* 345–367.

Meyer, B. (2004). "Praise the Lord…." Popular cinema and pentecostalite style in Ghana's new public sphere. *American Ethnologist,* 31(1), 92–110.

Meyer, B. (2005). Religious remediations. Pentecostal views in Ghanaian video-movies. *Postscripts 1*(2/3), 155–181.

Meyer, B. (2007). Pentecostal and neo-liberal capitalism: Faith, prosperity and vision in African Pentecostal-charismatic churches. *Journal for the Study of Religion, 20*(2), 5–28.

Meyer, B. (2008). Religious sensations. Why media, aesthetics and power matter in the study of contemporary religion. In H. de Vries (Ed.), *Religion: Beyond a concept* (pp. 704–723). New York: Fordham University Press.

Meyer, B. (2009). Introduction. From imagined communities to aesthetic formations: Religious mediations, sensational forms and styles of binding. In B. Meyer (Ed.), *Aesthetic formations. Media, religion and the senses* (pp. 1–28). New York: Palgrave.

Meyer, B. (2010a). Aesthetics of persuasion. Global Christianity and Pentecostalism's sensational forms. *South Atlantic Quarterly, 9,* 741–763.

Meyer, B. (2010b). "There is a spirit in that image." Mass produced Jesus pictures and Protestant Pentecostal animation in Ghana. *Comparative Studies in Society and History, 52*(1), 100–130.

Meyer, B. (2011a). Mediating absence—effecting spiritual presence. Pictures and the Christian imagination. *Social Research: An International Quarterly, 78,* 1029–1056.

Meyer, B. (2011b). Mediation and immediacy. Sensational forms, semiotic ideologies and the question of the medium. *Social Anthropology, 19*(1), 23–39.

Meyer, B. (2012). Mediation and the genesis of presence. Towards a material approach to religion. Inaugural lecture, Utrecht University, October 19.

Meyer, B., & Geschiere, P. (1998). Introduction. In globalization and identity. Dialectics of flow and closure (Special Issue). *Development and Change, 29*(4), 601–615.

Meyer, B., & Houtman, D. (2012). Material religion—How things matter. In D. Houtman & B. Meyer (Eds.), *Things—Religion and the question of materiality* (pp. 1–23). New York: Fordham University Press.

Meyer, B., Morgan, D., Paine, C., & Plate, S. B. (2010). The origin and mission of *Material Religion. Religion, 30*, 1–5.

Morgan, D. (1998). *Visual piety. A history and theory of popular religious images.* Berkeley, CA: University of California Press.

Morgan, D. (Ed.). (2010). *Religion and material culture. The matter of belief.* New York: Routledge.

Morgan, D. (2012). *The embodied eye. Religious visual culture and the social life of feeling.* Berkeley, CA: University of California Press.

Napolitano, V. (2007). Of migrant revelations and anthropological awakenings. *Social Anthropology, 15*(1), 71–87.

Orsi, R. (2012). Material children. Making God's presence real through Catholic boys and girls. In G. Lynch & J. Mitchell (Eds.), *Religion, media and culture: A reader* (pp. 147–158). New York: Routledge.

Riis, O., & Woodhead, L. (2010). *A sociology of religious emotion.* Oxford: Oxford University Press.

Schulze, G. (1993). *Die Erlebnisgesellschaft—Kultursoziologie der Gegenwart.* Frankfurt: Campus.

Schüttpelz, E. (in press). Trance mediums and new media. The heritage of a European term. In H. Behrend, A. Dreschke, & M. Zillinger (Eds.), *Trance mediums and new media.* New York: Fordham University Press.

Stolow, J. (2005). Religion and/as media. *Theory, Culture and Society, 22*(4), 119–145.

Stordalen, T. (2012). Locating the textual gaze—then and now. *Material Religion, 9*(1), 521–524.

Van de Port, M. (2004). Registers of incontestability. The quest for authenticity in academia and beyond. *Etnofoor, 17*(1/2), 1–24.

Van de Port, M. (2011). (Not) made by the human hand. Media consciousness and immediacy in the cultural production of the really real. *Social Anthropology, 19*(1), 74–89.

Van de Port, M. (2012). Genuinely made up: Camp, baroque, and other denaturalizing aesthetics in the cultural production of the real. *Journal of the Royal Anthropological Institute (N.S.), 18*, 864–883.

Weibel, P. (2011). Religion as a medium—the media of religion. In B. Groys & P. Weibel (Eds.), *Medium religion. Faith. Geopolitics. Art* (pp. 30–43). Köln: Walther König.

Woets, R. (in press). The moving lives of Jesus pictures in Ghana. Art, authenticity and animation. In M. Svasek & B. Meyer (Eds.), *Creativity in transition.* Oxford: Berghahn.

Media of Ancient Hebrew Religion

TERJE STORDALEN

The analytical categories of media and mediation have not been dominant in the study of ancient Levantine cultures.[1] It seems to me, however, a media perspective is capable of profiling aspects of ancient Hebrew religion that are not equally visible through other lenses. If pursued to the end this perspective might well change the way we perceive ancient Hebrew religion. This chapter is a, first, explorative attempt at laying some foundation for such research and to provide analysis of one single example. Let me start by clarifying what, more precisely, is the topic when turning to the 'media of ancient Hebrew religion.'

Religion

The concept of religion has proven difficult to define. For the present purpose we only need a preliminary definition to be used in this survey of ancient Hebrew culture. The definition must, however, enable us to start reflecting on religious media in historically reasonable ways. In the setting of pre-Roman Hebrew culture one need not worry too much about whether or not engagement with personified spiritual powers/gods are characteristic of religiosity: They are. On the issue of whether religion should be seen as a body of practices or of thought, I would for linguistic reasons (see below) opt for practice and action as the fundamental category, recognising that ideas or convictions expressed or implied in such practices are part of

the phenomenon. In the case of ancient Israel some religious practices were starkly oriented toward thought, such as those scribal practices that left us the biblical record. In such cases, one might say thinking is part of the practice. One modernist topic that has no place in the study of ancient religion is the view of religion as a private, individual, and interior (psychological) phenomenon. Anyone familiar with ancient Hebrew culture knows religion was both communal and individual in various configurations and often across the modern distinction between public and private. This is evident, for instance, in its shared cultural habits (circumcision, food habits, etc.), official ideology (as in royal mythology), or deeply existential public reflection (as in psalms of lament).

More problematic is the assumption that the 'body of religion' of a cultural group would be consistent, or coherent. For the current purpose I wish to avoid making that assumption, and shall in the end argue that ancient Hebrew religious media practices were in many ways probably not coherent or contiguous (socially, conceptually, etc.). So why would I nevertheless regard media of *religion* as one body? Would individuals in ancient Hebrew culture have recognised religiously charged practices in various settings as in some sense comparable? This is tantamount to asking whether there existed in ancient Hebrew culture a notion of anything similar to our concept of religion. Scholars seem to disagree on that issue. On the one hand, one will not find the English gloss 'religion' in historical dictionaries of biblical Hebrew,[2] and present-day Western bible translations often do not use the term 'religion' until they reach the later, Greek parts of the bible.[3] A comprehensive lexicon such as *Theologische Realenzyklopädie* does not trace the concept of religion further back than to late antiquity (Wagner, 1997). On the other hand, most scholarly analyses of the religion of Israel seem to take it for granted that 'religion' is an adequate analytical concept for historical studies of the Bronze and Iron Ages and early antiquity.[4]

In my view there are reasons to believe that ancient Hebrew people did perceive cults for different deities performed in widely diverse settings as belonging to the same class of action. Indications for that can be found when working backwards from the Latin and Greek bibles of late antiquity. The Latin Vulgate (translated by Jerome some 400 of the Common Era [CE]) applied words from the stem *religio* in a few translations of Hebrew terms.[5] The earlier Greek Septuagint (some 200 to 100 BCE) had a larger number of Greek terms where the later Vulgate used *religio*.[6] Tracing these Greek terms back into the Hebrew gives a view of what late antique Hebrew users like Jerome perceived as part of the semantic domain 'religion.' Pondering these Hebrew terms and their semantic fields, one starts approximating a sense of how earlier Hebrew people perceived matters that late antique Hebrew speakers saw as 'religion.' This is indeed a complicated issue, and it is baffling that it still seems to be unexplored. Without here being able to make the full argument, I hold that the biblical Hebrew terms sampled next denoted practices, attitudes,

and ideas that language users at the time would have been likely to associate to distinct cultic settings and still perceive as belonging to one semantic domain that we with modern classifications would call religion (where relevant I indicate only the Hebrew root consonants):

- 'to fear'/'the fear for' [a named deity] (ירא)
- 'serve'/'the service for' [a named deity] (עבד)
- 'to call upon the name' [of a given deity] (קרא בשם)
- 'expressing/having faith' [implicitly: within a given tradition] (אמן)
- encountering certain qualities that are characteristic for (specific?) deities, such as glory (כבוד) or holiness (קדש)
- such qualities are often encountered through religious experts such as priests, prophets, or scribes (numerous Hebrew terms) associated to specific cults/deities
- performing sacrifices [sometimes for a named deity] (numerous Hebrew terms)
- performing (ritual or habitual) expressions of veneration, joy, and grief [sometimes addressing a named deity] (numerous Hebrew terms)
- also important for mapping the semantic field are a number of negative denotations, such as idolatry and foreign cultic habits, implicitly confirming these activities are perceived as being of the same class as proper service and familiar religious habits

For the present purpose these examples should warrant an attempt to analyse diverse religious Hebrew media practices as an identifiable body despite varieties and even religious antagonism. They should also explain why I perceive ancient Hebrew religion primarily as action: Most of the terms mentioned above (including, for instance, 'fear' and 'serve') denote religiously charged action.

Media

This chapter applies what Birgit Meyer in this volume (and elsewhere) calls a broad definition of media.[7] In this perception a medium would be any device that facilitates communication between human beings including, say, technological or social structures and traditions needed to perform communication. To avoid a too broad and intractable concept of media, I say a device qualifies as a medium of religion only when it is used to produce a religiously charged symbolization (see next paragraph). While clothing is not always a religious medium, it is so when used to make some religiously relevant statement.

Media do not transport messages neutrally from sender to receiver; they provide shape, sensational activation, social setting, etc., to that message 'by virtue of their technological, social, and aesthetic properties and propensities, through specific formats and forms' (Meyer, Chapter 1, p. 4). All media rely on some symbolic or semantic system of signification to produce symbolic representations of the subject matter at hand. One of Meyer's points is that limiting the study of a given act of communication to its symbolic representation would be reductionist. If media are material frameworks enabling and constraining certain sets of social practices (Mazzarella, 2004, p. 346), the study of an act of communication should consider also, for instance, the social positioning and the sensational filtering provided by the medium. In the view adopted here, there is no process of 'sharing imaginaries, meanings and values, of binding, bonding and collaboration' (Meyer) that is not mediated. New generations in a group are socialised—or, if you like, cultured—by connecting to cultural media much in the way that children learn to understand and use language. In principle, everything a given group needs to share about its religion is negotiated in its religious media.

This renders the totality of a given group's cultural media highly relevant as historical documentation. For our purpose, we are particularly sensitive to cultural historical *diversity*. Social anthropologist Michael Carrithers (1992) takes the human capacity to perceive, perform, modify, and transmit a joint perception of life as the backbone of human *sociality*. Sociality is based on human cognitive, emotional, and social faculties that cause human individuals to perform a huge variety of social relations. The precise structures and symbolic representations invested in each case are, however, not generated by human physiology: They largely depend on the historically formed cultural record of that group (see Carrithers, 1992, pp. 55–75). In short, media would be arenas of what Carrithers called 'distributed processing' (p. 57). They reflect processes of encoding and decoding distributed cultural memory— what Edward Casey (1987) called 'memory not in the brain or mind but *in the world*' (p. 310; emphasis in original).[8] Hence, where the neurologist turns to the physiology of the brain to study individual memory, the cultural historian may turn to the material, social, symbolical, and other ecologies of various media to study processes of encoding and decoding of collective or distributed memory.

The media holding ancient distributed memory must have been diverse. Since the majority of people were illiterate, a study of ancient Hebrew religious media must include what Paul Connerton (1989) called non-inscribed memory: memory encoded in ritual, food habits, clothing habits, and other medial practices that do not use philological technologies to produce their symbolizations. As documented by archaeology of the region, common media such as pottery or clay figurines did rely on traditions of production technology, craftsmanship, and artistic expression. These traditions could be local or trans-local, and in either case they would be in

exchange with adjacent cultural traditions. Turning to inscribed media, we need to consider the distinction between canon and archive as established by Aleida Assmann (2008). The canon represents the past as the remembering group recalls it. Canons take on ideological and iconic functions and cannot be seen as simply representing historical fact (see Stordalen, 2012c).

Products in any medium were what Pierre Bourdieu (1993, 1996) would call cultural products. They were manufactured and circulated in fields that defined the distribution of power: Some parties had the power to define the product, others to dominate the economy of the field, while still others defined the symbolic capital of the field.[9] Various media would have various markets: Elite literature, for example, must have had a different circulation than cheap clay votive figurines. So differences in materiality could indicate different social framings for symbolizations that in other respects seem similar. For instance, while some have argued to see non-figurative 'standing stones' as indications of Israelite aniconism,[10] a media perspective is likely to say such stones were in fact the icons of a tradition that did not have the economy, convention, or inclination to have their icons figuratively elaborated. If so, it is hardly relevant to interpret standing stones raised by nomadic cultures through the prism of the sedentary elite and anti-iconic symbolization found in Deuteronomic literature of the bible.

Various media activate distinct sensory registers: Pictures communicate differently than texts, and performative media such as ritual, dance, or music engage an even wider sensory reception. If we see media as an intrinsic part of religion that helps in locating and shaping religious practices and experience (Meyer, 2011), this sensory variation may prove vital. In any event, this renders religion a factor in the emergence of 'aesthetic formations,' that is, the more or less continually forming of groups generated through shared sensory experience of the world (Meyer, 2009).

Ancient Hebrew Source Records

In the view of Michael Carrithers (1992), sociality explains our baffling capacity for social variation (pp. 1–4, 31–54). If various media of ancient Hebrew religion did generate specific social imaginaries through distinct aesthetic formations, we could not reconstruct the religion of ancient Israel primarily on scriptural sources without reflecting on the location of these texts in the larger web of ancient Hebrew religious media. Nevertheless, biblical studies has had a tendency to privilege textual media over other available sources and to assume that textual representations formulate systems of sense (semantic, symbolic, moral) by which all contemporary sources and media could be legitimately interpreted.[11] This position needs to be challenged.

First, it is evident that ancient Hebrew religion had a number of media whose symbolizations are lost: Only faint echoes of the media themselves remain, such as pictures of people performing religious music, or narratives randomly reflecting cultic offering, dancing, and other performances. Symbolizations that could not be contained in the scriptural or archaeological record were lost. Second, the fact that the biblical text became canonised meant that many media documented in the archaeological record (inscriptions, ostraca, figurines, carvings, cultic spaces, etc.) were later read according to scriptural systems of sense, and in practice were often muted as legitimate sources for ancient Hebrew religion.[12] Scholarship must break out of such limiting interpretive strategies by (a) starting to reconstruct a perception of the totality of ancient Hebrew religious media and (b) trying to explore how individual media in the archaeological and biblical records were located in this totality. We also need to form a critical genealogy of the 'textual gaze' of biblical studies (and of most other modern academic disciplines; see Stordalen, 2012b) and to see how the (current) canonicity of the biblical sources has sedimented itself in interpretive practices in the discipline of biblical studies.[13]

Music and Dance: Media of Ancient Hebrew Performative Religion

It is not possible to know the totality of ancient Hebrew religious media: Many media, media practices, and symbolizations are lost forever. Does that mean we are unable to pursue how different media provided shape, sensational activation, social setting (Meyer, Chapter 1) in ancient Hebrew religion? I do believe it is possible to explore at least some aspects of these questions. Indeed, I think that the interpretation even of Hebrew textual media improves as we sharpen our sensibilities for the existence of parallel religious media.

The most difficult media to reconstruct are the performative ones, such as music, dance, rites, and symbolic behaviour. If religion is understood as practice, these media are of primary historical value. Several of them would to a large degree have provided shapes, sensational activations, and social settings that were quite different from those of textual media. They should have a lot to contribute to our view of ancient Hebrew religion. Most importantly, performative media produced religious symbolizations that were vastly more widespread than the elite scriptural symbolizations recorded in the bible. In the following I briefly focus on performative medium—music, with a sideward glance to dance—to try to illustrate what kind of research a media perspective on ancient Hebrew religion could produce.

Music (and dancing) relied on traditions for making and playing instruments of various sorts, on schooling, and individual training. It was an evidently perfor-

mative medium, and yet it did leave traces in the historical record. Joachim Braun (2002) and Theodore Burgh (2006) have provided convenient overviews of textual and archaeological sources for reflecting on music (with dance) as a medium in ancient Palestine.[14] The sources tell a story of an 'autochthonous local musical culture which in many aspects was congenial to the great neighbouring musical cultures' (Braun, 2002, p. 5). Braun claims the Levantine tradition had identifiable features from the Chalcolithic and Early Bronze throughout the Byzantine period (some 500 CE). Musical practices using rattles, bells, and the human body seem to have been quite widespread. However, already in the late Chalcolithic there developed an elite musical culture of professional musicians using instruments that were more complicated to produce and operate (pp. 63–65). This social split continued (and transformed) throughout the period (pp. 93f; 133). In a media perspective, Braun's book documents the existence of a number of musical media (instruments, repertoires) and traditions (styles of composition and performance, social settings). It also documents that these media and traditions were important to religion—from common through royal and national rituals.[15] This picture is generally in tune with implications found in (partly later) comparative evidence.[16] Clearly, the scriptures now found in the Hebrew bible came out of a media texture where musical practices were probably more influential than those scribal practices that produced biblical texts.

Assuming that the scriptural record represents a minority outlook upon the world behind the Hebrew scriptures makes way for new insights. Take the issue of rhythm. The material record indicates that the musical repertoire would have had rhythm as a carrying musical structure, especially in more popular culture (rattles, bells, body drumming, small tambourines). In a comparative and phenomenological perspective rhythmic music and dance underpins, for instance, the kind of ecstatic prophetic-ritual performances that Annie Caubet (1996) found in Ugarit (second millennium BCE) and which in fact surface several times in biblical scriptures, too.[17] Biblical scholars still tend to regard such practices as peripheral to the core of biblical religion, despite Gary Anderson's (1991) brilliant documentation more than 20 years ago that musical dancing was a cultural practice for expressing (indeed: symbolizing!) grief and joy in ancient Israel. A host of biblical passages indicate that singing and dancing practices were part of a thick cultural web.[18] Still, biblical literature does not recognise any significant religious function to these practices: They occur as decorative of salvation history.

To a mind cultured in the Western European tradition it is not easy to perceive the characteristics of a religion that was symbolized, performed, and experienced through musical-rhythmical media. By all probability these religious practices would have been described by their uses in ways that differ from the concepts of religion underpinning modern research. Biblical scholars could have a first glance

into the world of sung and danced religion through the brilliant essay of Steven Friedson (2005) on trance dancing in contemporary Western Africa.[19] Friedson says that '[i]nstead of suppressing the body as an antithesis of a translucent knowledge guaranteed by intellection, trance dancing privileges the body as the cite of a gathering that declines into the world' (p. 110). And further, '[p]ossession trance may not be amenable to a retelling because the happening is not linguistically coded, but musically experienced' (p. 118). Friedson describes the frustration of a European encountering the music of the Ewe people. Because Western music privileges a linear metrical scheme, Europeans appropriate music by perceiving the first beat of every bar. In African music there are usually two or more rhythmical meters going on at the same time, opening a number of combinations that are not easily grasped by a musical ear cultured in the West (pp. 119–124)—although Europeans who experienced it would often testify that this music captured and moved their bodies.

I am not suggesting that ancient Hebrew and current Ewe music are the same. What I am suggesting is that the challenges for European biblical and religious scholars in perceiving ancient Hebrew religion may be similar to those of European ethnomusicologists approaching African music. It seems likely that ancient Hebrew media produced religious symbolizations that are as different to biblical scholars as Ewe rhythm is to European musicology. The situation reminds me of a passage in Michel de Certeau's book *The Practice of Everyday Life* (1984). He addressed the dichotomy between the standard *concept* of a city and those *practices* that constitute urban experience, describing the walking of pedestrians as 'one of these real systems whose existence in fact makes up the city.' One could symbolize this practice by plotting it to a city map. However, '[t]hese fixations constitute procedures for forgetting. The trace left behind is substituted for the practice. [This] causes a way of being in the world to be forgotten' (p. 97; see pp. 91–110). In view of the material above, there is reason to ask whether perhaps European intellectual maps for exploring ancient Hebrew religion have also caused ways of being in the world to have been forgotten. One way of exploring that issue would be to pay attention to echoes of the plethora of ancient Hebrew religious media and symbolizations that are still available.

'Transcoded' Rhythm in Biblical Text

In cultures where most individuals are illiterate, scribal media are influenced by oral forms of communication. This point was argued in general by Walter Ong (1988) and admitted even by Jack Goody (1987, p. 143). It was argued for ancient Hebrew culture, for instance, by Pieter Botha (2004) and Doron Mendels (2004),

and it can be verified in a highly scribal work such as the Book of Job (Stordalen, 2012a). It is reasonable to expect that some reflection of non-inscribed media would occur in script, and so the modern interpreter of those scriptures needs to know the spectre of media at the time to recognise such reflections.

Christoph Uehlinger (2005) gave theoretical form to this expectation within a media perspective. He showed that biblical visionary texts were designed so as to 'transcode' visual sensory experience into the textual medium. And from the early history of reception he argued that the culturally competent reader did 'recode' the text back into the original medium of (imagined) vision (pp. 45–47). I find this view of a trans-medial codification to be insightful and significant. In a version less oriented toward the media perspective, I have earlier argued that biblical allusions to the Garden of Eden presuppose conventionalised experience of physical gardens in ancient Hebrew culture. When this experience is not applied in modern readings of the Story of Eden, it is because modern readers lack the communicative competence presupposed in the text (Stordalen, 2000).[20] To form historically adequate perceptions of ancient texts, one must know neighbouring medial practices and symbolizations. Studying biblical texts within the texture of ancient Hebrew religious media is likely to change not only our perception of ancient Hebrew religion; it will cause a corresponding change in our perception of biblical texts and indeed *biblical* religion. I can only offer one example: Psalm 136.

Psalm 136 was likely incorporated into the collection in its later stages of composition.[21] The shapes of the poem in Qumran manuscripts 11QPsa and 11QPsb indicate that the process of composition of the poem had not been finally closed during the last centuries BCE so the current form is not very old, although the poem may have existed in earlier forms. One characteristic of this psalm is the 'chorus' concluding every single one of its 26 lines: *kî le'ôlam chasdô*. A literal translation of the Hebrew could read 'while forever [is] his-steadfastness.'

In the Masoretic accentuation for chant (notated perhaps as late as ninth century CE, but going back to earlier tradition), these three words are connected with conjunctive accents. A so-called *tarcha* links the first word to the second, a *mûnach* connects the second word to the third, and finally a *sillûq* indicates pausing at the end. So this 'chorus' forms one running sequence in a syllable of 1 + 3 + 2, each cluster stressing its final syllable: *kî le'ôlam chasdô* (intonation underlined). Psalm 118:2–4 indicates this was a communal reply, which nicely fits the pattern of our psalm. For community members to be able to join in, the chorus would need to be rhythmically fairly plain and with an entry point accommodating also less precise member voices. If the sequence 1 + 3 + 2 were performed as three steady beats, the opening *kî* would perhaps likely serve as the cue and the sound-space for the congregation to join in, also allowing rhythmical instruments to mark the pace. The final two beats would comprise 3 + 2 syllables. This gives more sound-space and ex-

position to the last syllable: *chasdô* ('his-steadfastness'). Such a coda in the last line of a poetic unit is frequent in biblical literature.[22]

The monotonous repetition of the chorus throughout the poem would serve like a beat maker, hammering in the focal point: the steadfastness of the biblical deity. The space exposed to that hammering would not primarily be intellectual. Drumming, dancing, and perhaps airophone music would inscribe this message on the very bodies of the congregation, in a presumably strongly bonding experience. The religious practice behind Psalm 136 was likely a performance of communal effort, with a sense of being dependent upon one another and with a confession of being gathered around the steadfastness of YHWH. It seems entirely possible that this experience might not easily lend itself to philological expression, simply because it was not primarily linguistically coded (see Friedson, 2005). It seems to have had strong physiological, emotional, and social dimensions that are not semantically symbolized in the text. A conventional theological reading of the psalm focusing its 'theology of creation' (in verses 1–9 and 25f) and its 'theology of history' (in verses 10–24)[23] does not do justice to the poem, not even to the written form, where the rhythm is so prominent. Reducing Psalm 136 to an illustration of a preconceived map of theological concepts does indeed cause ways of being in the world to be forgotten.

Like the 'pedestrian speech acts' of de Certeau (1984), performances of Psalm 136 would have had at least three functions: (a) they would reflect processes of appropriating Psalm 136 and the semiotic systems needed to perform its symbolizations: linguistic, rhythmic, bodily postures, etc.; (b) they would reflect individual performance of these semiotic systems; and (c) they would reflect how individual performers located and actualized these systems and symbolizations within their total web of practices and symbolizations. Unlike de Certeau, who is focusing a set of practices that could be observed and that are generally known today, biblical scholars may be unable to say much about these processes—save for the obvious assumption that they must have been there. For now, however, the point is to recognise the fundamental difference between theological concepts and religious practice. Ancient Hebrew religion was practiced and performed in many media, and this must be considered when interpreting the religious world of ancient Israel in which also the scriptural record took form.

Ancient Multi-Medial Religion

Ancient Hebrew religion was multi-medial in at least two senses. First, religiously charged practices took form in a number of different media, mostly based on a variety of oral and bodily registers.[24] Secondly, symbolizations in one medium could

'transcode' (Uehlinger, 2005) symbolizations from one medium into another so that, say, music could have a transcoded presence in text. To perceive such transcoding, the modern interpreter needs to 'trans-read' the sources with an awareness of alternative media and symbolizations contemporary to the biblical text. This is not the place to even start charting the huge number of media that need to be explored and their probably numerous criss-crossing interconnections. To indicate the contours of what needs to be done, let me simply name some media used to portray religiously charged symbolizations in ancient Israel.

These include, first, a number of performative media such as ritual, prayer, singing, dancing, music, recitation, etc. Several such media were again embedded in constructions of space or attached to artefacts that for the occasion also would function as religious media: a sanctuary or an alter for a ritual, a city gate for music, a street for religious parades, domestic space for family cult, etc. Some performative media are likely to have been very common, due to their low demand of economy and technology. Other performative media could be restricted to elite performances. It is not unreasonable to expect that individuals in a given society would know and use many different performative religious media. The elite dancer could go home and offer her domestic prayers using clay figurines; the scribe could recite the sacred text at work and sing popular chants in the square, etc. This opens the need for reflecting on possible transcoding and allusions across this material. It also calls for the analytical strategy to define each media practice as a separate discourse, relying on specific materialities, performing in certain life situations or institutions, depending upon and contributing to specific performative traditions, techniques, or procedures, etc.

The same goes for non-performative, still non-written, media that at occasions were used to make religiously charged symbolizations or statements. Typical items would be food, clothing, hair styles, pottery, furniture, coins, cultured landscape, and a veritable host of pictorial media such as carvings of all sorts and qualities: figurines, statues, standing stones, skin tattoos, seals, etc. Let us take the example of a fairly cheap figurine moulded in a cast and mass-produced perhaps in a thousand copies. One and the same copy could be used as, say, a medium for commemoration or domestic cult or a votive offering in the regional shrine. Copies from the same cast could serve different purposes, and different casts indebted to the same technological and artistic tradition could end up in different parts of the world.[25] This makes for a huge network of possible symbolizations.

Finally there are the many media relying on linguistic systems of symbolization: a wide range of speech genres, of writing in different technologies (on stone, wood, clay, parchment, or papyrus) in different genres, varying styles, and for diverse purposes. The list could go on, but the point should be clear: Ancient Hebrew religion was expressed in a complex of medial inter- and dis-connections—indeed in a web

remnant of what Latour (2005) called an actor-network. Tracing religious symbolizations through their media opens roads of interconnection and inter-media transcoding. These are not any roads and any interconnections: They are the roads initiated by the 'technological, social, and aesthetic properties and propensities' of various media (Meyer, Chapter 1, p. 4) and of the religious practices or communicative acts to which they are put in each case. Connections produced disconnections as well. Identifying the social field of a given medium opens the possibility that apparently similar symbolizations in other fields performed different communicative acts. Returning to the clay figurine above, its potential function in a magical ritual aimed to harm an enemy should not be aligned with its potential function in commemorating an ancestor.

Concluding Remarks

Exploring ancient Hebrew religion as a complex of inter- and dis-connected media practices and symbolizations invites 'thick description' in a much fuller sense of that phrase than originally intended by Clifford Geertz. If media are an intrinsic part of religion, then the following analytical procedures offer themselves as desirable for future research.

First, a scholar of religion must consider material, technological, social, aesthetical, and other characteristics of those symbolic systems and genres utilised in religious media. Already these communicative building blocks are likely to have been connected and dis-connected in specific ways, and to have communicated in specific social and aesthetic registers. Recovering and mapping their individual functionality and features contributes to our perception of the 'thickness' of ancient Hebrew religion.

Second, one needs to consider similar properties and propensities of the individual media employed in performing religiously charged symbolizations. These media and symbolizations relied on traditions, institutions, and cultural fields in specific ways. In view of their economic, artistic, and other features it will sometimes be possible to form at least some general idea of the kind of discourse(s) in which each symbolization took part—and sometimes also what other discourses it might transcode or reflect.

Third, considering ancient Hebrew religion across media and symbolizing systems begs a new sensitivity for the importance of non-linguistic dimensions of that religion. The presence of these dimensions is not at all surprising, but scholarship still is challenged trying to account adequately for them, not least in the case of ancient Israel. The interpreters need to develop strategies for perceiving transcoded presence of other media in the scriptural record, what I earlier described as a cul-

turally competent trans-reading. A media perspective offers a way to achieve that, shifting the emphasis of our perception of ancient Hebrew religion from being a predominantly intellectual product of its semantic symbolizations to being a medial mixture of practices and symbolizations with intellectual as well as emotive, physiological, psychological, and social dimensions.

Finally, and in continuation of the last point, a media perspective on ancient Hebrew religion calls for a fuller appreciation of its aesthetic and performative qualities. How did it engage human sensory systems? How did it invite continuous (re-)definitions of itself? How did it render religion and identity as phenomena that are not only portrayed in stable symbolizations (such as literature) but also constantly performed by individuals and groups (in, say, dancing and music)?[26] These performative trajectories are likely to have contributed religious dimensions that were in tension or conflict with those contributed in written symbolizations.

In short, a media perspective has the potential to contribute significantly to our perception of ancient Hebrew religion. Obviously, following up that perspective would require massive new research. Some of the desiderata listed previously are not likely to be fully or even remotely achieved. Still, already at a basic level this perspective contributes new understanding of biblical texts and biblical religion, as seen in Psalm 136 above. Biblical studies cannot afford to leave this perspective unexplored.

Notes

1. First, I am deeply grateful to Birgit Meyer for reading and discussing previous versions of this chapter. Also, basic impulses for the present chapter came from Peter Horsfield, when reading an earlier version of his chapter in this volume during a conference in Sigtuna in October 2010.

 Secondly, the "ancient" Hebrew religion considered here is broadly that between the late Iron Age (some 800 Before the Common Era [BCE]) through the Hellenistic age (ending in 146 BCE). 'Levant' names current-day Lebanon, Israel, Palestine, Jordan, and parts of Syria and Egypt.

 As for the more prominent examples of media perspectives on the ancient Levant, see Uehlinger, 2000; Hesberg, 2003; entries in Frevel, 2005a; Frevel, 2007; Schörner, 2008.

2. HALOT uses the word only as its own characterization, not as a gloss.

3. For example the NRSV's first instances are 1 Mac 1:43 in Greek Old Testament literature and Acts 17:22 in the New Testament.

4. As an example, see Miller, 2000.

5. In the Vulgate: Exod 12:26, 43; 29:9; Lev 7:36; 16:31; Num 19:2; Esth 8:17; 9:27; Dan 3:90, and also Sir 1:17–18, 26, where Hebrew text is currently not preserved. The Hebrew terms in question are prominently *'avodah'* (עֲבֹדָה) 'ritual service' and *chuq* (חֻק) 'ritual precept.'

6. Among these terms are prominently Greek *latreía* (λατρεία) 'religious observance,' see Hebrew *'avodah'* above; Greek *pístis* (πίστις) 'faith, belief,' see Hebrew *'emûn* (אֱמוּן) 'faith' and *tsedaqah* (צְדָקָה) 'righteousness'; Greek *hieras* (ἱερὰς) in the sense of 'sacrifice'—see a number of more specific Hebrew terms.

7. See her reflection on this definition also in Meyer, 2011. For a discussion on definition of media in research on antiquity, see Frevel, 2005b, pp. 5–13.

8. For encoding of memory, see Schachter, 2003, pp. 34–40.

9. See especially Bourdieu, 1993, Part 1; Bourdieu, 1996, Part 1.

10. See especially Mettinger, 1995.

11. Stordalen, 2012b; see also further contributions in that same conversation unit by Birgit Meyer, Christoph Uehlinger, and Abhishek S. Amar.

12. See Keel, 1992; Uehlinger, 2006. See the process for Christianity described by Peter Horsfield (Chapter 3).

13. For this point see Stordalen, 2012a; Stordalen, in press-b.

14. For a view of music in ancient Ugarit (leaning toward Mesopotamian origin), see Caubet, 1996.

15. Braun uses concepts such as '(private) secular [music]' (p. 116). I would doubt that, say, celebration of military victory would have been without religious charge, which implies an even wider use of music as a religious medium.

16. See Beck, 2006.

17. See Exod 32:19; 2 Samuel Chap. 6; 1Kings 18:26–29; Ps 30:11; 87:7; 149:3; 150:4.

18. Some examples from canonical literature only: Exod 15:20; Judg 11:34; 21:21–23; 1Sam 18:6; 21:12 (ET: 21:11); 29:5; 30:16; Qoh 3:14; Jer 31:4.

19. Thanks to Birgit Meyer for drawing my attention to this work.

20. See especially the theoretical reflections in Chapters 3 and 4.

21. On the composition of the book, see Wilson, 1985, and further for the important Qumran material especially Flint, 1997.

22. See, for instance, Watson, 1984, pp. 177–184.

23. See, for instance, Allen, 1983.

24. See a similar portrayal of early Christianity by Peter Horsfield (Chapter 3).

25. See discussion and in part documentation for all three possibilities in Stordalen, in press-a.

26. For a discussion on aesthetic qualities in a wide sense, see Meyer, 2009.

References

Allen, L. C. (1983). *Psalms 101–150* (Word Biblical Commentary Vol. 21). Waco, TX: Word Books.

Anderson, G. A. (1991). *A time to mourn, a time to dance: The expression of grief and joy in Israelite religion*. Philadelphia, PA: Pennsylvania State University Press.

Assmann, A. (2008). The religious roots of cultural memory. *Norsk Teologisk Tidsskrift, 109*, 270–290.

Beck, G. L. (Ed.). (2006). *Sacred sound: Experiencing music in world religions*. Waterloo: Wilfried Laurier University Press.

Botha, P. J. (2004). Cognition, orality-literacy, and approaches to first-century writings. In J. A. Draper (Ed.), *Orality, literacy, and colonialism in antiquity* (Semeia Studies, pp. 37–63). Atlanta, GA: Society of Biblical Literature.

Bourdieu, P. (1993). *The field of cultural production: Essays on art and literature.* Cambridge: Polity.

Bourdieu, P. (1996). *The rules of art: Genesis and structure of the literary field.* Cambridge: Polity.

Braun, J. (2002). *Music in ancient Israel/Palestine: Archaeological, written, and comparative sources.* Grand Rapids, MI: Eerdmans.

Burgh, T. W. (2006). *Listening to the artifacts: Music culture in ancient Palestine.* New York: T&T Clark.

Carrithers, M. (1992). *Why humans have cultures: Explaining anthropology and social diversity.* Oxford: Oxford University Press.

Casey, E. S. (1987). *Remembering: A phenomenological study* (Studies in phenomenology and existential philosophy). Bloomington, IN: Indiana University Press.

Caubet, A. (1996). La Musique à Ougarit: noveaux témoignages matériels. In N. Wyatt, W. G. E. Watson, & J. B. Lloyd (Eds.), *Ugarit, religion and culture* (Ugarit-Biblische Literatur, pp. 9–31). Münster: Ugarit-Verlag.

Connerton, P. (1989). *How societies remember* (Themes in Social Sciences). Cambridge: Cambridge University Press.

de Certeau, M. (1984). *The practice of everyday life.* Berkeley, CA: University of California Press.

Flint, P. (1997). *The Dead Sea Psalms Scrolls and the Book of Psalms* (Studies on the texts of the desert of Judah Vol. 17). Leiden: E. J. Brill.

Frevel, C. (2005a). *Medien im antiken Palästina: Materielle Kommunikation und Medialität als Thema der Palästinaarchäologie* (Forschungen zum Alten Testament II Vol. 10). Tübingen: Mohr Siebeck.

Frevel, C. (2005b). Medien in der Alltagskultur in der Antike: Eine Einführung. In C. Frevel (Ed.), *Medien im antiken Palästina: Materielle Kommunikation und Medialität als Thema der Palästinaarchäologie* (Forschungen zum Alten Testament II Vol. 10, pp. 1–29). Tübingen: Mohr Siebeck.

Frevel, C. (2007). *Kult und Kommunikation: Medien in Heiligtümern der Antike* (Schriften des Lehr-und Forschungszentrums für die antiken Kulturen des Mittelmeerraumes Vol. 4). Wiesbaden: Reichert.

Friedson, S. M. (2005). Where divine horsemen ride: Trance dancing in West Africa. In A. Hobart & B. Kapferer (Eds.), *Aesthetics in performance: Formations of symbolic construction and experience* (pp. 109–128). New York: Berghahn.

Goody, J. (1987). *The interface between the written and the oral* (Studies in Literacy, Family, Culture and the State). Cambridge: Cambridge University Press.

Hesberg, H., von. (2003). *Medien in der Antike: Kommunikative Qualität und normative Wirkung* (Schriften des Lehr-und Forschungszentrums für die antiken Kulturen des Mittelmeerraumes Vol. 1). Köln: Lehr-u. Forschungszentrum für die antiken Kulturen des Mittelmeerraumes.

Keel, O. (1992). *Das Recht der Bilder gesehen zu werden: Drei Fallstudien zur Methode der Interpretation altorientalischer Bilder* (Orbis Biblicus et Orientalis Vol. 122). Freiburg/Göttingen: Universitätsverlag/Vandenhoeck & Ruprecht.

Latour, B. (2005). *Reassembling the social: An introduction to actor-network-theory.* New York: Oxford University Press.

Mazzarella, W. (2004). Culture, globalization, mediation. *Annual Review of Anthropology*, *33*, 345–367.

Mendels, D. (2004). *Memory in Jewish, pagan and Christian societies of the Graeco-Roman world* (Library of Second Temple Studies). Sheffield: Continuum.

Mettinger, T. N. D. (1995). *No graven image? Israelite aniconism in its ancient Near Eastern context* (Coniectanea Biblica, Old Testament Series Vol. 42). Stockholm: Almqvist & Wiksell International.

Meyer, B. (2009). From imagined communities to aesthetic formations: Religious mediations, sensational forms, and styles of binding. In B. Meyer (Ed.), *Aesthetic formations: Media, religion, and the senses* (pp. 1–28). New York: Palgrave Macmillan.

Meyer, B. (2011). Mediation and immediacy: Sensational forms, semiotic ideologies and the question of the medium. *Social Anthropology*, *19*(1), 23–39.

Miller, P. D. (2000). *The religion of ancient Israel*. (Library of Ancient Israel). Louisville, KY: John Knox Press.

Ong, W. J. (1988). *Orality and literacy: The technologizing of the word* (Rep. of 1st ed. by Meuhen, London, 1982. New Accents). London: Routledge.

Schachter, D. L. (2003). *How the mind forgets and remembers: The seven sins of memory*. London: Souvenir.

Schörner, G. (2008). *Medien religiöser Kommunikation im Imperium Romanum*. Stuttgart: Steiner.

Stordalen, T. (2000). *Echoes of Eden: Genesis 2–3 and symbolism of the Eden garden in biblical Hebrew literature* (Contributions to Biblical Exegesis and Theology Vol. 25). Leuven: Peeters.

Stordalen, T. (2012a). 'His place does not recognise him' (Job 7:10): Reflections of non-inscribed memory in the Book of Job. In P. Carstens, T. Børnung Hasselbach, & N. P. Lemche (Eds.), *Cultural memory in biblical exegesis* (pp. 47-68). Piscataway, NJ: Gorgias.

Stordalen, T. (2012b). Locating the textual gaze—Then and now. *Material Religion*, *8*, 521–524.

Stordalen, T. (2012c). What is a canon of scriptures? In K. Ólason, Ó. Egilsson, & S. Stefánsson (Eds.), *Mótun menningar/Shaping Culture? Festschrift for Gunnlaugur A. Jónsson* (pp. 15–33). Reykjavik: Hið Íslenska Bókmenntafélag.

Stordalen, T. (in press-a). Adorant? Goddess? Ancestress? Iconographic reflections on a group of Egyptian terracotta figurines in the Ustinov Collection. [Forthcoming in a volume edited by Marina Prusac.[Publisher not decided]

Stordalen, T. (in press-b). Canon and canonical commentary: Comparative perspectives on canonical systems. In T. Stordalen & S.-A. Naguib (Eds.), *The formative past and the formation of the future*. [Publisher not decided]

Uehlinger, C. (Ed.). (2000). *Images as media: Sources for the cultural history of the Near East and the Eastern Mediterranean (1st millenium BCE)*. (Orbis Biblicus et Orientalis Vol. 175). Feibourg: Editions Universitaires.

Uehlinger, C. (2005). 'Medien' in der Lebenswelt des antiken Palästina? In C. Frevel (Ed.), *Medien im antiken Palästina: Materielle Kommunikation und Medialität als Thema der Palästinaarchäologie* (Forschungen zum Alten Testament II, Vol. 10, pp. 31–61). Tübingen: Mohr Siebeck.

Uehlinger, C. (2006). *Visible religion* und die Sichtbarkeit von Religion(en): Voraussetzungen, Anknüpfungsprobleme, Wiederaufnahme eines religionswissenschaftlichen Forschungsprogramms. *Berliner Theologische Zeitschrift*, *23*, 165–184.

Wagner, F. (1997). Religion II: Theologiegeschichtlich und systematisch-theologisch. In G. Müller, H. Balz, J. K. Cameron, S. G. Hall, B. L. Hebblethwaithe, W. Janke, & H.-J. Klimkeit (Eds.), *Theologische Realenzycklopädie Vol. 28* (pp. 522–545). Berlin: de Gruyter.

Watson, W. G. E. (1984). *Classical Hebrew poetry: A guide to its techniques* (JSOT Supplement Series Vol. 26; 2nd ed.). Sheffield: JSOT Press.

Wilson, G. E. (1985). *The editing of the Hebrew Psalter* (SBL Dissertation Series Vol. 76). Atlanta, GA: Scholars Press.

The Ecology of Writing and the Shaping of Early Christianity

PETER HORSFIELD

The intersection of media and religion has become a topic of quite extensive interest in the past three decades, spurred on by the rapid expansion and extension of mass media through the twentieth century and the rapid development of digital technologies and social media through the new millennium.

The distinctiveness of these new media developments and their implications for social religiosity can make it appear that what is happening today is unique and unprecedented. My proposition in this chapter is that the changes in social religiosity taking place today and their connection to new media developments are not unprecedented. Though distinctive in many of their particulars, they are continuous with changes that have taken place at numerous times in the past as the processes of the social construction of religion engage with the opportunities and constraints of social contexts, including the opportunities and constraints presented by the means of communicating within those contexts.

The issues raised by contemporary media developments provide a valuable lens by which to reexamine religious history to see whether contemporary perspectives on media may give new insights to an understanding of the interactions of media and religion in the past. I want to explore that proposition by looking at the contest between oral and written cultures in early Christianity, and the influence these contests had in the subsequent development of Christianity as we know it today.

The Media Culture of Early Christianity

From its beginnings Christianity has been an oral-literate movement. How those two cultural media forms—the oral and the written—have manifested themselves and their relative influence in the development of Christianity, however, has varied from time to time and from place to place. At the inception of Christianity, the relative proportions of the two were quite marked, with an estimated 95% of the first Christians being illiterate (Crossan, 1998). As critical theorists such as Bourdieu (1977) and Foucault (1972) have argued, language itself, the appropriate uses of spoken and written language and how they are integrated, are matters of social, political, and religious importance. There is evidence to indicate that the implications of these differences in language cultures and practices were the cause of significant debate and contention within early Christianity.

The roots of this contention are linked to Jesus himself and the high position he holds within the religion that bears his name. Jesus was strongly oral in his communication practices. Though the more common assumption and argument is that Jesus was also literate (see, for example, Borg, 1987), Crossan (1994) presents a strong argument that Jesus was illiterate and that his illiteracy was an important factor not only in his communication style but also in his self-concept and the political nature of his mission. A major theme in his religious message was the plight of the exploited, largely illiterate rural poor in Palestine—Jesus's own class. Whether he was illiterate or not, his communication style reflects strongly the characteristics of oral discourse and oral cultural practice that affirmed and validated the culture of the population to whom his message was addressed.

Oral patterns were dominant in the earliest communication of his first followers as well. The imperative in their communication wasn't a written *literal* one, it was performed oral *rhetoric*. In continuity with Jesus's religious vision and public practice, the followers spoke boldly, performed miracles, argued with the powers that be, spoke of God coming to them in dreams and visions, spoke in tongues, healed the sick, adapted the sayings of Jesus, and even invented new sayings of Jesus to convince and win people over to what they saw as a new reality.

From the beginning, possibly even while Jesus was alive, people who could write also wrote down things he said and accounts of things that happened. Though in the earliest stages writing was subordinate in what was a strongly oral speech movement, as the Jesus movement spread and grew and as more educated people joined the movement, the amount and use of written material grew. By the end of the first century, even though the vast majority of Christians still were illiterate, there was an extensive circulation of Christian writings taking place: letters, apocalyptic writings, defenses of the faith, manuals of practice, martyr stories, gospels,

and even fiction. Alfred Burns (1989) proposes that of gospels alone there were likely hundreds of different types and ascribed to various apostles.

Clement and the Defense of Writing

The relationship between the oral and written in the early formation of the Christian tradition has been the subject of a good deal of scholarly exploration and discussion. Much of the focus has been on the transition of oral traditions into the written record. More recently, scholars have begun to investigate differences between the oral and written traditions within early Christianity not just in content but also in their conceptualization of the nature of the faith and their hermeneutical methods for building meaning in communication with their audiences (see, for example, Kelber, 1997; White, 2004). Sawicki (1994) proposes that evidence of these conflicts can be seen even in some of the early writings and gospels.

Concerns about the adaptation of writing in the development of the young faith were strong in the end of the second century. The influential Christian teacher and writer Clement of Alexandria felt it important to explain and justify why as a Christian teacher he was writing. The issues identified in his *Stromata* provide a valuable insight into perennial issues arising in the relationship between media, media change, and the character of religious faith and identity. Clement, or Titus Flavius Clemens, was born of wealthy pagan parents around 155 and had extensive philosophical training in the Hellenistic traditions before converting to Christianity. He became the head of the Catechetical School in Alexandria, a major imperial center, where he died in 215. Clement's significance and the significance of his writings lie in going beyond a conceptual defense of Christianity to developing a systematic explication of Christianity into the intellectually and culturally influential Platonist framework of his time. He was a significant figure in the development of Christian literature.

The *Stromata* falls within a particular genre of writing, a collection of writings on particular themes. In the first chapter, Clement addresses what appears to be a series of concerns and objections to his writing down Christian teachings, concerns that were apparently of sufficient importance that he felt the need to address them explicitly.

> Book I Chapter I.—Preface—The Author's Object—The Utility of Written Compositions.
>
> ...that you may read them under your hand, and may be able to preserve them. Whether written compositions are not to be left behind at all; or if they are, by whom? And if the former, what need there is for written com-

positions? and if the latter, is the composition of them to be assigned to earnest men, or the opposite? It were certainly ridiculous for one to disapprove of the writing of earnest men, and approve of those, who are not such, engaging in the work of composition. (Clement of Alexandria, c. 198)

What is of interest for this particular study is that the concerns identified by Clement parallel significant concerns that are raised within Christianity, whenever a significant remediation of the religion occurs. This suggests that the questions about mass and electronic media in our present time are not exclusively modern questions. They are questions rather of how a religion is related to that religion's identity and practice. From his analysis of the chapter, Osborn (1959) identifies four major concerns that Clement was addressing. Osborn's analysis was primarily on the theological aspects of these (see also Fiskå Hägg, 2006; Kimber Buell, 1999). From a communication perspective the concerns identified provide an insight into the impacts being felt of the growing adaptation of writing into what were previously dominantly oral activities.

One was the perception that the living voice was seen as the best medium for the communication of Christian truth. "The writing of these memoranda of mine, I well know, is weak when compared with that spirit, full of grace, which I was privileged to hear" (Clement of Alexandria, c.198, Chapter I). In a movement that was dominantly illiterate and where the spread of the faith had been achieved through effective oral communication, it was difficult for many to perceive how a faith whose emphasis was on a personal relationship with God could be effectively communicated in any way other than through the lives and voices of living people. The Christian Papias reflected similarly when he wrote around the year 150, "For I did not think that what was to be gotten from the books would profit me as much as what came from the living and abiding voice" (Pamphilius, 1890, III. 39: 3,4). If communication of faith was separated from the interpersonal situation and put into a depersonalized medium such as writing, would it change the personal character of the faith?

A second concern was that writings were seen as public documents and to commit Christian teachings to writing was to be indiscriminate in whom Christian teachings were given to, running the risk of their being misunderstood or even misused. This reflects a critique of writing by Socrates, of whom Clement would be well aware from his Hellenistic education:

> And once a thing is put in writing, the composition, whatever it may be, drifts all over the place, getting into the hands not only of those who understand it, but equally of those who have no business with it; it doesn't know how to address the right people, and not address the wrong. (qtd. in Hackforth, 1952, XXV: 274B)

For many Christians, speaking and teaching face to face had been the dominant mode of teaching within the religion since its beginnings and provided a much more controlled situation for how Christian truths were to be preserved and passed on.

A third concern identified by Osborn (1959) centered on the question of inspiration and its place in judging the truth of a statement. In a face-to-face oral situation, it was possible for everyone present to read the person's body and reach a judgment about whether that person was "inspired" with the spirit of God or not—and therefore whether the message was true in a personal sense. The oral prophets and evangelists of Christianity argued the truth of their message on this sort of "embodied communication." The question arose, How can one tell if a writer was inspired if you couldn't see the writer? How could a person, particularly one who was illiterate, judge accurately that writings on one parchment were inspired but another set of writings weren't? Literacy has developed quite refined skills to discern differences in types of writing through nuances of grammatical structure, word selection and use, logical reasoning, cadence, and literary flow. The threat felt by illiterate Christians was they didn't have those skills and as a result were potentially being disenfranchised within the faith.

The fourth was that the heretics were seen to be using clever writing to mislead and corrupt people, and true faith should be kept separate from that heresy, not only in content but also in form. If Christian truth and heretical error were reproduced in the same medium, how would people be able to distinguish one from the other? Wouldn't encouraging people to read Christian writings also run the risk of having them read heretical ones?

Underlying each of these is a perception that the apparently simple act of remediation of the faith carried with it the potential of changing the faith culturally and in the process disenfranchising the majority of Christians who were illiterate. In line with Bourdieu's (1977) analysis of the power dynamics inherent in linguistic constructions, once Christian writings were written down only those who could read and write would have full participation in teaching roles and in the formation and transmission of Christian truths. Illiterate or orally based Christians could see that if Christian leadership required literacy, their authority and the contribution they could make to leadership would be diminished.

This media shift also raised important questions and a potential shift in the nature of Christian identity. One of the important characteristics of the early Christian movement was its attachment to the person of Jesus, the beloved teacher. Stories were told about his identification with the outcast, his Aramaic style of story telling, his down-to-earth parable-based theology, and his charismatic engagement with people (White, 2004, pp. 122–125). Jesus was possibly illiterate, he chose mostly illiterate people to be his followers, his message was accessible to everybody whether they could read or not, he didn't write and obviously didn't need

to write. Why should his followers? Would adopting a medium of communication that is accessible only to a minority of people lose this identification of the faith with the character of Jesus?

Clement responds to each of these concerns, not denying them but instead giving what we today consider to be valid arguments for adopting a useful medium. He counters the concerns by positioning writing as a complement, not a substitute, to the oral communication of faith: "If, then, both proclaim the Word—the one by writing, the other by speech—are not both then to be approved?" (Clement of Alexandria, c. 198, Chapter I). He also identifies a number of distinct advantages that writing brings: It preserves the tradition from being forgotten and plants seeds in people's minds that can be brought to fruition by others. It can also counter the heretics in their own medium.

> It were certainly ridiculous for one to disapprove of the writing of earnest men, and approve of those, who are not such, engaging in the work of composition. (The heretics) are to be allowed to write in their own shameful manner. But he who proclaims the truth is to be prevented from leaving behind him what is to benefit posterity. (Clement of Alexandria, c. 198, Chapter I)

Clement even suggests that writing can help Christian teachers avoid flattery, because their audience is not present before them. "He who speaks by writings escapes the reproach of mercenary motives" (Chapter I).

This particular incident from the third century illustrates a number of important aspects of the discussions about media and religion. Shifts in media that take place within the wider culture do not necessarily introduce something new into a religion that wasn't there before. Media changes frequently tap into and become part of differences and political struggles already underway within the religion, privileging one party over another or making overt something that is already latent. Clement's incident also highlights that changes in the mediation of religious faith have implications for the culture and identity of the faith that need to be negotiated.

The Consequences of the Widespread Christian Adaptation of Writing

Clement did not invent this argument within Christianity, and his defense of writing was certainly not the last word on it. But as Christianity developed and spread, writing grew in use and importance, to the extent that in time it became almost essential for every Christian congregation to have someone in the congregation who

could write, read, and interpret the scriptures, letters, and other writings. A formal position of *lector* or reader in a congregation is first mentioned by Justin Martyr around the year 160, and being a lector soon became an important step on the path to a place within the hierarchy of leadership in Catholic churches.

To understand the contribution that the media differences of writing had in the development of Christianity in its early centuries, it is necessary first to deconstruct the hegemony that has been built of what Christianity is. It is common in Christian theological thought to recognize a basic identifiable body of thought and practice as orthodox or "The Apostolic Tradition." Tanner (1997) provides an extensive critique of such a singular view. Questioning that hegemonic view is necessary also if we are to engage adequately with the diversity of Christian opinions that existed in those first centuries and the power struggles and the factors that contributed to the dominance of one of those opinions over the others. Hatch (1957) advocated the need to recognize a variety of "Christianities" in the religion's first centuries:

> If we were to trust the histories that are commonly current, we should believe that there was from the first a body of doctrine of which certain writers were the recognized exponents; and that outside this body of doctrine there was only the play of more or less insignificant opinions, like a fitful guerilla warfare on the flanks of a great army. Whereas what we find on examining the evidence is, that out of a mass of opinions which for a long time fought as equals upon equal ground, there was formed a vast alliance which was strong enough to shake off the extremes of at once conservatism and speculation. (pp. 10–11)

By the end of the second century, Christianity was a diverse movement with a variety of streams or traditions, all of which adapted the original Jewish prophetic message of Jesus to different cultural and philosophical contexts in different ways. Among what Hatch (1957) referred to as "a mass of opinions which for a long time fought as equals upon equal ground" were streams such as Jewish Christianity, which continued to see Jesus within Jewish terms as the predicted Messiah but not the Son of God; Gnostic Christianity, which aligned the Jesus tradition with the wider dualistic philosophical and religious movements of Gnosticism with a strong aescetic emphasis; Marcionism, which saw the god of the Jewish scriptures and the god of Jesus as different gods; Montanism, which was a largely oral, charismatic, prophetic, apocalyptic movement led by two women; and Logos Christianity, which aligned Jesus with Hellenistic culture through the philosophical concept of the Logos within hierarchically structured communities.

Out of this diversity, by the middle of the fourth century the Logos Christianity stream, or what I am calling the Catholic-Orthodox Party, had become dominant,

even though it was only one of various cultural adaptations that had been made of the original narrative of Jesus. It was helped in its dominance by the Roman Emperor Constantine, who saw in the Catholic-Orthodox Party's literate male leadership, cultural alignments, and centralized organizational structures a valuable religious tool in his political agenda of unifying and stabilizing the Empire. Constantine strengthened these political utilities by narrowing and standardizing Christianity within the Catholic-Orthodox model. He called, funded, and oversaw a church council (Nicaea, 325) to resolve ongoing doctrinal differences. He funded an extensive building programme of new Catholic-Orthodox churches in key imperial centers and endowed the churches with wealth and lands to support their clergy and ensure their ongoing upkeep (Cameron, 2006, pp. 546–547). He commissioned fifty elaborately produced copies of a set of scriptural writings in line with Catholic-Orthodox thought to standardize the core documents (Herklots, 1994).

The result was that by the middle of the fourth century the Catholic-Orthodox Party version of Christianity was politically enforced by the Emperor as the only true version of Christianity, even though, it could be argued, some of the key tenets of the Catholic-Orthodox Party position were significantly different from the religious vision originally posed by Jesus. In place of the inclusive communal authority advocated by Jesus, authority became hierarchically vested in male priests at the local level under a male bishop or overseer at a regional level. The Jewish monotheistic theological framework of Jesus was elaborated into a Hellenistic Trinitarian one. A direct human relationship with God espoused by Jesus was reconstructed theologically and ritually as an inter-mediated relationship in which divine salvation and forgiveness was dispensed only by the hierarchy of the Catholic-Orthodox Party.

Work on social movements identifies the processes of framing, or the construction of shared meanings for collective understanding and action as important elements in how social movements develop within themselves and in relation to their wider environment. Benford and Snow (2000) see this "reality construction work" as being "embroiled in the politics of signification," whereby different contenders for influence within the movement draw on extant and innovative "meanings, beliefs, ideologies, practices, values, myths, narratives and the like" to impose their cultural position and collective actions as definitive of the movement's identity (pp. 625, 629).

Communication scholars such as Ong (1982, 1985), Innis (1950), Goody (1987), and Finnegan (1988) have been foremost in identifying the character of the media factors of orality and literacy in the construction of cultures, patterns of consciousness, and social organization. While there has been significant analysis of the theological factors involved in the early development of Christianity, little has been done on the role of media in this formative early period. The contention explored in this study is that the widespread adoption of writing by the Catholic-Orthodox Party

and its growing importance to the identity and spread of the religion was a significant factor in how Christianity developed and a key element in the narrowing of the diversity of Christianity in its first centuries to be synonymous with just one of its expressions. Understanding the broad role that writing played in this provides a valuable perspective on how media and religion in general interact with each other.

A number of elements can be identified in the creation of this Christian hegemony.

1. The Repositioning of Christianity Culturally

Because Christians did not become involved in literacy education until well into the third century, those Christians who were literate in this early period tended to have received their education within the Greco-Roman educational system *before* they became Christians (Gamble, 1995). They were therefore more likely than most other Christians to be members of the middle or upper classes, a social capital that moved them more quickly into positions of religious leadership. As part of this social capital they brought with them familiarity with and appreciation for Greco-Roman values, Roman political processes, the cultural interests of the literate classes, and knowledge of and familiarity with the powerful communication systems of the Empire (Bourdieu, 1977).

This repositioning of Christianity into Roman literate culture involved not just administrative uses of writing but also the creation of a parallel Christian literate culture designed to pitch Christianity to this powerful political class (Mitchell, 2006). Part of the recommendation of Christianity to this literate class, where antiquity was a valued quality, was the construction of Christianity as an "old" religion. Indicative of this is Eusebius's influential *Ecclesiastical History* (early fourth century), which begins the history of Christianity not with Jesus but with the beginning of time.

The widespread recognition of the importance that Christian literature played in its wider cultural positioning is reflected in the Emperor Diocletian, during a period of persecution of Christians, issuing a decree that Christians hand over all their texts to be burned. Diocletian's successor, Maximus Daia, saw Christian writings as sufficiently influential that he composed a counter-literature, *The Memoirs of Pilate and the Savior,* and instructed that it be taught to school children for their memorization (Mitchell, 2006).

2. Enlistment of the Literate-Educated into Catholic Leadership

The centralized, empire-wide organizational structure and increasingly complex theology of Catholic-Orthodox Christianity required literate, experienced people to lead it. Though the other streams of Christianity also had literate people within

their leadership, the Catholic-Orthodox Party actively promoted the literate class into church leadership. Cyprian, addressed in more detail below, is one example of this. Similarly Ambrose, a highly educated and ranked Roman civil leader, when governor of Milan was called in to mediate a church dispute over appointment of a new bishop and was appointed as bishop himself, even though he wasn't baptized. It is not coincidental that the people now recognized as the "Fathers of the Church" were all writers and literate in writing before they became Christians.

3. Effective Utilization of the Systems and Political Advantages of Writing

The Roman Empire had in place a strong, fast, and effective empire-wide infrastructure of communication to support political, military, cultural, and trade activities. The individuals attracted, enlisted, and promoted by the Catholic-Orthodox Party had the necessary knowledge and resources to place and promote Christianity strategically into cultural forms and directions that exploited the media systems of their time. This included skills and familiarity with literate practices and protocols; knowledge of how the media systems worked and how to use those systems; the leisure time to write; and the financial resources or networks to procure a regular supply of writing materials, purchase other people's writings, establish and maintain effective libraries and archives, employ people to reproduce what they'd written, and organize and pay for distribution of what they wrote.

Writing provided those who could use it powerful "liberties of action" (Sawhney, 1996) or affordances not available to the illiterate membership of Christianity. Having the social and financial capital to locate oneself within the Imperial communication system made possible a range of social and political connections that weren't available to those Christian leaders whose power, authority, and activities were primarily oral and local. Written media made possible the wider spread and influence of the opinions of literate Christians over others. It gave this small minority within Christianity the ability to network and organize a common opinion against alternative Christian opinions on a regional and empire-wide basis. The permanence of written communication over the oral meant that the ideas of Christianity preserved for wider dissemination, later access, and reference were almost exclusively the ideas of the minority literate class who wrote.

Two figures serve as good examples of the extent to which key leaders of the Catholic-Orthodox Party were effective in making writing a significant factor in the shaping of the culture of belief and practice within Christianity.

Origen (c. 182–251) was a pupil of Clement, born into a Christian family in Alexandria but educated fully within a Hellenistic cultural framework. Küng describes Origen as "the only real genius among the church fathers, a man with an in-

satiable thirst for knowledge, a wide-ranging education and tremendous creative power" (Küng, 1994, p. 163). The focus of Origen's intellectual attention was to arrive at a definitive reconciliation between Christianity and the Hellenistic world. To this end he taught and wrote prodigiously.

Only a fragment of Origen's works remains today, partly because he was a controversial theologian and many of his books were destroyed. Eusebius, who inherited Origen's library, lists more than 2,000 written works, though Miller (1994) suggests there may be as many as 6,000. They covered a vast range of topics including a scientific doctrine of the Trinity, the first known systematic theology, writings on the Christian life and critiques of paganism, a theology of asceticism, and extensive biblical works and commentaries. His biblical works included the *Hexapla*, a manuscript of columns setting out side-by-side six versions of the Hebrew scriptures and a system of biblical interpretation that recognized three levels of textual meaning: the somatic or literal sense, the psychic or moral sense, and the allegorical or spiritual sense.

Origen's extensive influence on the philosophical development of Christianity was facilitated by the establishment of what was in effect a media production center, funded by a wealthy patron. Eusebius describes the arrangement in the following way:

> Ambrose urged him not only by countless verbal exhortations and incentives but also by furnishing abundant means. For, as he dictated, he had at hand more than seven shorthand writers, who relieved one another at appointed times, and copyists no fewer in number, as well as girls trained in beautiful penmanship. For all these Ambrose provided the necessary means in abundance. (Pamphilius, 1890, VI.23)

Origen traveled extensively, visiting Christian communities on invitation as a speaker or to mediate in church disputes, and took with him copies of his writing to distribute and reinforce his personal presence. Origen did not invent the reinterpretation of Christianity into the sophisticated literate culture of Hellenistic philosophy, but he contributed to it significantly.

Cyprian of Carthage (c. 200–258) was bishop of Carthage in North Africa from 248 to 258, a crucial time of empire-wide persecution of Christians. Prior to becoming a Christian, Cyprian was an educated, wealthy, aristocratic Carthaginian property owner, probably of senatorial rank. Trained within the Greco-Roman education system as a rhetorician, he was a skilled debater with experience in politics, the law, and civil administration. He became a Christian when he was 46 and two years later was made bishop of Carthage and overseer of the whole North African Church.

Cyprian's conversion to Christianity was partly a result of disillusionment with the political instability of the Empire and the decline in standards of civil society (J. Burns, 2002). When he became bishop, he drew on his legal and civil administration experience to further the development of the church as the new Roman Empire, divided into a curial class of clergy and laypeople parallel to the Roman division of citizens into property owners and ordinary citizens. In Cyprian's political ecclesiology, the bishop was the central authority of the regional church, the Bishop of Rome the first bishop, and the College of Bishops acting together declared to be incapable of error. In Cyprian's world, the Catholic institutional church became the imperial civil service of salvation, replacing the personal relationship with God that Jesus advocated with an institution-based system of penances dispensing salvation (Clarke, 1984).

Cyprian could not have exercised this substantial influence from his North African diocese without using his knowledge and experience of the imperial culture and systems of writing to extend his influence beyond his local setting. In the last eight years of his life, Cyprian wrote around a dozen treatises, some of them several volumes long. He wrote at least eighty-two letters to bishops, dignitaries, and officials around the Empire, many in multiple copies with multiple attachments that were intended to be read aloud publicly (Bévenot, 1961). One letter is copied to eighteen different recipients, another has thirteen attachments, another includes with his letter a long attachment of another writing with his 2,500-word critique of the attachment. All of these had to be written and copied by hand, requiring resources that one can assume Cyprian brought with him from his privileged background.

In a way that directly reflects Harold Innis's (1950) ideas about writing and the construction of empire, Cyprian provides a number of good examples of how the Catholic Party used the media distribution systems of the empire to transform Christianity into a global religious empire.

One of Cyprian's letters to Rome includes a list of African bishops and their sees to keep the central mailing list in Rome up to date, reflecting the Roman Church's role as a central archive and production house for Christian manuscripts. Cyprian claims of one of his open letters that "it has been circulated through the entire world and reached the knowledge of every church and every brethren" (Epis 55.5.2).

Letter 49 reports to Rome the outcome of a church council that had just finished in Carthage. It ends with a good example of how powerful writing was: "We are sending over news of these events written down the very same hour, the very same minute that they have occurred; and we are sending over at once to you the acolyte Niceforus who is rushing off down to the port to embark straight from the meeting."

In similar fashion, the influential theologian Augustine, at his base in Hippo North Africa in the fourth and fifth centuries, had so many copyists at his disposal

that "new books were distributed quickly and easily" and he was able to make a gift of the thirteen volumes of his *Confessions* in short time to a literary enthusiast who asked for it. The convent in Hippo (c. 412) had its own library with a staffed lending desk (Meer, 1961).

4. Constructing and Protecting the Brand "Catholic"

The dominance of the Catholic-Orthodox Party was also achieved through a hegemony-building strategy of identifying this particular stream of Christianity with "true" Christianity—what we would readily identify today as a media strategy of brand creation (Mendels, 1999). Such a strategy would not have been possible without the extensive use of writing. Reading these early centuries from this perspective, a number of elements in the building of this hegemony can be identified.

Appropriation of the concept (brand) "Catholic." The word "catholic" or *katholikos* means universal. Though meaning literally all Christian communities, it was appropriated early by Catholic-Orthodox Party male bishops and consolidated in writing to refer exclusively to their particular stream of Christianity, that is, churches headed by male bishops.

> Wherever the bishops shall appear, there let the multitude [of the people] also be; even as, wherever Jesus Christ is, there is the Catholic Church. It is not lawful without the bishop to baptize or to celebrate a love-feast; but whatsoever the bishop shall approve of, that is pleasing to God. (Ignatius, 106, Chapter VIII)

Construction of an "official" history of "Catholic" Christianity. Eusebius's ten-volume *Ecclesiastical History* (Pamphilius, 1890), which appeared in a number of editions between 313 and 325, is a good example of this. Preserved through constant reproduction across the centuries and therefore widely influential in shaping Christian self-understanding Eusebius's *History* is a partisan construction that gave legitimation to the Catholic-Orthodox Party as the only embodiment of the apostolic tradition and successful defender of the true faith—"We shall introduce into this history in general only those events which may be useful first to ourselves and afterwards to posterity" (Chapter 8. 2.2–3). Alternative Christian opinions are positioned as deviant or heretical. His work creates a historical justification of the male episcopal leadership with a genealogy that located every Catholic-Orthodox bishop in an uninterrupted historical, physically transmitted chain of transmission directly to Jesus's original disciples.

Defending the brand. The Catholic-Orthodox Party in its writings and statements continued to present itself as the only embodiment of what was universal

and orthodox in Christianity. Their monopoly ownership of the brand "Catholic" was finally affirmed and enforced politically by Emperor Theodosius I in 380:

> We desire that all people under the rule of our clemency should live by that religion which divine Peter the apostle is said to have given to the Romans ... as for the others, since in our judgment they are foolish madmen, we decree that they shall be branded with the ignominious name of heretics, and shall not presume to give their conventicles the name of churches. ("Theodosian Code XVI.i.2," 1943)

5. Media Censorship and Control

As much as possible, what was written in Christianity was brought under the control of the bishops, backed by the political and military might of the Emperor in line with his programme of imperial unification. Christian understandings that differed from the Catholic-Orthodox views were suppressed and Christians adhering to alternative understandings were declared deviant (heretical) and either exiled or executed. Christian texts expressing alternative views were burned or doctored and those possessing them were condemned. This censorship was so effective that until just recently, what was known about many of the alternative movements of Christianity was known only through what is said about them in Catholic condemnations of them (Ehrman, 2004).

This was a significant strategy also in minimizing and subverting the influence of alternative leadership models, including the challenges presented by the leadership of women and the oral prophets. Women's nature and leadership was denigrated in male writings (Schussler Fiorenza, 1983) and writings by women were branded as fanciful and dangerous (Davies, 1986). Women's access to writing was progressively denied to the extent that they were forbidden to write or receive letters without the explicit consent of their husbands:

> A woman may not write to other lay Christians without her husband's consent. A woman may not receive letters of friendship addressed to her only and not to her husband as well. (Synod of Elvira, early fourth century)

This media control included control of the authority of the oral prophets, the other major center of authority within Christian communities, the major alternative media form in the spread of Christianity, and the major source of women's leadership within the movement. To consolidate power in the writing-based episcopal office, the unpredictable and challenging oral charismatic style was routinized organizationally. At first the gift of prophecy was declared as strengthening

the authority of the local bishop, then it was declared to be an *ex officio* gift of the bishop, then in later centuries the challenge of the power of the oral prophet was fully contained by declaring that only the official hierarchy of male bishops could speak with God's own voice (Schussler Fiorenza, 1983).

The reasons for this ascendancy of the Catholic-Orthodox Party in Christianity were extensive. As with any cultural phenomenon, there are political, sociological, economic, practical, and organizational benefits and factors that interact and converge in such an outcome. There are numerous studies that explore these different aspects. What has not been studied to the same extent is the contribution that communication, in particular writing, played in this shift. This study seeks to open up that dimension.

This is not to say that writing was the sole nor necessarily the most significant influence. However it needs to be considered as more than just one factor. Eisenstein (1979) in her analysis of the influence of printing in Early Modern Europe and Finnegan (1988) in her case studies of orality and literacy both propose that media change needs to be considered in a different category from other contributors to change because of the multiplying effect that new media make possible. The extensive use of writing by the Catholic-Orthodox Party was not just one single factor but provided the means and set the conditions by which other changes were able to take place, in time shaping Christianity not just as a user of writing but as a particular form of religious media culture aligned to wider practices of cultural and political power.

References

Benford, R., & Snow, D. (2000). Framing processes and social movements: An overview and assessment. *Annual Review of Sociology, 26*, 611–639.

Bévenot, M. (1961). *The tradition of manuscripts: A study in transmission of St. Cyprian's treatises.* Oxford: Clarendon Press.

Borg, M. J. (1987). *Jesus: A new vision.* San Francisco: Harper.

Bourdieu, P. (1977). The economics of linguistic exchanges. *Social Sciences Information, 16*(6), 645–668.

Burns, A. (1989). *The power of the written word: The role of literacy in the history of western civilization.* New York: Peter Lang.

Burns, J. (2002). *Cyprian the bishop.* London: Routledge.

Cameron, A. (2006). Constantine and the "peace of the church." In M. Mitchell & F. Young (Eds.), *The Cambridge history of Christianity* (Vol. 1: Origins to Constantine; pp. 538–551). Cambridge: Cambridge University Press.

Clarke, G. W. (1984). *The letters of St. Cyprian of Carthage* (Vol. 1: Letters 1–27). New York: Newman Press.

Clement of Alexandria. (c.198). The Stromata, or Miscellanies, Book 1. *Early Christian Writings.* Retrieved from http://www.earlychristianwritings.com/text/clement-stromata-book1.html

Crossan, J. (1994). *Jesus: A revolutionary biography.* San Francisco: Harper.

Crossan, J. (1998). *The birth of Christianity.* San Francisco: Harper.

Davies, S. (1986). *The revolt of the widows: The social world of the Apocryphal Acts.* Carbondale, IL: Southern Illinois University Press.

Ehrman, B. (2004). *Lost Christianities: The battles for scripture and the faiths we never knew.* Oxford: Oxford University Press.

Eisenstein, E. (1979). *The printing press as an agent of change: Communications and cultural transformations in early modern Europe. In two volumes.* Cambridge: Cambridge University Press.

Finnegan, R. H. (1988). *Literacy and orality: Studies in the technology of communication.* New York: Blackwell.

Fiskå Hägg, H. (2006). *Clement of Alexandria and the beginnings of Christian apophaticism.* Oxford: Oxford University Press.

Foucault, M. (1972). *Discourse on language.* New York: Pantheon Books.

Gamble, H. Y. (1995). *Books and readers in the early church: A history of early Christian texts.* New Haven, CT: Yale University Press.

Goody, J. (1987). *The logic of writing and the organisation of society.* Cambridge: Cambridge University Press.

Hackforth, R. (Ed.). (1952). *Plato's Phaedrus.* Cambridge: Cambridge University Press.

Hatch, E. (1957). *The influence of Greek ideas on Christianity* (Original 1889 ed.). New York: Harper.

Herklots, H. (1994). Discovering the oldest New Testaments. *Christian History, 43*(XIII,3), 34–37.

Ignatius. (106). The Epistle of Ignatius to the Smyrnæans. Retrieved from http://www.ccel.org/ccel/schaff/anf01.v.vii.html

Innis, H. A. (1950). *Empire and communications.* Toronto: University of Toronto Press.

Kelber, W. (1997). *The oral and written gospel: The hermeneutics of speaking and writing in the synoptic tradition.* Bloomington, IN: Indiana University Press.

Kimber Buell, D. (1999). *Making Christians: Clement of Alexandria and the rhetoric of legitimacy.* Princeton, NJ: Princeton University Press.

Küng, H. (1994). *Christianity: The religious situation of our time.* London: SCM.

Meer, F. v. d. (1961). *Augustine the bishop: The life and work of a father of the church.* London: Sheed and Ward.

Mendels, D. (1999). *The media revolution of early Christianity: An essay on Eusebius's Ecclesiastical History.* Grand Rapids, MI: Eerdmans.

Miller, S. (1994). Mavericks and misfits. *Christian History, XIII*(3), 18–21.

Mitchell, M. (2006). The emergence of the written record. In M. Mitchell & F. Young (Eds.), *The Cambridge history of Christianity* (Vol. 1: Origins to Constantine; pp. 177–194). Cambridge: Cambridge University Press.

Ong, W. (1982). *Orality and literacy: The technologizing of the word.* New York: Methuen.

Ong, W. (1985). Writing and the evolution of consciousness. *Mosaic: A Journal for the Comparative Study of Literature and Ideas, 18,* 1–10.

Osborn, E. (1959). Teaching and writing in the first chapter of the Stromateis of Clement of Alexandria. *Journal of Theological Studies, 10,* 335–343.

Pamphilius, E. (1890). Church history. In P. Schaff (Ed.), *Eusebius Pamphilius: Church history, Life of Constantine, Oration in praise of Constantine.* Grand Rapids: Christian Classics Ethereal Library. Retrieved from http://www.ccel.org/ccel/schaff/npnf201.html

Sawhney, H. (1996). Information superhighway: Metaphors as midwives. *Media, Culture and Society, 18*, 291–314.

Sawicki, M. (1994). *Seeing the Lord: Resurrection and early Christian practice.* Minneapolis: Fortress.

Schussler Fiorenza, E. (1983). *In memory of her: A feminist theological reconstruction of Christian origins.* London: SCM.

Tanner, K. (1997). *Theories of culture: A new agenda for theology.* Minneapolis: Fortress Press.

Theodosian Code XVI.i.2. (1943). In H. Bettenson (Ed.), *Documents of the Christian Church* (p. 31). London: Oxford University Press.

White, L. (2004). *From Jesus to Christianity: How four generations of visionaries and storytellers created the New Testament and Christian faith.* New York: Harper.

Manuscript Culture and the Myth of Golden Beginnings

LIV INGEBORG LIED

This chapter examines the discursive functions of the routine references in religion and media studies texts to the introduction of print in Europe in the fifteenth century. In this academic literature references to the introduction and development of print are numerous, but typically brief and sweeping. They do not serve the purpose of providing nuanced descriptions of historical processes in the Middle Ages—the sketchy nature does not allow for that. Rather, the references are so often mentioned that they become commonplace. As part of the "front matters" of books, they are so well-known that only a slight remark is needed—a single sentence in the introduction, or a footnote with a reference to Elizabeth Eisenstein's seminal work (1979).[1]

In the research literature of the field of religion and media studies, references to the introduction of print are commonly found in presentations of the origin of modern media. These often belong to discourses on how media and media institutions came to challenge the religious practices and institutions of the day (Hoover, 2006, p. 7). Importantly, the references to the introduction of the printing press often serve as the primary and "founding" example of how media and media technology once changed religion. This example of how media affected religion is then used, explicitly or implicitly, to argue that media, media technology, and media institutions can have the same effect again—a salient point in a time like ours when media are continuously changing. Hence, the references to the introduction of the printing press tend to serve as ordering tools that structure discourse in an academic field.

In this chapter the academic accounts of the introduction of print will not be studied as neutral descriptions of "what once happened." Instead, I discuss these accounts as exponents and co-producers of a disciplinary narrative, or an academic myth of golden beginnings. In this myth, the introduction of print represents the year zero of the longer history of the relationships between religion and media. My main interest is the effect of the myth to the understanding of pre-print religion and media culture, that is, the relationships between religion and media in a manuscript culture. Broadly speaking, a manuscript culture is a media culture where literature is copied by handwriting and circulated in the form of manuscripts.[2] It is my contention that the myth tends to produce a notion of manuscript cultures that is better described as a rhetoric by-product to the description of post–printing press media culture. Rather than providing any accurate description of religion and media in a manuscript culture, the favoured depictions of manuscript cultures support the argumentation for the assumed role of media in contemporary society. What is the effect of this academic myth of golden beginnings of modern media on the description of religion and media in a manuscript culture? What images of pre–printing press religion and use of textual artefacts does the myth create? Which nuances and tendencies are systematically overlooked? And how does this myth obstruct the possibility of studying media culture across this presumed historical divide?

Religion and Media Studies and the Function of Academic Myths

The suggestion that the recurring references in academic texts to the introduction of print serve as part of a disciplinary narrative, or an academic myth, is not new. For instance, in the article "Religion and/as Media," Jeremy Stolow (2005) refers explicitly to the tale of the development of modern media, beginning with the printing press, as "a powerful myth" (p. 122). Similarly, in his 2006 book, *Religion in the Media Age*, Stewart Hoover describes the development of printing in the fifteenth century as "our 'received' story of the origins of the media in the West" (p. 7). Thus, both Stolow and Hoover suggest that the references to the developments following the introduction of print can be interpreted first and foremost as references to a shared tale of how the disciplinary "we" envision the dawn of modern media. Consequently, the references say something about "us," our conceptions, and our needs for historical legitimation of our own descriptions of contemporary society.

Hoover (2006) and Stolow (2005) have criticised the functions of the myth from two different angles. According to Hoover, the historical processes from the fifteenth century were much more complex than the myth typically allows for.

Whereas it has been argued that print challenged established religious institutions, since the dissemination of printed texts led to weakened institutional control over sacred texts and thus the establishment of a more democratic situation, Hoover contends that a one-factor explanation focusing on "the media" and its institutions as challengers, and religious institutions as challenged, would not represent the multifaceted changes that took place in a satisfactory manner. Hoover, thus, corrects the myth by suggesting that a new look at the social and cultural processes of the *fifteenth-century context* in fact proves it wrong (pp. 7–8).

Stolow (2005) chooses another vantage point. He argues that an examination of empirical data from *contemporary society* indicates that the predictive potential of the myth fails. Stolow holds that the reference to the change ignited by the printing press has principally served the purpose of stressing a common meta-narrative about the disembedding of religion. According to Stolow, this meta-narrative is "structured around the assumption that the mere expansion of modern communication technologies is somehow commensurate with a dissolution of religious authority and a fragmentation of its markers of affiliation and identity" (p. 122). Thus, the function of the myth is to portray modern media as agents of secularisation and social modernisation. Stolow criticises secularisation theory and points out that the expansion of modern media communication did not necessarily remove religion from the public sphere after all. Hence, this myth of social modernisation, starting with the printing press, and crediting modern media, turns out not to be true since empirical investigation of the current situation proves it wrong.

In this chapter, I take a third angle of criticism. Whereas Hoover (2006) criticised the myth by referring to the fifteenth-century context and Stolow (2005) referred to the empirical data of today's society, I wish to stress how the myth tends either to create a false image of *pre-print manuscript culture* or simply to leave the centuries before the introduction of print utterly in the dark.

Any academic field or subfield needs borders. These borders separate one academic field from another and make it possible for students to learn their trade, as well as for academic professionals to master their chosen subject. The reference to the introduction of the printing press has served as one such demarcation line between academic fields. Studies of religion and modern media have regularly neglected the period before the 1440–1450s, choosing to leave the study of the period before print to medieval studies and particularly to the field of book history.

To a certain degree, some division of academic labor is necessary. However, such divisions also have side effects. First, since the year zero of the disciplinary myth of religion and media studies has been allowed to keep its status as the starting point, the literature has not necessarily included new knowledge from the above-mentioned adjacent fields. In fact, in these adjacent fields, the historical content of the myth has been a key area of investigation since the late 1970s. And like most aca-

demic research, these studies have shown that the situation in the mid-fifteenth century was much more complex than the myth allows for.[3] Such understanding is now common knowledge in these fields, and the complexity is certainly recognised in the field of religion and media studies as well, as was noted, for instance, by Hoover (2006, pp. 7–8).[4] However, even though this new information is quite widely available, the myth still circulates in recent publications[5] and year zero tends to remains stable. Even for authors that clearly indicate that they disagree with making the introduction of print the starting point, such as Hoover, it is apparently still necessary to deal with these issues in the introductory part of the book. The reference is then perhaps best explained as important to an academic genre, disciplinary expectations, and communication with the intended reader; this is an expected starting point, even when the historicity of the starting point is falsified.

Second, since the introduction of print has been designated the year zero in the field of religion and media studies, there has been no need to pay any particular attention to earlier centuries. In the case of religion and media studies, the designation of a starting point has possibly hindered new knowledge about continuities across the assumed divide, and it has to a certain degree limited the possibility of exploring the longer lines in the relationship between religion and media. While the literature in the field readily considers the "before and after picture" of changes today, it has typically allowed only for the "after picture" in examination of changes in the Middle Ages. However, as, among others, Peter Beyer (2006) has pointed out, narratives, for instance, disciplinary narratives, have a beginning and an end, while actual social and cultural processes taking place in history do not (pp. 29–34). This paradox becomes particularly pressing when scholars invest meaning in those beginnings and ends and apply that disciplinary defined meaning to make a historical argument.

Religion as Mediated and the Interference of the Myth of Golden Beginnings

The discourse on the development of modern media starting with the printing press is not the only, nor necessarily the dominant, discourse in religion and media studies. Another competing, and partly overlapping, discourse in the field is that on religion *as mediated*.[6] While the first discourse tends to point explicitly toward the starting point in the 1450s, the latter suggests that religion is always mediated and does not accept a starting point as such. Rather, the relationship between religion and media, conceptualised as the mediation of religion, could be studied at all times.

However, in actual academic texts in the field, the myth of golden beginnings can still constitute disturbing interference, even in publications that explicitly sub-

scribe to the view that religion is always mediated. Two paradoxes tend to surface. In some cases, references to the myth are allowed to limit the discourse on the historical process of mediation of religion. While proposing in one sentence that religion is always mediated, the 1450s and the printing press are mentioned in the next, thus delimiting the scope of the study.[7]

At other times, as is the case of Stolow (2005), two stories and two timelines are allowed to exist as paradoxical parallels in the text. On the one hand, Stolow contends that religion can only be manifested through some process of mediation (p. 125). He describes the myriad forms in which communication with the sacred has been enacted through a plethora of media: texts, ritual gestures, images, and architecture, to mention only a few. Thus, in the context of a discourse of mediation, Stolow shows a clear awareness of the multimedial and complex situation of religious mediation in and throughout history.

On the other hand, and as mentioned initially, Stolow (2005) engages with the discourse on the development of modern media and the relationship between religious and media institutions. The main topic, and perspective, of Stolow's article is certainly the mediation of religion. By and large, his article is not about pre- and post-printing press media culture. This is an issue he simply mentions as a kind of prelude to further examination of religion, media, and the concept of mediation. In other words, Stolow appears to start his argument where he is expected to start— at year zero—and then quickly moves on. But in that quick move, the point that religion is and always has been mediated seems to be overshadowed by the myth of golden beginnings. Indeed, in the context of this discourse, two pages earlier, Stolow paints a quite different picture of mediation before the printing press, a situation that has moved from a simple, monolithic, and traditional context of mediation of religion, to a mediation of religion characterised by a dizzying complexity of media genres, technologies, and forms. He describes this "traditional" situation, which is not dated and thus cannot be identified any further, in the following way:

> In the context of our contemporary geography of digital information flows, virtual telepresence, panoptical visualisation, concentrated media ownership and fragmented audiences, it seems no longer possible to contain religion within the confines of "traditional" social logics of institutional loyalty, the performative demands of face-to-face interaction, the controlled circulation of sacred texts, or the localized boundaries of "ritual time". (Stolow, 2005, pp. 122–123)

Stolow rightfully points out several of the main elements of a "traditional" media culture,[8] before the introduction of the printing press. Sacred texts mediated in the form of handwritten manuscripts were not numerous; publication (or at least the

delivery part of that process) certainly could be a performative situation with face-to-face interaction; and certainly, the public reading of texts was often part of a ritual, or was a ritual *per se*.[9]

Still, Stolow (2005) seems to suggest that religion in a manuscript culture was characterised by control and by limits socially, as well as in time and space. This description of religion in a manuscript culture seems to have developed as the flip side to assumptions of print culture. This notion functions as the negative mirror image to the assumption that the printing press weakened church control over individuals' access to religious texts, and that the invention of the printing press led to a more "democratic access" to the same texts.[10]

Hence, to a certain degree, the myth of the development of modern media—a myth Stolow (2005) sets out to erase—seems to have carried him away. He allows it to define the starting point in a parallel story. I do not suggest that this explicit description of the post-printing press situation is necessarily wrong, but I hesitate to accept the picture of mediation in a manuscript culture that the discourse tends to produce. This supports the contention that sacred texts before printing were "under control," and it presumes that control over textual content and interpretation is equal to control over manuscripts. These ideas are not necessarily based on empirical evidence. Rather, this is how "year zero" interferes in the studies of religion as mediated.

From Side Effect to Main Focus: Insights from Manuscript Culture

To have a more historically informed discussion of religion and media across the printing press divide, I wish to look behind the myth of golden beginnings. I will present one historical example as well as some research perspectives from studies of religion and media in manuscript cultures conducted in the last decades. I do not aim to provide a full picture of the relationship between religion and media in a manuscript culture, but to focus on the key aspects typically produced by the myth of golden beginnings: the notion of a media culture defined by the local and immediate context, by control and by boundaries, as well as the assumed key role of the written text and its carrier, the manuscript. To what extent are these notions in fact fruitful and valid in the analysis of empirical material?

I take the media culture of medieval, Mediterranean, Syriac Christians as my main example. The term "Syriac Christians" refers to Christians who use the West Aramaic dialect of Syriac as their theological and liturgical language. Most of my source material stems from the Monastery of the Syrians (Deir el-Suryan) in the Scetis Desert in the northern part of Egypt. This monastery held one of the largest

collections of Syriac manuscripts in the Middle Ages and today these are among our main sources for the study of medieval Syriac monasticism. We are looking outside Europe, at a neighbouring and interconnected cultural sphere. Looking outside Europe is important per se in an academic field that to a large degree has been Euro-centric in its historical descriptions (Meyer, 2009). Moreover, Syriac monastic media culture is a particularly rewarding example, since Syriac texts, text production, transmission, use, and circulation reveal well a trait that scholars of medieval literature have referred to as a key characteristic of medieval manuscript culture: *variance* (instability; Penn, 2009, 2010).[11] Therefore, although Syriac monasticism is certainly only *one* specific cultural and historical example, crucial traits of Syriac monastic media culture are shared with other Christian, monastic, pre-print media cultures of the Middle Ages. In this sense, the Syriac example points out key dynamics in manuscript cultures, with clear parallels in other geographical areas, including Europe.

As a first challenge to Stolow's (2005) representation of pre-print media culture, it is far from clear which texts and textual artefacts and what literature the term "sacred texts" would refer to. One thing that needs to be established concerning the media culture in the Syriac speaking realm is that no texts were printed before the sixteenth century (Brock, 2006). And as suggested above, a main feature of Syriac "sacred texts" before the introduction of print was, indeed, a relatively large degree of variance.[12]

An important "sacred text," which presumably is included in Stolow's (2005) term, is the Bible. In fact, before the introduction of print, there was not even a standardised Bible in the Syriac speaking realm. Complete versions of the Syriac Bible were few, since these *pandects* were both expensive and bulky. The most common biblical codices would rather contain one book, or groups of biblical books, such as the five books of the Pentateuch, or the Gospels.[13] Thus, although most Syriac Bible manuscripts included (groupings of) the most commonly found books, it was not obvious what books a Bible should include, and neither was the order of these books given. As a consequence, Syriac Christians probably did not engage with "The Bible" as a fixed corpus of texts with a set wording and a given sequence of books in the form of a physically unified collection.

Moreover, a substantial part of the Syriac manuscripts that were copied in the Middle Ages were liturgical manuscripts, or at least literature that was used liturgically.[14] This means that many of the potential "sacred texts" that circulated in Syriac speaking milieus were not biblical manuscripts but instead various sorts of liturgical books. Liturgical manuscripts were needed in the context of public worship; they would occasionally wear out and were, therefore, readily copied and re-disseminated. Even though the monks of the Monastery of the Syrians had many biblical manuscripts in their library (storeroom),[15] it is known that Syriac lay con-

gregations would not always have had access to Bible codices. They had service books and lectionaries.[16] In these congregations, lectionaries would play a key role in worship: It was the socially observable source of reading of scripture. In other words, in a context where Bible codices were scarce, or alternatively, available in multiple forms, already when we try to establish what texts and books we refer to when we mention the "sacred texts" of Syriac Christians, there would probably be a certain degree of *variance* in the identification of the texts concerned.

Second, Stolow (2005) rightfully notes "the performative demands of face-to-face interaction" as an aspect of pre-print media culture. Indeed, liturgical books, as well as many Bible codices, were intended for use in Christian worship. In other words, these manuscripts were meant to be performed publicly, and in this sense they can be viewed as "scripts." They live up to their potential, so to speak, at the moment when they are read aloud in a context of worship. This means that to imagine the "publication" and use of these texts, we need to imagine the ritual context in which they were performed.[17] However, although the delivery of textual content could happen in face-to-face interaction, this does not necessarily mean that the interpretation of that content was under control, nor subject to "localized boundaries of 'ritual time'". Certainly, on the one hand, it is likely that the shared experience of hearing scriptural texts read in the context of worship would to some degree create a common interpretative frame among those present.[18] On the other hand, an important insight from ritual and performance studies is that rituals are also creative settings. These settings tend to produce new conceptions; they do not ensure a controlled communicative environment (Bell, 1997). In the context of the Monastery of the Syrians in the Middle Ages, worship would in all likelihood take place in the Church of al-Adra.[19] Depending on the occasion, in the twelfth to fourteenth centuries, a relatively large group of monks could have gathered there.[20] The reading of scripture, often in the form of public reading of lessons collected in lectionaries, was a key element of West Syriac worship practice.[21] And as lectionaries produced in the monastery indicate, scripture reading played an important part in the worship practices of the Monastery of the Syrians as well.[22] The understanding and interpretation of a given lesson among those present on occasions of worship, however, would be decided by a number of factors. Former instruction and education would certainly matter. In addition, the place, order, and contexts of scriptural readings in worship would probably influence interpretation. It is likely that interpretation would also be affected by the monks' ideas about the socially observable material artefact the lessons were gathered from; their understanding of the relationship between scriptural readings and other elements in liturgy; the general atmosphere in the room, the fragrances, lighting, decorations, paintings, and graffiti inside the church; not to mention the church architecture itself.[23]

Moreover, the notion that the communication in face-to-face ritual settings would lead to control over the text and the interpretation assumes that the communication is successful in the sense that the audience paid attention and understood what was being said. Although we must assume that parts of the audience did and that many were familiar with institutional liturgical theology, we must also take into consideration the possibility of communication failures of various sorts.[24] Some of the monks sojourning in the Monastery of the Syrians or visiting the monastery to attend liturgical services may not, for instance, have mastered Syriac to the fullest. They probably knew Coptic better. Library records reveal that refugees in the monastery had other language competencies, and graffiti in the Church of al-Adra are written in Greek, Coptic, and Arabic as well as Syriac (Innemeé et al., 1999). Moreover, the monasteries in the Scetis desert formed a truly multicultural environment, and the Monastery of the Syrians was formally within the organization of the Coptic Church.[25] In addition, we also know that the monks who lived their lives or who sojourned for a while in the monastery came from all parts of the Syriac-speaking world, representing different local variations of Syriac Christianity (Van Rompay & Schmidt, 2001). It must be expected that their theological interpretations would vary somewhat. And in terms of the extent to which these various groups of sojourners would partake in communal worship, they would probably have had experience of scripture readings different from those of other participants.

Importantly, we know that monks memorised texts. They did not memorise all texts or necessarily all works in their entirety, but they knew a key corpus of works and a large amount of scriptural extracts by heart.[26] This meant, first, that their appreciation of the "sacred text" was not confined to the "localized boundaries of 'ritual time.'" They certainly memorised scriptural passages *in order to* be able to partake in worship practices, but having memorised the texts they also effectively *brought their learning out* of that ritually confined space. Monks carried textual contents in their memory and could actively and creatively use memory-representations of textual content (recollection *and* imagination) in other parts of their interpretative activity.[27] Consequently, the engagement with sacred texts among these monks was not limited to local worship contexts. Thus, memorisation and the creative use of memorised texts, for instance, in new text production, represent another challenge to the notion that texts and contents were "under control."[28]

Third, there is also reason to question the idea that manuscripts, or the circulation of these manuscripts, were controlled activities. Studies of Syriac manuscripts show that alteration of existing texts was a highly common textual practice. As Michael Phillip Penn (2009, 2010) has pointed out, scribes, copyists, and readers would actively change the material textual artefacts and erase, add, correct, or note their own reflections in the manuscripts. At times, the changes they made were

small, such as the correction of a misspelling. At other times, changes concerned the theological content of a work and were intended to alter the existing text more fundamentally. In other words, active readers could add text, change content, or reframe an existing work to affect the next reader's experience of a work (Penn, 2009). In addition, in each process of copying of a manuscript, changes were likely to occur, either by chance or on purpose. Sometimes, what was once a marginal note was included in the main text of the new copy, changing the text forever (Penn, 2009, 2010). These commonly found manuscript practices did not exclude biblical manuscripts, even though there is a larger degree of standardisation in biblical texts than in some categories of other texts. Some biblical books, such as Psalms and the Gospels, were, for instance, favoured objects of mantic practices. In the flow of a biblical text we occasionally find sudden divinatory pronouncements. They do not even have to stand out from the rest of the text; they may blend in (Childers, 2011; Penn, 2009). According to Penn, medieval reading practices were active and ethical practices: Alterations of an existing text were expected and sometimes even encouraged by scribes. These practices show that the roles of author, scribe, and reader were not easily distinguishable and suggest that texts were basically fluid or under constant construction.[29]

Manuscript colophons and the library records of the Monastery of the Syrians also show that manuscripts were brought to the monastery from other Syriac speaking groups or centres on several occasions. Colophons and other marginal notes show clear evidence of book trade, gift exchange, and circulation of manuscripts.[30] They are cultural artefacts with several functions. They were not only carriers of sacred text but also gifts and commodities. By and large, we know that Syriac manuscripts were distributed over relatively large geographical areas. Syriac Christians lived all over the Eastern Mediterranean and Mesopotamian world and due to shared (liturgical) language the texts could be carried across both geographical and denominational borders and reach communities that could read them, but who did not necessarily approve of the ideas they contained. These readers felt the urge to change them to express their reservation or disagreement (see Penn, 2010). Such examples suggest that the idea that texts were "under control" is of limited value.

From Chaos to More and Other Chaos: Media Culture Across the Printing Press Divide

This relatively brief description of Syriac (monastic) manuscript culture highlights two objections that could be raised in response to Stolow's (2005) presentation of media culture before the introduction of print.

First, there is less control and fixity than has often been imagined. "Bibles" were not standardised until the sixteenth century, the conception of "sacred text" does not necessarily apply to a clearly defined group of texts, and texts and textual contents were typically not fixed, but more or less fluid. Manuscripts were spread and circulated across denominational and geographical borders, and these manuscripts were changed, sometimes several times. Face-to-face interaction may lead to some control over the interpretation of textual content, but several factors may also point in other directions. As noted above, even though an authority who held an actual manuscript had the greatest influence in terms of text interpretation during instruction and worship, this did not mean that audience interpretation of scriptural contents was uniform, and neither was it limited to a certain time and place.

Second, the common argument that the introduction of print led to the democratisation of access to sacred texts needs to be nuanced.[31] I am not suggesting that such a view is completely wrong. However, the story of the democratisation of religion after the introduction of print seems to produce the idea that pre-print media culture was totalitarian,[32] and that this assumed interpretational monopoly of religious authorities and institutions was based on the direct access to sacred text: the hands in contact with the actual textual artefacts (the manuscripts). The implicit suggestion of manuscript culture seems to disregard the effects of the multimedial characteristic of manuscript cultures and focuses narrowly on the role of the written artefact. Instead, we need to understand how a manuscript culture functioned *as a media culture* to explore how the introduction of print affected the access to sacred texts. On the one hand, the manuscripts, the carriers of "sacred texts," were certainly important. Compared with a post-print media culture, manuscript copies were few and were regarded as valuable. At times these cultural artefacts were, in their own right, approached with certain awe. They were, for instance, ritual objects.[33] On the other hand, we also need to remind ourselves that this media culture is more than the engagement with the actual physical artefact; we should discuss how much and what that artefact actually meant to the control over and access to textual contents. The sole focus on the textual artefact as the only transmitter of textual content probably does not emphasize the learning outcome of educational and liturgical practices. Moreover, widespread practices of memorisation and memory recall should at least be allowed to correct the idea of the manuscript artefact as the only source of continuing access to textual content.

When we look beyond the myth of the introduction of the printing press as the year zero of religion and media studies, we see that we are not moving from control to chaos; we are moving from chaos to more and other chaos. Even though the introduction of the printing press gave new readers physical access to the sacred texts, that access only added a new sort of complexity to the general complexity that already dominated the media culture. Likewise, we are not moving from a *uni-*

media setting to a multimedial one. We are not moving from a simple mediation context witnessing the delivery of a sacred text from an authoritative speaker to an attentive and controlled audience, to a complex one. Instead, we are moving from one complex situation of mediation to another. The importance of the introduction of print and the actual physical manuscripts can only be understood if we deal with that change within the context of the larger picture of a complex media culture.

Concluding Remarks

In this chapter I have dealt with the emblematic references to the invention of the printing press in academic texts in religion and media studies as part of a disciplinary narrative, as an academic myth. I have suggested that descriptions of manuscript culture have been used either as a background to the overall narrative or that these presentations are an ideological by-product, which does not match the knowledge we actually have about pre-print media culture. In this sense, the myth has stood in the way of interesting analyses of the relationship between religion and media across the printing press divide.

It should be acknowledged that the present analysis faces an obvious paradox in this regard. By referring to pre-print media culture as "manuscript culture" and treating it as something "other" than a print culture, this may bolster the myth it sets out to undermine. To a certain degree, there are clear reasons for suggesting that "manuscript culture" is a productive term, since as pointed out in the above analysis, media cultures characterised by chirographically transmitted literature[34] do indeed share some key traits that separate them from "print cultures." And yet, the term "manuscript culture" may also paper over the obvious differences among various manuscript cultures; it may hide the temporal variation within a given culture, as well as underestimate the continuities in media culture across the introduction of print.[35] Hence, a first step could be to stop using the term "manuscript culture" generically, as I have done here, and rather use the term "media culture" across the printing press divide.

If we allow for new analysis of religion and media across that assumed divide, researchers in current media culture could see that analytical perspectives need to become broader or change. We may find that our eyes are opened to new points of comparison, of similarities and parallels. We might see the dynamics of pre-print media cultures in another light—not just as a historical and religious "other" somewhere beyond the point in time we assume our modern history of religion and media starts. A look at these media cultures could also open our eyes to the effects the myth of year zero have had on our narrative regarding religious change and the role of media in that change. I do not believe that by shattering the myth the past

will unfold in front of us as a pure historical landscape. However, I do believe that we need to determine which established "truths" and ideas we should question in light of new knowledge. Some notions might be products of the year zero myth, "truths" that have served to support academic narratives of secularization, democratisation, and the key role of *the media* in religious change. I am not arguing that these descriptions are all wrong, but nevertheless, we should check our assumptions and our narratives again to find out how these assumptions have been allowed to affect our lines of reasoning. And last but not least, we should rethink how the myth may stand in the way of other stories we would like to tell.

Notes

1. See, for example, Lövheim, 2007, p. 30; Hjarvard, 2008, p. 13; Lundby, 2009, p. 10; Campbell, 2010, p. 5; Bailey & Redden, 2011, p. 7.
2. See, for example, Driscoll, 2010, p. 90.
3. Eisenstein, 2005; Hobbins, 2009.
4. See Stolow, 2005, p. 136 (note 6); Morgan, 2011, p. 141.
5. See, for example, Thompson, 1995, p. 46; Hjarvard, 2008, p. 13; Hjarvard, 2011, p. 127; Bailey & Redden, 2011, p. 7.
6. See, for example, Altheide & Snow, 1988; Krotz, 2008; Morgan, 2011.
7. See, for example, Lövheim, 2007, pp. 30–31; Campbell, 2010, p. 5.
8. The concept "media culture" is used for the study of Antiquity and the Middle Ages by, for example, Le Donne & Thatcher, 2011; Uro, in press; and in the ongoing research of Ward Blanton. http://www.gla.ac.uk/schools/critical/staff/wardblanton/
9. See, for example, Zumthor, 1972; Nichols, 1990; Most, 2005; Hobbins, 2009; Uro, in press.
10. See, for example, Hjarvard, 2008, p. 13; and Hoover's discussion of this assumption (Hoover, 2006, pp. 7–8).
11. See also so-called New Philology, a vivid branch of medieval editorial theory: Zumthor, 1972; Cerquiglini, 1989; Nichols, 1990; Busby, 1993; Driscoll, 2010.
12. Brock, 2006. See also Cerquiglini, 1989; Nichols, 1990; Lied, in press.
13. Brock, 2006; Lied, 2013.
14. See Phoenix, 2009; Uro, in press.
15. Wright, 1870–1872; Evelyn White, 1973; Van Rompay & Schmidt, 2001.
16. Connolly & Codrington, 1913; Burkitt, 1923; Brock, 2006; Chaillot, 2006. A lectionary, proper, is a collection of lessons excerpted from biblical texts and collected as readings in a separate book, intended to be read on Sundays and at festivals.
17. Hobbins, 2009; Penn, 2009; Uro, in press; Lied, 2013.
18. Lundhaug, in press 2013; Uro, in press.
19. See Innemeé, Van Rompay, & Sobczynski, 1999.
20. Eleventh-century records suggest that up to seventy monks lived in the monastery (Attiyâ, Abd al-Masîh, & Khs-Burmester, 1948; Meinardus, 1989; Innemeé et al., 1999).
21. Brock, 2006.

22. Lied, 2013.
23. Innemeé et al., 1999; Harvey, 2006; Lied, 2013.
24. See, for example, Terry, 2001; Uro, in press.
25. Jenner & Van Rompay, 1998; Van Rompay & Schmidt, 2001; Brune, 2009.
26. Carruthers, 2009, 2011; Penn, 2009; Lundhaug, in press 2013; Gamble, 1995.
27. Carruthers, 2011; Lundhaug, in press 2013; Uro, in press.
28. See Czachesz, 2010.
29. See Penn, 2009, pp. 239, 243; Penn, 2010, p. 295; Zumthor, 1972; Cerquiglini, 1989; Nichols, 1990; Bryant, 2002. For the fluidity of liturgical texts in particular, see Bradshaw, 1993; and in the Syriac context, see Baumstark, 1921; Burkitt, 1923; Brock, 2006; Harvey, 2006.
30. Evelyn White, 1973; Van Rompay & Schmidt, 2001; Immerzeel, 2009; Lied, 2013.
31. I do not discuss the fact that the shift from manuscript to print culture was gradual. This issue is covered elsewhere (see Eisenstein, 2005).
32. As Lundhaug (in press 2013) has pointed out, monastic communities had totalitarian tendencies, but the means to reach that aim would have been principally shared education, meditative focus, and ritual experience, and not the limited access to physical copies of sacred texts.
33. Hurtado, 2006; Uro, in press.
34. "Chirographically" refers to "penmanship" (Driscoll, 2010, p. 90).
35. Petrucci, 1995; Bryant, 2002; Eisenstein, 2005; Quinn, 2010.

References

Altheide, D. L., & Snow, R. P. (1988). Toward a theory of mediation. *Communication Yearbook, 11*, 194–223.

Attiyâ, A. S., Abd al-Masîh, Y., & Khs-Burmester, O. H. E. (1948). *History of the patriarchs of the Egyptian church* (Vol. 2). Cairo: Johns Hopkins Press.

Bailey, M., & Redden, G. (2011). Editor's introduction: Religion as living culture. In M. Bailey & G. Redden (Eds.), *Mediating faiths: Religion and socio-cultural change in the twenty-first century* (pp. 1–21). Farnham, Surrey: Ashgate.

Baumstark, A. (1921). *Nichtevangelische syrische Perikopenordnungen des ersten Jahrtausends.* Münster: Verlag der Aschendorffschen Verlagsbuchhandlung.

Bell, C. (1997). *Ritual: Perspectives and dimensions.* New York: Oxford University Press.

Beyer, P. (2006). *Religions in global society.* London: Routledge.

Bradshaw, P. F. (1993). Liturgy and "living literature." In P. Bradshaw & B. Spinks (Eds.), *Liturgy in dialogue: Essays in memory of Ronald Jasper* (pp. 138–153). London: SPCK.

Brock, S. (2006). *The Bible in the Syriac tradition.* Gorgias Handbooks 7. Piscataway, NJ: Gorgias Press.

Brune, K.-H. (2009). The multiethnic character of the Wadi Al-Natrun. In M. S. A. Mikhail & M. Moussa (Eds.), *Christianity and Monasticism in Wadi al-Natrun* (pp. 12–23). Cairo: American University in Cairo Press.

Bryant, J. (2002). *The fluid text: A theory of revision and editing for book and screen.* Ann Arbor, MI: University of Michigan Press.

Burkitt, F. C. (1923). The early Syriac lectionary system. *Proceedings of the British Academy,* 301–338.

Busby, K. (1993). Variance and the politics of textual criticism. In K. Busby (Ed.), *Towards a synthesis? Essays on New Philology* (pp. 29–45). Faux titre 68. Amsterdam: Rodopi.

Campbell, H. (2010). *When religion meets new media*. London: Routledge.

Carruthers, M. (2009). *The book of memory: A study of memory in medieval culture* (2nd ed.). Cambridge: Cambridge University Press.

Carruthers, M. (2011). Memory, imagination, and the interpretation of scripture in the Middle Ages. In M. Lieb, E. Mason, & J. Roberts (Eds.), *The Oxford handbook of the reception history of the Bible* (pp. 214–234). Oxford: Oxford University Press.

Cerquiglini, B. (1989). *Élogue de la variante: Histoire critique de la philology*. Paris: Seuil.

Chaillot, C. (2006). The ancient oriental churches. In G. Wainwright & K. B. Westerfield Tucker (Eds.), *The Oxford history of Christian worship* (pp. 131–169). Oxford: Oxford University Press.

Childers, J. (2011). *Hermeneutics and magic: Syriac biblical manuscripts as oracles of interpretation*. Paper presented at the SBL Annual Meeting. San Francisco, November 20.

Connolly, R. H., & Codrington, H. W. (1913). *Two commentaries on the Jacobite liturgy*. London: Williams and Norgate.

Czachesz, I. (2010). Rewriting and textual fluidity in antiquity: Exploring the socio-cultural and psychological context of earliest Christian literacy. In J. Dijkstra, J. Kroesen, & Y. Kuiper (Eds.), *Myths, martyrs, and modernity: Studies in the history of religions in honour of Jan N. Bremmer* (pp. 425–441). Leiden: Brill.

Driscoll, M. J. (2010). The words on the page: Thoughts on philology, old and new. In J. Quinn & E. Lethbridge (Eds.), *Creating the medieval saga: Versions, variability, and editorial interpretations of Old Norse saga literature* (pp. 85–102). Odense: Syddansk Universitetsforlag.

Eisenstein, E. L. (1979). *The printing press as an agent of change: Communications and cultural transformations in early-modern Europe*. 2 Vols. Cambridge: Cambridge University Press.

Eisenstein, E. L. (2005). *The printing revolution in early modern Europe*. Cambridge: Cambridge University Press.

Evelyn White, H. G. (1973). *The history of the monasteries of Nitiria and of Scetis*. Part II of *The Monasteries of Wâdi 'n Natrûn*. New York: Arno Press.

Gamble, H. (1995). *Books and readers in the early Church: A history of early Christian texts*. New Haven, CT: Yale University Press.

Harvey, S. A. (2006). *Scenting salvation: Ancient Christianity and the olfactory imagination*. Berkeley, CA: University of California Press.

Hjarvard, S. (2008). The mediatization of religion: A theory of the media as agents of religious change. In S. Hjarvard (Ed.). *The mediatization of religion. Northern Lights. Film and Media Studies Yearbook*, Vol. 6. Bristol: Intellect.

Hjarvard, S. (2011). The mediatisation of religion: Theorising religion, media and social change. *Culture and Religion*, 12(2), 119–135.

Hobbins, D. (2009). *Authorship and publicity before print: Jean Gerson and the transformation of late medieval learning*. Middle Ages Series. Philadelphia, PA: University of Pennsylvania Press.

Hoover, S. M. (2006). *Religion in the media age*. Media, Culture and Religion. London: Routledge.

Hurtado, L. (2006). *The earliest Christian artifacts: Manuscripts and Christian origins*. Grand Rapids, MI: Eerdmans.

Immerzeel, M. (2009). A play of light and shadow: The stuccoes of Dayr al-Suryan and their historical context. In M. S. A. Mikhail & M. Moussa (Eds.), *Christianity and monasticism in Wadi al-Natrun* (pp. 246–271). Cairo: American University in Cairo Press.

Innemeé, K. C., Van Rompay, L., & Sobczynski, E. (1999). Deir al-Surian (Egypt): Its wall-paintings, wall-texts, and manuscripts. *Hugoye, 2*(2), Retrieved from http://www.bethmardutho.org/index.php/hugoye/volume-index/72.html

Jenner, K. D., & Van Rompay, L. (1998). New Syriac texts on the walls of the al-"Adra" church of Dayr al-Suryan. In K. Innemée, P. Grossmann, & L. Van Rompay (Eds.), New Discoveries in the al-"Adra" Church of Dayr al-Suryan in the Wadi al-Natrun. *Mitteilungen zur Christlichen Archäologie, 4*, 96–103).

Krotz, F. (2008). Media connectivity: Concepts, conditions, and consequences. In A. Hepp, F. Krotz, S. Moores, & C. Winter (Eds.), *Connectivity, networks and flows: Conceptualizing contemporary communications* (pp. 13–31). Cresskill, NJ: Hampton Press.

Le Donne, A., & Thatcher, T. (2011). *The fourth gospel in first century media culture*. Library of New Testament Studies 426. London: T&T Clark.

Lied, L. I. (2013). *Nachleben* and textual identity: Variants and variance in the reception history of *2 Baruch*. In M. Henze (Ed.), *2 Baruch—4 Ezra: 1st century Jewish apocalypticism* (Preliminary title). Proceedings of the Sixth Enoch Conference, 2011. Leiden: Brill.

Lied, L. I. (in press). Die syrische Baruch-Apokalypse und die Schriften—Die syrische Baruch-Apokalypse als Schrift. In E. Tigchelaar (Ed.), *The Old Testament Pseudepigrapha and the Scriptures* (Preliminary title). Proceedings of the Colloquium Biblicum Lovaniense, 2012.

Lövheim, M. (2007). *Sökare i cyberspace: Ungdomar och religion i ett modernt mediesamhälle*. Stockholm: Cordia.

Lundby, K. (2009). Introduction: "Mediatization" as key. In K. Lundby (Ed.), *Mediatization: Concept, changes, consequences* (pp. 1–20). New York: Peter Lang.

Lundhaug, H. (in press 2013). Memory and early monastic literary practices: A cognitive perspective. In R. Beck & L. Martin (Eds.), *Data from dead minds: Challenges on the interface of the history of religions (in Graeco-Roman Antiquity) and the cognitive science of religion*. Cognition and Culture. London: Equinox.

Meinardus, O. F. A. (1989). *Monks and monasteries of the Egyptian deserts*. Rev. ed. Cairo: American University in Cairo Press.

Meyer, B. (Ed.). (2009). *Aesthetic formations: Media, religion, and the senses*. Religion/Culture/Critique. New York: Palgrave Macmillan.

Morgan, D. (2011). Mediation and mediatisation: The history of media in the study of religion. *Culture and Religion, 12*(2), 137–152.

Most, G. (2005). Editor's introduction. In S. Timpanaro, *The genesis of Lachmann's method* (pp. 1–32). Ed. and trans. G. Most. Chicago: University of Chicago Press.

Nichols, S. (1990). Philology in a manuscript culture. *Speculum: A Journal of Medieval Studies, 65*(1), 1–10.

Penn, M. P. (2009). Monks, manuscripts, and Muslims: Syriac textual changes in reaction to the rise of Islam. *Hugoye, 12*, 235–257.

Penn, M. P. (2010). Moving beyond the palimpsest: Erasure in Syriac manuscripts. *Journal of Early Christian Studies, 18*, 261–303.

Petrucci, A. (1995). *Writers and readers in Medieval Italy: Studies in the history of written culture*. Trans. C. M. Radding. New Haven, CT: Yale University Press.

Phoenix, R. (2009). Review of M. Debié et al. (Eds.), *Les apocryphes syriaques. Journal for the Study of the Pseudepigrapha, 18*, 308.

Quinn, J. (2010). Introduction. In J. Quinn & E. Lethbridge (Eds.), *Creating the medieval saga: Versions, variability, and editorial interpretations of Old Norse saga literature* (pp. 13–37). Odense: Syddansk Universitetsforlag.

Stolow, J. (2005). Religion and/as media. *Theory, Culture & Society, 22*, 119–144.

Terry, A. (2001). The iconostasis, the choir screen, and San Marco: The veiling of ritual action and the participation of the viewer in Byzantine and Renaissance imagery. *Chicago Art Journal, 11*, 15–32.

Thompson, J. B. (1995). *The media and modernity: A social theory of the media*. Cambridge: Polity Press.

Uro, R. (in press). The interface of ritual and writing in the transmission of early Christian tradition. In I. Czachesz & R. Uro (Eds.), *Mind, morality and magic: Cognitive science of religion approaches in biblical studies*. London: Equinox.

Van Rompay, L., & Schmidt, A. B. (2001). Takritans in the Egyptian desert: The Monastery of the Syrians in the ninth century. *Journal of the Canadian Society for Syriac Studies, 1*, 41–60.

Wright, W. (1870–1872). *Catalogue of Syriac manuscripts in the British Museum acquired since the year 1838*. 3 Vols. London: British Museum. Retrieved from http://www.archive.org/stream/catalogueofsyriao1brituoft#page/168/mode/2up

Zumthor, P. (1972). *Essai de poétique médiévale*. Paris: Éditions du seuil.

Contested Ritual Mediation

Brahmin Temple Priests in South India

UTE HÜSKEN

Introduction

This chapter focuses on aspects and processes in South Indian Hindu temple traditions that trigger criticism and conflict. More often than not, these are situations of change. Change provokes discussion and instantiates reflection, and reflection always goes hand in hand with evaluation. If there is a general consensus that the change is for the better, things are fine. If, however, opinions are split about the value of the transformation, conflict is likely to emerge. It is especially these moments and situations of conflict that make the mediated-ness of religion visible. These moments also make the conditions of these mediations explicit, which might remain implicit when not contested.

In my chapter, I concentrate on issues of authorization of mediation, and on the media's[1] own agency in South Indian temple Hinduism, reflecting on the crucial question as to what determines whether media are invested with religious efficacy. This question is raised, for example, by Birgit Meyer in a 2011 article when she argues with respect to visual images that "[t]he 'power of pictures' can only be grasped by bringing to the fore the structures of power that organize what and how we see and do not see" (Meyer, 2011a, p. 1051). South Indian Brahmin temple priests are "media," in a literal and in an abstract sense. As we will see, the contestations of their "media-ness," which start in the first centuries CE and continue up to the

present day, point to processes of historical changes in power structures in society at large, in which the priests themselves are only one among many agents.

I concentrate on "eligibility" and "competence" and how these issues—historically and in contemporary South India—feed into mediation of religion in this specific context. Historically, in the context of South Indian Brahmin temple rituals, the priests' exclusive access to the deity always has been of foremost importance. The monopoly of access to the gods is claimed and jealously guarded by the Brahmin priests and at the same time is, as we will see below, constantly under discussion, a source of never-ending conflicts.

Mediating Hinduism

I take Birgit Meyer's substantial contributions to the field "religion and media" as my starting point to reflect on the roles of temple priests in South Indian temple cultures. Meyer not only insists that religion is always mediated but also that religion and media are not separate realms. She makes the important point that media are intrinsic to religion (Meyer, 2009, p. 1; 2011b, p. 23). In her insightful introduction to the volume *Aesthetic Formations. Media, Religion, and the Senses*, Meyer (2009) argues that religion itself can be understood as a practice of mediation (p. 2). I understand "media" in this essay with Meyer as those specifics (persons, things, practices, and technologies) that connect people with each other and with the divine (see Meyer, 2011b, p. 27).[2]

In fact, mediation between the sacred and the "everyday" is central to many forms of Hinduism. Mediation between humans and the transcendent takes place through rituals, festivals, temples, icons, persons, and holy places (see Flood, 1996, p. 14).

In the context of "public" temple ritual,[3] the temple priests occupy a central role: The Brahmin priests are the only ones who are allowed to touch the divine image. They protect and serve the god. The interaction between the god and the devotees is always mediated through them: They receive the offerings from the devotees, they hand them over to the god, they handle and transform the offerings physically (they break the coconut, open the banana peel, etc.) and metaphysically (the offerings are transformed into the blessing of the god, the material becomes the leftover of the god).

Priests as Mediators Between Interest Groups

Importantly, priests redistribute what was given to the god, and they decide about sequence, material, and quantity of the redistribution. Thus, while the priests in this way mediate between the divine and the human realms, they also act as mediators

between the diverse participants in the temple rituals. They are at the center of the redistribution process of the temple: They have a key role as mediators between diverse interest groups, since the redistribution of ritual honors in the temple directly feeds into honor and status in society at large.

Rituals in South Indian temples constitute the frame in which individuals and groups participate in a dynamic redistributive process, considered immensely important by the participants.[4] The objects of this redistribution are material resources, "shares" (*paṅku*), and honors (*mariyātai*) in the temple rituals. Depending on the context,

> one's share in the ritual process has a different concrete content. But the sum of one's rights, over time, constitutes one's share in the ritual and redistributive process of the temple. This share is given public expression and authoritative constitution by some combination of a finite set of substances transvalued by association with the deity, which are referred to as 'honours'. (Appadurai & Breckenridge, 1976, p. 198)

All participants in the diverse rituals, from the ordinary devotee to the temple priests, claim a unique and individual relationship to the deity, which is expressed through separate and autonomous shares in the ritual (Appadurai & Breckenridge, 1976, p. 198f). The participants have a strong desire to receive the "share" they believe they are entitled to, since these shares are the material expression of "recognising the recipients specialised and hence indispensable contribution to the temple's complex liturgical cycles" (Good, 2004, p. 19).

One example expressing the importance of these "ritual shares" is a conflict about a flower garland that is worn by the god during a festival. The person who sponsored a festival was agitated about the fact that he did not receive the garland directly after the festival. This was a matter of great importance to him, and clearly not at all related to the material value of the garland. He gave his story:

> The Senamudaliar festival took place, and I was the donor....[The main deity] Perumal is invoked, and a turban and a flower garland is brought from [the main deity] Perumal to [the sub-deity] Senamudaliar. With that turban and garland Senamudaliar comes straight to the Nammalwar shrine [the shrine of a saint]. There the garland is taken and put on [the image of the saint] Nammalwar....That garland has to be given to the donor—that is to me. [...] They [the priests] should give the garland to me also automatically, without any request, without any court order....But they don't give it to me. What I am asking the temple administration is, the garland that is coming from [the main deity] Perumal to [sub-deity] Senamudaliar

and from him coming to [the saint] Nammalwar. I want the garland per-
taining to Perumal. Even if the garland is dry it is alright, even if it is leaf
alright, lastly if it had become sand also it is alright, I want it, at least the
sand of the garland pertaining to Perumal.

The perceived injustice this donor expresses is based on the fact that a donor of a
specific festival is usually entitled to receive the garland, which was worn by the god
during worship. However, often other participants are also entitled to a garland or
another "share," since there are many people contributing in different ways to a fes-
tival. They might receive a garland for their service, such as fanning the god during
worship. It often happens that individual contributors to the festival compete with
other contributors about the honors, which take a material form and which are
often handed over to them on the ritual stage for everyone to see. The public na-
ture of the temple rituals makes the diverse contributors' roles in the ritual visible
through the sequence of the distribution of honors. Although even in festivals with
a main sponsor everybody present receives the material benefits of worship, the
main donors should receive it first.

Such "ritual shares" in a temple are part of a redistributive process that are form-
ative for social standing. At the center of this redistributive process is the deity,
represented by the priests. Participation in temple rituals is a valued good, which is
why there always have been fierce fights over these "ritual shares" and duties within
the temple, and over the distribution of ritual honors. These contestations thus can
be understood as a vying for prominence within the multilayered ritual landscape
of the temple. This has a long tradition, and instead of vanishing into oblivion, at
present this is going through a strong revival. Many members of the emerging mid-
dle class underline their power, wealth, and social standing by sponsoring lavish
temple rituals (Fuller, 2003). Today, court procedures are a quite common means to
ensure or enforce the "proper" due of ritual honors.[5]

The Priests' Central Position in the Redistributive Process

The temple priests occupy a central position within this redistributive process that
is focused on the deity residing in the temple. They act on behalf of the deity, but
during worship they *are* the deity. Mediation in Hindu traditions is characterized
by blurred boundaries between media and the transcendent, since during the ritu-
als the media, and especially icons, persons, and places, merge with the divine: They
are seen as *identical* with the transcendent. The icon *is* the god, a possessed person
is the deity, and the temple priest *is* the deity he serves. The priest's actions are di-
vine actions, and his body is the source and seat of the deity.[6]

The priest's role is therefore central, since he, as god, orchestrates the diverse ritual devices, and since he is in the position to grant or deny access to the god in the context of temple rituals. The priests are powerful agents in these processes that constitute mediation. Yet the priests are not the exclusive mediators of religion—the idea that the god is present during worship is also conveyed by a number of sensory devices. The presence of the god is seen (his image is present, there are many carvings on the temple walls and pillars), felt (special clothing is required in the temple, a special body posture is taken, people are barefoot), heard (drums sound, mantras are recited, the echo of the temple architecture), smelled (the ever-present Indian everyday odors are shunned in the temple—incense and flowers dominate the olfactory experience), and tasted (the devotees taste the "leftover" water that is scented with *tulsi* herbs, they eat the god's leftover food the priest gives them). Yet the priest's role is central, since he orchestrates these devices, and he is in the position to grant or deny access to the god in the context of temple rituals.

It follows that there is a strong urge from the side of other powerful players in society to restrict and control the power of the priests. This becomes possible because the identity between subject and object of worship coexists with a *fundamental difference* between the two. During temple worship, the priests *are* the god, but they remain themselves at the same time.[7]

Yet the identity between god and priests and the priests' prominent role usually is confined to "the particular circumscribed ritual situation" (Flood, 1996, p. 15). For the Brahmin temple priest this specific ritual situation starts with his personal ritual preparation for the worship, continues with his invocation of the deity in the image, and goes on with further ritual actions directed toward the deity, until the god in the evening is put to bed by the priests and then "dismissed" or "released" from the image (*visarjana*).[8] This situation is not only performatively but also spatially framed: All these ritual actions take place in the temple, or—on occasion—on the processional routes (Flood, 1996, p. 15).[9] That the priests are the god only in these specifically framed situations creates an ambivalence that becomes evident by taking a closer look at their position beyond the ritual frame.

Beyond the Ritual Frame: The Priests' Low Status

The ritual frame of the priests' actions clearly marks these activities off from the same persons' everyday actions. Looking more closely at the Brahmin priest *beyond* such specifically framed ritual situations, we are confronted with the puzzling phenomenon that they are considered low in the hierarchy of Brahmins. While during the worship they literally "vanish into the substance that they mediate" and are

identical with the god, this is not at all the case outside worship: They are rather low in status, and are even socially marginalized. This is no new phenomenon. We find first traces of the temple priests' low status among the different Brahmin sub-castes in normative texts from the first centuries CE. Already in some early *dharmaśāstras* differences between diverse Brahmins are described. These differences rest on relative purity and impurity, which largely depends on their occupation. By no means are or were all Brahmins priests, nor are all priests Brahmins. Those Brahmins whose activities were non-religious were often assigned a lower status by the texts (see Kane, 1974b, p. 130). The texts, however, also list divisions, which rest solely on religious or ritual differences. Some of these factors change the status of a Brahmin for the better, but some are polluting factors, which result in a diminished status (see Kane, 1974a, p. 132). For example, Brahmins who "sacrifice for many," who "sacrifice for the whole village," or who are "employed by a village or town" are considered comparatively low. This implies that ritual activity *for others*, or as a profession, is regarded negatively. In many ancient Brahmin texts the term *devalaka* is used for temple priests, often with a negative connotation.[10] These *devalakas* are said to "live off the god's wealth," which also is clearly meant negatively. Some authors mention *devalakas* as servants of an image of god, who are further differentiated: Those *devalakas* who practice their office as a profession for more than three years are judged negatively.[11] In general a negative connotation attaches to the term *devalaka* when it is understood to refer to a professional temple priest.

The low view of temple priests is conditioned by several factors. The earlier Vedic religion knew no permanent temple, and the place of sacrifice existed only for the duration of the sacrifice itself and was afterward dissolved. By virtue of their birth, the priests were in a position to summon the gods. The maintenance of this exclusivity became more difficult with the later increasingly sedentary way of life and the ethnic and cultural mix thus brought about. This was accompanied by a more polished art of sacrifice on the one hand, and on the other by an intensified critique of Vedic sacrifice and the position of priests. These are the roots, Michaels (1994, pp. 305–310) argues, of the continuing Brahmin skepticism toward temples: A temple as a permanent place for the gods requires the worshipper to leave the house, which is comparatively secured against ritual impurities. It implies contact with strangers and their impurities, and the difficulty of preserving relative purity in general. The temple priests are permanently exposed to these impurities and are therefore viewed with suspicion. The acceptance of gifts, which is normally polluting, also plays an important role here: The priests' contact with the devotees and their gifts is ritually polluting, since the relative impurity of the giver is accepted together with the gift (see Colas, 1996, p. 135). Accordingly, in the negative judgments of temple priests in ancient Indian literature regular "payment" (gifts) to priests is criticized most of all.[12]

Clearly, the temple priests' role as mediators between the human and the divine realm is and has been strictly confined to the spatial and temporal frame of the public rituals they perform. At the same time, their role as media accounts for the paradoxical fact that they have a very low status outside this role. Their state of being a medium is not anchored in their person but is attributed, and the effects of this attribution clearly are ambivalent and contradictory, which is connected to their potential power the priestly role brings about.

The Importance of Textual Knowledge and Performative Skills for Temple Worship

Much of the critique of Brahmin temple priests is grounded in the priests' claim to have the exclusive right to act as media between the human and the divine realms. This claim was the cause, throughout history, of conflicts with political authorities. One of the politically motivated moves to control priests is the attempt to redefine ritual competence.[13]

As we could see, criticism of temple priests has a long history in India. Their priestly competence was even more widely put into question and publicly discussed at the end of the nineteenth century and throughout the twentieth century. At these times, in the course of modern temple reform in the South Indian state Tamil Nadu, many complaints were voiced about mismanagement of temples, and also about the alleged "low performance standards," "ignorance," "laxity," and lack of education of the priests (see Presler, 1978, p. 115). This negative assessment was primarily based on the idea that texts are the only source of authoritative knowledge. Hence the "lack of education" meant mainly that the priests were ignorant of texts and were incapable of giving standardized meanings to the rituals they routinely performed. This situation led to attempts to offer standardized training for temple priests and other ritual specialists in special training institutions (named Āgama schools, Pāṭhaśālā or Vidyāpīṭha).

The definition of "proper ritual knowledge and authority" as based on textual knowledge, however, departed significantly from traditional ways of assessing ritual competence. In fact, a uniform standard as it was promoted at that time had never actually existed. Formerly, learning was primarily individual, and regulatory authorities outside the tradition were never referred to, since no ritual tradition claimed universal applicability. The mode of transmitting ritual knowledge had been determined by the personal relationship between the student, teacher, and the learning environment created by the teacher. Often the teacher was an older male relative (father, uncle, grandfather, etc.). The establishing of institutionalized training centers such as the Āgama schools thus resulted in the de-individualizing as well as the de-localizing of the training: Neither the specific relationship between

teacher and student nor local traditions and customs were supposed to shape ritual practice. The main learning tools in these Āgama schools became then normative mediaeval Sanskrit ritual texts (Āgamas and Saṃhitās), which had never been printed and published before (see Fuller, 2003, p. 86). This represented a radical departure from the then prevalent practice. What was presented and perceived as a "return to tradition" did thus result in a "reinvention of tradition" (Hobsbawm & Ranger, 1983), and in a homogenizing of the tradition.[14]

The importance of these newly established Āgama schools was then highlighted by new service rule by the Hindu Religious and Charitable Endowment Department in 1964, according to which every newly appointed priest needs a certificate issued by an Āgama school or its equivalent.[15] As Presler (1978, pp. 123ff.) reports, in the late 1970s ironically the temple priests' organization "South India Arcaka Sangham" itself demanded compulsory education for the temple priests, establishing learning institutions for them, and not admitting uneducated priests even if they enjoy hereditary rights. It thus seems that the accusations of "low performance standards" were soon internalized by the priests themselves.

However, many contemporary Brahmin temple priests still strongly emphasize the importance of practice for the education of young priests. In my conversations with senior priests and other temple staff at the Varadarāja temple in Kāñchipuram,[16] it became evident that they consider the predominantly text-based training in the Āgama schools insufficient. They explicitly say that the ability to perform the rituals is not acquired in these institutions. Priestly competence does not only include the adherence to written ritual rules but also the ability to perform authoritatively and convincingly. The performers achieve such knowledge of the rituals' practical performance in the first instance from learning with their fathers, or with other male elders, and through their constant exposure to the temple's ritual procedures. This dimension of ritual performances is connected with aspects of technique, but also with contextual knowledge, and with the performer's interactive and improvisational abilities (see Schieffelin, 1998, p. 198). When the senior priests talk about their own education, being with elders, helping senior members of the communities with their ritual tasks, traveling with elders, and other frequent physical exposure to ritual practice (either passively or with active involvement) are emphasized as prime modes of learning to become ritual specialists.

Even the actual use of texts in their physical form (mostly as printed handbooks in Tamil script, with Sanskrit texts and explanations in Tamil) during the ritual performances is assessed ambivalently. While on the one hand the use of the books insinuates that the rituals are performed according to norms and standards given in the book, on the other this also publicly demonstrates that the performers are not experienced enough to perform the rituals based on their embodied knowledge and experience.

However, in spite of the rather negative view on the education the children receive in the Āgama schools, most temple priests' families send their male children to these schools. In this way they secure a certificate from a government-approved institution, which then allows them to take over the position of their father, uncle, or grandfather.

Today, the importance of printed texts for the performance of temple ritual is promoted by political authorities, temple priests' associations, and other interest groups. Looking closer at what is going on "on the ground," however, shows that texts did not replace performance and mimetic learning as media to acquire ritual competence in the context of South Indian temple rituals, even though they are important as a rather abstract point of reference.

Social Reform Versus the Inherited Nature of Priesthood

These tensions continue until today as the repeated attempts to break down the priests' exclusive right as mediators between the human and the divine realms show. Closely related to the ongoing competition between text and performance as source of ritual authority is another—again politically inspired—issue that questions the priests as embodied media of religious authority. This conflict periodically emerges as "social reform" in Tamil Nadu and challenges the traditionally exclusive right of a certain group of Brahmins to serve as priests—as mediators between the gods and the devotees.

In conservative and orthodox South Indian Hindu temples, such as the Varadarāja temple in Kāñcipuram, Brahmin priests are the sole mediators between god and human beings: The priestly profession in these temples is traditionally limited to certain Brahmins. The medieval ritual texts in Sanskrit give detailed prescriptions as to who may act as mediator between the god in the temple and the devotees. Here, this right to perform rituals is termed *adhikāra* ("eligibility"). This eligibility to perform rituals in south Indian Vishnu temples is tied to certain preconditions and is then actualized through a number of initiation rituals (*dīkṣā* and *saṃskāra*). In addition, there are also local regulations, often fixed in court documents, that determine who may act as priests in the specific local temple.[17] In short, temple service at this temple is the inherited privilege of male Brahmins from a restricted number of families.

However, the most basic precondition, namely that the candidates have to be male Brahmins, is periodically challenged by politicians. This has to be seen in the context of a traditional anti-Brahmin sentiment among many Tamilians, which is also on the political agenda of a number of political parties. I will briefly describe one such move by the government of Tamil Nadu to challenge the Brahmin privilege to perform temple rituals.

In mid-May 2006 the DMK government[18] of Tamil Nadu decided that "qualified persons" of any caste can be priests in any temple run by the Hindu Religious and Charitable Endowments. In accordance with this demand, the DMK also ventured to set up several schools (or "training camps") for Brahmins and non-Brahmins in Tamil Nadu, teaching them how to perform temple rituals.[19] It was announced that young men "of all communities" (i.e., of all castes) who had passed the eighth standard, aged between 14 and 24 years, could join the training program. The one-year-long training course, accommodation, food, clothing, and teaching materials were free for the students. Furthermore the students were given a monthly stipend of 500 Indian rupees. As mentioned, traditionally in South Indian Viṣṇu and Śiva temples the ritual is performed by specially initiated Brahmin priests alone. Therefore, as soon as this new training program was announced, protest was voiced by the temple priests and their organizations.[20] An association of priests from Madurai and Trichi[21] successfully filed a petition, and on August 14, 2006, the Supreme Court stayed the Tamil Nadu Government Ordinance on the basis of the argument that the "T[amil] N[adu] ordinance amounts to interfering in religious freedom."[22] The Tamil Nadu Government responded by proposing a 69% reservation rate for students from all communities.[23] The main objections of the priests and their organizations against this program were concerned with interference of the secular government in religious affairs, especially in trying to influence the performance and language of temple rituals.[24] Even though these objections did not lead to an abolishing of the program, in 2012 none of the schools established were still functioning. While most students had left the schools without any post as priest, some—albeit few—non-Brahmin students were posted in small temples in rural areas. For the time being, the issue is not discussed publicly anymore.

However, the lack of success of this move by the DMK government has to be sought not only in the priestly opposition but in other factors as well. Becoming a priest (*arcaka*) in South Indian Brahmin temples is tied to certain preconditions, only one of which was challenged by this new legislation of opening up the priestly profession to members of all communities. While this legislation aimed at abolishing the Brahmin privilege to serve as priests, other important preconditions for becoming a temple priest were not put into question. Important are the initiations a candidate has to undergo to be eligible to serve as a priest. Part of these initiations is that the teacher (*guru, ācārya*) initiates the candidate into the use of specific *mantras* (sacred formulas in Sanskrit). Most of these *mantras* contain the syllable "oṃ." In the ancient Brahmin normative texts (*dharmaśāstra*) it is, however, repeatedly ordained that this syllable may not be taught to non-Brahmins. Accordingly, many of the Brahmin teachers in the training camps refused to initiate the non-Brahmins students into these *mantras*. Yet another more implicit issue clearly stood in the way of the success of this initiative by politicians, namely the embod-

ied nature of ritual competence, referred to above. One major difficulty for the non-Brahmin students of these new schools was therefore the lack of exposure to the ritual proceedings of the temple from early childhood on. In addition, it is important to realize that being a priest means being a "public person." Priests, as exclusive mediators between devotees and the divine, are under constant public surveillance, since their ritual purity determines the efficacy of the rituals they perform. This holds especially true in temples considered "orthodox," such as the Varadarāja temple in Kāñcipuram. Here, the rules of conduct within the temple, the appearance of those persons employed in the temple, the mode of worship, and other issues correspond to the idea of "age old custom" and strict adherence to purity rules is obligatory. This implies that the priests are expected to lead an exemplarily pure life, which means, for example, that they and their wives consistently wear traditional clothes.[25] Other important issues are the strictly vegetarian diet, absolutely no smoking and no alcohol consumption, and not to have any other occupation than the priestly profession. Seeing that the adherence to such a strict bodily regimen requires lifelong training, it becomes clear that the question of the ability, in contrast to the eligibility to perform the rituals in the temple, is an aspect that was not at all taken into account by the politicians who demanded that "temple service should be open to all."

Ritual Religion

Both the ongoing "on the ground" opposition to the preeminence of textual knowledge over performative skills for priestly competence and also the failure of the training camps for non-Brahmins point to the important fact that the body remains central for the mediation of religion. And looking at South Indian Brahmin temples, I argue that ritual *is* mediation of religion.[26] Ritual is not something done *to* religion, it *constitutes* religion. Even the idea of belief and doctrine as opposed to practice and ritual does not hold well. Religious ideas are never disembodied or immaterial. There exists no "purely cognitive" side of religion, since every human process is performative to some extent. Beliefs and doctrines are externalized and expressed to be shared as religious idea, and externalization also is always a practice. Practice therefore encompasses belief, and belief is embodied practice, too (see Meyer, 2009, fn 15).[27]

In Indian contexts belief is often rather negligible and practice trumps belief. During my many years of fieldwork in the Varadarāja temple in Kāñchipuram, other temple visitors often approached me, after they had noticed that I spent most of my time in the temple. Many of them told me that they considered me a very fortunate and devout person, since I spent so much time in their beloved god's

temple. I often felt compelled (out of drive to be sincere) to explain that my presence in the temple was part of my job, for which I received a good salary. However, in the eyes of my conversation partners, this fact rarely diminished the religious merit that I accrued through my constant presence in the temple: "You might think that you are here because of your job," they would say, "but it is the god who called you and who wants you near him—you are very blessed and clearly his favorite!"

Clearly, intention, belief, and sincerity did not matter as much as what I actually did. From such perspectives, religion is what one does, it is one's practice, it is the rituals one performs.

The conflicts about the Brahmin priests' eligibility to be the exclusive role as mediators in South Indian temples described above therefore always in one way or another have ritual practice at their center, which is *the* mediation of religion.

Ritual, Mediation, and Authority

The South Indian Brahmin temple priests' role as mediators between the human and the divine realm is strictly confined to the spatial and temporal frame of the public rituals they perform. At the same time, their role as media accounts for the paradoxical fact that they have a low status outside this role. Clearly, the effects of being media are ambivalent and contradictory.

Their state of being media is not anchored in their person, but is attributed. While on the one hand anything can be made to operate as a medium and "media-ness" is not intrinsic to a specific person, thing, or process, on the other the acceptance as valid medium always depends on an authorization process, which is the result of negotiations between diverse agents. Accordingly, the acceptance or rejection of a change in religious mediation depends largely on the (religious) authorization of mediation practices (see Meyer, 2011b, p. 27). While the necessity of mediation between the devotees and the transcendent remains unchallenged in the context of South Indian public (temple) ritual, the authorization of Brahmin temple priests to solely fill this role is strongly contested. It is the base of their authority (textual knowledge or performative skills), and their claim to exclusive access to the deity, which are negotiated most in the complex network of competing players and power dynamics.

These conflicts are closely connected to the potential power the priestly role brings about. This points to the important fact that media also have the power to shape and transform what they mediate. The priests act on behalf of the deity, and they have the authority to assign or withdraw status. Accordingly, they can have a lot of power, and as we saw in the examples above, other forces within society try to keep this power under control. As Meyer points out, the entering of new media

into the religious sphere and their reception is often also a political issue. Political authorities sometimes promote, and sometimes try to prevent, the use of new media. For South Indian Brahmin temple culture, this became especially evident in the context of colonialism, when priestly competence was redefined as being based on textual knowledge rather than on performative skills. This entanglement of colonial ideas, namely that texts alone constitute religious authority, with conflicting local perceptions pose a still unresolved tension between diverse groups of agents. Until now, in spite of all initiatives by political authorities, texts did not replace performance and mimetic learning as media to acquire ritual competence in the context of South Indian temple rituals. Also the politicians' attempts to introduce a different group of priests, which challenged the traditional form of ritual mediation, have not yet succeeded.

Clearly, temple priests as media are not just mechanical means to convey a message, but they shape and affect what they transmit (see Meyer, 2011b, p. 31). Latour (2005, pp. 39ff.) differentiates between mediators and intermediaries. Mediators, he says, "transform, translate, distort, and modify the meaning or the elements they are supposed to carry." They have their own agency and have the power to transform what they transmit. Intermediaries, in contrast, "transport meaning or force without transformation."[28]

While in South Indian temple traditions mediation through rituals clearly is accepted as a necessary ingredient for the practice of religion, the conflicts about the Brahmin priests' role have to be understood as attempts to transform them from mediators into intermediaries. An important side of this continuing opposition against the ritual mediation of temple religion solely by Brahmin priests is the political attempt to keep their power under control.

Notes

1. I use the terms *media* and *mediator* interchangeably, since I am talking about a group of persons as *media* who, as I argue here, have a good deal of agency. The boundaries between media and the *nomen agentis* mediator, therefore, are blurred.

2. Meyer coined the notion of sensational forms to grasp diverse aspects of mediation. She explains: "sensational forms are relatively fixed modes of invoking or organizing access to the transcendental, offering structures of repetition to create and sustain links between believers in the context of particular religious regimes" (Meyer, 2011b, p. 29). However, I refrain from using this rather technical term here, and refer to *media*, *mediator(s)*, and *mediation* instead.

3. On the differentiation between rituals performed "for others" (*parārtha*) and "for oneself" (*ātmārtha*) see, for example, Brunner, 1990.

4. See especially Appadurai & Breckenridge, 1976.

5. That secular courts are resorted to in these conflicts is the result of a historical development. In pre-colonial times, Hindu kings built, endowed, and protected temples. Their administrative departments supervised and controlled the temples. First the East India Company followed suit, but the British withdrew in 1863 CE from participation and donations to rituals. The management of temples was then handled by trustees with unrestricted control over temple assets. Law courts became the only source for redress for the priests, temple staff, and devotees (for details, see Mukund, 2005).

6. See Freeman, 2010.

7. See Fuller, 1992, and also the notion *identifikatorischer Habitus*, coined by Michaels, 1998.

8. For details, see Freeman, 2010.

9. However, the presence of the god in the image continues to linger on, at least for the average devotee, even after the god is "released" from the image. For example in museums even discharged images of gods still receive worship by the museum visitors and are treated as if a divine power still resides in them.

10. Thus, according to Manu Smṛti (3.152) *devalakas* are not even to be invited to death rituals (see Kane, 1974b, p. 711). *Devalakas* are also represented negatively in the Mahābhārata (12.77.8, 13 App. 4.3251–2, 13.24.14 and 13.90.10). For details, see Hüsken, 2009, pp. 54ff.

11. See Kane, 1974a, p. 109, note 232; see also Colas, 1996, p. 135, fn. 2.

12. As convincing as such explanatory models are, group-specific and regional factors are also influential in ranking within the caste hierarchy (see Fuller, 1984, pp. 49–54).

13. For details, see Hüsken, 2010.

14. However, as Freeman (1999) rightly cautions, this ongoing transformation took place not on account of the colonial initiatives alone, but was also received and promoted by diverse individuals and groups within the local settings.

15. Although this service rule has so far not been consequently enforced, the priests are well aware of the fact that this might happen.

16. This temple is a famous and important pilgrimage site visited throughout the year by tens of thousands of Hindu pilgrims from all over India.

17. The texts further specify that the priests have to belong to specific clans (*gotras*). In addition in this temple priests can only be recruited from specified six families in Kāñchipuram who inherit the right to do temple service.

18. This party, the Dravida Munnetra Kazhagam (DMK), from its beginning in the late 1940s stood for the interests of the Tamilians and is especially opposed to the sanskritic-Brahmanic traditions, which are seen as "foreign." The DMK in 1971 abolished hereditary priesthood (see Presler, 1978, pp. 106ff.). The priests successfully opposed this and in 1974 brought to pass a stay order stating that in all temples the rituals should continue "according to tradition." Thus, the hereditary transmission of the priestly profession continues to be practiced.

19. According to the Tamil Newspaper "Dinamalar" (dated May 12, 2007) training institutions for Vaishnava temple priests (*arcakas*) have been set up in Chennai and in Shrirangam. For priests of other Hindu traditions training institutions have been set up in Tiruvannamalai (at the Arunacaleshvara temple), in Madurai (at the Minakshi temple), and in the Palani and Tiruchandur Murugan temples.

20. However, while most priests protested, some—albeit few—of the temple priests evidently volunteered as teachers in these training programs. One of their motivations was certainly that being involved as major actors might give them a chance to influence the proceedings.

21. The Adi Saiva Sivachariyargal Nala Sangam.
22. See TheHindu.online, August 14, 2006; see also NDTV.com, August 14, 2006.
23. See "Dinamalar," dated May 27, 2007. On similar procedures in the early 1970s, see Presler, 1978.
24. Although the language question was not prominent in the program, the priests' worries about the language of the ritual performances are not unfounded, since the DMK government repeatedly tried to enforce temple service to be conducted in Tamil instead of Sanskrit.
25. The lower body of a priest is covered with an unstitched white cloth, and his upper body remains bare or is covered with another smaller white piece of cloth called uttarīyam. The wives of the priests are supposed to wear a nine-yard Sari, which is considered old-fashioned (as opposed to the six-yard Sari).
26. In whatever way one defines "ritual," it does not exist beyond its enactment: "whatever else it is, ritual is a kind of action, and it is enacted by agents, many of whom are human actors.... So there is no way around the most basic fact of ritual: embodied human beings enacting, or performing" (Grimes, 2011, p. 11ff.).
27. Yet it is important to realize that "intentionality" and "inner attitude" is discussed in ancient Indian traditions, too. Is, for example, the circumambulation of a shrine, done by a dog chasing another dog, an efficacious ritual? Or is it substantially different from the circumambulation of a devotee who knows that this curcumambulation is meritious and leads to salvation?
28. Even media in the narrow sense of (new) technologies, or technological possibilities, are rarely "just" technical means to mediate a message (Latour, 2005, p. 40).

References

Appadurai, A., & Breckenridge, C. (1976). The South Indian Temple: Authority, honor and redistribution. Contributions to Indian Sociology, 10(2), 187–211.

Brunner, H. (1990). Ātmārthapūjā versus Parārthapūjā in the Śaiva tradition. In T. Goudriaan (Ed.), The Sanskrit tradition and tantrism (pp. 4–23). Leiden: Brill.

Colas, G. (1996). Viṣṇu, ses images et ses feux. Les métamorphoses du dieu chez les vaikhānasa. Paris: École Française d'Extrême-Orient.

Flood, G. D. (1996). An Introduction to Hinduism. Cambridge: Cambridge University Press.

Freeman, R. (1999). Texts, temples, and the teaching of tantra in Kerala. In J. Assayag (Ed.), The resources of history. Tradition, narration and nation in South Asia (pp. 565–579). Paris: Ecole française d'Extreme-Orient.

Freeman, R. (2010). Pedagogy and practice. The meta-pragmatics of tantric rites in Kerala. In A. Michaels & A. Mishra (Eds.), Grammar and morphology of ritual (pp. 275–305). Wiesbaden: Harrassowitz.

Fuller, C. J. (1984). Servants of the goddess: The priests of a South Indian temple. Cambridge: Cambridge University Press.

Fuller, C. J. (1992). The camphor flame. Popular Hinduism and society in India. Princeton, NJ: Princeton University Press.

Fuller, C. J. (2003). The renewal of the priesthood: Modernity and traditionalism in a South Indian Temple. Princeton, NJ: Princeton University Press.

Good, A. (2004). *Worship and the ceremonial economy of a royal South Indian temple.* Lewiston: Edwin Mellen Press.

Grimes, R. L. (2011). Ritual, media, and conflict: An introduction. In R. L. Grimes, U. Hüsken, U. Simon, & E. Venbrux (Eds.), *Ritual, media, and conflict* (pp. 3–33). New York: Oxford University Press.

Hobsbawm, E. J., & Ranger, T. (Eds.). (1983). *The invention of tradition.* Cambridge: Cambridge University Press.

Hüsken, U. (2009). *Viṣṇu's children. Prenatal life-cycle rituals in South India.* Wiesbaden: Harrassowitz.

Hüsken, U. (2010). Challenges to a Vaiṣṇava initiation? In A. Zotter & C. Zotter (Eds.), *Hindu and Buddhist initiations in India and Nepal* (pp. 299–306). Wiesbaden: Harrassowitz.

Kane, P. V. (1974a). *History of Dharmaśāstra* (6 Vols.). Government Oriental Series. Poona: Bhandarkar Oriental Research Institute. Vol. 2.1.

Kane, P. V. (1974b). *History of Dharmaśāstra.* (6 Vols.). Government Oriental Series. Poona: Bhandarkar Oriental Research Institute. Vol. 2.2.

Latour, B. (2005). *Reassembling the social: An introduction to actor-network theory.* New York: Oxford University Press.

Mahābhārata. V. S. Sukthankar, S. K. Belvalkar, P. L. Vaidya et al., (Eds.). Poona, 1927–1966.

Manu Smṛti, with commentary of Kullūkabhaṭṭa (Nirnaya-Sagara press), Bombay, 1909.

Meyer, B. (2009). Introduction. In B. Meyer (Ed.), *Aesthetic formations. Media, religion, and the senses* (pp. 1–28). New York: Palgrave.

Meyer, B. (2011a). Mediating absence—Effecting spiritual presence: Pictures and the Christian imagination. *Social Research, 78*(4), 1029–1056.

Meyer, B. (2011b). Mediation and immediacy: Sensational forms, semiotic ideologies and the question of the medium. *Social Anthropology/Anthropologie Sociale, 19*(1), 23–39.

Michaels, A. (1994). *Die Reisen der Götter. Der nepalische Paśupatinātha-Tempel und sein rituelles Umfeld* (Nepalica 6). Bonn: VGH-Wiss. Verlag.

Michaels, A. (1998). *Der Hinduismus: Geschichte und Gegenwart.* München: Beck Verlag.

Mukund, K. (2005). *The view from below. Indigeneous society, temples and the early colonial state in Tamil Nadu, 1700–1835.* New Delhi: Orient Longman.

Presler, F. A. (1978). The legitimation of religious policy in Tamil Nadu. In B. L. Smith (Ed.), *Religion and the legitimation of power in South Asia* (pp. 106–133). Leiden: Brill.

Schieffelin, E. L. (1998). Problematizing performance. In F. Hughes-Freeland (Ed.), *Ritual. Performance, media* (pp. 194–207). London: Routledge.

On Digital Eloquence and Other Rhetorical Pathways to Thinking About Religion and Media

PETER SIMONSON

Rhetoric is one of the major vehicles through which religion manifests and organizes itself in the world of humans. Along with ritual, it is an ancient and primary form for mediating religion—for making present what sometimes lies beyond the immediate senses. As a result, rhetorical concepts and theoretical perspectives potentially have a great deal to offer the interdisciplinary study of religion across media, cultures, and time. I will elaborate on these claims below but for now say that I am using *rhetoric* first in the spacious sense of communicative address with the potential to alter *or* solidify beliefs, sensibilities, identities, communal attachments, and ways of living in the world for the audiences who receive it—including that special internal audience that hears our own words and silent thoughts. *Rhetoric* additionally refers to a particular intellectual tradition and body of concepts that make sense of such communicative address—rhetorical theory, if you will, for interpreting rhetoric as socially manifest. That intellectual tradition emerged and gained its name in ancient Greece and, developed through the Latin world, came to inform dimensions of Western learning into the contemporary age. It also entered into Islamic thought and practice, and, as recent scholarship has helped us to see, it has analogues in other civilizations and cultures as well. Western and non-Western rhetorical concepts, I will argue, are potentially important tools for making sense of mediations of religion and their power on people.

Historically, rhetoric as a social practice takes on particular significance in culturally unsettled moments—those marked, for instance, by significant change,

marked disagreements, or widespread doubts. In such moments, rhetorical prac-
tices become primary media through which emergent and traditional forms of life
make themselves felt upon hearts, minds, and bodies swimming in larger seas of in-
stability or competing voices. As the anthropologists Ivo Strecker and Stephen
Tyler (2009) have argued, experiences and ideas "remain unstable and incomplete
as long as we do not manage to persuade both ourselves and others of their mean-
ings," and this work is done through rhetorical means (pp. 26–27). Rhetoric as an
intellectual discipline has also frequently flourished in culturally unsettled mo-
ments—including those marked by transformations in media environments, reli-
giosity, or both, as I illustrate briefly below. As a theoretical vocabulary developed
over more than two millennia, then, rhetoric provides a cultural hermeneutic whose
history trails multiple and deep encounters with emergent media and changing re-
ligious orientations.

In this chapter, I offer an extremely condensed sketch of that longer intellectual
history, make a case for rhetorical ways of understanding how religion impresses it-
self upon embodied hearts and minds, and introduce digital religious eloquence as
a theoretical concept. In the first two sections, I offer the briefest introduction to
rhetoric for non-rhetoricians, sketching aspects of Western and non-Western
rhetorical traditions that I hope might stoke fresh ways of thinking about religion
and media and cast questions about it in long historical relief. Following those
broader orienting remarks, I turn to digital religious eloquence as a category of
contemporary rhetorical address that blends traditional and emergent cultural sen-
sibilities and creates potentially meaningful experiences for audiences exposed to it.
I conceptualize digital religious eloquence in relation to Birgit Meyer's idea of aes-
thetic formations, provide a couple of examples, and lay out ways that scholars of
rhetoric, anthropology, and media studies can productively work together to ad-
vance the study of religion across media.

An Extraordinarily Short Introduction to the Long History of Rhetoric, Religion, and Media

The Greek word *rhetorikē* was apparently coined in the fourth century BCE to
name a social practice growing in cultural importance as city states such as Athens
democratized—the art (*-ikē*) of the public speaker (*rhētor*; Schiappa, 2003). The
coining of the term coincided with the formalization of the art and the early cod-
ification of principles for guiding the production and interpretation of speech. The
sophists were its earliest teachers, with men such as Protagoras asserting that every
argument (*logos*) had its contraries (*dissoi logoi*), a multi-sided perspective that un-
dermined the authority of any position that declared itself true and helped make

Protagoras one of the first characters in the West to have his books burned (Billig, 1996). He was surely not helped by his skepticism about the gods, stating that he couldn't be sure whether they existed or not, since the question was difficult and life was short. Other early teachers of rhetoric would deploy the art to less skeptical ends—Isocrates, for instance, who taught oratory as a medium for expressing knowledge, advancing good, and deliberating internally about them; and Aristotle, who defended rhetoric against his teacher Plato's famous attack on it, established it as an art of mobilizing available means of persuasion, carved out space for it in the domains of opinion (*doxa*) and belief (*pistis*, also the New Testament word for *faith* [Kinneavy, 1987]) through which humans necessarily moved, and argued that it was necessary in a world of uncertainty. This Greek art entered the Roman world, where Cicero, extending Isocrates, advanced the ideal of *eloquence*, not mere persuasion, as rhetoric's governing end. Capturing the ideal of wisdom or truth artfully rendered, eloquence in turn entered the Christian tradition through St. Augustine, who had been deeply influenced by Cicero when he was a teacher of rhetoric before his religious conversion. After a period of medieval scholasticism, when dialectic and grammar dominated rhetoric in the arts of language (McLuhan, 1943/2006), Renaissance humanists would revive and extend the Ciceronian ideal, championing eloquence as an ideal governing oratory, literature, and the arts (McKeon, 1971/1987). Though rhetoric's fortunes declined in the Enlightenment and Romantic movements, when its artifice was denigrated in comparison to natural reason, empirical science, and more direct intuitive contact with nature or the soul, Transcendentalists such as Ralph Waldo Emerson continued to defend eloquence as a spiritual and political ideal manifest through oratory that moved hearts as well as minds.[1]

I'll return to the idea of eloquence below, but first I want to gesture toward macro-level dimensions of some of the social settings in which rhetoric has flourished as an intellectual discipline. This begins in ancient Greece, where rhetoric emerged as a distinct and codified body of thought within a culture that was undergoing fundamental changes in its media and religious environments. The introduction of writing and literacy helped fuel a process by which, as Eric Havelock put it, "language emancipates itself from the oral-poetic tradition," and a humanist-rationalistic worldview came into being against the backdrop of a longer mythic-poetic form of life (quoted and discussed in Schiappa, 2003, pp. 24–32). As an art of using words to alternately challenge or defend existing beliefs and practices, rhetoric served as both instrument and medium for advancing the rationalistic worldview. When Protagoras taught his students to argue both sides of a question and give their breath to countervailing *logoi*, when he boasted that he could make "the lesser appear greater," he helped create a medium through which under-recognized perspectives could gain social stature. In purportedly burning his books, his critics

were recognizing the power of the disembodied word to further undermine authority about the gods and other cherished matters. In its birth moment, then, rhetoric was intimately tied to shifting religiosities and newer media. Painting with an equally broad brush, we can cast the Renaissance in analogous terms. The flowering of Ciceronian rhetorical humanism took shape against the backdrop of the Reformation and Counter-Reformation, within new cultures of print that were themselves overlaid upon older oral and chirographic forms of communicative life—oratory, conversation, and letter-writing, for instance, all flourished as traditional media alongside the newer medium of print (see Rebhorn, 2000; P. Burke, 2013; Eisenstein, 2011; McLuhan, 1962). Again, rhetoric gained force as both a theoretical vocabulary and family of social practices in an epoch of fundamental religious and media change.

Another chapter in this story has unfolded since the late nineteenth century, when two idiosyncratic geniuses, utterly marginal in their own day, rediscovered and intellectually refigured rhetoric in their own ways. Against the backdrop of the rise of religious unbelief and unorthodox spiritualities in Europe and North America (Taylor, 2007; Turner, 1986), Charles Sanders Peirce and Friedrich Nietzsche wrote seminal works that laid the foundations for reconstructive and deconstructive rhetorical theories in the next century. Over four decades, Peirce outlined a new "speculative rhetoric" that addressed "the formal conditions of the force of symbols, or their power of appealing to a mind" (1992, p. 8) and that united hermeneutics and communication (Peirce, 1998, ch. 23; see Bergman, 2009; Lyne, 1980). He worked out his new rhetoric over a period in which he also wrote his fascinating if enigmatic essays, "Evolutionary Love" (1893) and "A Neglected Argument for the Reality of God" (1908). Nietzsche, meanwhile, was famously on a different course, delivering lectures on rhetoric that fed his theory that truth was a mobile army of metaphors and "a sum of human relations which were poetically and rhetorically heightened, transferred, and adorned, and after long use seem solid, canonical, and binding to a nation" of rhetorically heightened human relations (in Gilman, Blair, & Parent, 1989, p. 250). Soon after, he would declare in *The Gay Science* (1882) that God was dead, for we had killed him.

In their own different ways, Peirce and Nietzsche presaged an intellectual moment that would not be born until the late twentieth century, when two well-placed scholarly observers would declare that "not since the Renaissance ... have students of rhetoric and religion had so much to say to one another" (Jost & Olmsted, 2000, p. 1; see also Pernot, 2009; Zulick, 2009). That more recent development would take form after a host of philosophers, literary critics, and social scientists had turned their attention to the old subject of rhetoric, beginning in the 1920s and 1930s. They did so at the moment that the American historian Robert Albion (1932) was identifying and naming "the communication revolution" that had begun a century ear-

lier. It issued in a dizzying array of new media and transportation systems that provided the material substrate for a heterogeneous array of rhetorical practices, some of which helped to constitute established and emergent cultures of belief and unbelief, marked by their own certainties and uncertainties about truth, goodness, and right living.

Looking back across the Western rhetorical tradition that runs from the sophists to the present, forged partly in contexts of social transformation, we can find composite theoretical material for piecing together a philosophical anthropology for *Homo Rhetoricus* (Oesterreich, 2009) or, as I prefer, *Zoon Rhetorikon*, the rhetorical animal. That project, even in outline, is well beyond the scope of this chapter, but I point toward it as a way of hinting at the fuller promise of rhetorical pathways of thought. The Western rhetorical tradition has always featured ideas of performance, bodies, emotions, aesthetics, style, and the deep sociality of humans—standing always already as a critique of Cartesian rationalism and the abstract ego, as it were. It offers a range of theoretically rich traditional concepts ripe for ongoing retrieval and updating, including *pathos* (ongoing moods and catalyzed emotions), *ethos* (socially cultivated character as recognized by particular audiences), *style* (as manifest through figures, tropes, and culturally specific aesthetics of the fitting and the striking), *presence* (whereby distant or un-sensed entities are brought palpably close to an audience), *kairos* (the opportune moment in time and space), and *decorum* (the culturally determined sense of what is appropriate and possible for particular settings, topics, or participants)—not to mention *eloquence*, which combines these qualities into an ideal of morally truthful and affectively powerful rhetorical address. Moreover, from the introduction of writing in ancient Greece, these principles have proven themselves adaptable to a range of media outside the body, from letters to printed treatises, the fine arts and architecture, radio and television broadcasting, and the new digital realm.

Rhetoric Across Cultures

Though the tradition called "rhetoric" was formalized and developed from ancient Greece, other cultures had their analogues, as recent comparative scholarship has shown us. In contrast to the Western tradition, though, where rhetoric was a distinct discipline and body of knowledge, other cultures generally embedded principles for the production and interpretation of speech within broader doctrines of proper conduct or embedded them in religious or literary texts or oral traditions (see Kennedy, 1998; Lipson & Brinkley, 2004, 2009; Oliver, 1971). One could argue that, in the West, rhetoric's status as an independent discipline has both reflected and contributed to instrumental, strategic thinking and practice in communica-

tion—borne out in everything from church propaganda and evangelism to public relations, advertising, and marketing—all of which make use of techniques that can be applied to many ends. But all cultures have implicit or fully articulated norms about addressing others through speech, which can be read as more-or-less explicit "rhetorical theories" that provide immanent resources for interpreting historical and contemporary expressions of religion through a range of media.

Some of these traditions came into contact with Greek or Latin rhetorical teachings, resulting in hybrid, religiously oriented rhetorical practices. The ancient Hebrew tradition, for instance, which cast more attention than the Greeks on the duties of the listener (Zulick, 1992), spread around the Mediterranean, where diaspora Jews were exposed to and sometimes formally studied Greek rhetoric. Paul of Tarsus's letters, for instance, displayed patterns of both Greek rhetoric and Jewish argumentation, and were in addition mediated through voice, body, and live performance—dictated to a secretary, carried by messenger, read aloud to gathered members of a local church, and eventually collected in a medium, the codex, which distinguished itself from the older medium of the Jewish scroll. Greek rhetoric also made its way through North Africa and the Arab world, where it came to inform both Christian and Muslim understandings and practices with regard to speaking and writing. Augustine of Hippo was a teacher of rhetoric in Carthage and then Rome, and he would bend that learning to the first great Christian rhetorical treatise, *On Christian Doctrine*, while also exercising the rhetorical art in the *Confessions* and other writings (see Troup, 1999).

In the Islamic world, Aristotle's *Rhetoric* was translated into Arabic with commentary by the tenth century, when scholars drew it toward Islamic understandings (Ezzaher, 2008; Watt, 1995). These commentaries fed the tradition of *al-khatāba* (the art of the public speaker), sometimes rejected as pagan, but also incorporated into the practices of Muslim preachers, some of whom cast the Prophet Muhammad and his contemporaries as unsurpassable models of the art (Halldén, 2005). Another Islamic tradition, *al-balālgha* (eloquence), consisted of a science of meanings (hermeneutics), a science of clarity, and a science of ornamentation. Both traditions were subsumed under Islamic law as arbiter of proper procedure in public speech, with *shari`a* serving "as the definer of *decorum* in human behavior generally" (Halldén, 2005, p. 23). Recently, Nabil Echchaibi (2013) has interpreted contemporary Egyptian televangelism in the contexts of this longer Islamic tradition, showing the value of a rhetorical hermeneutic for differently mediated religious address.

Indian and Chinese civilizations also had well-developed ideas about speech and its proper use, embedded within canonic ancient texts, and pointing toward traditional understandings of spoken and embodied mediations of social order, right conduct, and truth in the broadly religious register (see, e.g., Chen, 2009; Kennedy, 1998; Lipson & Brinkley, 2009; Oliver, 1971). Indians "put a very high

value on speech, higher perhaps than that found in any other ancient culture," with even the longest texts memorized and transmitted orally, and knowledge of sacred texts controlled by priests (Kennedy, 1998, p. 172). *The Upanishads* includes an excursus on the idea that Brahma, the ultimate principle of the world, "is speech" (p. 179). Robert T. Oliver (1971) has argued, too, that the caste system that placed Brahmins at its top was a kind of "rhetoric in being," which he defines in terms of "customs, folkways, habits, regulations which shape communicative behavior, including thinking, speaking, listening, and responding" (p. 31). This "macro-rhetoric," if you will, helps to establish the social grammar of rhetorical performance: who speaks, to whom, in what manner and settings, and through what sorts of linguistic and gestural conventions. It provides its own mediation of sacred and profane by regulating and coding public expression of them, and opens out into a different register of rhetorical interpretation of social communication.

In sum, even if they have no word or distinct subject that corresponds to the Greek *rhetorikē*, non-Western cultures carry their own traditional understandings about speech and its relation to piety and right order. These in turn furnish anthropologically and historically embedded frameworks for interpreting religious address within those cultures, raising questions about what rhetorical understandings inform religious communication, what attitudes toward persuasion inform discourse as it circulates through different media, what standards of rhetorical excellence are operative, and what "rhetorics of being" help structure the interpretive work done by audiences and producers. These questions in turn point toward more general pathways for thinking rhetorically about religion across cultures, media, and time.

The Rhetorical Power of Eloquence

Eloquence is one traditional rhetorical ideal, found across multiple religious traditions, which I have briefly touched upon. I want to elaborate further and introduce the idea of *digital religious eloquence* to name a rhetorical effectivity that, in tandem with what Birgit Meyer calls aesthetic formations, serves as a kind of communicative mechanism through which religion is mediated and impressed upon the affectively colored minds of the faithful. To help fill out that claim, let me combine traditional ideals of eloquence with some key insights from contemporary rhetorical theory.

In the twentieth-century revival I alluded to earlier, rhetorical theory broadened out in sociological and anthropological directions, providing the basis for making sense of humans as rhetorical animals thrown into symbolic worlds that make claims on their minds and bodies. One of the key developments occurred

when the literary critic Kenneth Burke shifted rhetoric's traditional focus from persuasion to *identification*—the process of generating commonality among disparate particulars, be they people, actions, institutions, or any other entities or phenomena that can be grouped together within some named category, X. Burke drew attention to the way in which all discourse reveals and advances both particular views of reality (X, not Y) and bonds of community (we are people agreed in X)—at the same time that it invites identification's opposite, division—X is not Y, we are not them (K. Burke, 1950). Carefully examined, Burke argued later, that same discourse reveals the presence of linguistically structured hierarchies of being and value that are essentially religious, crowned by "god terms" that organize value and ethico-religious energies (K. Burke, 1961; Booth, 1991, 2000; Carter, 1992). These insights in turn fed the idea that rhetoric can be "constitutive"—helping to create the collective identities and other social realities that it purports merely to describe (e.g., Charland, 1987) and to underwrite particular, morally weighted attitudes and worldviews.

Complementary insights have arisen from other quarters. Members of the Rhetoric Culture project, for instance, a recent collaboration among rhetoricians and anthropologists, have built a research agenda around the twin facts that rhetoric is both "the instrument with which we *describe*" culture and "the means by which we *create* culture" (Strecker & Tyler, 2009, p. 2). Mapping "interrelationships between cultural forms of practice, passion, and reason" as well as "culturally generated orders of discourse—and their technologies of production" (p. 21), they cast rhetoric as culturally inscribed force for fixing meanings and other shared realities by means of inward (self-talk) and outward address. Their view accords with that forwarded in an important University of Chicago religious studies project that advances rhetoric as "a family of questions about what is involved in influencing oneself and others regarding (the interpretation of) any indeterminate manner" (Jost & Olmsted, 2000, p. 2). Rhetoric, in other words, is a social and psychological force for solidifying particular ways of life in a world of competing alternatives, including all manners of religiosity.

I would then add that what I'm calling digital eloquence is one class of rhetoric as a culture-generating, culture-fixing potentiality and practice. It is the latest material mediation of eloquence, the ancient ideal involving the artful, appropriate, and affectively forceful expression of wisdom, knowledge, or ethical truth. Originally an ideal governing oratory of a civic sort (Cicero's "wisdom expressed with fluency"), eloquence was transferred by Tacitus to other forms of written and oral expression as well, from prose to poetry (Baumlin & Hughes, 1996). St. Augustine established the contours of a distinctively Christian eloquence exemplified for him in Paul's letters (*On Christian Doctrine*, Book 4, Chs. 5–7). Several centuries later, Syed Al-Radi advanced a Muslim eloquence in the *Nahj al-Balagha* (*Peak of Elo-*

quence), a collection of sermons and writings by the Prophet's son-in-law, Ali, put forth as inimitable masterpieces of divine wisdom perfectly expressed (www.nahjul balagha.org).

Besides artfulness, which marks its aesthetic dimension, and wisdom, which links it to perceived truths, eloquence is also marked by affective force, which means that it carries the power to *move* audiences. Eloquent rhetoric registers emotionally on those who come to *feel* the wisdom in its words, images, or performance. This was the dimension of eloquence the French *Encyclopédie* picked out when it announced, somewhat ambivalently, "Eloquence was created to speak to sentiment, and can impose silence even upon reason" (D'Alembert, 1751/1995, p. 33). A century later, Ralph Waldo Emerson (1847) expressed this quality through a material metaphor to indicate how eloquence could mediate the divine: "the essential thing is heat, and heat comes of sincerity. Speak what you do know and believe; and are personally in it; and are answerable for every word. Eloquence is the power to translate a truth into language perfectly intelligible to the person to whom you speak." The romantic trope of "heat" indexes the felt quality of eloquent address—the impression it can make upon embodied sentiments and culturally inscribed sensibilities.

While eloquence can serve many truths and has frequently served socially dominant (and dominating) institutions, it also holds special place in the arsenals of the dispossessed and marginalized—calling out injustices, mobilizing supporters, and doing battle for the hearts and minds of potential sympathizers and broader publics. We can see this exemplified in the long fight for African-American equality in the United States, where an esteemed tradition of religious and religiously inspired orators have mobilized eloquence for the cause—including the freed slave and abolitionist Frederick Douglass through Martin Luther King Jr., Jesse Jackson, and the philosopher Cornel West in our own day. From the deep baritone voice and commanding bodily presence of Frederick Douglass, this power has always been mediated through material forms that help underwrite its cultural force. They index scores of lesser-known ministers, civic leaders, and grassroots activists whose vernacular eloquence has moved local audiences in analogous ways, extending Augustine's vision of Christian eloquence and realizing the power of eloquence to, in Thomas Farrell's (1995) perceptive account, transform mindsets, alter meanings, advance new cultural forms, and mediate the particular with the moral universal.

Digital Religious Eloquence and Aesthetic Formations

The texture of eloquence changes across media environments. Kathleen Hall Jamieson's (1988) study of "eloquence in an electronic age" pointed the direction here, detailing the ways in which broadcast political eloquence differed from ear-

lier varieties—being more intimate, conciliatory, and conversational than the fiery, agonistic, and stylistically highly adorned speech of more traditional Ciceronian oratory (see Cmiel, 1990). Television also made room for a kind of visual eloquence, represented in one way by African American civil rights protestors being sprayed with fire hoses, in another by John F. Kennedy delivering his famous Cold War "Ich bin ein Berliner" speech in front of the Berlin Wall. Finally, American broadcast eloquence took shape in a culture with little taste for long, carefully reasoned speeches, where sound bites circulating through news media define rhetorical events and audiences resonate more with catchphrases from popular culture than quotations from Shakespeare or the Bible.

While her focus is televisual political speech, Jamieson (1988) moves us along toward thinking about the contours of digital religious eloquence. The first point to make is that digital eloquence comes in a number of qualitatively different forms— from digital books and long-read online journalism to YouTube videos, blogs and other material from webpages, Twitter posts, and even SMS messages. In this regard, the digital is a more formally heterogeneous rhetorical space than that constituted through orality, print, radio, or television. It hosts excellent examples of old-school oral and written eloquence (transcripts and recorded speeches of grand oratory from the past, digitized essays and books), remediating and disseminating them, but not fundamentally altering the nature of eloquence in the process. It is the newer digital forms that have been hosting their own, reformulated eloquence, some of which expresses elements of established or emergent forms of religiosity.

Digital religious eloquence represents both a continuation of and departure from traditional standards of eloquence. As a continuation, it continues to represent that category of rhetorical address that moves audiences toward some truth, carries moral weight, registers emotionally, and achieves some culturally defined sense of the fitting, appropriate, and aesthetically pleasing—and it does those things while expressing or amplifying religion or some sense of the religious. In doing these things, digital religious eloquence, like more traditional oratorical varieties, charges audience members with a kind of rhetorical energy (see Kennedy, 1992) that helps establish identifications, fix meanings, and emotionally enhance their relationships with religious symbols and embodied religious experiences.

Digital religious eloquence as a broader category in turn differs from traditional forms in at least five ways. First, as I mentioned above, it is more heterogeneous in form and genre than eloquence associated with other media. Second, it is more mobile and rhizomatic than oratorical, print, or broadcast eloquence, which are paradigmatically anchored in the oratorical body and its live performance, the author and print artifact, and the national network and television set, respectively. Digital eloquence on the other hand is hyperlinked, always already connected to cross-cutting networks and Internet connections, and experienced by audiences

through widely dispersed and geographically mobile computers, cell phones, and other personal electronic devices. Third, while the figure of the great orator or virtuoso writer animated and individuated the traditional ideal of eloquence, digital eloquence accelerates processes of democratization that date back to the nineteenth century and earlier. Fame still matters in both drawing attention to digital eloquence and disposing audiences to be moved by it, but it is a more socially dispersed kind that adheres less in the figure of the great orator and more in characters that emerge from the din of competing voices and abundant discourses. Fourth, digital eloquence is often (though not always) multimodal, blending words, images, and sounds with the embodied sensations of audience members who experience it. Fifth, digital eloquence is frequently brief—140 characters in the case of eloquent tweets, perhaps only a minute or two for some eloquent YouTube videos, sometimes no more than two or three paragraphs for an eloquent blog entry, and in this way differs considerably from longer-play sermon and oratory.

Digital religious eloquence does some of its rhetorical work in conjunction with what Birgit Meyer (2006, 2009, 2010) has called sensational forms and aesthetic formations. She argues that religion is mediated through cultural aesthetics understood in the broad sense of the ancient Greek *aesthesis*—referring to "humans' capacity to perceive the world with their five senses and to interpret it through these perceptions" (Meyer, 2010, p. 747), and simultaneously encompassing sensation, the senses, and beauty (Porcello Meintjes, Ochoa, & Samuels, 2010, p. 57). This sort of aesthetic mediation is accomplished through sensational forms—historically generated "modes for invoking and organizing access to the transcendental that shape both religious content (beliefs, doctrines, sets of symbols) and norms," and which are in turn embedded in broader sensibilities that change over time and thus offer "an excellent point of entry into processes of religious transformation" (Meyer, 2010, p. 751). Sensational forms are manifest in "concrete social situations" peopled by subjects variably open and attentive to them (Meyer, 2006, p. 23), and they are embedded in larger aesthetic formations that both form cultural sensibilities and are formed through them. As Meyer describes them, they have a rhetorical dimension, too, for "sensational forms...repeatedly persuade people of the truth and reality of their sensations." Persuasion "does not imply a 'free' subject yet to be persuaded," she goes on, for "an aesthetics of persuasion itself works within religious structures of repetition" in which people are "already constituted as particular religious subjects with certain desires and doubts. Thus, aesthetics of persuasion is intrinsic to sensational forms, whose power convinces religious believers of the truthfulness of the connection between them and God and the transcendental" (2010, p. 756).

Digital religious eloquence, I argue, encompasses a class of artifacts and experiences that do exactly this kind of broad persuasion, inviting audiences to dwell in aesthetically fitting words, sounds, and images whose affective moral power serves

to underwrite religious aspiration and truth. In that capacity, such eloquence designates one means through which aesthetic formations make themselves felt upon audiences in particular situations. But digital religious eloquence and related sensational forms do their rhetorical work through means other than persuasion in any straightforward sense. Here we should turn toward Burkean identification as a clue to seeing how sensational forms generate and regenerate bonds of commonality and difference among people, symbols, doctrines, actions, and other socially defined entities. And the constitutive turn out from Burke points to ways that the identities of subjects and collectives are themselves generated through rhetorical discourse that allows them to recognize and characterize themselves. I would argue that what Meyer terms "structures of repetition" are themselves constituted through a large number of discrete rhetorical acts addressing subjects in particular situations and inviting them to experience the world through a structured cultural aesthetic and moral sensibility. Eloquence names one class of such acts, whose blend of emotional appeal, perceived moral truth, and aesthetically striking composition give them particular capacity to lodge in the consciousness of audiences. The specific energy of eloquence resides in the way it brings together substance, style, and affect to create a distinctly *moving* rhetorical experience with more than average potential to advance both the repetition of existing habits and what Jacques Rançiere calls "the invention of sensible forms and material structures for a life to come" (quoted in Meyer, 2010, p. 755). By mediating and "objectifying the transcendental into material, sensational forms" (Meyer, 2006, p. 32), digital religious eloquence contributes to both cultural repetition and invention.

Two brief examples point us toward forms of digital religious eloquence and ways in which it is embedded within and advances broader aesthetic formations. The first is well-illustrated through Charles Hirschkind's (2012) recent study of excerpts of Muslim sermons (*khuṭub*) as posted on YouTube. The clips he discusses, which range from one to ten minutes long (reminding us of the relative brevity of digital eloquence), are described by viewers as *mu'aththir*, a term that encompasses ideas ranging from "effective, affecting, moving, emotional, impassionate, stirring, exciting, a kind of impact on the senses that . . . leaves a track, trace, touch, taste, or imprint (specifically, on the heart or soul)" (p. 6). A *mu'aththir* sermon, Hirschkind goes on, is one that brings listeners toward devotional dispositions such as humility, regret, fear, hope, pious tranquility, or a stillness of the soul—it is, in palpable ways, *moving*, a term often used to describe them. The category is illustrated through excerpts of *khuṭub* preached by Muhammad Hassan, an Egyptian well known for "his mellifluous voice as well as his ability to engender powerful emotional responses from his listeners with his impassioned rhetoric" (p. 8). Hirschkind distinguishes the affect of this form of online devotion with that characteristic of *khuṭub* as delivered and experienced live in mosques, with the former issuing in

moments of intense but fleeting affect shorn of some of their religious specificity and "reduced to a generalized pious feeling" (p. 15). At the same time, attitudes about the visual component of the YouTube videos, Hirschkind argues, reveal what Meyer would call an aesthetic formation that still privileges "the ethical and devotional resonances of the human voice" and the continued "vibrancy of an Islamic tradition of acoustically mediated piety" (p. 17). Without using the concept, Hirschkind illuminates one variety of digital religious eloquence, maps affective currents generated in real-world audiences, and draws out continuities and discontinuities from more traditional eloquence—showing us the evolution of a sensational form as it moves to a new medium.

A second set of examples come from the world of tweeted religious eloquence. Last year, Twitter conducted an in-house study of the popularity of tweets as gauged by retweets and responses to them. They discovered a group of evangelical Christian leaders and writers whose inspirational tweets revealed an extremely high ratio of responses and retweets per follower—something they called an "engagement effect." Some involved Bible verses, which translate exceptionally well to the 140-character limit since they run, on average, about 100 characters (O'Leary, 2012). In these instances, classic seventeenth-century King James biblical eloquence meets a twenty-first-century digital medium, where Twitter users might pass through or dwell, perhaps finding a spiritual locus that grounds them in the moment, reaffirming their devotion and identity through a process of repetition, (re)invention, and passing on the energy through retweets and other responses. The style and content of the language stand out from everyday speech, providing words and internal sounds that focus and add spiritual timbre to heart, soul, and mind. We see on Psalms & Proverbs (@Psalms_Proverbs), for instance, one of numerous Twitter accounts devoted to tweeting Bible verses: "Whatever the Lord does, it will be forever—Ecclesiastes 3:14 (please retweet)" (June 24, 2012); and "Better is a dinner of vegetables where love is, than eating a lot-fed bull and having hatred with it—Proverbs 15:17" (June 25, 2012). African Americans and people of color are heavily represented among the followers of Psalms & Proverbs, suggesting that we might read it as a contemporary manifestation of the longer tradition of eloquence in African American religiosity, pointing toward an aesthetic formation where anachronistic language (by the standards of everyday secular life) meets mobile electronic devices, and where affective religious devotion is materially mediated through digitized fonts and screens. Like the Egyptian YouTube *khuṭub*, these tweeted King James Bible verses represent one subcategory of digital religious eloquence, a kind of aphoristic spiritual wisdom that remediates the letter and spirit of traditional religious texts, all of which is embedded in the linguistic sensibilities, aesthetic tastes, and rhetorics-of-being practiced by the audiences called out by them.

Conclusion

My main goal in this chapter has been to make a case for rhetoric as a framework for understanding mediations of religion across epochs and cultures. That work has perhaps been more suggestive than demonstrative, but I have tried to provide a big-picture conceptual introduction and *longue durée* historical sketch to supplement and add new dimensions to interdisciplinary conversations about media and religion. I have said that *rhetoric* names both communicative address with inherent potential to move or stabilize the symbolic and material worlds of audiences hailed by it, as well as the theoretical vocabularies and intellectual traditions that have grown up to make sense of that address. The Greek-derived discipline of *rhetorikē* came to inform both Latin-Christian and Arabic-Muslim traditions of practice and thought, where it helped mediate the divine for enfleshed audiences, in part through ideals and achieved approximations of eloquence. Outside those traditions, however, other cultures also have their own principles for producing and interpreting communicative address, implicit rhetorical theories that provide their own understandings of speech that mediates religious truths for audiences. I have suggested that these too stand ready for use in the contemporary study of religion and media over time.

My conceptualization of digital religious eloquence has been equally suggestive, intended to lay the groundwork for future empirical studies that blend theory, textual analysis, and ethnographically oriented audience study as well as indicating the potential power of combining historically oriented rhetorical, anthropological, and media analysis. I lay it out partly as a thought experiment: If religious eloquence is traditionally understood as the artful, appropriate, and affectively forceful expression of moral wisdom and higher truths, then what would that look like in digital media environments? What forms might it take, and what rhetorical work can it accomplish? I laid out the start of an answer by portraying rhetoric as that power of address that fixes meanings and identifications and solidifies affective and cognitive attachment to them—realizing that some of this work happens precisely by challenging other meanings and identifications, and through address to self as much as to others. Digital religious eloquence names one species of such rhetoric, which does its work by articulating itself with broader aesthetic formations and other kinds of sensational forms—the kind of entities that Meyer and her students have done so well in illuminating for us. Sometimes the work of digital religious eloquence can be dramatic and eventful (the YouTube video of the Iranian martyr Neda is one powerful example), but more often it serves to punctuate ongoing processes of devotion within the rhythms of everyday life (as in the tweets from Psalms & Proverbs).

In closing, let me list some of the rhetorical work accomplished or partly accomplished through digital religious eloquence, thereby providing a set of hypotheses for future empirical studies: (1) focusing ethico-religious conviction for a self that has multiple demands and possible loci of attention; (2) establishing and ritually reconfirming identities and identifications among people and other social objects; (3) mediating religious truths and unseen realities in a way that they are *felt* and meaningfully experienced by corporeal beings who are *moved* by them; (4) serving as a discrete mechanism through which aesthetic formations are manifest in particular situations and places; (5) providing occasion, material, or communicative links for further religiously directed rhetorical work; and (6) offering discrete pulses of symbolic energy that help solidify (or challenge) lived religiosity as manifest in the embodied lives of people.[2]

Notes

1. For book-length introductions to the history of Western rhetorical thought, see Conley, 1990; Kennedy, 1990; Glenn, 1997; Vickers, 1998. For a chapter-length history, see Eagleton, 1981. For a good conceptual introduction to rhetoric, see Jasinski, 2001. For excellent historical and contemporary discussions of rhetoric and religion, see Jost and Olmsted, Eds., 2000.
2. The author would like to thank Heidi Campbell, Lisa Flores, Deborah Whitehead, Pascal Gagné, and especially Knut Lundby for their encouraging and very helpful comments on earlier drafts of this chapter.

References

Albion, R. G. (1932). The "Communication Revolution." *American Historical Review, 37,* 718–720.

Baumlin, J. A., & Hughes, J. J. (1996). Eloquence. In T. Enos (Ed.), *Encyclopedia of rhetoric and composition: Communication from ancient times to the information age* (pp. 215–218). New York: Garland.

Bergman, M. (2009). *Peirce's philosophy of communication: The rhetorical underpinnings of the theory of signs.* London & New York: Continuum.

Billig, M. (1996). *Arguing as thinking: A rhetorical approach to social psychology.* Cambridge: Cambridge University Press.

Booth, W. (1991). Rhetoric and religion: Are they essentially wedded? In W. G. Jeanrond & J. L. Rike (Eds.), *Radical pluralism and truth: David Tracy and the hermeneutics of religion* (pp. 62–80). New York: Crossroad.

Booth, W. (2000). Kenneth Burke's religious rhetoric: "God terms" and the ontological proof. In W. Jost & W. Olmsted (Eds.), *Rhetorical invention and religious inquiry: New perspectives* (pp. 25–46). New Haven, CT: Yale University Press.

Burke, K. (1950). *The rhetoric of motives.* Berkeley, CA: University of California Press.

Burke, K. (1961). *The rhetoric of religion: A study in logology*. Berkeley, CA: University of California Press.

Burke, P. (2013). Conversation. In P. Simonson, J. Peck, R. T. Craig, & J. P. Jackson (Eds.), *The handbook of communication history* (pp. 122–132). New York: Routledge.

Carter, C. A. (1992). Logology and religion: Kenneth Burke on the metalinguistic dimensions of language. *Journal of Religion, 72*, 1–18.

Charland, M. (1987). Constitutive rhetoric: The case of the *Peuple Québécois*. *Quarterly Journal of Speech, 73*, 133–150.

Chen, R. (2009). Chinese religious rhetoric. In L. Pernot (Ed.), *New chapters in the history of rhetoric* (pp. 385–401). Leiden: Brill.

Cmiel, K. (1990). *Democratic eloquence: The fight over popular speech in nineteenth-century America*. New York: William Morrow.

Conley, T. M. (1990). *Rhetoric in the European tradition*. Chicago: University of Chicago Press.

D'Alembert, J. L. (1751/1995). *Preliminary discourse to the Encyclopedia of Diderot*. Chicago: University of Chicago Press.

Eagleton, T. (1981). A small history of rhetoric. In *Walter Benjamin, or towards a revolutionary criticism* (pp. 101–113). London: Verso.

Echchaibi, N. (2013). Islam, mediation, and technology. In P. Simonson, J. Peck, R. T. Craig, & J. P. Jackson (Eds.), *The handbook of communication history* (pp. 440–452) New York: Routledge.

Eisenstein, E. (2011). *Divine art, infernal machine: The reception of print in the West from first impressions to the sense of an ending*. Philadelphia, PA: University of Pennsylvania Press.

Emerson, R. W. (1847). Eloquence: An essay. Retrieved from http://www.rwe.org/complete-works/viii-letters-and-social-aims/eloquence.html

Ezzaher, L. E. (2008). Alfarabi's book of rhetoric: An Arabic-English translation of Alfarabi's commentary on Aristotle's *Rhetoric*. *Rhetorica: A Journal of the History of Rhetoric, 26*, 347–391.

Farrell, T. B. (1995). *Norms of rhetorical culture*. New Haven, CT: Yale University Press.

Gilman, S. L., Blair, C., & Parent, D. (Eds.). (1989). *Friedrich Nietzsche on rhetoric and language*. New York: Oxford University Press.

Glenn, C. (1997). *Rhetoric retold: Regendering the tradition from antiquity through the Renaissance*. Carbondale, IL: Southern Illinois University Press.

Halldén, P. (2005). What is Arab Islamic rhetoric? Rethinking the history of Muslim oratory art and homiletics. *International Journal of Middle East Studies, 37*, 19–38.

Hirschkind, C. (2012). Experiments in devotion online: The YouTube *khuṭba*. *International Journal of Middle East Studies, 44*, 5–21.

Jamieson, K. H. (1988). *Eloquence in an electronic age: The transformation of political speechmaking*. New York: Oxford University Press.

Jasinski, J. (2001). Introduction: On defining rhetoric as an object of intellectual inquiry. In *Sourcebook on rhetoric: Key concepts in contemporary rhetorical studies* (pp. xiii–xxxv). Thousand Oaks, CA: Sage.

Jost, W., & Olmsted, W. (Eds.). (2000). *Rhetorical invention and religious inquiry: New perspectives*. Chicago: University of Chicago Press.

Kennedy, G. A. (1990). *Classical rhetoric and its Christian and secular tradition, from ancient to modern times*. Chapel Hill, NC: University of North Carolina Press.

Kennedy, G. A. (1992). A hoot in the dark: The evolution of general rhetoric. *Philosophy and Rhetoric, 25*, 1–20.

Kennedy, G. A. (1998). *Comparative rhetoric: An historical and cross-cultural examination.* New York: Oxford.

Kinneavy, J. L. (1987). *Greek rhetorical origins of Christian faith: An inquiry.* New York: Oxford University Press.

Lipson, C. S., & Brinkley, R. A. (Eds.). (2004). *Rhetoric before and beyond the Greeks.* Albany, NY: SUNY Press.

Lipson, C. S., & Brinkley, R. A. (Eds.). (2009). *Ancient non-Greek rhetorics.* West Lafayette, IN: Parlor Press.

Lyne, J. (1980). Rhetoric and semiotic in C. S. Peirce. *Quarterly Journal of Speech, 66,* 155–168.

McKeon, R. (1971/1987). The uses of rhetoric in a technological age: Architectonic productive arts. In *Rhetoric: Essays in discovery and invention* (pp. 1–24). Woodbridge, CT: Ox Bow Press.

McLuhan, M. (1943/2006). *The classical trivium: The place of Thomas Nashe in the learning of his time.* Berkeley, CA: Gingko Press.

McLuhan, M. (1962). *The Gutenberg galaxy: The making of typographic man.* Toronto: University of Toronto Press.

Meyer, B. (2006). Religious sensations: Why media, aesthetics, and power matter in the study of contemporary religion. Lecture delivered October 6, 2006. Retrieved from http://www.fsw.vu.nl/nl/Images/Oratietekst%20Birgit%20Meyer_tcm30-44560.pdf

Meyer, B. (Ed.). (2009). *Aesthetic formations: Media, religion, and the senses.* New York: Palgrave Macmillan.

Meyer, B. (2010). Aesthetics of persuasion: Global Christianity and Pentecostalism's sensational forms. *South Atlantic Quarterly, 109,* 741–763.

Oesterreich, P. (2009). Homo rhetoricus. In I. Strecker & S. Tyler (Eds.), *Culture and rhetoric* (pp. 49–58). New York: Berghahn Books.

O'Leary, A. (2012). Twitter dynamos, offering word of God's love. *New York Times.* June 2. Retrieved from http://www.nytimes.com/2012/06/02/technology/christian-leaders-are-powerhouses-on-twitter.html

Oliver, R. T. (1971). *Communication and culture in ancient India and China.* Syracuse, NY: Syracuse University Press.

Peirce, C. S. (1992/1998). *The essential Peirce.* Vols. 1 & 2. Bloomington, IN: University of Indiana Press.

Pernot, L. (2006). Rhetoric and religion. *Rhetorica, 24,* 235–254.

Porcello, T., Meintjes, L., Ochoa, A. M., & Samuels, D. W. (2010). The reorganization of the sensory world. *Annual Review of Anthropology, 39,* 51–66.

Rebhorn, W. (Ed.). (2000). *Renaissance debates on rhetoric.* Ithaca, NY: Cornell University Press.

Schiappa, E. (2003). *Protagoras and logos: A study in Greek philosophy and rhetoric* (2nd ed.). Columbia, SC: University of South Carolina Press.

Strecker, I., & Tyler, S. (Eds.). (2009). *Culture and rhetoric.* New York: Berghahn Books.

Taylor, C. (2007). *A secular age.* Cambridge, MA: Harvard University Press.

Troup, C. L. (1999). *Temporality, eternity, and wisdom: The rhetoric of Augustine's* Confessions. Columbia, SC: University of South Carolina Press.

Turner, J. (1986). *Without God, without creed: The rise of unbelief in America.* Baltimore: Johns Hopkins University Press.

Vickers, B. (1998). *In defence of rhetoric.* Oxford: Clarendon.

Watt, J. (1995). From Themistius to al-Farabi: Platonic political philosophy and Aristotle's *Rhetoric* in the East. *Rhetorica, 13*, 17–41.

Zulick, M. (1992). The active force of hearing: The ancient Hebrew language of persuasion. *Rhetorica, 10*, 367–380.

Zulick, M. (2009). Religious rhetoric: A map of the territory. In A. Lunsford, K. H. Wilson, & R. A. Eberly (Eds.), *The Sage handbook of rhetorical studies* (pp. 125–138). Los Angeles: Sage.

Religion, Space, and Contemporary Media

KIM KNOTT

A spatial turn in the humanities and social sciences that took place in the final decades of the twentieth century has by now influenced most fields of social and cultural studies, including those focusing on both religion and media. It sought both to put space back on a scholarly agenda that had become preoccupied with time and the temporal and to re-theorize the spatial, moving away from Cartesian, abstract, and geometrical notions to those that recognised space in material, social, and political terms, and as interconnected with bodies, power, relationships, and time. The principal spatial theorists of the late twentieth century, among them Lefebvre, Foucault, Jameson, and de Certeau, represented different theoretical traditions—Marxist, post-structuralist, and post-modernist. Between them, however, they brought new ways of thinking about space, place, and geography that were subsequently adopted by scholars keen to spatialize their own areas of study. In media studies, for example, these intellectual developments can be witnessed in *MediaSpace: Place, Scale and Culture in a Media Age*, a collection of essays by Nick Couldry and Anna McCarthy (2004a) in which notions of social connectivity, network, and virtuality are discussed. In the study of religions, they are evident in Thomas A. Tweed's *Crossing and Dwelling: A Theory of Religion* (2006) and in my own book, *The Location of Religion: A Spatial Analysis* (Knott, 2005), in which a fluid, interconnected, embodied, material, and political sense of space is at the fore.

Although both fields have their own geographies and their share of actual physical as well as virtual places to be studied, a key challenge noted by scholars

of media and religion is the relationship between 'space' and 'text.' Couldry and McCarthy (2004b) accept that the 'implicit spatiality of media is hard to recognise in the "space" of the media text' (p. 1). In work on the location of religion in secular discourses, I considered the relationship between space and text and asked whether texts can be treated as spaces, and whether spaces can be read (Knott, 2006, pp. 179–181). My answer to the first was positive. Texts are discursive spaces that configure ideas, words, descriptions, characters, events, grammatical and punctuation marks, and pauses; they may constitute or contain representations of other spaces, sometimes real and material places, bodies, landscapes, objects, organizations, systems, or relationships. As such, texts are open to spatial analysis. But can spaces be read? We are advised by the social theorist, Henri Lefebvre (1974/1991), to tread with care:

> Yes, inasmuch as it is possible to envisage a 'reader' who deciphers or de-codes and a 'speaker' who expresses himself by translating his progression into a discourse. But no, in that social space can in no way be compared to a blank page upon which a specific message has been inscribed Both natural and urban spaces are, if anything, 'over-inscribed': everything therein resembles a rough draft, jumbled and self-contradictory. (p. 142)

Spaces are infused with power that is often hard to read, and may take the form of dissimulation as often as outright instruction or prohibition: 'Thus space indeed "speaks"—but it does not tell all' (p. 143).

Given that the cases for discussion later in this chapter take the form of media representations and new media spaces, such questions are an important starting point. But in what ways are media and religion spatial? Are they really appropriate arenas for a spatial analysis? In the case of the media, Couldry and McCarthy (2004b, pp. 5–8) identified five levels of 'MediaSpace': (1) the study of media representations; (2) the study of how media images, texts, and data flow across space and, in so doing, reconfigure social space; (3) the study of the specific spaces at either end of the media process, the space of consumption, and the space of production; (4) the study of the scale-effects (local, national, global), or complex entanglements of scale, which result from the operation of media in space; and (5) studying how media-caused entanglements of scale are variously experienced and understood in particular places. These provide useful entry points for a spatial analysis of media processes and activities. While all of them offer possibilities for those who work on the interface between media and religion, some are more relevant than others for the cases I will discuss later in this chapter. There the focus will be on media representations (level 1) and on media consumers and producers (level 3), as well as on the complex entanglements of scale in media spaces (level 4).

In an earlier assessment of the shared territory between religion and space (Knott, 2005, pp. 94–123), chief among the areas I identified for study were geographies of religion, religious mapping and sacred space, to which I added religion and locality, and religion and globalization, including religious transnational and diasporic movements. I noted, however, that, while scholars frequently studied religion in situ, they rarely reflected on the impact of those places on religion itself. When they did, they employed either a poetics of space or a politics of space (Bachelard, 1957/1992; Chidester & Linenthal, 1995; Kong, 2001): phenomenological—in the case of those employing a poetics of place and the sacred—or social scientific—for those articulating relations among politics, religion, and the contestation of space (Knott, 2010a, pp. 29–43).

Methodologies, no less than theories, proceed from particular understandings of the world, scholarly standpoints, priorities, and values. The methodological approach that I will proceed to elaborate in this chapter for thinking about intersections among religion, space, and media is informed in particular by the theoretical contributions of Lefebvre (1974/1991) and Foucault (1968/1986; 1991), who despite other differences shared an interest in the relationship between the body, space, and power. Like them, I favour a politics rather than a poetics of space.

Religion and Media: A Spatial Approach

The rationale for a spatial approach begins with our human embodiment (Knott, 2005, 2008). We are spatially organized and orientated in terms of front and back, up and down, in and out, left and right; we are positioned in relation to others; we are situated in and move through space. These fundamental bodily characteristics and experiences provide pre-conceptual resources for our cognitive, linguistic, and social development. Immanuel Kant (1768/1968) gave some thought to these issues early in his career in 'Concerning the Ultimate Foundation of the Differentiation of Regions in Space.' Although his ideas about body and space had the potential to be transformative, he set his conclusions within a Cartesian framework that has subsequently been challenged (Johnson, 1987, pp. xxvi–xxix).

It is to the work of George Lakoff and Mark Johnson (1980, 1999) that we must turn for a 'philosophy in the flesh' that works from the same basic principles but connects body, space, mind, and language and recognises power and values. They link our human bodies and innate spatial experience with the metaphors we use and our attempts at categorization by means of the cognitive unconscious. We are 'evolved to categorize,' they say, categorizing as we do 'because we have the brains and bodies we have and because we interact in the world the way we do' (Lakoff & Johnson, 1999, p. 18). The human body, its verticality and sidedness, the regions around it, its inside

and outside are resources for the mind in the exercise of reason and the development of the concepts and metaphors we use for understanding the world, our place within it, our relationships and identity (Lakoff & Johnson, 1980, p. 14; Lakoff & Johnson, 1999, p. 34). They identify several spatial 'image schemas' that are used metaphorically to structure other complex thoughts and abstract concepts, in particular the CONTAINER image schema. But, as Lakoff (1987) notes, although 'categories (in general) are understood in terms of CONTAINER schemas,' other structural aspects of categorization, such as hierarchy and relations between parts, are understood in terms of other spatial schemas, such as UP–DOWN, LINK, TRAJECTORY, and CENTRE–PERIPHERY (p. 283). These spatial schemas also produce the following metaphorical terms: inside/outside, inner/outer, boundary, open/closed, inclusion/exclusion, opposition, inversion, front/back, and left/right.

Intrinsic to the image schema of containment is the notion of force, as a result of which authoritative insiders will resist or exclude those outside the border, and restrict the movement of those within it (Sørensen, 2007, p. 42). Applying Lakoff and Johnson's theory to the categorization and boundary-making of religion and magic, Sørensen lists the possible force relations arising from the interaction of CONTAINER and TRAJECTORY image schemas: rejection, annexation, attraction, retention, expulsion, and repulsion (p. 167). Such relations may be expressed and performed strategically in discourse and practice, as we will see later.

Veikko Anttonen (1996) also draws on these ideas of interiority, exteriority, boundary, and categorization in his theorization of the 'sacred.' He identifies 'human body' and 'territory' as fundamental pre-conceptual structures for the generation of discourse and practice pertaining to the 'sacred' (p. 41). It is the inter-relationship of body and territory, or what Anttonen calls their 'co-extensiveness as bounded entities' (p. 41), that is significant for generating the concept. The boundaries that separate body, territory, and beyond then become cognitive markers for distinguishing between entities on the basis of their value and for establishing rules for their engagement and transformation. These cognitive markers are culturally dependent, but they are not limited to religious contexts. Rather, as will become clear in the first case study below, they operate according to the worldviews, beliefs, and values—religious, nationalist, secularist, or whatever—of different groups and communities.

Although Lakoff and Johnson's (1999) work pertains to cognitive linguistics, Sørensen (2007) and Anttonen (1996) have adopted it for thinking about religion, magic, and the sacred (see also Knott, 2006, 2008, on differentiating the religious and secular). Focusing this still further, on intersections between religion and media, the work of Lakoff and Johnson alerts us to the spatial concepts and metaphors in use both in media representations of religion and by religious groups themselves as they use various media to assert and express their interests and differentiate themselves from others. Moreover, Sørensen's and Anttonen's contribu-

tions remind us that the categories and boundaries inscribed in discourse (whether media or religious discourse) are rarely neutral. They entail both force and value. We will see this at work in the analysis of two media cases later in the chapter.

The spatiality of human embodiment is not only important for the development of categories and concepts and their deployment in discourse, it is also at the heart of 'the production of space' (Lefebvre, 1974/1991; see Knott, 2005, 2011b). For Lefebvre, 'The whole of (social) space proceeds from the body, even though it so metamorphoses the body that is may forget it altogether.... The genesis of a far-away order can be accounted for only on the basis of the order that is nearest to us—namely the order of the body' (p. 405). In his discussion of gestural systems—which are simultaneously physical, social, and mental spaces—he notes the centrality of the body's spatiality, of high and low, right and left. Such systems and the spatial codes they draw on are culturally embedded. They 'embody ideology and bind it to practice' (p. 215). As such, space is far from being a vacuum or backdrop in or against which human action takes place, but an arena of struggle (Lefebvre, 1974/1991, p. 11, p. 417; see Foucault, 1991). It is 'full of power and symbolism, a complex web of relations of domination and subordination, of solidarity and co-operation' (Massey, 1993, p. 156). Indeed, without a space to produce and shape, ideas and beliefs, principles and values—whatever their ideological character or political or religious hue—remain ephemeral and ungrounded, lacking 'an appropriate morphology' (Lefebvre, 1974/1991, p. 44, p. 417).

Lefebvre's dual conceptions of (a) the forces and struggles at work in space and its production and (b) of the individual and collective compulsion to secure ideals and values by making an appropriate space for them, whether material, social, or discursive, are pertinent for reflecting on religion and media and their intersections. As I noted earlier, if we employ a politics rather than a poetics of space, in which interests, forces, and struggles between competing positions are foregrounded in an analysis of places and their production, then our attention is drawn to how both religious and media actors use the technology and language of the media to secure a space, represent interests, and express values.

To analyse the location of religion in secular contexts, including the media, I drew on the theoretical contribution of Lefebvre and Foucault among others to develop an interpretive spatial methodology (Knott, 2005). It entails the systematic application of spatial thinking based on the following: (1) the body as the source and resource of space; (2) the dimensions of space (physical, social, and mental); (3) the properties of space (configuration, extension, simultaneity, and power); (4) the aspects of space (perceived, conceived, and lived); and (5) the dynamics of space. Thinking through these elements (which are elaborated in Knott 2005, 2011a) enables a close reading or deep contextualization of a spatial entity, whether a place, body, object, text, organization, or community. I have used such an approach to identify and analyse religious and secular beliefs and values and their contestation

in a range of contexts, from the left hand to urban spaces and public organizations such as schools and health centres. Later in this chapter it will inform my discussion of religion, media representations, and new media spaces.

In this section I have discussed two related resources for a spatial analysis of religion and media, one arising from embodied cognitive linguistics, the other from sociocultural theories of the production of space. The first is particularly useful for analysing spatial metaphors and references in media discourse; the second for interpreting how religious and other ideological actors produce and utilise media spaces, and mediate the sacred.

Before moving on to the application of these in the remaining sections of the chapter, it is appropriate to connect this theoretical and methodological discussion to debates in media studies about representation, discourse, mediation, and mediatization. The first of these terms is commonly used to refer to the social construction of 'reality,' both the process and its outcome. But, as Poole (2002) notes, reality is never objectively re-presented, 'there is always a mediating effect whereby an event is filtered through interpretive frameworks and acquires ideological significance' (p. 23). Not confined to the media, the concept of representation has a wide use and meaning in relation to all contexts in which reality is (re)produced, whether in ideas, beliefs, norms, or practices, and in the built environment as well as in social and discursive arenas. Indeed it was Lefebvre's (1974/1991) choice of term for the analysis of spaces and the operation of ideology and power therein.

Discourse analysis is normally used to analyse media representations because of its focus on the identification and deconstruction of forces and 'regimes of truth' within a text (Stuart Hall, qtd. in Poole, 2002, p. 101). However, a spatial analysis that takes seriously issues of power and ideology may also be used. It is likely to be more attentive than discourse analysis to spatial language and references, and to issues of location, positioning, and the reproduction of space within texts and other forms of representation.

Can thinking spatially add anything to our scholarly understanding of mediation and mediatization, particularly as they are applied to religion?

The media are by no means the only setting where contemporary religious communication and struggles within and between religions and secular bodies are produced, but it is difficult to overestimate the media's importance for their mediation. Inward-focused religious activities and self-referential discourses are no longer sufficient for maintaining religious identities, transmitting religious cultures and traditions, and gaining a public foothold. But this process of mediation is not without its consequences for religion or the media. Religion must conform to—and is thereby shaped by—the 'logics' of the media (Hjarvard, 2011); the media, in turn, find themselves gatekeepers of public religious literacy and ethical debate, and exposed to the criticisms of misrepresentation and bias. Both institutions, in fact, 'draw on a very

general form of symbolic power to represent the world,' making analogies and comparisons between them inevitable (Couldry, 2012, p. 151; Meyer & Moors, 2006). Stig Hjarvard (2011) goes beyond a mediation framework, however, in asserting that 'as a cultural and social environment, the media have taken over many of the cultural and social functions of the institutional religions and provide spiritual guidance, moral orientation, ritual passages and a sense of community and belonging'; they also 'circulate various banal religious representations [which] become the backdrop for the modern individual's knowledge about religious issues' (p. 119). No longer the agent of its own destiny or representation, according to this view, religion is mediatized.

Mediation and mediatization are spatial insofar as they link the spaces of production and consumption and are processes of transition and transformation. As both religious and media agents proceed to forge new spaces, the processes (of mediation and mediatization), the spaces themselves, and any ensuing discourses or representations are open to a spatial analysis. Thinking spatially with hypotheses about mediation or mediatization in mind offers a different lens on the relationship between religion and media.

This spatial approach will now be applied to several media/religion intersections, the first two of which are media debates in which spatial language and references were employed in the struggle between competing ideological positions, secular as well as religious. In the final section I examine the way in which a religious group exploited the spatiality of the media in the process of mediating their beliefs, values, and practices.

Representations of the Religious and the Secular in Two Media Case Studies: A Spatial-Linguistic Analysis

In the first of two examples, I focus on the articulation of opposing beliefs and values in British newspapers during the controversy surrounding the publication of Salman Rushdie's *The Satanic Verses* (1988). I draw on an earlier case study in which I explored the boundary between religion and non-religion with reference to the categorical and oppositional language of both Muslims and secularists (Knott, 2010b). Using the spatial language of containment—of boundaries, sides, penetration, and opposition—allied to metaphors of warfare and sexual violence, commentators articulated their opinions, on the one side on the blasphemy of Rushdie and, on the other, the offence to freedom of speech.

From the beginning of the controversy in late 1988, the tone of Muslim comment in the media signalled that a boundary had been violated and feelings deeply injured: One commentator, for example, suggested that the offence caused by the book was akin to a public reading of a poem about the private parts of one's par-

ents (Mazrui, 1989, p. 13). The extent of the blasphemy was such that Shabbir Akhtar (1989, p, 35), writing in *The Guardian* (February 27, 1989), commented that 'any Muslim who fails to be offended by Rushdie's book ceases ... to be a Muslim. *The Satanic Verses* has become a litmus-paper test for distinguishing faith from rejection.' He saw the book as a sacred boundary, with Muslims, however notional their religious practice, on one side and non-believers on the other.

Akhtar (1989) was one of the first to note the non-negotiable nature of the developing counter-position, 'the liberal inquisition' as he called it (p. 37). He chastized liberal media commentators for reducing the affair to 'a simple neo-Victorian opposition between our light and their darkness' (*The Guardian*, February 27, 1989). Noting that 'Muslims have reason to think the Crusades are not over yet,' he made clear that he believed the controversy was between two forms of fanaticism, one based on absolute faith in God and the prophet, the other on deeply held liberal values, particularly freedom of speech.

This view was borne out by Salman Rushdie himself and other liberal, often anti-religious, writers and journalists. Referring to a passage from his novel—'Secular versus religious, the light versus the dark'—Rushdie employed the spatial language of containment, force, and warfare by writing that the 'battle has now spread to Britain' and by calling on people to take 'sides' (*The Observer*, January 22, 1989; see also Appignanesi & Maitland, 1989, pp. 74–75). This language and tone was reiterated in a supporting statement penned by Homi Bhabha and published in the *New Statesman* (March 3, 1989; Appignanesi & Maitland, 1989, pp. 137–140). One moderate Muslim critic felt compelled to respond: 'For them [the signatories], freedom of expression has become a fetish. To them, that alone is sacred' (El-Essawy, *The Guardian*, February 1989, cited in Webster, 1990, pp. 50–51).

Despite the rhetoric, however, the scholar of blasphemy, Richard Webster (1990), held that the battle was not between two opposed and incommensurate positions, but between 'two factions of the same religious tradition—the Judeo-Christian tradition to which, ultimately, Islam belongs' (p. 59). Part of a single epistemological field, their complex historical relationship was masked by their current struggle and the violence of their oppositional language. Critically, claims about matters of principle and value, and attributions of the 'sacred' made with reference to spatial language, were pronounced by liberal as well as Muslim exponents. Exponents on both sides of the controversy had no qualms about using the term 'sacred' itself, as well as explicitly religious terminology such as 'faith,' 'holy,' and 'fundamentalism,' to signal the deeply held and non-negotiable nature of their beliefs and values (Knott, 2010b). In this case the forceful articulation of ideological categories and positions (both Islamic and secularist) and the struggle between them was achieved with reference to containment, insides and outsides, inclusion and exclusion, left and right, sides and boundaries, territories and forces, to inversion, opposition, repulsion, and to rivalries and battles.

In a second media debate, twenty years later, the issue of freedom of speech was again addressed, this time with reference to both Islam and Christianity. Geert Wilders, the Dutch right-wing politician and producer of the inflammatory and Islamophobic film *Fitna*, was invited to speak in Britain in February 2009. In the event, the British government banned him on arrival at Heathrow and he was sent home (though permitted to enter the following year). In the media storm following his unsuccessful visit, several major themes were exposed and debated in discourses on Britain and Britishness: anxiety about increased religious diversity (particularly Islam), the marginalization of Christianity, and the rise of a vociferous secularism (Knott, Taira, & Poole, 2013).[1] In their representation of this event, the news media were engaged in an internal struggle to define the identity of the nation with reference to its majority–minority relations. In the right-wing press, Britain was constructed as a Christian country; in the liberal press, as secular rather than Christian. Secular and Christian interests, however, were often in alliance against Muslims rather than Muslims and Christians standing together to fight the further erosion of religion in the public sphere (Knott et al., 2013).

In addition to examining commentators' use of spatial language, analysing the debate with reference to the spatial properties I referred to earlier (configuration, extension, simultaneity, and power) revealed several different strategies for narrating the nation. Rather than the immediate news coverage of the ban on February 12 and 13, 2009, articles by four commentators from newspapers representing different political persuasions have been analysed: by John Laughland in the *Mail on Sunday* (February 14, 2009), Janet Daley in the *Daily Telegraph* (February 15, 2009), Leo McKinstry in the *Daily Express* (February 16, 2009), and Timothy Garton Ash in *The Guardian* (February 16, 2009).

In the space of this media episode, various tropes were configured to produce discourses on the nation. While each commentator developed his or her argument on the foundation of current news stories, deploring the banning of Wilders, they also made reference to debates about the banning of Muslim clerics, and several prominent cases in which individual women had been either sacked from their jobs or chastized for the expression of overt Christian beliefs or symbols. Clustering these news stories together to create a flexible resource for the development and articulation of differing opinions was a key strategy for all commentators.

Thinking through the property of spatial extension requires us to consider whether our current space (the state of the nation as seen by these four commentators) contains or is constructed with reference to earlier spaces. 'Extension' refers to diachronic, historical spaces; 'simultaneity' to synchronic ones—those that are similar or related, and contemporaneous. All the commentators made use of these, with three referring back to the same geographical and historical context—but for rather different ends. Laughland in the *Mail*, McKinstry in the *Express*, and Gar-

ton Ash in *The Guardian* all referred to the Soviet bloc, to the Iron Curtain, East Germany, Romania, and variously to totalitarianism, Marxism, communism, socialism, and the Stasi. Laughland (2009), writing in a right-of-centre newspaper, made reference to the hard-line progressivism of French revolutionary liberalism. Nazi totalitarianism was also mentioned. Evoking these time-spaces enabled commentators to make explicit or implicit connections and thus judgements about the condition and temperament of the state in Labour's Britain.

But the past is not a foreign country, warned Laughland. 'Modern liberalism is distinctly Soviet,' he wrote, in its 'imposition' of an equality and diversity agenda, and its 'intrusions' into people's privacy, liberties and opinions. (In common with most other commentators, his view was that banning Wilders was a knee-jerk reaction, contrary to freedom of speech, which took away people's opportunity to make up their own minds.) Garton Ash (2009), in *The Guardian*, used the same trope in the same way to criticise the British state (Labour and Conservative alike) for curtailing freedoms, but—crucially—his left-of-centre perspective did not place the blame on liberalism at all but on politicians who had 'lost their way.' Their pursuit of national security had led them to give up liberal gains. His choice of language was all important here: 'Liberty in Britain is facing death by a thousand cuts'; our liberties are being 'sliced away'; they are being 'curtailed.' Garton Ash depicted Britain as a container—thinking back to Lakoff and Johnson's (1999) image schema—at the centre of which is a state bureaucracy exercising surveillance over its citizens in the name of security, social order, and community cohesion. What was needed, he pleaded, was to fight back, to reclaim lost liberal territory from within, and to halt the 'bad dream' of Britain as a totalitarian state.

Commentators from right and left made use of common spatial references and drew on similar tropes, one to berate liberalism and the other to bemoan its loss. Leo McKinstry (2009)—a well-known right-wing commentator for the *Daily Express*—raised the spectre of socialism/Marxism for a different purpose, to warn of 'the increasingly vicious war against our traditional British culture and values' and to explain, as his title and boxing metaphor suggested, 'Why Christianity is on the ropes in Labour's Britain.'

Using a similar metaphorical strategy to Laughland and Garton Ash, McKinstry drew on a simultaneous but imagined totalitarian space as a foil: 'In this Orwellian world, our history is forgotten, our identity traduced and our liberties destroyed.' George Orwell's world of *1984* was a fictional inversion of a society at ease with its liberal traditions, values, and freedoms, and such was the fate of the British state, according to McKinstry. Its principal ideological strategy was to replace the Christian faith with 'the twin Marxist ideologies of equality and multiculturalism' as the central strand in 'the fabric of our civilization.'

In a further display of power relations within his text, McKinstry drew on the tropes of invisibility and expulsion, referring to Christian symbols 'disappearing,' being 'outlawed' and 'air-brushed' out of public life, and to Christian employees being 'suspended,' 'sacked,' and 'isolated' from their positions. In his final paragraphs, the *bête noir* of the narrative became clear. Using a spatial metaphor of warfare, McKinstry referred to 'the state's willingness to "collude" with the Islamic fundamentalists' (*collusion* requires there to be an 'us' and 'them,' and for the boundary between the two to be breached by an enemy within). The metaphor was developed further with reference to the 'surrender' of the Government to Islam, and ultimately to the 'Islamification' of Britain and the marginalization of Christianity.

The last of the four commentators is Janet Daley (2009). Her article in the *Daily Telegraph*, while also criticising discrimination against Christians, struck a very different tone, one focused on the spatial strategies of openness and attraction rather than rejection and repulsion (Sørensen, 2007). An analysis of the spatial properties of extension and simultaneity in her article revealed her drawing on autobiographical and professional recollections to develop her argument: 'The more we discuss religious differences the safer we will be.' Daley is Jewish and chose to make reference to the Gaza conflict, to her childhood experiences with Irish Catholic and Ulster Protestant neighbours in Boston, and to a taxi ride with a naïve but rather bigoted Muslim driver. She used similar metaphors to McKinstry, but with a different end in mind. Discussing relations across and between spaces, she chose not to speak of 'collusion' with the enemy, but of 'staying on good terms with both sides,' of 'exposure' to the other, and of how 'confrontation' with the beliefs of others can 'disarm' potential enemies. Her narrative strategy drew its strength from socio-spatial concepts of good neighbourliness, gracious exchange of differences, and the value of exploring our 'common humanity.'

These commentators expressed different ideals of the nation and its proper values. Because of the nature of their subject matter—Wilders's expulsion from the UK—they were bound to make use of spatial tropes while drawing, in addition, on the language of warfare. But we have also seen how they invoked other time-spaces as a foil to make their case. Interrogating their use of spatial references and language has helped to clarify the ideological currents in their discursive strategies.

Sikh Religious Mediation: A Spatial Reflection

Moving from media discourse on the religious and secular to the mediation of religion, in this final section I reflect spatially on the transmission of Sikhism among young British Sikhs.[2]

In new research, Jasjit Singh (2012) has focused on the arenas in which young Sikhs are exposed to the mediation of their religion, including the family and school, *gurdwaras*, university Sikh societies, youth camps, and the Internet. They offer different contexts for the transfer of knowledge about Sikhism, as well as different authorizing strategies (and authorized individuals), and modes of transmission. A close examination of these spaces reveals the kinds of knowledge about Sikhism that flow through them, how such knowledge changes in the process, who are its producers and consumers, and where the power lies in the transmission process. And the spaces themselves are dynamic. For example, British *gurdwaras*, and their role in the passing on of Sikh tradition, have changed considerably in the last thirty years as knowledge of both *Gurmukhi* (Sikh sacred language) and Punjabi have declined among young people. Many *gurdwaras* have harnessed the Internet to use dedicated Sikh websites, such as Sikhitothemax.com with its power to search the *Guru Granth Sahib* (Sikh scripture), to select key texts and display and translate them from *Gurmukhi* into English. Sikh youth camps too have changed since their inception in the late 1970s, now representing a variety of sectarian subcultures that mediate Sikh teachings in different ways and contribute to the production of rather different kinds of young Sikhs.

Turning to the space of the Internet, young Sikhs go online for diverse reasons: to discuss taboo subjects; to answer questions about Sikh tradition and explore differing practices within Sikhism; to access songs, stories, and English translations of Sikh scriptures; to get advice or direction; to find out more about Sikh events; to purchase Sikh books, clothes, and photos; and to understand more about the legal position of Sikh articles of faith (Singh, 2012). Many of these enable them to extend and deepen their offline Sikh identity and practices, rather than to cast them off in favour of online ones. Singh suggests that a more significant consideration is how young Sikhs employ the Internet: whether they use it as a space for *religious knowledge*, for example, about taboo subjects or diverse Sikh ideologies, or as a space for *religious engagement* with fellow Sikhs, the *Guru Granth Sahib* or an online event. This distinction between knowledge and engagement reflects Sikhs' interaction with the Internet as a source of information (a cognitive and discursive space) and a site of interaction (a social space).

In Singh's (2012) study the Internet emerges as an important space of transmission in several ways. Although it endorses some traditional forms of authority, particularly Sikh texts, it facilitates the emergence and transnational presence of a number of young British Sikhs as religious authorities, particularly those who are competent in both English and Punjabi. Through their own websites, but also through social networking, their ideas and interpretations have become accessible in new ways and have circulated at speed, although the nature of online communication means that consumers may remain unknown to them and may take or leave what they have to say with no guilt or other consequences.

Although there is a great deal of online engagement between young Sikhs, membership of online communities is rarely made permanent unless the group has an offline social presence. However, the Internet has shown its capacity to mobilize like-minded individuals across the Sikh diaspora behind a number of shared causes. YouTube and Facebook, for example, are increasingly used to challenge traditional religious structures and their representatives. As Singh (2012) notes, it is not infrequent for indiscretions to be posted online and commented on by the Sikh media before formal Sikh authorities have had time to formulate and circulate a response.

Young Sikhs are discerning when it comes to the reliability of the knowledge available online, and who provides it. There is no automatic deferral to rank, age, or seniority. As one young Sikh noted,

> The whole point of SikhiWiki [an online Sikh encyclopedia] is that you don't have to be a scholar, a pundit or a *gyani* to contribute. We all have the experience of what it means to live as a Sikh. Now's the time to share our wisdom, insights and experiences with each other and this is the place to do that. (Singh, 2012)

The Internet appears to be more democratic and less hierarchical than other, offline spaces where Sikhism continues to be transmitted. It is an interactive space that enables peer-to-peer transmission. Sikhism is being mediated in new ways by new media. However, perhaps more importantly, through their online practices and engagements, young Sikh agents are beginning to challenge and transform the process of transmission. Although new media to some extent shape the knowledge to which they have access, young Sikhs exercise a considerable degree of control over what they take, from whom, and how they use it.

Conclusion

In cases that focus on media representations of Islam, Christianity, and secularism, and the mediation of Sikhism, I have employed an analytical approach that uncovers the employment of different spaces and multiple spatial metaphors and references to debate the nation, its identity and relation to others, to juxtapose religious and secularist positions, and to forge new spaces and strategies for religious transmission. But where does thinking spatially and employing a spatial methodology get us in understanding media representations and the mediation of religion?

It helps us to see how ideological exponents and actors (both religious and nonreligious) struggle with others and seek to establish themselves. As Lefebvre (1991)

suggested in *The Production of Space*, groups and individuals must forge a space—whether physical, social, or mental—to express themselves and reproduce their beliefs, practices, values, and ideals. What I have looked at here is how this is achieved discursively, with reference to spatial language, and practically, as young people selectively acquire and transmit their traditions. That language and practice has its roots in our biological condition. We draw on our embodied cognitive and linguistic resources to mediate our religious identities, to represent others, and to produce innovative ideological and practical spaces. This is a spatial process. And that is why a spatial approach is appropriate for examining it.

Notes

1. This case study was one of two conducted as part of a collaborative research project by Kim Knott, Elizabeth Poole, and Teemu Taira, 'Media Portrayals of Religion and the Secular Sacred' (AHRC/ESRC Religion and Society Programme): http://www.religionand society.org.uk/research_findings/featured_findings/traditional_practice_may_be_down_but_media_coverage_of_religion_is_up. In another project within the same programme, 'Fitna and YouTube,' Liesbet van Zoonen, Sabina Mihelj and Farida Vis examined young people's digital responses to Geert Wilders's film.

2. This draws on research conducted by Jasjit Singh in a collaborative doctoral project that I supervised, 'Keeping the Faith: The Transmission of Sikhism Among Young British Sikhs, 18–30' (AHRC/ESRC Religion and Society Programme).

References

Akhtar, S. (1989). *Be careful with Muhammad! The Salman Rushdie affair*. London: Bellew.

Anttonen, V. (1996). Rethinking the sacred: The notions of 'human body' and 'territory' in conceptualizing religion. In T. A. Idinopulos & E. A. Yonan (Eds.), *The sacred and its scholars: Comparative religious methodologies for the study of primary religious data* (pp. 36–64). Leiden: E. J. Brill.

Appignanesi, L., & Maitland, S. (Eds.). (1989). *The Rushdie file*. London: Fourth Estate.

Bachelard, G. (1957/1992). *The poetics of space*. Boston: Beacon Press.

Chidester, D., & Linenthal, E. T. (Eds.). (1995). *American sacred space*. Bloomington, IN: Indiana University Press.

Couldry, N. (2012). *Media, society, world: Social theory and digital media practice*. Cambridge: Polity Press.

Couldry, N., & McCarthy, A. (Eds.). (2004a). *MediaSpace: Place, scale and culture in a media age*. London: Routledge.

Couldry, N., & McCarthy, A. (2004b). Orientations: Mapping MediaSpace. In N. Couldry & A. McCarthy (Eds.), *MediaSpace: Place, scale and culture in a media age* (pp. 1–18). London: Routledge.

Daley, J. (2009, February 15). The more we discuss religious differences the safer we will be. *The Telegraph.*

Foucault, M. (1968/1986). Of other spaces (Des espaces autres). *Diacritics, 16*(1), 22–27.

Foucault, M. (1991). Space, knowledge, and power. In P. Rabinow (Ed.), *The Foucault reader: An introduction to Foucault's thought* (pp. 239–256). London: Penguin.

Garton Ash, T. (2009, February 19). Liberty in Britain is facing death by a thousand cuts. We can fight back. *The Guardian.*

Hjarvard, S. (2011). The mediatization of religion: Theorising religion, media and social change. *Culture and Religion, 12*(2), 119–135.

Johnson, M. (1987). *The body in the mind: The bodily basis of meaning, imagination and reason.* Chicago: Chicago University Press.

Kant, I. (1768/1968). Concerning the ultimate foundation of the differentiation of regions in space. In *Kant: Selected pre-critical writings and Correspondence with Beck.* G. B. Kerferd & D. E. Walford, Trans.. Manchester: Manchester University Press.

Knott, K. (2005). *The location of religion: A spatial analysis.* London: Equinox.

Knott, K. (2006). The case of the left hand: The location of religion in an everyday text. In E. Arweck & P. Collins (Eds.), *Reading religion in text and context: Reflections of faith and practice in religious materials* (pp. 169–184). Aldershot: Ashgate.

Knott, K. (2008). Inside, outside and the space in-between: Territories and boundaries in the study of religion. *Temenos: The Nordic Journal of Comparative Religion, 44*(1), 41–66.

Knott, K. (2010a). Theoretical and methodological resources for breaking open the secular and exploring the boundary between religion and non-religion. *Historia Religionum, 2,* 115–133.

Knott, K. (2010b). Religion, space and place: The spatial turn in research on religion. In. S. Coleman & R. Sarró (Eds.), *Religion and society: Advances in research, 1* (pp. 29–43). New York: Berghahn Books.

Knott, K. (2011a). Spatial theory for the study of religion. *Religion and Place* (Wiley virtual issue on the geography and sociology of religion). Retrieved from http://eu.wiley.com/Wiley-CDA/Section/id-610471.html

Knott, K. (2011b). Spatial methods. In M. Stausberg & S. Engler (Eds.), *The Routledge handbook of research methods in the study of religion* (pp. 491–501). London: Routledge.

Knott, K., Taira, T., & Poole, E. (2013). Christianity, secularism and religious diversity in the British media. In D. Herbert & M. Gillespie (Eds.), *Religion, media and social change.* Berlin: de Gruyter.

Kong, L. (2001). Mapping 'new' geographies of religion: Politics and poetics in modernity. *Progress in Human Geography 25*(2), 211–233.

Lakoff, G. (1987). *Women, fire and dangerous things: What categories reveal about the mind.* Chicago: University of Chicago Press.

Lakoff, G., & Johnson, M. (1980). *Metaphors we live by.* Chicago: University of Chicago Press.

Lakoff, G., & Johnson, M. (1999). *Philosophy in the flesh: The embodied mind and its challenge to Western thought.* New York: Basic Books.

Laughland, J. (2009, February 14). The sacking of Carol Thatcher and why Liberals don't believe in tolerance. *Mail on Sunday.*

Lefebvre, H. (1974/1991). *The production of space.* Oxford: Blackwell.

Massey, D. (1993). Politics and space/time. In M. Keith & S. Pile (Eds.), *Place and the politics of identity* (pp. 141–161). London: Routledge.

Mazrui, A. A. (1989). *The Satanic Verses or a satanic novel? Moral dilemmas of the Rushdie affair.* Greenpoint: Committee of Muslim Scholars and Leaders of North America.

McKinstry, L. (2009, February 16). Why Christianity is on the ropes in Labour's Britain. *Daily Express.*

Meyer, B., & Moors, A. (Eds.). (2006). *Religion, media and the public sphere.* Bloomington, IN: Indiana University Press.

Poole, E. (2002). *Reporting Islam: Media representations of British Muslims.* London: I. B. Tauris.

Rushdie, S. (1988). *The satanic verses.* London: Viking Penguin.

Singh, J. (2012). *Keeping the faith: The transmission of Sikhism among young British Sikhs (18–30).* PhD thesis. School of Philosophy, Religion and the History of Science, University of Leeds, Leeds.

Sørensen, J. (2007). *A cognitive theory of magic.* Lanham, MD: AltaMira Press.

Tweed, T. A. (2006). *Crossing and dwelling: A theory of religion.* Cambridge, MA: Harvard University Press.

Webster, R. (1990). *A brief history of blasphemy: Liberalism, censorship and The Satanic Verses.* Southwold: Orwell Press.

Zoonen, L. van, Mihelj, S., & Vis, F. *Fitna and YouTube.* Retrieved from http://www.religionand society.org.uk/research_findings/featured_findings/fitna_and_youtube

Mediating Gypsiness Through the Holy Spirit

Pentecostalism and Social Mobilization Among European Roma

DAVID THURFJELL

In the kitchen of a three-room apartment in one of Stockholm's poorer suburbs sits Sonja with a cup of coffee. The apartment is owned by the municipality and usually used for housing refugees waiting for their asylum decision. Sonja and her family have lived here for years. Letting them stay in a refugee flat, although they are all born and raised in Sweden, is a special solution that the authorities have come up with because Sonja's family has had so much trouble finding a permanent place to stay. Sonja is in her mid-40s and she is a Kaale Rom. The Kaale Roma—or Finnish gypsies as they are often referred to by outsiders—are one of Europe's many Romani communities. They live in Sweden and Finland, they speak Finnish, Swedish, and Romani, and they are recognised by their distinguishable outfit. The women wear big black velvet skirts and beautifully embroidered lace blouses, and the men wear creased black trousers, shiny patent-leather shoes, short black jackets, and hairdos that are reminiscent of the 1950s, shiny, slicked back hair with sideburns.

Sonja rarely leaves her apartment. She has no job and although the social services sometimes force her to attend educational programmes of different sorts, most of the time she stays at home. She reads the Bible, drinks coffee in the kitchen, smokes on the balcony, and talks to friends and relatives on the phone. She has also arranged a little office for herself in one of the apartment's wardrobes. It is not a big place, hardly more than two square meters, but it is enough to hold a computer and a chair. Every day when she cannot think of anything better to do or when she needs some privacy and peace away from the children, Sonja goes in to her little

wardrobe office. She takes her seat in the chair there, turns on the computer, and connects to a website called Paltalk.com. There they have chat rooms where you can talk through your headset to other people about different topics and in different languages. There are some chat rooms where Charismatic Christian Romani people meet to talk, discuss, sing, and pray together. These are the ones Sonja picks. She can spend hours sitting there talking and singing with the others. They speak about the Bible, about the hardships of Romani people all over Europe, about how their situation is a sign of the imminent return of Jesus. They pray and sing hymns of praise together, and sometimes they speak in tongues.

Sonja is a Pentecostal. She grew up in the Pentecostal movement and has seen it grow in influence among Roma. In her lifetime she has witnessed the growth of a specifically Romani version of Pentecostal Christianity, a version that is intimately connected to the rise of a new pan-Romani identity and to the political struggle for Romani rights. Through the means of several different media—revivalist meetings, educational campaigns, novels, journals, pamphlets, broadcasted sermons, and Internet sites such as Paltalk—Pentecostal ministers, human rights activists, and bureaucrats have managed to articulate a new way of thinking about what being a Rom is (or should be) about. Through these various media they have managed to promote a Romani identity that brings together different Romani groups in Europe by means of a Pentecostal discourse (Acton, 1979).

In this chapter I will explore this new religiously flavoured mediation of "Gypsiness." I shall briefly present the situation of the Romani communities in Europe and propose an analysis of the Pentecostal revival that is blowing through these. The main point is that this revival can be understood as a response to societal pressure from the majority societies. I will hence suggest that the new religious articulation and mediation of "Gypsiness" can be analysed as a means for social mobilisation and empowerment. The train of thought that is summarized in this chapter draws on the results of an ethnographic study on Pentecostal revivalism among the Kaale that I have previously published (Thurfjell, 2013).

Four Paradoxical Processes

To understand the significance of the new religious articulation of "Gypsiness" that this chapter seeks to explore, it is necessary to take a general look at the situation of Europe's Romani communities during the latest few decades. If we do so we will soon find that there are several clearly distinguishable processes of social change that are taking place among these communities. Interestingly, we will also find that these processes are somewhat contradictory insofar as they seem to lead in quite different directions. The processes, then, are (1) *increasing antiziganism*, (2)

increasing social problems, (3) *increasing efforts to secure human rights for Roma,* and (4) *Pentecostal revivalism.* Let me now say something about these one by one.

Increasing Antiziganism

Analogous to the concept of anti-Semitism, the term *antiziganism* denotes hatred, prejudice, and discrimination of Romani peoples as a collective (Wippermanns, 1997). Similar to anti-Semitism, antiziganism has been a part of the relations between Roma and *gaje* (the Romani word for non-Roma) more or less throughout history (Hancock, 2002). In World War II, it led to the murder of hundreds of thousands of Roma in Europe who died alongside Jewish victims of anti-Semitism in the death camps (Marsh, 2011; Hancock, 2006).

The history of Roma-*gaje* relations can be described as moving between periods of peaceful coexistence and periods of strong hostility (Marsh, 2009). The latest decade bears witness to an increase of antiziganism in many European countries (Forsberg & Lakatos, 2003). In the countries where large Romani populations live, this development is most obvious. However, also in other European countries are Roma subjects of discrimination. They are discriminated against in the housing and job markets as well as in school and health services. In many European countries,[1] Romani children have been segregated from normal schools. There are recent reports of forced sterilisation of Romani women. Romani people also often suffer assaults in city streets and there are several examples on how attackers have sought out families in their homes and attacked them without distinction between adults, old people, and small children.[2]

Human Rights Commissioner Thomas Hammarberg, from the Council of Europe, is one of many experts who have expressed their fear for what the present situation is going to lead to: "today's rhetoric against the Roma," says Hammarberg, "is very similar to the one used by Nazis and fascists before the mass killings started in the thirties and forties."[3]

Increasing Social Problems

The second process is that of increased social problems. Most Romani groups and individuals are very poor. Economically, every day is a struggle for many Roma. The old traditional trades, such as horse trading or copper smithing, are long gone and few Romani communities have managed to smoothly transfer into other trades. To find a regular daytime job is close to impossible for many, mostly due to their lack of education and because of the antiziganist sentiments of many employers. Some Roma are also hesitant to the idea of being the employee of a *gaje* employer. To

many, such a dependant situation echoes of the rather recent experience of being kept as slaves. School is also a problem, although there are big differences between different groups, many Romani children drop out of school early. In Scandinavia, it is usually at the age of 12 or 13 that this happens. In this age, adolescent young people start to play out their identity more clearly and when this happens the fact that Romani children are Roma becomes more obvious. This, in turn, creates tensions to both the school and the other children that often results in the Romani children dropping out (Rodell Olgaç, 2006), a development that leads to the perpetuation of their exclusion from the job market. In addition to all these problems, Romani people have a health situation that is significantly worse than that of the majority populations. There are also vast difficulties when it comes to drug abuse, social problems, family violence, and criminality (*Romer i Sverige*, 1997). Contrary to what one would hope and expect there are indications that these problems are increasing rather than disappearing lately.

Needless to say all these problems are connected to the first process. There is a lingering feeling of mistrust between many Roma and the majority populations. Among many Roma, there is a justified fear that *gaje* will try to extinguish them. There are recent memories of severe oppression and even of attempts of annihilation from the majority cultures. In Romania many Roma lived in serfdom until the nineteenth century when many of them, following the ban on slavery in Romania, moved westward. During World War II, hundreds of thousands of Roma were murdered by the Nazis for no other reason than them being Romani. In northern Europe there have been no direct murders, but there have nevertheless been attempts at annihilating the Romani minorities by means of forced sterilisation and confiscation of children. In Norway, an infamous "labour colony" known as Svanviken did not close until 1978 (Halvorsen, 2004).

It is hardly surprising therefore that many Roma feel a disinclination to completely adjust to the society. There is no trust. Present-day *gaje* efforts to help Romani people integrate are often met with suspicion. The Roma, or at least very many of them, are outsiders in society, and largely because of this distrust, many of them want it to remain like that too. This attitude makes an effort to come to terms with the social problems more difficult, which takes me to the third process.

Increasing Efforts to Secure Human Rights for Roma

The third process, then, is the opposite of the first and second processes. It is the increasing awareness about the existence and situation of Romani people in the media as well as among public authorities, people in general, and among the Roma themselves. The last couple of decades have seen a dramatic increase in the atten-

tion that is given to Romani groups in Europe. Before the 1970s interest in Romani matters by non-Roma was limited to romanticized orientalist depictions in films and storybooks, and in an often equally orientalistic academic interest in "Gypsy lore." Real Romani people, their lives and problems, were, it seems, of little interest. Since then much has changed. Now newspapers, television programmes, and radio shows dedicate attention to the situation of Roma like never before. There are museum exhibitions, educational programmes, and political councils for the improvement of their situation. In academia, Romani studies has become a discipline in which the debunking of stereotypical representations and discrimination is on the top of the agenda. High ranking representatives of states and churches, including the Pope, have publicly apologized for atrocities committed against Roma in the past. Juridically, Romani people have been acknowledged and given status as an official minority in many places and their language has received official status as minority language (Carling, 2005). The Council of Europe *has* a commissioner with the task of working for Romani rights. And the critique against discrimination of Roma has at times been outspoken and severe. These are all changes that point in a direction that is opposite to the first process.

Pentecostal Revivalism

Now, in the midst of these contradictory developments there is religion, more precisely the rise of Romani Pentecostalism. Charismatic Christian revivalism among Roma has sprung up in many different places in Europe and it is difficult to pinpoint one particular starting point for the general movement of Romani Pentecostalism. However, according to the historiography of the movement itself it all began in France in the 1950s with the zealous evangelism of a French *gaje* minister by the name of Clément le Cossec. Le Cossec started to preach to the Manouche travellers in France and gained many converts among whom he soon started to ordain new ministers (Acton, 1979, p. 293; Le Cossec, 1985; Fraser, 1992, p. 313; Lindahl, 1955; Maximoff, 1965, p. 152). From its cradle in France, the movement then spread like fire throughout Europe, and French Romani ministers evangelized in other countries or connected their revival with revivals that were already growing among Romani groups elsewhere. In the 1990s it was estimated that half a million Roma from different groups across Europe had been baptized in the Holy Spirit. By that time there were about 4,600 Romani ministers in the movement. And since then it has continued to grow (Locke, 1997, p. 21). Although not all Roma are Pentecostal, Charismatic Christianity can be said to be the foremost religious expression of Roma across Europe today. It is likely that a vast majority of Romani persons with an active religious engagement (i.e., persons who participate in religious services,

work for a religious organisation, or take part in other collective religious activities) do so within the framework of some kind of Charismatic Christianity.

So, we have four processes that significantly have changed the lives of Romani people across Europe during the last couple of decades that, at a first glance, seem somewhat contradictory and diverse. As I have studied them more closely, however, a different picture has emerged. It turns out that they are deeply interconnected. That aniziganism and social problems are interrelated is clear. But the processes of increased awareness and Pentecostalism are connected too. This is so, first, because of the people involved. Many, if not most, Romani rights activists are also Pentecostal, often they are Pentecostal ministers, and at the Pentecostal meetings as in their journals, pamphlets, and magazines, the theme of social mobilisation and empowerment is a most prevalent one (Strand, 2001, p. 2, 12; Acton, 1979, 1998; Fraser, 1992; Gay y Blasco, 1999, 2000). So it turns out that processes three and four are in fact largely orchestrated by the same people and through the same media and by the same organisations.

However, in addition to these, there is also a more profound interconnection between the four processes, an interconnection that also links the first two negative processes with the latter ones. In the following I will propose that they are deeply interconnected because of the way they all, through the various media that they have access to, contribute to a new articulation of who the Roma are, in other words: Together they bring about a new way of defining and mediating "Gypsiness." At the midst of the struggle against discrimination, and in the religious revivalism, and, also in the midst of rising antiziganism, then, lies another process: the discursive process of establishing a new ethnic category: that of a united Romani people.

If we want to understand what goes on in the real life of Roma in Europe today, we need to lift our eyes onto the level of mediated discourse. We need to understand the story that is being told by Roma—as well as by *gaje* people—about who the Roma are. An enquiry into the present state and status of Europe's many Romani groups will lead to an enquiry about the publicly mediated discourse that defines who they are.

Who Are the Roma?

To explain what I mean here I have to backtrack a little. The new articulation process that is integrated in the four processes pinpointed above is about creating a unified identity for all Romani people in Europe. For this to make sense at all one needs to understand that Romani people are not—or at least have not been—a united group. In the stereotypical and romanticizing image of *gaje*, they have always been seen as more or less one group: Gypsies with their caravans. But in the self-understanding of most people belonging to these groups this has not been the case. Instead there have been a number of different groups referred to by a number of different ethnonyms.

Hence we have the *Gypsies, Sinti, Travellers, Gitano, Dom, Lom, Roma, Kaale, Kalderash, Manoush, Lovaria, Romanichal, Zigenare,* and so on. Throughout history, these groups have lived at the margins of society, often in vast poverty and with few resources to expand or develop their culture beyond the struggles of everyday life.

Traditionally these different groups have had little knowledge of each other. Most of them have not recognised each other as members of the same community. They have spoken different languages, had different religions, and lived in different areas. If they are to be thought of as one group, or category of groups, therefore, it would primarily be their societal marginalisation and their vagrant (or post-vagrant) lifestyle that would be their foremost commonality (Svanberg & Tydén, 1990, p. 157). In addition to this they are sometimes also brought together by a common notion of origin, a conception of a shared history, a series of cultural reference points that includes cleanliness taboos and a dichotomy around ideas of purity and impurity, as well as, sometimes, an awareness of a series of linked dialects including a common lexicon for many terms.

Now, *Roma* is an ethnonym that originally was, and that still is, used to denote *one* of these many groups. The Roma live in east and central Europe as well as in the Balkans. Most of the groups mentioned above (for instance, the Manoush, the Kaale, the Sinti, or the Gitano) are not Roma in this traditional sense.

The most important discursive change that the above mentioned processes have brought about, then, is the widening of the concept of Roma to include these and many other groups as well. The words *Rom, Roma,* and *Romani* as they are used in media, by public officials, politicians, human rights commissioners, Pentecostals, and academics (including myself in this chapter) today are hence neologisms. To think of *Roma* as an umbrella term for all the groups mentioned above is a new thing, and it is the result of the discursive change that the above mentioned processes have brought about.

An important agent in making this happen was Clément le Cossec and the first Romani Pentecostals in France. As I have mentioned above, le Cossec started his movement among the Manouche in France. The Manouche are not Roma in the original sense. Rather they constitute another travelling community that shares some, but not all, features with the (original) Roma in central and eastern Europe. In the public understanding of the *gaje,* and perhaps of the Manouche themselves, however, the ethnic, linguistic, and social distinctions between different groups of vagrants in Europe was not clear. To most people, regardless of where they lived or how they defined themselves, these groups were simply *Gypsies* if we are to use the English term. In France, they were simply *Tsiganes* or perhaps *Bohémiens,* and in Scandinavia, they were simply *Zigenare*—different names in different countries—and little did the majority populations care about their differences and subgroups. Most *gaje* settled, and still settle, with one generalizing and often pejorative ethnic label.

Now, when le Cossec and the other leaders of the Manouche Pentecostal move-
ment sought to spread their revival outside France, they were influenced by the ho-
mogenizing tendency of the common conceptions about these groups. Hence, the
Gypsies in England, the Gitanos in Spain, the Roma in Eastern Europe, and the
Kaale in Finland were all thought of as members of the same community, and were
hence singled out as the object of le Cossec's famous *aventure chez les tziganes* (le
Cossec, 1991).

Through the publications of le Cossec's movement, not least the Pentecostal
magazines and periodicals of his organisation *Vie et Lumière*,[4] then, the generaliz-
ing view—that le Cossec had inherited from the simplified public conception of
Romani peoples in France—became merged with his Pentecostal revivalist cam-
paign. Pentecostalism hence became a powerful vehicle for the propagation of a
new way of thinking about one's ethnic belonging in these groups. Pentecostal
ministers belonging to one vagrant group, say the Manouche, presented themselves
to another group, say the Kaale of Finland, as their long lost Romani cousins now
bringing both the Gospel and Romani unification to them (see also Gay y Blasco,
1999, 2000; Strand, 2001, p. 45). Through this process a new way of thinking about
one's own identity emerged. Pentecostalism, to put it in other words, helped bring
about the ethnogenesis of Roma as a general ethnic label (Gheorghe, 1997, p. 158).
Through it, the word Roma no longer came to denote one particular community
only, but all travelling communities in Europe and elsewhere.

Now, two of the other processes described above—increased antiziganism and
increased awareness—clearly contribute to the same ethnogenesis. Although the
processes and the intentions of their proponents go in completely opposite direc-
tions, they share the homogenizing tendency when it comes to the Romani peoples
in Europe. Rarely, if ever, do government officials, human rights activists, museum
exhibitions, and mass media of antiziganist propaganda describe Romani peoples
as anything else than a homogenous ethnicity.

Difficulties of Difference

The next question, then, is why this happens. Why do Romani right activists and
Pentecostals seek to create a united ethnicity for all these differing communities?
In the following I will propose that the answer to this question lies in the specific
form of difference and outsidership that characterizes the situation of many Ro-
mani groups.

To begin with, then, it is important to note that one of the main (perhaps *the*
main) common features of all groups referred to as Roma is their societal margin-
alisation and cultural otherness. By this I mean that all the groups are defined and

define themselves as different from the majority population in the countries where they live. Indeed, some would argue that at least for some of the groups, this experience of being something different is the main factor that constitutes their identity.

Furthermore, the difference here spoken of is more profound than the difference that you would find between other cultural groups. Other groups—say Finns, Persians, and Somalis—may find themselves to be very different from each other. Yet they share a conception about the major categories in which people can be different. They might differ in what language they speak, what country they come from, what food they eat, what holidays they celebrate, what book they think of as holy, and so forth. But they are similar insofar as they agree that the categories of language, country, food, holidays, etc., are the fundamental components of culture, that these are things that we all have and that it is through them that our differences become visible, they constitute the perimeters of what having a culture is about.

Now, the difference of the Romani peoples is more profound since it concerns this very perimeter of what culture is and should be. The Roma do not and have never had a country of their own. Instead the traditional lifestyle has been vagrant, travelling in between the countries of the *gaje*. There is no nationalism either, no dream of a homeland or a return, no equivalent of Jewish Zionism. Instead there is the transnational lifestyle or at least an awareness of transnational connections. There is no single institutionalised King, but more loosely held together family and tribal structures of authority. Traditionally there has been no standardized language—no Bible translations to set the blueprint for proper language use—but instead ever changing dialects constantly mixing with the languages of the surrounding society. There are no books, no papers, no written documents, but an oral tradition built around the memories and words of the elders. No chronological history or record of past events, but spoken folklore. No institutionalised society or transparent legal procedures, but an oral law, the authority of elders and shared notions about purity and impurity that help keep things as they are meant to be, and there is no common traditional practice that *gaje* would recognise as religion (church going, reading, uniformity, etc.) but often adherence to different religions, a strong belief in God, and certain ritual practices. In other words, the Romani communities have an experience of being different from the majority cultures in a very profound way.

Discursive Oppression

Now, to understand their situation and the social mechanisms that constantly reposition Romani peoples on the margins, I think it is necessary to understand that the oppression under which they suffer is not only found within such measurable fields as employment, education, and health. Oppression and discrimination within these

spheres we can easily understand; they are also the ones that are focused in all governmental reports on the situation and discrimination of Roma. But there is another more subtle type of oppression that is more difficult to grasp, but that I think is possibly even more important. That is the discursive one. Discursive oppression, then, is the oppression that results from profound difference mentioned above. *Gaje* society categorises the world and the way we live and should live in it according to categories that are different from the Romani ones. The Romani groups do not only differ in what geographical region they come from, but in their view of geography and settlement per se.

This difference, I would like to propose, becomes oppressive when the categories and views of the majority are hegemonial, that is, when they are felt to be—not one of many alternative ways of categorising life and society—but *the* way to categorise. The *gaje* way is the *normal* way. To suggest something else would come through as a bit crazy or perhaps stupid or funny.

In the field of postcolonial studies, the relations between hegemonial discourses and the dispossessed, or subaltern, subject cultures have been explored. One prominent analysis here is summarized in the idea that "the subaltern cannot speak." This idea, first promoted by Gayatri Spivak (1988), in short means, first, that the voice of those who are marginalised will never be listened to by those in power, and, second, that the ideas of the marginalised would not make sense to those in power. Hegemony, hence, means that the experience of the subaltern will not even be heard, their point of view is not interesting because it is too different.

Now, as I understand it, this means that in order to be heard, the subaltern must adjust to the demands of the hegemony. They must speak of themselves and their problems in the ways the majority does and they must admit that the solutions are to be found in the ways of the majority. When it comes to the Roma in Europe, the majority societies demand that they succeed in the arenas defined by the hegemony. To be counted as more than a social problem you need to prove yourself in school and on the job market. Literacy, health, education, and employment are the signs of success that count regardless of whether you agree with this or not.

For individual Roma this becomes problematic. They are asked to measure themselves on the scales set up by the majority. When they do so, however, the result is that they seem to be complete failures. When it comes to health, education, and employment, the Roma are not very successful. This means that accepting the majority's view of these as the only achievements worth striving means a heavy blow to one's self-respect and pride. Given the fact that this is requested from the same majority society that repeatedly has tried to annihilate them, it is hardly surprising that many Roma feel a bit hesitant.

The result of the majority's pressure, then, is a situation where many Roma have to choose between (1) being listened to by the majority while perceiving themselves

as failures or (2) remaining unseen and marginalised but with an upheld sense of exclusivity and pride. This, I have found, is the predicament that many Roma are experiencing. It makes many of them hesitate about engaging wholeheartedly in the well-intended educational and social programmes that *gaje* arrange for them. To struggle hard for success in the school system of the *gaje* would be to accept that it, so to speak, is only the *gaje* scale that counts.

This situation, I believe, can be described as a deadlock. Roma, especially young people, are caught between a rock and a hard place—either they can accept their marginalisation but keep a feeling of pride, or they can yield to society's demands and its scales of measurement to get some success along these scales, but lose some self-respect.

One way to illustrate the point that I am trying to make here is to use a metaphor that is sometimes used by Roma themselves. Among some Romani groups it is common to refer to *gaje* as farmers. All *gaje* people, regardless of what they do for their living, are farmers. That is, they live by the logic of a settled person. In their lives, for instance, regularity and predictability are important, as are reading, writing, keeping times, and being able to articulate things in a clear way. All these things are important for the farmer type of life, and even if many *gaje* are not farmers anymore, the same logic keeps permeating their way of thinking (Hazell, 2002).

Now, the Roma are not farmers. They are nomads (at least in this metaphor). This means that they do not need the same things as farmers, they do not need regularity and predictability, but flexibility and loyalty. They do not need to be able to keep times, but to solve unexpected situations.

When farmers try to solve the problems of nomads, then, the only thing they can do is to help them become better farmers, that is, to become like they themselves are. This means that even well-intended help entails an element of cultural coercion. Let me exemplify: Vagrant Roma have health problems so the well-intending majority culture builds them houses so that they can live proper lives. Romani horse merchants have problems making a living on their trade, so the *gaje* authorities put them in an educational programme so that they can get a proper daytime job. These attempts are all very well meaning but they nevertheless entail the imposing of *gaje* culture on the Roma that are being helped.

Allow me to use another proverbial metaphor to make this point clear. The situation of the Roma is a little bit like that of the innocent man who was asked the question: "have you stopped beating your wife?" It is a difficult question since it forces the person answering to accept the presuppositions of the asker. Answering "no" would mean that one has not stopped beating one's wife, but answering "yes" would mean that one has been beating her in the past. Both answers are false from the perspective of the answerer. Also, they both confirm the false presupposition of the asker.

The Roma-*gaje* situation is similar. The *gaje* do not see or acknowledge difference that is so profound that it challenges the categories by which they compare cultures. Hence, they offer suffering Roma a type of help that unintentionally entails a pressure on them to assimilate to a *gaje* way of life. Here the Roma face a situation similar to the accused wife-beater. Either they accept the help, and hence accept the *gaje* presupposition about the source of their problem—that is, that they are not enough *gaje*—or they reject the help and thereby confirm the *gaje* prejudice that the causes of the problems are themselves.

In an ideal world, the Roma would articulate a more profound critique of the way they are treated by the majority societies. And ideally that critique would be listened to by the society. But we do not live in an ideal world, and very few Roma have the status and position it would take to formulate such a critique and to be listened to. And so the situation remains unchanged.

A New Articulation

I would now like to suggest that the new articulation of what it is to be Roma, brought forth by Romani Pentecostals and that I have presented above, could be seen as a response to this ambiguous situation and predicament. There is no way the Roma can resist the discursive pressure of the hegemonial majority societies in which they live. They cannot articulate a critique that challenges the categories and presuppositions of the *gaje* understanding of them, neither can they make themselves be seen as a community that wishes to organise its life in a way that is genuinely different from the ways of the majority's settled, farmer-like, lifestyle.

What then can they do? One option would be to simply yield to the *gaje* pressure and accept a *gaje* image of themselves as people who have failed on all scales of measurement that matter in life (i.e., *gaje* schooling, employment, *gaje* social status, financial resources, etc.). But doing that would mean a complete loss of self-respect.

So, instead of this, what they have to do is to find a way to yield to the *gaje* discursive pressure without losing self-respect. It is here, I would argue, that the ethnogenesis and the new mediation of Gypsiness that Pentecostalism brings about comes in.

Pentecostals and Romani rights activists have managed to create a unified Romani identity based on the criteria stipulated by the majority cultures. With efforts to standardize Romani languages, with the widened use of the word Roma, and with global organisation and united political representation Romani people have united in a way that resembles the nation-building processes of the European nation states in the late nineteenth century. The organisations and new self-awareness provides a platform from which Romani people can take part in political debates and hence in-

fluence policymaking. In other words: at the same time as they have abandoned some major features of what has constituted their difference, they have gained access to social and infrastructural tools necessary for empowerment in *gaje* society.

Now, no attempts at uniting Romani people despite their traditional differences have been as successful as the Pentecostal one. This movement, not least through the efforts of Clément le Cossec and his *Vie et lumière* organisation, has managed to connect Roma from different countries and create an enthusiasm that, by far, outperforms that of other more secular attempts.

The reason for this, I would like to suggest, lies partly in the religious character of the Pentecostal discourse, and partly in Pentecostalism's character of *gaje* counterculture.

First, then, a recurrent theme in the religious language of Pentecostalism is that of a god that comes in to your life and fixes your problems once you give yourself up to him. Most Pentecostal practitioners have an individual testimony about their personal way to faith and at meetings such testimonies are shared all the time. One central idea here is that God will solve your problems if only you let him into your life. Often (at least among the Romani Pentecostals that I have followed) there is a story of past alcoholism in the testimonies. Many testify that they were stuck in an addiction from which they could not escape. No matter how hard they tried, they did not have the strength to break the habit on their own. Then they gave themselves to God and he gave them the strength to stop drinking. Now, there is a parallel between the deadlock situation of being caught in alcoholism and the societal situation of the Roma that I have described above. In both cases you want two incompatible things at once and this predicament leads you to self-destructive behaviour. In the case of alcoholism you need to drink to quench your thirst and smother your anxiety, but at the same time another part of you wants to be sober and responsible. In the case of the situation of many Roma, you on the one hand want to rebel against the *gaje* pressure to assimilate, but at the same time you need the stability that yielding to it would entail. In both cases, then, the problem is to handle an ambiguous volition. Pentecostalism, through its dogmatic content, its discourse, and its rituals, offers a solution to this type of predicament, namely that of salvation through Jesus. By giving up one's attempt to solve these problems by oneself and by instead giving one's self up to Jesus, a miraculous solution to the situation is believed to happen. (Whether this solution actually works or not is a different issue that I will not discuss here. Suffice it to say that this is the way it is presented and believed by Pentecostals.)

Now, in the case of the Roma and the pressure they live under, this miraculous solution comes in the shape of a pan-Romani identity that is positioned in the framework of the cosmic drama of Christian theology: Life in this world is a test, and our suffering is a part of God's plan. The Roma have been given a specific role

in this drama by God himself. They are one of the lost tribes of Israel and their coming back to God is a sign that the time of Jesus's return is imminent (Gay y Blasco, 1999, p. 55). In the Gospel of Luke (Chapter 14) Jesus tells the story of the great banquet. It is the story of a man who was organising a feast. The guests he invited did not want to come. Instead they started coming up with excuses of different sorts. The man then turned to the poor, lame, and blind and invited them to come to the feast. But still there were seats left. In a final effort to fill his banquet, he then asks his servant to "Go out to the roads and country lanes and compel them to come in, so that my house will be full" (Luke 14:23). Now, the Romani Pentecostals identify themselves with the last ones to be invited. And this also is what makes them and their movement an eschatological sign. They are the last to come to the feast, the lost tribe of Israel brought back home, and when they have come God's plan is finished and Jesus can return (Ridholls, 1986).

Pentecostalism is a *gaje*-dominated religion, and Romani people's turn to it is, in a way, an expression of an acceptance of the *gaje* pressure to assimilate. At the same time it is an assimilation to a form of *gaje* culture that in itself is countercultural. The *gaje* Pentecostals are not part of the mainstream society, they are outsiders to and critics of much that goes on in the majority culture, yet they are—by virtue of their ethnicity—closer to the mainstream than the Roma have traditionally been. When Roma rearticulate their identity as Romani Pentecostal, they hence take a significant step closer to the majority while still maintaining their countercultural position, albeit in a different way than before. By framing this move in a theological language that singles out Roma (that is all different Romani groups) as one of the lost tribes of Israel, it also contributes to a unification of the various vagrant groups referred to as Roma, without losing the self-respect and pride of being something other and special. Pentecostalism, hence, through a re-articulation of what being Roma is about, offers a solution to many of the challenges that Europe's Roma are facing today.

Notes

1. See www.dr.dk/Regioner/Kbh/Nyheder/Politik/20060118073049.htm
2. See www.humanrightsfirst.org/discrimination/pages.aspx?id=85
3. See www.adevarul.ro/rss/articol/femeia-roma-care-rapeste-copiii-este-doar-un-stereotip.html
4. Of special importance here is Clément le Cossec's own magazine, *Lumière du monde*, later renamed to *Vie et Lumière*. With several issues per year, this periodical follows the development and work of the *Vie et Lumière* across Europe over three decades. During his lifetime, Clément le Cossec also produced other periodicals of a similar character. *La Délivrance* was published in six issues in 1958 and *Le chemin qui mène à la vie* with similar frequency during 1959 and 1960. From the late 1960s onwards the *Vie et Lumière*-magazine was also published in English as *Gypsy Work* magazine or *Gypsies for Christ*, in German as *Stimme der Zigeuner*

and in Finnish as *Elämä ja Valo*. Today many of these periodicals are available online through the Clément le Cossec official website: www.clement-le-cossec.org

References

Acton, T. (1979). The Gypsy evangelical Church. *The Ecumenical Review: Journal of the World Council of Churches, 31*(3), 289-295.

Acton, T. (1998). *Authenticity, expertise, scholarship and politics: Conflicting goals in Romani studies.* Inaugural Lecture Series. London: University of Greenwich.

Carling, G. (2005). *Romani i svenskan: storstadsslang och standardspråk.* Stockholm: Carlssons.

Forsberg, A., & Lakatos, A. (2003). *Romernas upplevelse av diskriminering i Sverige.* Socialhögskolan.

Fraser, A. (1992). *The Gypsies.* Oxford: Blackwell.

Gay y Blasco, P. (1999). *Gypsies in Madrid.* Oxford: Berg.

Gay y Blasco, P. (2000). The politics of evangelism: Masculinity and religious conversion among Gitanos. *Romani Studies, 10*(1), 1–22.

Gheorghe, N. (1997). The social construction of Romani identity. In T. Acton (Ed.), *Gypsy politics and traveller identity* (pp. 153–163). Hatfield: University of Hertfordshire Press.

Halvorsen, R. (2004). Dynamics of control and resistance: Reactions to the modern policy of assimilation of the travellers in Norway. *Hjem: Special Issue on Northern Minorities, 15,* 149–166.

Hancock, I. (2002). *We are the Romani people: Ame sam e Rromane dzene.* Hatfield: University of Hertfordshire Press.

Hancock, I. (2006). On the interpretation of a word: Porrajmos as Holocaust. In *Romani Archives and Documentation Centre* (RADOC). Retrieved from www.radoc.net

Hazell, B. (2002). *Resande folket: Från tattare till traveller.* Stockholm: Ordfront.

Le Cossec, C. (1985). "Phénomène pentecôtiste" ou réveil religieux. *Études Tsiganes, 1*(85), 19–21.

Le Cossec, C. (1991). *Mon adventure chez les Tsiganes.* Le Mans: Private.

Lindahl, G. (1955). *Zigenarväckelse.* Stockholm: Förlaget Filadelfia.

Locke, S. (1997). *Travelling light: The remarkable story of Gypsy revival.* London: Hodder & Stoughton.

Marsh, A. (2009). *The Roma situation in Europe.* Lecture at Södertörn university, Stockholm, March 3.

Marsh, A. (2011). *The mechanics of marginalisation; the Gypsies and genocide, 1900–2011 (O Baro Parrajmos).* Cardiff: Romani Arts.

Maximoff, M. (1965). The evangelical Gypsies in France. *Journal of the Gypsy Lore Society.* Series 3, Vol. 44.

Ridholls, J. (1986). *Travelling home: God's work of revival among Gypsy folk.* Basingstoke: Marshall Pickering.

Rodell Olgaç, C. (2006). *Den romska minorieteten i majoritetssamhällets skola: Från hot till möjlighet.* Stockholm: Intellecta docusys.

Romer i Sverige: Tillsammans i förändring. (1997). Departementsserien 1997:49. Stockholm: Näringsdepartementet, regeringen och regeringskansliet. [Report from the Government offices: Roma in Sweden, Together in Change]

Spivak, G. C. (1988). Can the subaltern speak? In C. Nelson & L. Grossberg (Eds.), *Marxism and the interpretation of culture* (pp. 66–111). Chicago: University of Illinois Press.

Strand, E. P. (2001). *Moving hearts: Pentecostalism and Gypsy identity.* Masters dissertation. Greenwich: School of Social Science, University of Greenwich.

Svanberg, I., & Tydén, N. (1990). Zigenare, tattare och svensk rashygien. In J. O. Johansen (Ed.), *Zigenarnas holocaust,* (pp. 145–151). Stockholm: Symposion.

Thurfjell, D. (2013). *Faith and revivalism in a Nordic Romani community: Pentecostalism among the Kaale Roma of Sweden and Finland.* New York: I. B. Tauris.

Wippermanns, W. (1997). Wie die Zigeuner. In *Antisemitismus und Antiziganismus im Vergleich.* Berlin: Elefanten Press.

Taming the West

Mediations of Muslim Modernities

NABIL ECHCHAIDI

Everywhere, at every national/cultural site, modernity is not one
but many; modernity is not new, but old and familiar; modernity is
incomplete and necessarily so.

—DILIP PARAMESHWAR GAONKAR (2001, P. 23)

The demonstrations and rhetorical firestorm provoked by the release of the 2012
YouTube video *The Innocence of Muslims* revealed once again an enduring skepti-
cism about the place of Islam in the modern secular world. Similar to the contro-
versy around the Prophet's cartoons in 2005 in Denmark and the 1988 Rushdie
Affair, the video sparked a contentious debate about whether Muslims can tolerate
religious dissent and effectively shed the suffocating dogma of the sacred.[1] In place
of a vibrant intellectual revolution, we are told, the Muslim world (often used as an
undifferentiated essence) can only produce "thin-skinned moralists" (Majid, 2012).
The remarkable social uprisings that toppled the 23-year-old dictatorship in Tunisia
and the 30-year-old iron rule of President Mubarak in Egypt in 2011 provided,
however, a temporary blip to counter the popular imagination of Muslim societies
as young Arabs took to the street to protest hardline governments and neoliberal
economic inequalities. The sight of Muslim men and women in major Arab city
squares chanting political slogans of freedom and equality was surprising to West-
ern audiences and marked a radical break with clichéd representations of Arab so-

cieties plagued with ideological fanaticism and deep political and economic malaise. But the resounding success of reconfigured Islamist parties in recent elections in Egypt, Tunisia, and Morocco has quickly overshadowed this "ray of hope" and became construed in the West as a vindication of an age-old politicized Islam and a potential warning of cultural confrontation. "[W]hy the Arab Spring has failed," wondered the *Daily Mail.* "Is the Arab Spring Failing Its People?" asked CNN. "Arab Spring or Islamist Winter?" cautioned *World Affairs Journal.* "Is Islam an Obstacle to Democracy?" asked the *New York Times.*

The significance of these protests dubbed "The Arab Spring" is indeed unparalleled in modern Arab political history, but one of their most enduring consequences, I argue, might be the emergence of a different wave of cultural and political Islamism that bears little resemblance to earlier Islamist movements. The remarkable surge of support for Islamists represents a paradigmatic shift as a new generation of Muslims seeks alternative frames of political and cultural identification beyond the exclusionary binaries of modern–traditional, Western–non-Western, or even religious–secular. It is not an aversion but rather a strong proximity to modernity that has prompted this important rethinking of Muslim Arab identity. Islamic media, both broadcast and digital, have recently served as a prime stage for this critical reflexivity between Islam and modernity. Such a dialectic has been ongoing, with the objective of finding an alternative model to Western liberal and secular modernity. This chapter explores the complex mediation of this dialectic with modernity, particularly in the work of prominent tele-Islamists and the important role they play as contemporary brokers of an arguably modern and particularistic Islamic identity. My arguments here are drawn from the literature on multiple modernities to help me anchor Muslim popular and everyday narratives of and responses to modernity in a larger context of how Muslim subjects imagine and deploy multiple frames of reference in their path toward an "authentic" and "purposeful" modernity.

In the Waiting Room of Modernity

Recent historiographical scholarship has complicated monist narratives of modernity in an attempt to reverse the exclusive proposition that only Western tradition equals civilizational progress and development and foreground localized and more culturally specific experiences of modernity. One of the central arguments of this thesis, which draws from postcolonial theory, is to develop a new critical intellectual sensibility that would recuperate the voices of the non-West in the production of knowledge and values of modernity. Values such as human rights, equality, and freedom have been historically posited as essentially Western attributes that the

rest of the world can acquire only if it submits to a prescribed and mechanical program of social development and capitalist reconfiguration of its economic system. Traditions, according to the thesis of multiple modernities, do not simply retard or prevent progress, but in them may also reside new possibilities of rethinking the present and revalorizing concepts Eurocentric models have often read as archaic and outmoded. In other words, an emphasis on polycentric forms and narratives of modernity would not only account for equally viable lived experiences of the modern both historically and in the present, but it would also defy, as anthropologist and historian Dipesh Chakrabarty (2007) contends, the historicist intellectual assumptions that have made the West the ultimate paradigm against which all is measured. In this historicist framework, Europe is fastidiously erected as the cradle, the genesis of modernity, while the rest of the world must linger in an imaginary "waiting room of history":

> According to Mill, Indians or Africans were not yet civilized enough to rule themselves. Some historical time of development and civilization (colonial rule and education, to be precise) had to elapse before they could be considered prepared for such a task. Mill's historicist argument thus consigned Indians and Africans, and other "rude" nations, to an imaginary waiting room of history. In doing so it converted history itself into a version of this waiting room. We were all headed for the same destination, Mill averred, but some people were to arrive earlier than others. That was what historicist consciousness was: a recommendation to the colonized to wait. Acquiring a historical consciousness, acquiring the public spirit that Mill thought absolutely necessary for the art of self-government, was also to learn this art of waiting. This waiting was the realization of the "not yet" of historicism. (p. 8)

This view of a linear trajectory of modernity that smacks of theological determinism of the saved and the purged, Amit Chaudhuri (2004) argues, "is what has once liberated, defined and shackled us in its discriminatory universalism" (p. 7). Resistance to this linearity is both defined and animated by a desire to provincialize the West as the "writer" of universal history and privilege alternative narratives that also seek to become reference points of meaning for people in local and global contexts.

Before I explore further this field of alternative or multiple modernities and its relevance to an Islamically inflected version, I believe a clearer definition of modernity in the Western experience is needed. In fact, when we speak of the modern, what are we referring to precisely? Is it the institutions, the structures of governance, the opening of markets, the cultural traits of people, the relationship to tradition, the adoption of technologies, or the commitment to individualism? There

are many theoretical routes to answer these questions, but I will focus on some more common and mainstream definitions of the modern as they are understood in public (also academic) discourse and implemented on the ground. It is important to note here that even as I try to locate a dominant vision of modernity, Western modernity itself has never been singular or totalizing because it was born out of internal tensions and contradictions as a project of social transformation (Eisenstadt, 2000).[2] Bjorn Wittrock (2000) tells us that modernity refers to a particular social organization that requires the existence of a set of societal institutions and practices of the political and economic kind followed by a necessary process of acculturation that values individualism over collectivism and reason and doubt over the absolutism of dogmas. Much of this theorizing around the attributes of a modern social configuration was authored primarily in the work of eighteenth-century writers such as Rousseau, Montesquieu, and Voltaire and by classical sociological theorists such as Durkheim, Weber, and Marx, who wrote about the differences between modern European societies and earlier agrarian and feudal societies. More recent scholars have reinforced the ideological roots of the modernity project as a distinctive Western formation different from traditional pre-modern societies.

Philosopher Charles Taylor (2000) describes two conceptions of modernity. Cultural modernity reflects the differences between Western moderns and their medieval ancestors in the same way one can talk about those differences with medieval China or India. Like other cultures, the West is conceived here as a culture with its own "understanding...of person, nature and the good" (p. 172). Contrastingly, acultural modernity refers to a universalist process of social, economic, and political transformations guaranteed to produce modernization for any traditional culture. For Taylor, acultural modernity, a rampant paradigm historically, assumes that "any culture could suffer the impact of growing scientific consciousness, any religion could undergo secularization, any set of ultimate ends could be challenged by a growth of instrumental thinking, any metaphysic could be dislocated by the split between fact and value" (p. 173). The problem with an acultural conception of modernity, Taylor argues, is that it conceals some fundamental falsehoods about the transition from tradition to modernity. One of these falsehoods is that values such as instrumental rationality, individual freedom, and scientific knowledge are normal desires all human beings aspire to, and that the only path to these values lies in forsaking the limiting world of tradition and the enchanting order of the sacred. As if by design, humans are all destined to reach these "truths" through a natural psychic revolution that is devoid of any cultural influence.

Taylor (2000) and other scholars working from the alternative modernity paradigm have given us a vocabulary to speak about the plurality of the modern experience. But problematizing modernity as a discourse and a concept does not mean to uncritically celebrate its contending versions as more authentic and simply en-

gage in a politics of cultural relativism. I understand modernity in a Kantian sense not as a historical phase but as a perpetual attitude and a particular approach of relating to a given contemporary reality. It is a social imaginary and a reflexive exercise people choose to deal with the demands and pressures of their present (Gaonkar, 2001). Accordingly, my focus on Muslim modernities is a way to recognize first that there is no original or "exemplary modernity" (Kahn, 2003) as in a universal trajectory of the modern project, and second that articulations of the modern should be explored from the bottom up, in the everyday, and among ordinary people, and not solely in official and elite proclamations. The media in this sense become critical in providing the space to fulfill this vision of modernity, as Gaonkar (2001) tells us, as the interrogation of the present. Muslims are therefore interpellated through these media via a particular ideological frame to produce their "modern self." Whether the outcome of this reflexive interaction leads to the production of a new modernity, at least discursively, is the subject of the next sections of this chapter.

Muslim Modernities, Muslim Publics

It is difficult to locate the beginning of the modern era in the Arab Muslim world, precisely because of the tenuous concept of modernity as a political and cultural project. It would be naïve to claim that Muslims were introduced to narratives of change and progress only as an impact of their encounter with the West. But the question of how to relate to Western modernity with its liberal teleology and prescribed social and economic programs has been a strident concern for Muslims and Arabs since Napoleon's invasion of Egypt in 1798. Arab notions of progress and development up until that point had never been articulated from a modernity (*hadatha*, as it was translated into Arabic) paradigm as we understand it in the Western tradition. In fact, Arabs spoke of *taqaddum* (development), *nahda* (renaissance), and *sahwa* (awakening) but never of *hadatha*. Napoleon's incursion in Egypt brought with it a new vocabulary, new technologies, new knowledge, and later a new set of institutional reforms enacted by Muhammad Ali to inaugurate a modern Egyptian state à la française. Ali and his successors introduced new land ownership laws, new tax structures, new trade and commerce rules, and new urban development projects. The modernization campaign in Egypt sent ripple effects across Arab lands and became the object of vehement debates about the place of religion in building a modern Arab Muslim identity.

Much of these debates, which took both secular nationalistic and nativist religious tones, revolved around the issue of authenticity and tradition in any process of change and development. For those advocating a religious revivalism, a sound

program of societal change can only be informed by a return to the wisdom of the original texts and a submission to the ethics and values of Islam. Arab intellectuals and Muslim scholars clashed over the meaning and the terms of this rhetoric of return, which still reverberates in contemporary reflections on Islam, Arab identity, and modernity. In the eighteenth century, Wahabbis in Saudi Arabia and other Salafi groups in North Africa and India, for instance, called for a strict literal revalorization of the Qur'an, the prophetic tradition, and (fiqh) Islamic jurisprudence as the only antidote against the incursion of Western culture in Muslim lands (Abou El Fadl, 2001). They denounced any knowledge that is not based on a pristine and pure reading of the Qur'an as heretic. By contrast, Muslim modernist scholars in the nineteenth century called for a more nuanced and critical Islamic revivalism to fight the intellectual slumber of the Muslims world and face off to European imperialism and secular modernization. The modernist movement of the late nineteenth and early twentieth centuries, led by Jamal din al-Afghani, Mohammed Abdu, Rachid Reda, and Muhammad Iqbal, cautioned against the rigidity of Islamic orthodoxy and worked to reinterpret the heritage in light of the demands of contemporary life. The value of the Qur'an for these scholars was never a question, but reforms were urgently needed in the reformulation of the meaning of the primordial texts to bring them more in line with the exigencies of modern life (Esposito, 2011).

A historicist position in this debate, however, has called for a rupture with the past and a break with heritage as the only solution for a genuine and lasting emancipation of thought. For Mohammed Arkoun and Abdellah Laroui, for instance, a new epistemological culture is required to make a distinction between religion and religious knowledge. Unlike the Salafis, the Muslim Brotherhood, and Jamaat-e-Islami, the historicist take on Islam sees no value in what Arkoun calls a "closed official corpus" that is rendering any doubt about the text unthinkable and unthought (Arkoun & Institute of Ismaili Studies, 2002). Arabs and Muslims, for scholars like Arkoun and Laroui, seek refuge in the past and this makes it difficult to achieve any real progress. The alternative, as Laroui (1976) says, is to think of the past in practical terms and "take what was needed from it by a radical criticism of culture, language and tradition, and use it to create a new future" (p. 19).

Yet it is fair to say that Islamic revivalist movements have been more successful, or at least more vocal, in capturing the imagination of ordinary Muslims today, as made clear in their continued ascendancy on both the political and cultural stage in Muslim-majority countries. But the emphasis on religious nativism in these movements should not be necessarily taken to mean a rejection of change and an inability to engage with the present. Public discourse often readily dismisses narratives of change based on religion precisely because they complicate our received notions of how we understand modernity as a categorical separation of religion

and state. As Charles Hirschkind (2008) asks, "What displacements or fractures occur within the story of European modernity once religion is no longer identified as an obstacle that is overcome by modernity, but rather as itself a constitutive element of a modern political order?" (p. 68).

In her work on a new visible public Islam, sociologist Nilüfer Göle (2008) makes a distinction between two important phases in contemporary Islamism. A political strand, galvanized by the momentum of the 1979 Islamic revolution in Iran, focused on religious power through state control and collective Islamic identity politics, and a more culturalist form that seeks a more intimate renewal and revalorization of piety through the individual for the sake of a comprehensive Islamic transformation of society. In this latter phase, some Muslims, Göle contends,

> blend into modern urban spaces, use global communication networks, engage in public debates, follow consumption patterns, learn market rules, enter into secular time, get acquainted with values of individuation, professionalism and consumerism, and reflect upon their new practices. Hence we witness a transformation of these movements from a radical political stance to a more social and cultural orientation, accompanied by a loss of mass mobilization capacity, leading some researchers to pronounce the end of Islamism and "the failure of political Islam." (pp. 119–120)

The resurgence of Islamist parties following the recent Arab Spring revolutions in Egypt and Tunisia belie the sunset of political Islam thesis, but it would be misleading to argue that the Islamist coalition that rules Egypt today and the Nahda party in Tunisia hold the same ideological sensibilities and sociocultural strategies as the Islamists in earlier phases of Islamic revivalism. In fact, the successful campaign of these new Islamists in contemporary Muslim societies and the fact that large majorities are prepared to vote for them in fair democratic elections is largely made possible by a psychic revolution in which Muslims have been hailed to engage with the values and terms of modernity as a site of both contention and identification, in the same way Göle describes in the quote above. This process, which is not new as I tried to explain in this section, has taken an unprecedented popular dimension in the last decade as new Muslim actors and protagonists of this dialectic of Islam and modernity have emerged on television and on the Internet, creating an interventionist public sphere where a new social imaginary of a religiously informed modernity is not only talked about but also performed. This social imaginary borrows from the toolbox of modernity and reconciles any tensions with a Muslim understanding of what constitutes a modern emancipated self. As Göle argues, Muslim subjects emerge in this phase both comfortable with and critical of the language and the public performativity of Western modernity by making the body and

corporeal visibility, for instance, a major focal point to expose secularism's marginalization of faith and modesty in the construction of modern identity. In other words, Muslims who share this Islamist sensibility arrive at an understanding of their modern selves not opposed but via the same route as secular modern subjects.

The source of appeal in this carefully constructed narrative of resistance to mimicry of Western modernity lies primarily in its invitation to continue using the toolbox of modernity as an integral part of the process of reconstructing a "true" modern identity. While other forms of Islamism such as Osama bin Laden's challenge to the West from outside of its hegemonic structure by seeking to neutralize (through bombing) the nerve of its economic and material progress, the kind of culturalist Islamism presented here calls into question the normative values of Western modernity from within that hegemonic framework. The culturalist turn in Islamist politics is a response to the intellectual failure of political Islamism in its various manifestations to offer a viable alternative to Muslims and produce durable sociocultural changes in Muslim societies (Roy, 2004). This Islamist critique of modernity may also seem empowering to a generation of Muslims who seek what Göle (2011) calls an "extra" sense of modernity as "something that is added to modernity and not subtracted from it" (p. 100).

This kind of proximity to Western narratives of modernity also implies an interventionist stance in Islamic modernity on two fronts: First, a revalorization of tradition allows Muslims to reconcile tensions between religious subjectivities and modernity. This requires a reflexive articulation that might be at variance with conventional beliefs in the Islamic tradition. Muslim women who choose to veil, for instance, do so not to passively follow a religious prescription that would consign them to a private existence, but they do it as a way to challenge the way we speak of and understand individual emancipation, public space, and gender mixing in the Islamic tradition. This fragmentation of these values provides an "extra" practice and embodiment of modernity and adds more ambiguity to its meanings, which is appealing to those who insist on inhabiting modernity arguably on their own terms. Second, proximity to Western forms of modernity also engenders a reflexive re-appropriation and control not only of the language but also the sites of secular modernity. This culturalist strand of Islamism disrupts the secular harmony of public spaces by introducing religious versions of the original secular space with the intention of validating it as a field of religious action and intervention. Everything, as Göle (2008) contends, becomes a site of Muslim "modern self-presentations" (p. 131) from schools, parliaments, workplaces, beaches, concert halls, and fashion shows. I would add tourism, banking, business, television entertainment, and music.

The emergence of these new forms of modern Muslim practices, aesthetics, and tastes constitutes important sites for the interrogation of the mediation of Islam and the making of Muslim subjectivities beyond the limitations of traditional Islam

and secular modernity. My emphasis on Muslim modernities should not be read as an ideological stance Muslims simply use to vindicate their marginalization in the primordial narrative of modernity. Rather, I foreground the publicization of Islam in these discourses as a way to highlight dynamic reflective processes of identity negotiation among contemporary Muslims. The media sites I will discuss in the remainder of this chapter have become a politically significant lever to usher in the conditional entry of Muslims into modern spaces of social life. Their condition is to embrace those spaces while retaining their capacity to resist the meta-narratives of Western modernity—itself a discursive construct—and its mainstreaming of Enlightenment values such as individualism, secularism, pluralism, and equality. It is worth cautioning at this point that my discussion of these media practices should in no way be seen as a normative evaluation of what constitutes a better modernity. It is first and foremost one of the many ways in which Muslims defy the hegemony of religious tradition and defend their faith from the common assumption that it has a deficit of modernity.

Islamist Media: Global Flows of Muslim Modernity

There is no shortage today of what can be identified as Islamic media. The last decade has seen a revolution in television programming and digital media with a clear purpose of edifying Muslim piety and spreading Islam around the world. In television, for instance, there are more than thirty 24-hour Islamic channels in Arabic alone, representing a wide array of religious sensibilities from Sunni, Shia, and Salafi Islam. Similar channels exist in India, Indonesia, and Malaysia, and like their Arabic counterparts, they feature a wide variety of programming from traditional religious advice shows, Islamic drama series, Qur'anic recitation contests, religious reality shows, to fashion programs and music contests (Echchaibi, 2011). Even more significantly, the Internet has enabled a new cultural space for Muslims to create new networks of Islamic learning, praxis, and deliberation, causing an important shakeup in top-down approaches to religious authority and introducing new influential actors as the face of a public, visible, and global Islam (Bunt, 2009). Digital media are also reconfiguring the kind of public hailed by this highly performative, engaged, and confident Islam. As Eickelman and Anderson (2003) argued in the introduction of their book, *New Media in the Muslim World*, the proliferation and creative use of digital media is the engine behind a massive objectification of Islam, a process they call the "re-intellectualization" of the Islamic doctrine (p. 13). Many more believers participate in this critical process, conferring greater authority and influence on those who know how to communicate effectively in a more sophisticated, transnational mediated public sphere.

Perhaps one of the most innovative and striking features of this new media competency can be located in the work of the tele-Islamist or digi-Islamist (since their preaching bridges both media), a genre loosely based off the televangelist media and entrepreneurial figure in Evangelical Christianity. The personality of the tele-Islamist has become an influential force in contemporary mediated Islam as the facilitator of a deliberative faith focused more on social action and vehicled through market consumerism. In fact, some of them talk about morality and piety, not simply as religious virtues but also as integral prerequisites for a larger project of community building they call the "Islamic Nahda" (renaissance). Western modernity's brutal incursion in Muslim lands, these tele-Islamists argue, has caused a remarkable crisis of identity that alienated Muslims from their own heritage and turned them into superficial cultural mimics. Moez Masood, a former Egyptian advertising producer and a part-time preacher on Islamic transnational television, says traditional Islamic authority could not help Muslims deal with important issues brought about by a blind immersion in Western modernity:

> We have not woken up from Western modernity. We are processing 500 years of gradual, steady modernization in 50 years. It was given to us as a zip file and we're still dealing with it. We have indigestion. That was fast. Modernity happened and it happened too quickly. All the questions: marriage, banks, relationships, gender roles. We're teaching people how to live. This is unprecedented. We're getting there and but it will take time. We have models now like Turkey and Indonesia, and we will be crafting our own path, but it will be a long process. For example, Muslims should be choosing theo-centric leaders instead of theocracies. This is a balanced view that is neither traditional nor completely modern as we understand it in secular modernity. We need to come up with our own conceptual ways of dealing with our realities based on our own understanding. We need a radical middle way to move forward. (personal interview, 2011)

Much like other religious media personalities, Masood sees himself as providing that dialectical bridge between Islam and modernity in ways that are accessible and easy to apply. As a young tele-Islamist, Masood created a number of television shows with a specific agenda on how to address young Muslims with questions of faith and daily life. His first show *A-tareeq A-ssah* (*The Right Path*), a 20-part slick television series in which he tours the streets of London, Cairo, Jeddah, Al Madinah, and Istanbul interviewing Muslims and non-Muslims about spirituality, romance, homosexuality, drugs, and veiling, was closely watched by millions of viewers across the Arab world, and more than 1.5 million episodes were downloaded from YouTube.

Masood, an economics graduate of the American University in Cairo and currently a PhD student in religion at the University of Cambridge, believes young Muslims who grew up immersed in a media and consumer culture saturated with secular Americana prefer an Islam that is less punitive and more embracing of what the world has to offer in terms of ideas, technologies, leisure, and other opportunities. His latest television show, *Thawrah ala Nafs: Rihlatou Al-yaqin* (*Revolution on the Soul: The Journey to Certainty*), goes even further and reprimands traditional authority in Islam for stifling dissent and denouncing doubt when it comes to faith. The title of the show is quite indicative of an open relationship with doubt, which Masood says reflects the state of mind of average Muslims today as they seek real answers to questions and religious values long held as irrevocable absolutes. Muslims today, Masood says, want to know why the Qur'an talks about gender equality and pluralism while Muslim leaders, including those who came to power recently as the ultimate representatives of Islam, show no regard for these values. The show features a series of street and studio interviews with young Egyptian men and women on the place of religion in governance, social life, and the cultural orientation of Egypt as a nation. Many of the interviewees voice their concern about a governing religious class they see at odds with the values of their faith.

Masood believes certainty dwells in the texts and the prophetic tradition and the only way to get closer to it is through a healthy dose of doubt and questioning that does not alienate people from their faith but makes them disciplined students of its theology. The journey, he repeats, is an arduous but necessary one to rethink the link between religion and modern life away from blind tradition and the secular tendencies of Western modernity. Here, doubt animates a different dynamic by never questioning the sacred wisdom of scriptural authority, but by only displacing the role of interpretive religious tradition in informing the contemporary lived experience. He says the modernity deficit of Muslim societies and individuals is not in their religion but in what he calls "Attadayyun al Maghloot" (imperfect religiosity).

One way in which this kind of discursive intervention in traditional Islam becomes more apparent is in the use of cultural signs and spaces usually associated with an either-or thinking around the binary of tradition versus modernity. Masood is keen on presenting a diverse picture of the Muslim woman by interviewing both veiled and unveiled Egyptians. He said on many occasions that the veiling issue has become an unnecessary existential problem in Muslim societies and that the choice of wearing a veil or not should be exclusively left to the Muslim woman as an exercise of her autonomy and her ability to make informed decisions based on her own understanding of piety and modesty. Masood's call for a radical middle ground in dealing with religion takes on an interesting dimension on the issue of veiling. In a 2012 interview on Egyptian television, he said, "if a woman does not wear a veil on her head, but she covers modestly her body, I consider her 90% veiled

and never as traditionalists would have it, unveiled." Masood holds similar views on a number of questions regarding how Muslims as individuals should relate to faith in regimenting their behavior, which probably explains his popularity among young Muslims across the Arab world.

But one of the most symbolic messages in this careful presentation of veiling on Masood's shows lies in the re-appropriation of a forbidden cultural sign in modernity, that is, the veil and its re-inscription in public with the same values of female autonomy and freedom its elimination usually entails. The veiled women who appear on these shows are strong, articulate, and successful professionally, not so surprising in real life but quite powerful as a message on public television. Often, the women invited on these shows, and some of them have their own shows,[3] are former actors who quit lucrative acting careers in Egypt's secular film industry after they wore the veil. Some have denounced such acts as caving in to regressive religious politics, but many of these women have come back to religious television and pious film productions and continued working, branding in the process a comfortable relationship between strong faith and a public role in entertainment media. On television soaps, veiled actresses insist on keeping their veils, reject compromising scenes of kissing and embracing, and accept only socially viable scripts. As Van Nieuwkerk (2011) suggests in her work on halal soaps, "these productions are not simply pious performances, but also performing piety" (p. 187). In a powerful way, and much like earlier Egyptian Muslim women removed the veil in the 1920s to protest a patriarchal society, these women returned to the veil, a rejected symbol in modernity, to defy a patriarchal society that in the name of progress and modernity exploits the female body. The language of these women also includes rights, freedom of choice, and emancipation, generating an ambiguous discourse both within Islamic and secular circles.

No one has subverted the sites and symbols of modernity more than the original tele-Islamist, Amr Khaled, a former accountant turned television preacher. With the help of his producer, Ahmed Abu Haiba, Khaled became the architect of a new genre of programming called Islamic Entertainment Television, which included talk shows, advice programs, drama series, and reality television (Echchaibi, 2011). Khaled had indeed revolutionized a religious media market already well developed by an earlier generation of preachers through audiocassettes and VHS tapes, but his preaching style sets him apart from his earlier counterparts. His presentation on television is carefully orchestrated to mark a shift from classical traditional preaching and move into a new cultural realm where both aesthetics and content matter. Clean-shaved, elegantly dressed with Armani suits or polo shirts, and looking young (he is 45), Khaled preaches a generous Islam where Muslims are invited to enjoy life within God's laws and focus on normalizing their faith with a modern lifestyle. His highly emotive rhetorical delivery, the elaborate storytelling

he employs, the slick studio sets where he records, the complex website and social networks he runs, and the entrepreneurial personality he embodies effectively complicate the narrative of fixed tradition versus innovation and change and modern materialism versus religious asceticism.

Khaled's early television shows focused on a self-piety edification program designed to free Muslims from the shackles of blind imitation of tradition and an undisciplined mimicking of Western culture. Themes cast a wide net of interests from drug prevention to small business entrepreneurship, veiling, relationships, music, education, and banking. As part of a social program he designed for young Muslims, Khaled was able to go beyond the habitual task of learning rules and obeying religious orders. He opened up a new social imaginary where Islam was not simply talked about as the "great solution," already a motto of the Muslim Brotherhood for years, but as a blueprint for a faith-based social and cultural renaissance not divorced from modernity. His second television show, *Sunae Al Hayat* (*Lifemakers*), was an instant hit in 2005 and became known for its social contract to help the less fortunate across the Arab world.

In fact, Khaled's ascent to fame owes much to his skillful re-branding of the image and role of the Muslim preacher as an engaged public figure who can turn the abstraction of scripture into practical social action. His *Lifemakers* project has become a social movement of small-scale community organizing initiatives across the world where Muslim youth fundraise and volunteer their time and work for meaningful social change. An important feature of this kind of preaching is Khaled's ability to resuscitate the role of Islamic figures in social change, starting from the Prophet, to inspire a culturally disoriented Muslim youth, he says, stuck on narratives of progress and change that are foreign to their historical experience. In an episode on the value of music in Islam, Khaled refrained from the chorus of denunciation so common in traditional preaching circles and called on Muslims to help him edify and cleanse the Arab music industry from its secular vice of sexual decadence and objectification of Arab women's bodies. As part of his social program to move Muslim societies forward, Khaled urged his viewers and website visitors to write compelling letters to music video producers and secular music channels to protest women's exploitation and idle pursuits of materialism. Thousands of letters were sent, some even wrote new songs with "clean lyrics," and shortly after Khaled's shows and website began to feature singers and musicians who represent what he called *Al Fan Alhadef* (purposeful art), a more exalted art form with a social message. Moez Masood soon followed suit and created an "Artistic Corner" on his website.

Khaled's influence became more significant as emerging artists began new lucrative careers in purposeful art and provided another visual terrain of action where Muslims can claim a meaningful role in defining their own entertainment. This

new art genre is promoted today through recently founded record label companies such as Awakening, which defines its music records, books, and videos as "Islamic Media Redefined" and "faith-based" and "value driven" media productions. Khaled's long-time producer, Ahmed Abu Haiba, recently launched *4Shbab*, a 24-hour Islamic music video channel quickly dubbed the "Islamic MTV." Funded by Saudi investors, 4Shbab features various Muslim artists and bands (only men) from Muslim countries, Western Europe, and the United States who sing in Arabic and English about their love for the prophet, the importance of religious piety, and the value of charity and filial obedience. A promotional video used at the time of the inauguration of the channel in 2009 invites young Muslims through a strong and confident voiceover to create "a new vision for art, for beauty, and for the human," while a silhouette of a muscular young man walks determinedly toward the camera, suggesting the beginning of a new era where Muslim youth are supposedly in control of their own cultural production. More recently, Khaled has adapted prominent reality television series such as Donald Trump's *The Apprentice*, which in Arabic he titled *Mujaddidun* (*The Reformers*). But instead of the pugnacious demeanor of the highly competitive contestants in the American version, *Mujaddidun*'s contestants help each other to success and work more as a team rather than as combative individuals overzealous in their Machiavellian quest to wipe out their competitors. Khaled's contestants, both men and women from nine Muslim countries, work only on charitable projects with meager budgets and the winner of the show is not rewarded with a high-paying managerial job at a successful firm, but a prize of $140,000 to lead a socially conscious development project in his or her home country.

The concept is also used today to refer to a blooming industry of "clean cinema," which has become an ethical cultural project to restore a sanitized link between art, social action, and faith. One enduring message in this re-inscription of religion in modern, contemporary art is to provide Muslims with an alternative mode of embodiment and self-presentation that had never been spelled out so clearly. The fact also that "clean films" are starring a familiar generation of "repentant actors" who stopped acting after a newfound religiosity gives this art form a particularly salient dimension of individual agency and reflexivity. As Karim Tartoussieh (2007) argues:

> It [clean cinema] immediately conjures up its opposite: dirty cinema. If the label clean describes the new mode of cinematic production/consumption are to be described as dirty, an epithet that the film critics themselves would reject.... Certainly, there is a new regime of cleansing films of overt sexuality and that regime can expose a great deal about new modes of cinematic production. (p. 20)

It is precisely this ability to act on something so intrinsic and desirable in daily life as art that makes this reflexive exercise appealing and legitimating for those who participate in its reform. Islamic revivalism here is defined as a social and cultural project that summons all Muslims to regain control of the terms of their engagement with modernity, thereby creating a resistive discourse that defies both the subjugation of tradition and the exclusionary logic of secular modernity.

Conclusion

I have tried to show how Islam's contemporary visibility is inscribed in a dialectical relationship with modernity that seeks to invert the latter's most recognizable symbols and sites. A reconfigured Islamic media have become a critical sociocultural practice for this reflexive performance by engaged Muslim actors. This new subjectivity, I argue, draws its strength and legitimacy from a culturally specific critique and reevaluation of modernity, its secular logic, and its discursive biases against a dormant Islamic tradition. These new material forms of embodying piety in Islamic media through body politics and social action are, as Nilüfer Göle (2008) says, public performances that are "not alien to Muslim memory and culture.... But they are not simple conventions that have always been there and that are unconsciously handed down from generation to generation" (p. 133). Much of the global debate on Islam has focused on issues of security and confrontations with the West, but what requires our most immediate attention are the complex and modern ways in which Muslims dynamically engage modernity as a frame of both reference and contention.

Notes

1. News reports confirmed that small minorities of Muslims protested the film in comparison with the much bigger crowds that came out in support of political reform and human rights during the events of the Arab Spring. For more on this, see Meagan Reif's (2012) comparative chart, which shows that a mere .01% of Muslims protested the YouTube video: http://twicsy.com/i/Arseqc

2. Eisenstadt (2000) argues that Western modernity as a project was never a uniform concept. Even within the classical Weberian conceptualization of modernity, there was always contestation and tension about what modernity really meant.

3. Dr. Suad Saleh, a professor of Islamic jurisprudence at al-Azhar University, was one of the first veiled women in Egypt to have her own religious advice show. *Women's Fatwa* aired on a government-owned satellite TV channel.

References

Abou El Fadl, K. (2001). Islam and the theology of power. *Middle East Report, 221*, 28–33.

Arkoun, M., & Institute of Ismaili Studies. (2002). *The unthought in contemporary Islamic thought.* London: Saqi.

Bunt, G. (2009). *iMuslims: Rewiring the House of Islam.* Chapel Hill, NC: University of Carolina Press.

Chakrabarty, D. (2007). *Provincializing Europe: Postcolonial thought and historical difference.* Princeton, NJ: Princeton University Press.

Chaudhuri, C. (2004). In the waiting-room of history. *London Review of Books, 26*(12), 3–8.

Echchaibi, N. (2011). From audio tapes to video blogs: The delocalisation of authority in Islam. *Nations & Nationalism, 17*(1), 25–44.

Eickelman, D. F., & Anderson, J. W. (2003). *New media in the Muslim world: The emerging public sphere* (2nd ed.). Bloomington, IN: Indiana University Press.

Eisenstadt, S. N. (2000). Multiple modernities. *Daedalus, 129*, 1–29.

Esposito, J. L. (2011). *Islam: The straight path* (4th ed.). New York: Oxford University Press.

Gaonkar, D. P. (2001). *Alternative modernities.* Durham, NC: Duke University Press.

Göle, N. (2008). Forbidden modernities: Islam in public. In A. Sajoo (Ed.), *Muslim modernities: expressions of the civil imagination* (pp. 119–136). London: I.B. Tauris.

Göle, N. (2011). *Islam in Europe: The lure of fundamentalism and the allure of cosmopolitanism.* Princeton, NJ: Markus Wiener.

Hirschkind, C. (2008). Religious difference and democratic pluralism: Some recent debates and frameworks. *The Finnish Society for the Study of Religion, 44*(1), 67–82.

Kahn, J. S. (2003). Islam, modernity, and the popular in Malaysia. In V. Hooker & N. Othman (Eds.), *Malaysia: Islam, society and politics* (pp. 149–166). Singapore: Institute of Southeast Asian Studies.

Laroui, A. (1976). *The crisis of the Arab intellectual: Traditionalism or historicism?* Berkeley, CA: University of California Press.

Majid, A. (2012, September 20). Fury unbound: The Muslim dilemma [Blog post]. Retrieved from http://www.juancole.com/2012/09/fury-unbound-the-muslim-dilemma-majid.html

Reif, M. (2012, September 16). Comparison of crowd size estimates for Arab uprisings and anti-film protests [Blog post]. Retrieved from http://sitemaker.umich.edu/megan.reif/files/reif_arabspring_film_crowd_comparison_16sep2012.jpg

Roy, O. (2004). *Globalized Islam: The search for a new ummah.* New York: Columbia University Press.

Tartoussieh, K. M. (2007). Pious stardom: Cinema and the Islamic revival in Egypt. *The Arab Studies Journal, 15*(1), 30–43.

Taylor, C. (2000). Two theories of modernity. *Public Culture, 11*(1), 153–174.

Van Nieuwkerk, K. (2011). *Muslim rap, halal soaps, and revolutionary theater: Artistic developments in the Muslim world.* Austin, TX: University of Texas Press.

Wittrock, B. (2000). Modernity: One, none, or many? European origins and modernity as a global condition. *Daedalus, 129*, 31–60.

New Media, Religion, and Gender

Young Swedish Female Bloggers

MIA LÖVHEIM

In August 2012, while writing this chapter, the trial of the Russian feminist punk band Pussy Riot was a salient topic in the regular news flow as well as in postings on Facebook and blogs. The story begins February 21, 2012, when three young female band members without permission performed a song and a prayer asking Mother Mary to free them from the rule of the sitting president Vladimir Putin in the Cathedral of Christ the Savior in Moscow. Church officials interfered to stop their action but the performance was filmed, uploaded on YouTube, and accessed by more than 2 million people (Панк-молебен "Богородица, Путина прогони" Pussy Riot в Храме). The three women became accused and eventually sentenced to prison August 17, not for political riot but for libel against religious groups, primarily the Russian Orthodox Church. In comments posted on the support webpage Free Pussy Riot! people argued against the sentence and the Church, enhancing the values of freedom of speech, women's rights, and gender equality.

The performance by and trial against Pussy Riot might be exceptional in the degree of media coverage it received, but it illustrates in several ways how new, digital media set the scene for the public visibility of religion in contemporary society. As this chapter will argue, this process challenges previous conceptions of the actors, arenas, and issues through which religion is transforming in contemporary society. These challenges actualize questions about distinctions between official and non-official expressions of religion, and between public and private spheres and issues. Furthermore, events such as the Pussy Riot case bring out how gender is a

core aspect of these distinctions, as a source for structuring identities and values within religious traditions and social hierarchies but also as a source for questioning these distinctions (Klassen, 2009).

This chapter focuses on how questions concerning distinctions between various expressions of religion and of public and private arenas and issues become actualized in women's use of new digital media to communicate religious and existential issues. Through the examples of two contemporary young Swedish female bloggers, the chapter discusses how digital media might enable new media actors to express their personal stories of religion in a mediated public sphere.

One of the insights that is emerging from almost two decades of research on digital mediations of religion is that continuity rather than radical transformations characterizes the relation between online and offline expressions of religion (H. Campbell & Lövheim, 2011). Thus, when discussing the meaning of new, digital forms of communicating religion, it is important to look back to earlier forms of women's mediated testimonies. Relating patterns in mediated religion across "older" and "new" media forms is not least important to understand how new arenas are structured by social, cultural, and religious gender conventions and norms in the wider context where they are situated. By placing the case of young Swedish female bloggers in this context, this chapter shows how new forms of mediated self-expressions can contribute to ongoing discussions about changes in the public role of religion in contemporary society.

Approaching New Media and Religion

My understanding of the concept "new media" is drawn from Leah A. Lievrouw and Sonia Livingstone's (2006) approach to the relation between media technology, social practice, and cultural meaning as "social shaping of technology." They argue that new media cannot simply be identified with particular content or particular devices such as the Internet or the iPhone but consist of an infrastructure of technological artifacts, the practices in which these are used, and the social arrangements and organizational forms that develop around them. Thus, technologies are constitutive of society and culture, but the way they shape these can never be understood outside of the practices, social relations, and contexts in which they are used.

Lievrouw and Livingstone (2006) describe two modes of social shaping that distinguish new media from older forms of media (pp. 4–7). The first is "recombination," meaning that new media incorporate and appropriate older media forms, but also constantly develop, elaborate, and extend their functions—often as a result of practices of usage and the social and cultural arrangements that develop around these. The second concerns the infrastructure of new media as enabled by "inter-

connected technical and institutional networks." Finally, they point to how three key characteristics of new media technology and its uses—ubiquity, mobility, and interactivity—make social interaction through new media more immediate, interconnected, and responsive than earlier media forms.

Heidi Campbell (2010) has applied this approach in developing a theory of "the religious social shaping of technology." She argues that religious individuals in their use of digital media not simply change their practices according to affordances given by the medium, but also reshape technology through uses and social arrangements that adjust technology to fit with their values and lifestyle. The social shaping technology approach also informs Lynn Schofield Clark's (2011a) definition of mediatization as

> the process by which collective uses of communication media extend the development of independent media industries and their circulation of narratives, contribute to new forms of interaction and action in the social world, and shape how we think about humanity and our place in the world. (p. 170)

These perspectives on the relation among digital media, social interaction, and religion combine a focus on agency with a concern for constraints brought by new technology. Furthermore, they emphasize the interplay between the characteristics of particular forms of new, digital media and existing communication patterns within the religious contexts in which new media are used (see Lövheim, 2011a).

New Arenas for Religion

Heidi Campbell (2012) has argued that several key traits of how religion is expressed online exemplify social and cultural changes at work in religion more generally. Current research in primarily European sociology of religion following the critique of secularization theory as a general paradigm for understanding religious change has increasingly come to focus on a possible "resurgence" of religion in the public sphere (Habermas, 2006) or, rather, the emergence of new forms of public religion (Woodhead & Cato, 2012). This research focuses on expressions of religion outside of religious institutions, where one of the most important arenas is mass media. While scholars researching this situation largely agree that this means a "mediatization of religion" in the sense that mass media become the prime arena for the public presence of religion, arguments about the implications for the public significance of religion differ. Will the logic of various media increasingly mold religion into more banal and subjective forms (Hjarvard, 2008), or might a "re-pub-

licization" of religion enhance the public presence and significance of religious symbols and discourses (Herbert, 2011)?

The discussion of the increased mediation of religion in contemporary society underlines the value of approaching religion as "practices of mediation," claiming to "mediate the transcendent, spiritual, or supernatural and make these accessible for believers" (Meyer & Moors, 2006, p. 7). Following these understandings, the challenge for studying the interplay between religion and new, digital media becomes "to explore how the transition from one mode of mediation to another, adopting new media technologies, reconfigures a particular practice of religious mediation" (ibid.).

Gender a Core Aspect of Contemporary Religious Change

An emerging theme in research on new forms of public religion is the significance of gender. I approach gender here as "a constitutive element of social relationships based on perceived differences between the sexes" that includes "signifying relationships of power" (Scott, 1986, pp. 1067–1068). Gender is expressed and enacted in religious symbols, in norms and discourses structuring the interpretation of these symbols, and in practices and social institutions formed around these interpretations.

Several theories of secularization have been based on an understanding of modernization where institutional differentiation of functions and spheres in society played a key role (Casanova, 1994). The division of a public and a private sphere, where the former encompassed wage labor, politics, economics, and law and the latter the home and personal life, also included a gendered division. The public was constituted as male and the private as female sphere (Woodhead, 2005). With the Enlightenment critique of religion and increasing rationalization and industrialization of society, religion lost much of its social and cultural influence in the public sphere. The intersection of the "privatization" of religion and the constitution of the private sphere as female came to mean that religion became connected with feminine activities and characteristics (Brown, 2001). Within religious institutions, women's religious expressions have gone through a similar marginalization. Even though women's religious involvement exceeds men in most national contexts (Inglehart & Norris, 2003), women's religious experiences have often been deemed unofficial and trivial in contrast to the official religion expressed and guarded by a male elite (McGuire, 1981).

Contemporary articulations of religion within politics and media call for a rethinking of these divisions between religion, the public, and the private sphere. As argued by Vincett, Sharma, and Aune in *Women and Religion in the West: Challeng-*

ing Secularization (2008), women's religious experiences in late modernity challenges the dualistic split between public and private spheres in several ways. First, in women's daily life experiences with religion various forms of "thirdspaces" are particularly prevalent. These are physical, mental, and social spaces that blur the dichotomy of public and private and thus can be described as "both/neither spaces" (p. 9). A second aspect of how women's engagement with religion blurs distinctions between religion, public, and private is the centrality of gender issues in discussions regarding the interrelation of religion, culture, and the state in politics and media (Reilly, 2011, p. 24). These debates often center on women's appearance, such as the presence of veiled Muslim young women in public spaces (Göle, 2006; Duits & van Zoonen, 2006), or the juxtaposition of women's, gays', and lesbians' sexual freedom and the rights and duties of religious minorities (Butler, 2008). Both of these examples bring out the tendency to approach the place of religion in the public sphere through topics that have previously been associated with gender and the private sphere.

Women's Mediations of Religion Across Time

The topic of gender has so far been a marginal area in studies of media and religion (Lövheim, in press). Nevertheless, several studies of women's mediated religious experiences in history as well as present times have been published. Pamela Klassen and Kathryn Lofton argue (in press) that there are certain similarities in how Christian women across time and medium have used new media formats, from the printing press to blogs, to articulate their testimonies. One of the most salient is how women's bodies have played a key role in this mediation, at once a source for their authority *and* their exclusion as legitimate witnesses of faith. Another recurrent theme is the interaction between experiences and insights originating from women's personal, everyday life, the social relations they are involved in, and the wider religion and social context in which they participate. As pointed out by Kristy Maddux (2010, p. 14; see also K. Campbell, 1989), this mode of discourse has been one significant strategy for women to carve out an alternative method of participation in a male-dominated mediated public sphere since the early nineteenth century. Klassen and Lofton (in press) further argue that there seems to have been an especially "unbound" relationship between women's mediation of their religious self and commercial aspects of mediation (see also Lofton, 2008). This can be seen as related to women's exclusion from the traditional positions of authority within religious communities, and thus as having a creative and emancipating potential. However, as they point out, the commercial side of this religious mediation also brings in a tension between the testimony as a story about the saving power of

God, and the danger of sliding into self-promotion. In her analysis of the development of the Salvation Army from a marginal evangelical mission into a successful charitable organization in the early twentieth century, Diane Winston (2011) shows how this dynamic among the media's commercial logic, gender, and religion contributes to a commodification of the female, religious subject and a transformation of the identity and practices of a religious movement.

Blogs and Gender

New, digital media incorporate older media forms but also develop and extend their functions, often as a result of practices of usage and the social and cultural arrangements that develop around them. In comparison to the production of print media or films in the early twentieth century, contemporary digital media bring new possibilities for self-representation expressed, for example, in personal webpages and more recently in personal blogs. Toril Mortensen and Jill Walker (2002) argue that blogs construct a space for communication between private and public spheres: "With the weblog the public is invited into the privacy of the diary of an individual," but the blog as a part of interconnected new media networks also "connects the public arena with that of individuals" (p. 258).

The growth in use of the Internet and computers following technological developments in the early twenty-first century meant an increased presence of women of different ages and social background. As pointed out by Consalvo and Paasonen (2002), the popularization of new media forms often gives rise to debates about a trivialization and commercialization of the content and cultures of the medium. The discourse on blogs has been closely bound up with conceptions of domestic and personal issues, the traditional domain of women, as less valuable than political issues, traditionally the domain of men (Gregg, 2006). Herring, Kouper, Scheidt, and Wright (2004) concluded in a survey of blogs that the largest category was not the political or topic oriented "filter blog," but the "personal blogs" primarily authored by women and youth. Thus they argued that "women and young people are key actors in the history and present use of weblogs, yet the reality is masked by public discourses about blogging that privilege the activities of a subset of adult male bloggers" (p. 8). However, through mixing forms of communication conventionally associated with male and female writing, blogs can also become spaces for the performance of gender identities that blur traditional binaries (van Doorn, van Zoonen, & Wyatt, 2007, pp. 155–156).

Several studies have shown that young women find blogs a useful space for personal writing about daily life experiences and reflections. As paper diaries, a form for mediated self-representation often used by young women, blogs can provide a

safe space for self-expression (Stern, 1999) as well as a possibility to keep a record of the process of forming an identity (Bortree, 2005, p. 37; see also Serfaty, 2004). In contrast to the paper diary, blogs are attractive to girls because they can be used to communicate with their friends, manage friendships, and build communities (Bell, 2007, p. 103). This public nature of blogs presents an opportunity as well as a challenge that calls for developing skills to represent oneself in a way that builds intimacy with friends and the same time ensures social acceptance in a larger group of readers (Bortree, 2005, p. 25).

Religion and Gender in the Blogs of Young Swedish Women

Insights from previous research shows that the mediation of women's experiences through various media forms highlights the dynamic between personal experiences and the values and conditions for communication that shape the larger, mediated public sphere. Bringing religion into the picture further underscores how these conventions and norms are gendered, and also informed by ideas about the nature of religion and how it can be mediated in late modern, highly mediatized, and commercialized cultures. The themes of agency, authority, and authenticity stand out as central to this discussion: agency in the meaning of opportunities for women to participate in the circulation of religious experiences in the public sphere, authority in the meaning of debates over legitimate representations of religion, and authenticity in the meaning of the tension between the truthfulness of the personal testimony and the popularization and commercialization of particular media forms.

The coming analysis of young women's mediation of religion through blogs will focus on how these themes become actualized in the blogs of two young Swedish women.

The two bloggers used as examples were part of my study of female "top-bloggers" age 16–24 in Sweden conducted in 2009 and 2010 (see Lövheim, 2011b). As "top-bloggers" they were during the time of the study ranked among the most visited blogs on the largest Swedish blog portal Bloggportalen.se. The number of visitors to the blog means that the experiences of these bloggers differ from the regular personal blog. One aspect of this experience is the large number of comments they receive, which means that managing their relationship to readers is a core part of their blogging (Lövheim, 2012b). Finally, they also distinguish themselves from other personal bloggers through the aspects of professionalization and commercialization that they develop, as many of them over time came to more or less make a living out of their blogging.

Stina: Welcome to the Confession

Stina is a woman in her early 20s blogging about her everyday life since 2006. In her blog she has created a category of postings where she shares her own experiences and opinions on issues such as beauty and gender ideals, sexuality, blogging, alcohol, friendship, and self-confidence. A regular element of this category is "the confession": an invitation to readers to send in postings about their concerns and problems.[1] The confession is open for a particular slot of time, usually in the evening, and is repeated about once a month. The quote below is taken from Stina's invitation to confession on December 6, 2011:

> The confession has become popular here in the blog which of course delights me when I know how incredibly nice and important it can be to sometimes get the chance to actually open up and let everything out that so easily gets piled up in there—difficult thoughts, things that embarrass you, feelings, memories, experiences yes anything really. Come on, make a real soul cleaning now and leave room for new and fresh things! Hugs to you all, you are the best and welcome in here. And remember, we are never alone and this confession is a real evidence of that, isn't it?[2]

As this invitation shows the confession is presented in a warm and informal language. Drawing on the image of a "cleaning" of the soul, Stina encourages the reader to "let everything out" and leave room for a fresh start. The character of the interaction between Stina and the readers is presented as friendly, supportive, and generous. There is no clear marking of Stina as an authoritative figure, a leader, or a counselor. Rather, she seems to be acting in the role of a friend or a moderator in a discussion. No explanation is given in the blog as to why Stina chose to name these events "confession." There are no references to religiously charged terms such as sin, commandments, or redemption in her invitation. The only explicit reference to religion is a cartoon depicting a scene where an older, male, smirking priest receives a confession from a troubled man seated in what seems to be a traditional Catholic Church setting.

The invitations to confession in Stina's blog generate between 300 and 500 answers, almost exclusively from other young women. After the confession time is passed Stina writes a posting commenting on the number of responses, the themes raised in general, and picks up one or two of them that she responds to with advice and reflections.

Going back to the themes of agency, authority, and authenticity, the confession can be seen as an example of a practice where new digital media potentially enhance the agency of young women. A religious communicative practice like the

confession, which in its original setting is performed by a formal, often male religious authority, is here picked up and used as a form for another communicative practice by someone representing a new form of media authority, a blogger gaining her position through writing in an engaging manner about her personal experiences and everyday life. The ritualized character of the confession, as an event set apart by happening in a particular time frame and in form through postings sent to the blogger, has parallels to other forms of communication practices developed by and circulated by young female top-bloggers, for example, "question times" and the posting of comments to readers comments in the blog to raise a particular issue. These practices are developed to balance between guarding the blogger's privacy and managing a relationship to readers who expect high levels of access and insights into the blogger's private life (Lövheim, 2011c; Sørensen, 2009). As described in previous research, these practices, developed over time in interaction with readers, make the topics and discussions—although personal in content—into public and collective events.

These aspects of the communicative practices developed by young female top-bloggers such as Stina become salient in the comments and the discussions concerning the position of the blogger that followed one of the confession events. This discussion clearly illustrates how the agency and authority Stina might gain through her blogging is connected to authenticity—and how this connection is shaped by gender norms and expectations. Two days after the invitation to the confession quoted above, Stina posts a comment expressing her concern about the responsibility she takes on by this initiative, and she asks her readers to share their thoughts about it. Most of the comments to the posting were positive and affirmed her position as an authority and a role model, not least with reference to how she, as one reader expressed it, takes so much interest in her readers' lives and concerns even though she is such a successful blogger. However, there were also some negative comments that show the tension between the blogger as a friend identifying with her readers and her position as a professional seeking to find ways to maximize the number of visits to her blog and thereby her income and position. Thus, the positive response is very much shaped by how the blogger negotiates these two aspects of her position with her readers.

Ana-Gina: Am I a Fake Muslim?

My second example in this chapter is the blog of Ana-Gina. She is a woman in her early 20s with a Palestinian origin, who started her blog in 2009 and has since become one of the most famous bloggers in Sweden as well as a popular hostess of entertainment programs in Swedish public television (SVT). Ana-Gina's blogs be-

came know for her humoristic, provoking videos on prejudices and stereotypes of Muslims and immigrants. The posting presented below is from August 22, 2010, and is titled "Am I a fake-muslim?"[3]

This posting is written in response to comments generated from an image of Ana-Gina wearing a short dress at a blogging award dinner party. The photo was published by another blogger after the event. The posting starts:

> A problem in society today is that many people believe that you as a Muslim must be VERY STRICT, or VERY PROMISCUOUS....Apparently I am now a promiscuous, alcohol drinking girl who sleeps around because I went to this blog dinner and happened to be in a photo where my dress looked very short?

The posting generated 101 comments. One salient theme in the comments concerns whether Ana-Gina has transgressed norms governing the proper behavior of Muslim women by being in a place involving alcohol and other "misleading activities." Part of the postings are critical to her behavior, but a majority of the readers are supportive of Ana-Gina's response to this event and engage in the theme of the problems surrounding the dichotomous view of Muslims that she expresses in her posting. These readers see her as a role model for young Muslim women in her efforts to argue for a position between these stereotypes. This discussion is of particular interest for the questions raised in this article; it illustrates the connection between agency, authority, and authenticity described in the previous example. In defense to comments questioning her faith Ana-Gina, on the one hand, refers to the recommended practices of pious Muslims. She writes: "I pray now and then, I donate money every month to the poor and needy and I fast when I am well, just as the Quran says!" On the other hand, she also states that she is not "VERY strict." Further on in her posting she argues against her positioning as a "promiscuous alcohol drinking girl" and argues for her right to be independent from certain religious ideals and live her life according to her own choices, as when she writes: "I have NEVER said that I am a perfect Muslim, I have never said that I am in a certain way" and further "I am no representative for Muslims, I am just an ordinary girl who happens to be Muslim."

This ambiguity between referring to ideals and norms of a pious Muslim girl and the asserting of her independence to choose her own lifestyle is taken up in the responses to the posting. Those that are supportive encourage Ana-Gina's struggle to combine ideals and norms from the different contexts in which she participates, as a sincerely believing Muslim girl and as a famous blogger taking part in a public discussion. Commenters who are more critical pick up on what they see as a discrepancy in her argument, as well as between previous postings in the blog where

she presents herself as very religious and respectable and this re-circulated photo. This tension, and the way it stains her authority as a role model as well as the authenticity of her message, is expressed in a comment from one of the readers: "the whole thing is that it clashes with what you write/say in your blog. That is called double standards."

In this example we see more clearly how the potential of enhancing young women's agency and authority that new media technology can imply is structured by religious norms and ideals. In Ana-Gina's case the authority she has established by her skills as a professional and famous blogger is, in another way than Stina, weighted against in what way she also fulfills religiously coded conventions of female modesty in dress and behavior. However, the discussion on double standards shows how she too has to negotiate and "pass" within certain norms and ideals for the personal and female blogger vis-à-vis her readers. As the analysis of Stina's discussion with her readers brings out, a key value in this relationship is authenticity. This quality is performed by being truthful, by being consistent across postings and contexts, but also by caring for and expressing identification with readers in their life and dilemmas. The significance of this last point comes across strongly in Ana-Gina's exclamation that she does not aspire to be a "perfect Muslim" but just an "ordinary girl."

Mediation and Reconfiguration

These examples illustrate two ways in which young women refer to and negotiate religious symbols and practices in their blogging and how they contribute to a process of reconfiguration of religious mediation. Stina's confession can be seen as an example of the circulation of religious symbols outside of the control of religious institutions, and of how they become used by new actors for various purposes. The case of Ana-Gina is an example of how discussions on how to live as a pious Muslim in Western society today take place in arenas outside of religious and mass media institutions. Online spaces such as blogs, social network sites, and video sharing sites can thus become spaces for alternative articulations of religious subjectivities that challenge religious conventions and mainstream media representations of Muslim women (see Vis, van Zoonen, & Mihelj, 2011).

Both cases involve reconfigurations of religious practices where a young woman acts in a role previously occupied by formally trained and appointed male authorities—the priest and the imam. In this they represent examples of how new digital media such as blogs contribute to a process of reconfiguring religious authority. An interesting aspect of this process is how the blogger's position as an authority is established in the interaction with her readers, and how ideals and norms for a legitimate performance is negotiated with and between various opinions in the audience.

This construction of authority relates clearly to Lynn Schofield Clark's (2011b) discussion of how new media play into a process of "managing and producing consensus that, in turn, provides legitimacy to authority" (p. 113). In her article she analyzes the "consensus based interpretive authority" of the American television comedian Stephen Colbert. Colbert's authority, she argues, is not primarily a matter of replacing traditional religious authorities but rather established through his ability to interpret religion's role in contemporary American culture in line with views that are consensually accepted by his audience. This is not least important in a situation where people have to negotiate their religious faith in relation to various and perhaps conflicting norms and values in an increasingly culturally plural context.

How gendered values and norms shape this process is not part of Clark's (2011b) analysis. As we have seen, earlier studies of responses to women's mediated expressions of religion show that gendered norms and values structure the acceptance of their position as authorities. In both of the above examples, arguments about the blogger's authority as compromised by her bodily appearance or by commercialization become salient. In Stina's case the focus is primarily on the suspicion of commercial interests behind her empathy for her readers. In the case of Ana-Gina it is her clothing and behavior that become associated with promiscuity. These ideals and norms can be traced to strong conventions of femininity as characterized by modesty and care for others. To maintain their position as authorities the bloggers have to align with these conventions while they perform a new role as professional, successful bloggers.

This shows that, on the one hand, blogs can be considered examples of how new digital media can open up arenas where new forms of authority draw on interpretation, mediating, and consensus rather than formal training and a position sanctioned by a religious institution. It also seems as if many of the things that in the past have stained women's authority—the connections between the personal experiences and the public discourse on religion, building authenticity through relating to others, making use of commercial potentials in new media to build a position outside of established institutions—can become an asset in this process. However, the examples of how young women become involved in a constant negotiation of suspicion and critical remarks when they transgress traditional female values and roles call into question if blogs may be an arena to negotiate stereotypes and conventions of normative femininity within religious communities and mainstream media.

Concluding Discussion

In the introduction I stated that events such as the performance and trial against the Russian punk band Pussy Riots show how expressions of religion through digital media challenges conceptions of the actors, arenas, and issues driving religious change.

As the previoius discussion shows, the ways in which bloggers such as Stina and Ana-Gina relate to religion in their interaction of readers actualizes these challenges.

As for arenas, blogs as well as other forms of new digital media construct what I have elsewhere referred to as "ethical spaces" (Lövheim, 2011c; Christensen & Jerslev, 2009, pp. 21–23, 27). In a similar way as the "thirdspaces" described by Vincett, Sharma, and Aune (2008, p. 9) these spaces blur the dualistic split between public and private spheres. The blogs used as examples in this chapter become such spaces in that they, as we have seen, starting from expressions of existential issues and dilemmas in young women's lives, initiate collective discussions that involve negotiations of religious and cultural norms and ideals. In this they cross boundaries of the private domain of girls' everyday life and the larger public contexts they share with others. The emphasis on consistency across contexts, in particular the tension between being a famous blogger and being an ordinary girl, shows how young women struggle with conflicting gender ideals. In this, the personal experiences shared by the blogger invoke a discussion about gender conventions and norms in general, as well as on broader social relations and commercial interests structuring young women's lives.

As for actors the bloggers presented here represent examples of how young women can use new media to perform new forms of authority, such as the role of counselor and role model, based on skills of interpreting and mediating between the various contexts in which young women live and encounter religion in contemporary society. The ability to interpret and mediate values and identities across various contexts is crucial to build authenticity and legitimacy for these new forms of authority. The experiences of famous bloggers such as Stina and Ana-Gina also tell something about the ambiguities of the "networked" character of new digital media and their social consequences. The ubiquity and interactivity of blogs that make social interaction more immediate, interconnected, and responsive than previous media forms is a mixed blessing, at once creating new opportunities for agency and authority and challenging this position through demanding constant work to pass within and/or negotiate ideals and norms among various groups of readers. Furthermore, these bloggers also bring out how authorities emerging through new media might circumscribe traditional hierarchies, but become structured by new actors of powers: Why and with what consequences do certain young women with religious "markers" become popular and famous? Clearly, this is not just an individual but collective process with social and political connotations.

The discussion in this chapter has aimed to show that to further understand how new media technology can elaborate, extend, and appropriate but also refashion the functions of previous forms of religious communication gender is crucial. By connecting to themes highlighted in earlier research on women's mediation of religion these changes and continuities can become clearer. The possibilities of new actors using these potentials to be recognized as authorities in a wider public dis-

cussion on religion, ethical, and existential issues is structured by deeply gendered conventions about what is private and public, popular and political in a mediated public sphere. The lens of gender brings out the uneven and ambiguous character of the reconfigurations that happen in these spaces.

The characteristics of new actors and arenas for the mediation of religion emerging through new, digital media also pose questions about the transformation of religion in modern society. Signs of religion becoming more "personalized" and less confined to traditional institutional spaces do not necessarily mean that religion loses its public and political significance. The interactions taking place in these spaces represent signs of how religion is becoming publicly visible in modern society to a large extent through what was previously considered "private" issues: as a locus for questions of values, moral, ethics, and existential issues. This chapter illustrates how a dynamic between media and women's religious lives and positions is at the heart of this development. On the one hand, media bring the public space into the private space and thus widen the space of the traditionally homebound female audience. On the other hand, new digital media can make the private sphere into a public sphere. Thus, women's traditional competences in handling relations and values across these spaces are a crucial part of the shaping of modern religious identities.

Notes

1. This example is also discussed as part of the analysis in Lövheim, 2011c.
2. Translations from Swedish to English have been made by the author.
3. This blog has also been part of the analysis in Lövheim, 2012a.

References

Bell, B. (2007). Private writing in public spaces: Girls' blogs and shifting boundaries. In S. Weber & S. Dixon (Eds.), *Growing up online* (pp. 95–111). New York: Palgrave.

Bortree, D. S. (2005). Presentation of self on the web. An ethnographic study of teenage girls' weblogs. *Education, Communication & Information, 5*(1), 25–39.

Brown, C. (2001). *The death of Christian Britain*. London: Routledge.

Butler, J. (2008). Sexual politics, torture, and secular time. *The British Journal of Sociology, 59*(1), 1–23.

Campbell, H. (2010). *When religion meets new media*. London: Routledge.

Campbell, H. (2012). Understanding the relationship between religion online and offline in a networked society. *Journal of the American Academy of Religion, 80*(1), 64–93.

Campbell, H., & Lövheim, M. (2011). Introduction. Rethinking the online–offline connection in the study of religion online. *Information, Communication & Society, 14*(8), 1083–1096.

Campbell, K. K. (1989). Introduction. In K. K. Campbell (Ed.), *Man cannot speak for her. Volume I; A critical study of early feminist rhetoric* (Contributions in Women's Studies). New York: Praeger.

Casanova, J. (1994). *Public religions in the modern world.* Chicago: University of Chicago Press.

Christensen, C. L., & Jerslev, A. (2009). Introduktion. Nye grænser, nye medieformer og nye publikummer. In C. L. Christensen & A. Jerslev (Eds.), *Hvor går grænsen? Brudflader i den moderne mediekultur* (pp. 9–35). Copenhagen: Tiderne skifter.

Clark, L. S. (2011a). Considering religion and mediatisation through a case study of J+K's big day (The J K wedding entrance dance): A response to Stig Hjarvard. *Culture and Religion, 12*(2), 167–184.

Clark, L. S. (2011b). Religion and authority in a remix culture: How a late night TV host became an authority on religion. In G. Lynch, J. Mitchell, & A. Strahn (Eds.), *Religion, media and culture: A reader* (pp. 111–119). London: Routledge.

Consalvo, M., & Paasonen, S. (2002). Introduction: On the Internet, women matter. In M. Consalvo & S. Paasonen (Eds.), *Women & everyday uses of the Internet. Agency & identity* (pp. 1–18). New York: Peter Lang.

Duits, L., & van Zoonen, L. (2006). Headscarves and porno-chic: Disciplining girl's bodies in the European multicultural society. *European Journal of Women's Studies, 13*(2), 103–117.

Free Pussy Riot! Official website. Retrieved from http://freepussyriot.org/

Göle, N. (2006). Islam in European publics: Secularism and religious difference. *The Hedgehog Review, 8*(1–2), 140–145.

Gregg, M. (2006). Posting with passion. Blogs and the politics of gender. In A. Bruns & J. Jacobs (Eds.), *Uses of blogs* (pp. 151–160). New York: Peter Lang.

Habermas, J. (2006). Religion in the public sphere. *European Journal of Philosophy, 14*(1), 1–25.

Herbert, D. E. J. (2011). Theorizing religion and media in contemporary societies: An account of religious "publicization." *European Journal of Cultural Studies, 14,* 626–648.

Herring, S., Kouper, I., Scheidt, L. A., & Wright, E. L. (2004). Women and children last: The discursive construction of weblogs. *Into the blogosphere: Rhetoric, community, and culture of weblogs.* Retrieved from http://blog.lib.umn.edu/blogosphere/introduction.html

Hjarvard, S. (2008). The mediatization of religion. A theory of the media as agents of religious change. *Northern Lights, 6,* 9–26.

Inglehart, R., & Norris, P. (2003). *Rising tide: Gender equality and cultural change.* Cambridge: Cambridge University Press.

Klassen, P. (2009). Introduction. In P. Klassen, S. Goldberg, & D. Lefebre (Eds.), *Women and religion. Critical concepts in religious studies, Volume I* (pp. 1–8). Abingdon: Routledge.

Klassen, P., & Lofton, K. (in press). Material witnesses: Women and the mediation of Christianity. In M. Lövheim (Ed.), *Media, religion and gender: Key issues and new challenges.* London: Routledge.

Lievrouw, L. A., & Livingstone, S. (2006). Introduction. In L. A. Lievrouw & S. Livingstone (Eds.), *The handbook of new media. Social shaping and social consequences of ICTs* (2nd student ed.; pp. 1–14). London: Sage.

Lofton, K. (2008). Public confessions: Oprah Winfrey's American religious history. *Women & Performance: A Journal of Feminist Theory, 18*(1), 51–69.

Lövheim, M. (2011a). Mediatization of religion: A critical appraisal. *Culture and Religion, 12*(2), 153–166.

Lövheim, M. (2011b). Personal and popular. The case of young Swedish female top-bloggers. *Nordicom Review, 32*(1), 3–16.

Lövheim, M. (2011c). Young women's blogs as ethical spaces. *Information, Communication and Society, 14*(3), 338–354.

Lövheim, M. (2012a). A voice of their own: Young Muslim women, blogs and religion. In S. Hjarvard & M. Lövheim (Eds.), *Mediatization and religion. Nordic perspectives* (pp. 129–146). Göteborg: Nordicom.

Lövheim, M. (2012b). Negotiating empathic communication. *Feminist Media Studies*. Retrieved from http://www.tandfonline.com/doi/abs/10.1080/14680777.2012.659672

Lövheim, M. (in press) (Ed.). *Media, religion and gender: Key issues and new challenges*. London: Routledge.

Maddux, K. (2010). *The faithful citizen, popular Christian media and gendered civic identities*. Waco, TX: Baylor University Press.

McGuire, M. (1981). *Religion, the social context*. Wadsworth: Belmont, CA.

Meyer, B., & Moors, A. (2006). Introduction. In B. Meyer & A. Moors (Eds.), *Religion, media, and the public sphere* (pp. 1–25). Bloomington, IN: Indiana University Press.

Mortensen, T., & Walker, J. (2002). Blogging thoughts: Personal publication as an online research tool. In A. Morrison (Ed.), *Researching ICT's in context* (pp. 249–279). Report no. 3. Oslo, InterMedia, University of Oslo.

Панк-молебен "Богородица, Путина прогони" Pussy Riot в Храме. [Pussy Riot gig at Christ the Savior Cathedral]. Retrieved from http://www.youtube.com/watch?v=GCasuaAczKY

Reilly, N. (2011). Rethinking the interplay of feminism and secularism in a neo-secular age. *Feminist Review, 97*, 5–31.

Scott, J. W. (1986). Gender: A useful category of historical analysis. *American Historical Review, 91*(5), 1067–1068.

Serfaty, V. (2004). *The mirror and the veil. An overview of American online diaries and blogs* (Vol. 11). Amsterdam: Rodopi.

Sørensen, A. S. (2009). Den intime blog. Selvbekendelsen som etisk talehandling. In C. L. Christensen & A. Jerslev (Eds.), *Hvor går grænsen? Brudflader i den moderne mediekultur* (pp. 203–230). Copenhagen: Tiderne skifter.

Stern, S. (1999). Adolescent girls' expression on Web home pages: Spirited, sombre and self-conscious sites. *Convergence, 5*(4), 22–41.

van Doorn, N., van Zoonen, L., & Wyatt, S. (2007). Writing from experience: Presentations of gender identity on weblogs. *European Journal of Women's Studies, 14*(2), 143–159.

Vincett, G., Sharma, S., & Aune, K. (2008). Introduction. In K. Aune, S. Sharma, & G. Vincett (Eds.), *Women and religion in the West, challenging secularization* (pp. 1–22). Farnham: Ashgate.

Vis, F., van Zoonen, L., & Mihelj, S. (2011). Women responding to the anti-Islam film Fitna: Voices and acts of citizenship on YouTube. *Feminist Review, 97*, 110–129.

Winston, D. (2011). The angel of Broadway: The transformative dynamics of religion, media, gender and commodification. In G. Lynch, J. Mitchell, & A. Strahn (Eds.), *Religion, media and culture: A reader* (pp. 122–130). London: Routledge.

Woodhead, L. (2005). Gendering secularization theory. *Kvinder, køn og forskning, 1*, 24–35.

Woodhead, L., & Cato, R. (2012). (Eds.). *Religion and change in modern Britain*. London: Routledge.

Evolving Religion in the Digital Media

STEWART M. HOOVER

The twenty-first century has dawned with its own characteristic concerns and discourses of change. Change in the worlds of politics, culture, society, and religion has become commonplace. Change in technology and particularly in media technology and the means of communication is also now taken for granted, as is the assumption that change in media, increasingly defined by what we might call "the digital revolution," now centers much of this talk. And, the impact of changes in media in other social and cultural sectors is worth much scholarly and public attention. The particular combination of "religion" and "the digital" has raised intriguing and challenging questions. It is my purpose here to explore the range of issues and implications that seem to have emerged at this intersection.

All religions are mediated in some way. A broad definition of media encompasses nearly all the ways that religions perform the basic tasks of remembering their histories and beliefs and expressing those beliefs to new generations and to broader publics. These forms of mediation can take on other forms of practice, most notably ritual, through which the work of religion is extended and deepened. This description fits most closely those religions that are most institutional or structured, as is typical in the West and to an extent with the three great Abrahamic faiths, where both the maintenance of the tradition and its expression are overseen by structures and systems of authority.

If we expand our definition of religion, the picture of its mediation becomes even broader and more complex. Clifford Geertz's (1993) description of religion,

for example, as "meaning and motivations made real and immediate" (I paraphrase) centers our consideration of the religion "object" in a new way. Religion becomes meanings or practices that can in a sense float free from the aspirations and conditions of established structures and authorities. What individuals and groups do to make meanings that are unique and deeply convincing then becomes the issue in question. This opens consideration of a wider range of practices and motivations in contemporary life. It also opens the door to new forms of expression, of aesthetics, of visualization, and of symbolism to be thought of as mediations of "the religious."

Religion and Media in History

Received understandings of "the religious" and of that which can legitimately be thought of as religion have for most of the past century run up against entirely new and systematic forms of mediation, those forms that fit generally under the definition of "mass media." Mass communication is not all that new, depending on one's definition of "mass," but the evolution of public communication certainly entered a new phase with new force with the industrialization of communication in the late nineteenth century. Mass production of newspapers meant for the first time that media and mediations of politics, culture, society, and religion would be available to entirely new communities and reading publics, and that those mediations would be available broadly and quickly. The mass media era[1] had the effect of instantiating a force in public communication that had been emerging at least since the Gutenberg revolution. As Elizabeth Eisenstein (1979) noted in her definitive study of printing, one of the major effects of the printing revolution in early modern Europe was the emergence of a new class of cultural authority: the publisher. Publishers and the process of publication were initially in the control of other authorities—the church and the state—but that they *needed* to be controlled or conditioned was a measure of their potential influence through their control of the means of public discourse (Habermas, 1992).

This industrialized communication began in the "print" era of mass communication but gained force and momentum with media change at the turn of the twentieth century. Electric, and then electronic, communication brought new forms, practices, and networks to the fore, and the implications for religion became harder and harder to ignore (Goethals, 2000). In North America, at this same time new forms of religion emerged that were almost defined by their mediation. This introduced a new valence of mediated religion in public discourse. The American fundamentalist movement, rooted in the urban evangelism of the nineteenth century (these large and sensational gatherings being themselves forms of mass mediation) found an easy contiguity with emergent mass media, and "the Funda-

mentalist Radio Preacher" became an icon of that movement and that era, almost definitive of the form of faith and of religion (Carpenter, 1985; Hendershot, 2004). Religion's mediation—in this case—was in some ways its constitution, its structure, and its authority. Pentecostalism, now an even more influential and global movement, also found its roots in the urban environments of North America and quickly developed as a mediated phenomenon. The differences between Fundamentalism and Pentecostalism in this regard are telling: Fundamentalism works more easily with traditional ideas of media-as-transmission where the authoritative reading and interpretation of scripture is in the leading place (Quebedeaux, 1974); Pentecostalism is less concerned with this kind of authority—stressing more the power of networks of relationship and affinity (Hoover, 1988). Thus the "broadcast" era of electronic communication was more salubrious for Fundamentalism. Pentecostalism has found its comfort zone more in the era of new and digital media, which I will get to presently.

Considering Media and Religion

Our thinking about the relationship between religion and these new and emergent forms of mass communication has evolved. One of the major points of evolution has been our gradual realization (not yet fully accepted) that successive eras of media change are not something that must be seen in relation to a rather fixed and immutable form we call "religion." Instead, we need to understand the ways in which these changes in media are actually changing religion, resulting in new forms, expressions, understandings, contexts of practice, and sources of authority (Campbell, 2012; Clark, 2008; Helland, 2012; Hoover, 2006, in press; Meyer & Moores, 2006). This realization or this claim, by scholars and others, remains controversial and emergent. But it is an important shift in paradigm, one that is gaining increasing credibility as these developments move ahead.

Cultural elites in religion and in the academy have been slow to understand these developments. It has been too easy to think of "media" and "religion" as separate and hermetic spheres of action, meaning, and structure, and that the important question should be the effects of one upon the other (see Warren, 1997). This was in evidence at the time of the major revolution in media and religion brought about by satellite communication in the 1970s. For a variety of technical reasons, that one change led quickly to a new frame of thought and discourse about the mediation of religion (Horsfield, 1984). Satellites allowed alternative networks of television distribution to emerge, and this coincided historically with the emergence of a new form of Fundamentalism, first called "neo-Evangelicalism" and now simply "Evangelicalism" (Quebedeaux, 1974). Evangelicals, like Fundamentalists,

were quite comfortable with electronic mediations that were instrumental and focused on transmission. Whole new forms of media, and particularly of television, emerged. We should not overlook the class and cultural implications of all of this. This also meant that a kind of religion once identified with marginal social classes, defined by Weber as mystical, heartfelt, and embedded, was suddenly outside of its box and available to broad national and international audiences (Peck, 1993). The easy assumption—persistent from the time when only a few powerful corporations or institutions could control broadcast channels—led many to treat this new development with fear and apprehension (see Hoover, 1988, 2006).

The emergence of Evangelical broadcasting, what we now call "televangelism," led to a broad public discussion about the implications and potentials of the electronic mediation of religion. Voices in the academy and in religious institutions began to explore the implications. In keeping with the Manichean "separate spheres" view of media and religion, this was generally put in terms of the "profane" world of media confronting the "sacred" world of religion (Hadden & Swann, 1981). Most thinking about this then—and indeed most lay and public discourses now—focus on one of two questions, that of the media "effects" on religion, or of religious "use" of media. There are large literatures in each area. The former concerns primarily the way that religion is framed by news and entertainment media, the latter the ways that religion and religious groups use media to further their ends and goals. The prior approach, interestingly, has within it works that are more typical of the "critical" paradigm of media research—referring to Paul Lazarsfeld's classic (1941) formulation—while the latter approach has tended to be more "administrative" in its perspective and orientation.

Rethinking Media and Religion

It is easy to see why so much of our scholarly and public discourse has focused in these ways. It is rooted in our received senses of both media and religion. Each is thought (in relation to the Abrahamic faiths, at least) to be primarily concerned with transmission and with instrumental effects. We think of religions as institutions or traditions that have an aspiration or even a mandate to convince, to share their values and symbols. We think of mass media as institutions that are fundamentally about selling things and ideas. How these two major forces in the culture would collide is conceivable in terms of effects of one upon the other. But, in recent years, new paradigms have begun to emerge that see things in less Manichean, "separate spheres," terms. Scholars who have focused on studies of the mediation of religion have begun to suggest different ways of thinking about religion and media—ways that think of them together, in terms of their convergence, more than in terms of the

conflict of hermetic spheres. Scholarship has begun to unpack both "media" and "religion," to understand their constitution, and the emergent scholarship of media *and* religion has taken these new and denatured ways of thinking about media and religion and now increasingly sees them working together and upon one another, to produce something new and different in the so-called media age.

Emerging Paradigms

Elsewhere (Hoover, in press), I have suggested that, as scholarly consideration of the intersection of media and religion has matured, new and distinct formulations have emerged. There I describe four contemporary paradigms that seek to account for the mediation of religion by industrial mass communication in all its forms, in new ways. The first of these is the scholarly discourse around the "mediatization of religion" thesis (Hjarvard, 2012). This approach retains the notion of separate spheres of media and religion, suggesting that the mediation of religion in fact changes religion. To paraphrase its major voice, Danish media scholar Stig Hjarvard, "religion then takes on a media form." Hjarvard and others in this paradigm note that media are in fact working this way in a variety of fields, from education, to business, to government. Across many sectors, they argue, the fundamental functioning and structure of these other sectors are being changed by their interactions with modern mass communication. Something new is emerging. In this way, the mediatization thesis is a persuasive advance over prior theories, in that it suggests that it is not just what media do to religion that matters but that new forms and functions and practices of religion are emerging due to media.

The second paradigm I point to is one I call the "mediation of religion" thesis. This holds that all religions have always been mediated, and that new forms of media simply introduce new forms through which religion is circulated. Birgit Meyer (2008) is a proponent of this view, joined by many of her colleagues in the field of anthropology. Meyer goes on to a point that is particularly helpful to my project here—the discussion of digital religion—by suggesting that the contemporary mediation of religion needs to be seen in terms of its aesthetic capacities, its "sensational forms." These aesthetic forms, and more particularly their affordances, define the capacities of media today to mediate religion, and condition and encourage the means by which forms of "the religious" are deployed in various communities and contexts. Over against the notion of "mediatization," Meyer would argue for a less institutional, structural view of religion, one that thinks of religion (along with a growing paradigm in the field of religious studies itself) as practice, rather than as doctrine or institution. It is perhaps telling that the primary field of empirical work for the mediatization-of-religion scholars is the industrial West,

and that of Meyer and many of her colleagues is the two-thirds world and Global South, but that is a discussion for another day.

A third paradigm that persists in the study of media and religion is what I call the "anachronistic" view that focuses on the abiding and definitive nature of religion, particularly of religious *Gemeinschaft*, and its instantiation on modern media. This idea had influential early proponents in Marshall McLuhan and Jacques Ellul and is clearly at the center of the work of Walter Ong and of many of the neo-Marxists and structuralists who have looked at the question of religion in the context of contemporary media. This paradigm focuses on abiding and persistent characteristics of "the religious" as immutable and fixed capacities and sensibilities in society and culture, and it thinks of the media sphere as necessarily the context in which they are worked out today. These approaches essentialize religion—to a greater or lesser extent—and look for residual expressions of the essentially religious in contemporary media experience. This category could include much of the work that has been done on media ritual (Couldry, 2003; Dayan & Katz, 1992) as well as compelling and fascinating new work on "the sacred" in contemporary life (Lynch, 2012).

The fourth approach that I point to is one that is emergent and in formation, but one that responds much more directly to the emergence of the digital media, which is the focus of my writing here. That is what my colleagues and I call the "third spaces of digital religion." I will discuss this in more detail later. First, the digital revolution.

The Challenge of Digital Media

These various ways of thinking about media and religion have been upended, to a degree, by the emergence of digital media. Many of the guiding assumptions about the nature of media and mediation are at least thrown open by the way that these new media forms have developed, been deployed, and enter circulation. In fact, the digital revolution—and its consideration in scholarships of media and religion—have been underway at least since the mid-1990s.[2] Much of the early work in this area tended to take on board the "separate spheres" view of religion and media, contending with questions of how these "new media" were affecting religion (Brasher, 2004; Hadden & Cowan, 2000; O'Leary, 1996). But, even in this early work was the implication that some new and different dimensions were coming to the fore with these new media. Brenda Brasher's (2004) work, for example, focused rather early on the capacities of these new media to form new communities, new senses of community, and new centers of authority. Tom Beaudoin (2000), in his influential work on religious youth cultures, suggested that new forms of media were also articulated demographically, with important implications for youth and religion as young people increasingly gravitated to these new media. Brasher's work focusing on women's

spiritualities in these media also suggested that it was not just age demographics that were important but also the capacities of these media to articulate the resistive interests of voices and communities that had been overlooked by conventional religious authority, including women and young people(see also Clark, 2005).

That new communities might well be empowered by these media to do religion in new ways was implied by Christopher Helland's (2000) classic paradigm, comparing "religion online" (that is, religious use of the online environment) and "online religion" (that is, the capacities of these media to enable entirely new forms of "the religious"). Helland and others now recognize that this is perhaps too simple a way to look at things (see Helland, 2012), that a range of different combinations of religious capacity, gesture, aspiration, and possibility are present in digital spaces. It is also the case that such entirely novel uses of digital media may account for only a small minority of total online digital activity related to religion (Hoover, Clark, & Rainie, 2004).

In a review of the literature on digital religion, Heidi Campbell (2012), herself an important contributor to that literature, describes five "traits of digital religion," rooted in empirical work on emergent practices there. These traits are convergent practice, multi-site reality, networked community, storied identity, and shifting authority. We can see in these a radical shifting of the terms of discussion away from the idea of "separate spheres." What Campbell (and indeed, the scholarship she reviews) identifies as contemporary religion in the digital sphere is a range of dimensions, layers, and activities. What is systematically at the center are a set of sensibilities that have been unleashed by the capacities and affordances of digital media. The logics of practice are of the kind anticipated by Birgit Meyer's (2008) notion of "sensational forms" and the rise of "the aesthetic." What these media invite people to do, the positionalities into which they "hail" them, are centered in experience, expression, resistance, and negotiation, not in some sense that the media or the mediation of religion might be "effective" in some religiously essentialist sense.

The work Campbell (2012) reviews also reinforces the notions I raised earlier, that the digital media have a particular role in relation to demographics, particularly age demographics, and gender, and that in both cases they have the capacity to either articulate the interests of those who have been traditionally overlooked or to actively resist (see Lövheim, 2012). Much of what we have seen in digital religion is much more mundane and domestic than that (Campbell, 2011; Hadden & Cowan, 2000; Hoover, Clark, & Rainie, 2004) but it is the capacity of digital practice to do this that introduces some of its most important implications for the evolution of religion.

From the beginning, digital media began to raise important challenges to received ideas of religion across a range of contexts. That they might define or even empower new communities made this even more potentially challenging. Implicit

in this early discourse about them was the implication that they carry within them capacities and affordances that will directly intersect with traditional understandings of religion, of religious and spiritual practice, and of "the religious." As we think about the implications of digital media for religion, these capacities are the ones that will draw attention and may well form the core of our emerging sense of how and where these media are significant in religious terms. These are the places where we can expect controversies and conflicts to erupt, new hypotheses and claims to be focused, and these describe the range of things that new and emergent theories of digital religion must account for.

Considering the Digital

These are the capacities and affordances of digital media that seem most important to our understanding of their implications for religion.

First, digital media are, in some ways more insistently than traditional or "legacy" media, available in real-time; they are instantaneous. This is in part due to industry practice in relation to these media, in that their availability as distribution channels has meant that publication cycles have been shortened, with a "24-hour cycle" now being the norm for news and for information online. This means that their circulation is in a way more real and more present than might have been the case in the past, and as "audiences" (I use the term advisedly) encounter online material they are invited by the context to think of themselves as being connected "in real time."

Similarly, digital media carry the implication that they transcend great space and distance. People can see and hear things from well beyond their local contexts, and these interactions function in important ways for them. Significantly, it appears that it is not that space as elided (as was implied by McLuhan's notion of the "global village"), but that space is also instantiated. Audiences participate in the circulation of messages across space often with the consciousness that they do, in fact, "bind" space (to use Innis's classic formulation). They are conscious that space is being transcended, that they are experiencing and expressing things across distance. This consciousness of being part of a local context in relation to larger contexts (Redfield, 1960) is important and salient. In empirical terms, what is important to recognize here is that the question of space (and the question of time, too, for that matter) can be and is negotiated by those who participate in digital space. Thus, religious sensibilities of difference and sameness, otherness and sharing, and universalistic saliencies (one thinks here of Victor Turner's ideas about the power of pilgrimage) are all potentially meaningful dimensions of digital experience.

That the digital media can transcend time and—more importantly—space, engaging individuals in online interactions well beyond their physical locations as

from the beginning of digital media, raised questions about the question of "community." "Can community be virtual?" the question is typically put, and there has been a vibrant discourse about this for years. This is significant particularly in relation to the Abrahamic faiths, which share an ethic of community and of common life. Often, the question of online or virtual community has been a kind of evaluative frame for religious authority as it has looked at "the digital." Can online community be "real"? Can it substitute for "real" community? These are the common questions. Research has consistently shown that the question is more complex than that. Kinds of community online can function as "real," it seems (Campbell, 2005; Fernback, 2002). It all depends on how and under what conditions the practice takes place and what its functions are. The question of whether online interactions are vicarious or real will no doubt continue to challenge analysis and scholarship. They are clearly, however, questions with important religious implications.

This introduces another dimension of "the digital" in relation to "the religious," one that has obtained attention from the beginning, as we have seen. That is the capacity of the digital to engender new forms of religious community, new and novel networks of relationship, and—potentially—entirely new religions. This would obviously be an important question to religious authorities, as they might find themselves facing competition from new or novel religious expressions. There have been many examples of new religions springing up online. Many of them have been clearly ironic or playful, such as the widely circulated "Church of the Flying Spaghetti Monster." While such efforts are perhaps less important to the larger question of religion, they nonetheless introduce more choice and differentiation into the inventory of religious symbolic resources available online and thus have some necessary implication in relativizing religion.

Online community, though, is much more likely to challenge or threaten authority in a different way. As Brasher and other early observers of "online religion" saw, the affordances of these new media, rooted perhaps in issues of class, seemed to open the door to expressions and explorations of religion and spirituality that were more portentous for conventional religion. Some online expression is clearly focused on the opportunities these online spaces offer as alternatives for individuals and groups that have traditionally been outside the mainstream of the received traditions. Other examples—including formally coded sites—offer points or grounds of actual resistance to received religious authority.

This is related to another factor that must be considered here, the affordance or hailing of digital media in relation to the autonomy or reflexivity of its audiences. As Campbell has observed in her analysis of online religion "traits," many of these are driven by the autonomous initiative and aspirations of individuals to make their own sense of things using the online environment. This putative autonomy (I do not suggest that digital media solve once and for all the "agency" vs. "deter-

mination" controversy in social theorizing about media) is an important marker or frame of digital practice. As has been widely observed (see Jenkins, 1992, with regard to media in general), it is fundamental to digital spaces and practice that users are encouraged to think of themselves as autonomous and empowered in digital spaces. The whole notion of "pro-sumption," the active participation of users in the creation of online content, further instantiates this idea. This is the central point of the so-called viral media as well. Thus there is a double-layered capacity to the imagination of action in online community formed around religion. These media provide a particularly effective and meaningful context of interchange and dialogue—an online community, if you will—and they provide it in such a way that encourages them to feel autonomous and empowered, something that almost seems to invite resistance.

But this affordance of autonomy and dynamic action, implied in discourses about enabling viral media and using the capacities of "social media" to form communities of action among youth, need not necessarily be about resistance or contestation. The literature on digital religion increasingly considers examples of this in relation to religious traditions in the Abrahamic category and beyond it (Campbell, 2005; Helland, 2012).

The digital media are significant in relation to religion as well for their international and intercultural scope and capacity. The distances these media transcend and bind are national and international, regional and transregional. And, to the extent that consciousness of this is important to meaning-making using them, the fact of their exogeny is sure to be significant. There are examples of this online, where social media contexts including YouTube, discussion boards, Twitter, and Tumblr have been used by religious networks to connect across vast geographic and cultural distances. Congregations and networks in the United States, the UK, or Canada can connect with congregations or networks in Africa or Asia in a direct, seemingly horizontal, one-to-one way. The instantaneity and reality of these interactions adds to their attraction and dynamism. Digital spaces thus allow for the globalization of religion in a way that has not been possible in the same way before, and digital media are being used effectively by groups across the globe for such purposes. This possibility or affordance intersects with the issues of autonomy and authority I discussed above. As individuals increasingly can speak and connect across great distances, their sense of autonomy and efficacy may increase. A kind of empowerment through connection and framing may result.

As I have said, traditional uses, motivations, and sensibilities persist. There is much evidence that the majority of religion in digital spaces is what Helland (2012) called "religion online," or the commonplace use of the Web for rather conventional religious purposes by conventional religious groups or interests. There is also an increasing presence on the Web of traditional religious institutions and author-

ities. The most notable—and talked about—have been the online efforts of the Vatican. The Pope now has a Twitter feed, as does the Dalai Lama (though neither of them actually writes their own tweets!), and the Vatican has an ever-expanding online edifice in its website. Interestingly, and perhaps as a measure of how religious authority will think about the affordances of digital media, the Vatican site is curiously without opportunities for feedback or dialogue. The canons of "social media," that it is all about interaction and pro-sumption, seem not to apply. Religious authority can also be seen to be policing the boundaries of digital space. In the fall of 2012, the Mormon Church moved to sanction David Twede, a Mormon who ran an influential website commenting on Mormon affairs and politics (Daily Beast, 2012).

Implications of Digital Religion

These affordances and capacities of digital media raise a number of interesting issues that will continue to drive scholarship about digital religion. It will probably remain the case that these media will be particularly active in relation to certain demographic categories more than others. Most significantly, it is likely that online cultures will continue to be youth cultures. The digital and social media are the comfortable geographies of youth today, and their activity in, and emerging ethical and normative ideas about, these spaces will continue to drive meanings and practices online. Elsewhere, my colleagues and I have published a series of case studies of digital religion that include examples of the particular demographic logics of digital practice (Hoover & Echchaibi, 2012). Among those studies are a number, including of the "hactivism" of the so-called Anonymous movement, of the global circulation of the icon of the Irania youth martyr Neda Agha-Soltan, and of the circulation of religion and spirituality in the influential online site PostSecret. In each of these, we can see the expression of particular and specific emergent ideas, values, and sensibilities articulated to digital space.

This demographic logic of digital religion is rooted in another dimension that I raised earlier: the idea that the digital space is organized and practiced in a way determined by aesthetic as opposed to other logics. Birgit Meyer (2008) and David Morgan (1999) have demonstrated the ways that means and contexts of expression, what Meyer calls "sensational forms," need to be understood for their capacities to direct and determine religious and spiritual action. Religion is not just about doctrine, or theology, or history; it is also about embodied practice and experience. Mediations of religion thus go beyond the rational and linear expression of religious ideas or impulses to "spread the faith" to unbelievers. Mediations of religion include those places and contexts and means by which religion is experienced and

celebrated. And, as Meyer has suggested, this realm of the aesthetic can and does provide important frames and logics for the performance of religion along these lines. Thus the capacities of digital media dovetail with the impulse to express religious ideas and meanings. What the digital media allow become the framework, the nomenclature, and the linguistic and symbolic systems through which senses of "the religious" can be articulated.

Aesthetics provide, then, a powerful challenge in another important area, that of authority. As David Morgan (1999) has argued, religious authority is nervous about systems of expression such as the visual, which are thought to be symbolically open and unstable. Visual expression, he notes, carries with it the uncomfortable (to authority) implication that interpretation and circulation can be open and free-floating, conditioned by things and in contexts outside the control of those authorities. Thus it is with the whole range of modes and channels of meaning and communication, from the visual to the aural, that are the commonplace provenance of digital media.

In this and in other ways I've described, religious authority is in the frame as digital media become more and more active in religion and spiritualty, or rather that religion and spirituality become more and more active in digital spaces. Beyond this issue of its control over the aesthetic representation and experience of religion, authority must contend, in the digital sphere, with other, competing sources of religious and spiritual insight and resources. It is subsumed, to an extent, in an ever-broadening marketplace of religious supply. It is increasingly relativized as religious traditions become simply one among many sources of symbolic resources, even about their own faith or tradition.

Authority is further threatened by the affordances of digital media to engender in their audiences and communities a sense of individual autonomy and action. As individuals are encouraged to think of themselves as their own producers of ideas and symbols and values, the implication is that any individual authority—including clerical authority—is less necessary. This accelerates the already-extant and widely noted decline in the overall authority of religion, its decline in the face of increasing personal autonomy over matters of faith. It can't be said that the media—digital or otherwise—are responsible for this decline, but there is a consonance between them.

New Approaches for New Media

As scholarly and lay discourse looks at and evaluates digital religion, then, it is a complex picture. The developments in digital religion follow in important ways trends I talked about in the pre-digital era of the so-called legacy media. In a way, these media are merely another iteration of the ongoing development of industri-

alized mediation through which religion has been known since the development of printing. Structures and systems of authority in digital media are not that different from what existed in the electronic media. Religious authority suffered challenges in earlier eras, too. The idea was that the media could provide a context outside religious institutions through which some of the same "work" (symbolism, meaning-making, ritual, etc.) emerged long ago. The digital revolution is in a way only another, more intense cycle of these trends.

But, it appears that there is something entirely new about religion in relation to digital media, and that is the way that audiences and users are positioned and the way that they think of themselves. These media are shaped and defined by audience action (again, I am not intending here to argue that this autonomy is absolute). And, more importantly, audiences and users are involved in ways that position them and through which they position themselves, very self-consciously on the digital media "map." What emerges is a system of practice and interaction between the technology and audience practice that is not easily described using the traditional paradigms of religion and media.

My colleagues and I have elsewhere called for a new paradigm instead, one we call "the Third Spaces of Digital Religion" (Hoover & Echchaibi, 2012). By this we intend to account for what appear to be the emergent normative practices of digital religion. Individuals today act as if these spaces are contexts from which they can articulate and advocate new ideas, in which they can circulate symbols and symbolic re-mediations, and in which they can form new communities and networks of common purpose. They do not necessarily imagine that these are practices that take place alongside of real or physical or structural contexts. Instead, they seem to imagine that new and elastic contexts and boundaries of practice and action are possible.

This links directly with the affordances or capacities of "the digital" I've discussed above. These media define a user-involvement and user-generation. They operate with a clear and objectified sense of their temporal and geographic meanings. Users are invited to find new locations of meaning through these media and are invited to think of these media as actual contexts, as actual spaces. These are spaces alongside many of the received spaces. They are alongside "private" and "public," alongside "individual" and "community," alongside "person" and "structure," alongside "physical" and "conceptual," etc. Thus our term "third spaces." It is important to note here that this whole idea of "third spaces" is articulated into the framework of individual user practice in digital media, that it is about the individual and about individual action and meaning and purpose. Individuals are thus reflexively engaged in these spaces, and so they are spaces that are constructed with a degree of self-consciousness.

Much remains to be done to develop the theoretical and conceptual resources necessary to the task of accounting for the emergence and evolution of "digital re-

ligion," as I have called it. We are only at the beginning. Some implications are clear, as I have said, not least for the prospects and aspirations of religious authority. I began by referring to Geertz's definition of religion, that it is about meanings and motivations and the capacities to make those meanings and motivations seem particularly real. We can see in the aesthetic logics of digital media and emergent digital practice how Geertz's version of religion is particularly implied by media that are all about such meanings. That is where the particular challenge provoked by the aesthetic logics of these media is particularly profound.

I want to end by suggesting another dimension on which the evolution of digital religion is particularly significant for religious authority in particular. Paulo Farias, the distinguished scholar of African and Afro-Caribbean religion and culture, was once asked for his definition of religion. He replied, "a religion is that which has the power to establish the meanings of signs." In the digital age, not just the power of definition but the contexts of definition and the practices through which religion is defined and understood and expressed have radically shifted away from the traditional contexts. It remains to be seen how important this will turn out to be. For now, it seems rather portentous.

Notes

1. I use this term advisedly in the context of a book where many other chapters will wish to contest and nuance our easy assumption that the present era is, in fact, new and unique.
2. On a personal note, at the first international public conference on media, religion, and culture, in 1996, which I directed, most of the press attention was focused on a panel of papers looking at "religion and new media."

References

Beaudoin, T. (2000). *Virtual faith: The irreverent spiritual quest of Generation X*. San Francisco: Jossey-Bass.

Brasher, B. (2004). *Give me that online religion*. New Brunswick, NJ: Rutgers University Press.

Campbell, H. (2005). *Exploring religious community online*. London: Peter Lang.

Campbell, H. (2011). *When religion meets new media*. London: Routledge.

Campbell, H. (2012). Understanding the relationship between religion online and offline in a networked society. *Journal of the American Academy of Religion, 80*(1), 64–93.

Carpenter, J. (1985). *Tuning in the Gospel: Fundamentalist radio broadcasting and the revival of mass evangelism, 1930–45*. Paper delivered to the Mid-America American Studies Association, University of Illinois, Urbana, April 13.

Clark, L. S. (2005). *From angels to aliens: Teenagers, the media, and the supernatural*. New York: Oxford University Press.

Clark, L. S. (Ed.). (2008). *Religion, media, and the marketplace.* New Brunswick, NJ: Rutgers University Press.

Couldry, N. (2003). *Media rituals: A critical approach.* London: Routledge.

Daily Beast. (2012). Mormons want to excommunicate Romney critic. Retrieved from http://www.thedailybeast.com/articles/2012/09/21/mormons-want-to-excommunicate-romney-critic.html

Dayan, D., & Katz, E. (1992). *Media events: The live broadcasting of history.* New York: Harvard University Press.

Eisenstein, E. (1979). *The printing press as an agent of change.* Cambridge: Cambridge University Press.

Fernback, J. (2002). A case study of the construction of computer-mediated neo-pagan religious meaning. In S. M. Hoover & L. S. Clark (Eds.), *Practicing religion in the age of the media: Explorations in media, religion and culture* (pp. 254–275). New York: Columbia University Press.

Geertz, C. (1993). Religion as a cultural system. In *The interpretation of cultures* (pp. 87–125). New York: Oxford University Press.

Goethals, G. (2000). The electronic golden calf: Transforming ritual and icon. In B. Forbes & J. Mahan (Eds.), *Religion and popular culture in America.* Berkeley, CA: University of California Press.

Habermas, J. (1992). *The structural transformation of the public sphere: Inquiry into a category of bourgeois society.* New York: Polity Press.

Hadden, J. K., & Cowan, D. (2000). *Religion on the Internet: Research prospects and promises.* New York: JAI Press.

Hadden, J. K., & Swann, C. E. (1981). *Prime-time preachers: The rising power of televangelism.* Reading, MA: Addison-Wesley.

Helland, C. (2000). Online-religion/religion-online and virtual communitas. In J. K. Hadden & C. E. Cowan (Eds.), *Religion on the Internet: Research prospects and promises* (pp. 205–224). New York: JAI Press.

Helland, C. (2012). *Internet communion and virtual faith: The new face of religion in the wired West.* New York: Oxford University Press.

Hendershot, H. (2004). *Shaking the world for Jesus: Media and conservative Evangelical culture.* Chicago: University of Chicago Press.

Hjarvard, S. (2012). Three forms of mediatized religion. Changing the public face of religion. In S. Hjarvard & M. Lövheim (Eds.), *The mediatization of religion: Nordic perspectives* (pp. 21–44). Gothenburg: Nordicom.

Hoover, S. (in press). Introduction. Religious authority in the media age. In S. M. Hoover (Ed.), *The media and religious authority.*

Hoover, S., & Echchaibi, N. (2012). The third spaces of digital religion. In S. Hoover & N. Echchaibi (Eds.), *Finding religion in the media: Case studies of the 'third spaces' of digital religion.* Boulder, CO: Center for Media, Religion, and Culture, University of Colorado.

Hoover, S. M. (1988). *Mass media religion: The social sources of the electronic church.* London: Sage.

Hoover, S. M. (2006). *Religion in the media age.* London: Routledge.

Hoover, S. M., Clark, L. S., & Rainie, L. (2004). Faith online. Pew Internet & American Life Project.

Horsfield, P. (1984). *Religious television: The American experience.* New York: Longman.

Jenkins, H. (1992). *Textual poachers: Television fans and participatory culture.* New York: Routledge.

Lazarsfeld, P. F. (1941). Remarks on administrative and critical communications research. *Studies in Philosophy and Science, 9,* 3–16.

Lövheim, M. (2012). A voice of their own: Young Muslim women, blogs and religion. In S. Hjarvard & M. Lövheim (Eds.), *The mediatization of religion: Nordic perspectives* (pp. 129–146). Gothenburg: Nordicom.

Lynch, G. (2012). *The sacred in the modern world: A cultural sociological approach.* London: Oxford University Press.

Meyer, B. (2008). Religious sensations: Why media, aesthetics and power matter in the study of contemporary religion. Lecture, Faculty of Social Sciences, Free University of Amsterdam, July.

Meyer, B., & Moores, A. (Ed.) (2006). *Religion, media, and the public sphere.* Bloomington, IN: Indiana University Press.

Morgan, D. (1999). *Protestants and pictures: Religion, visual culture, and the age of American mass production.* New York: Oxford University Press.

O'Leary, S. D. (1996), Cyberspace as sacred space: Communicating religion on computer networks. *Journal of the American Academy of Religion, 64*(4), 781–808.

Peck, J. (1993). *The gods of televangelism: The crisis of meaning and the appeal of religious television.* Lexington, MA: Greenwood Press.

Quebedeaux, R. (1974). *The worldly evangelicals.* San Francisco: Harper.

Redfield, R. (1960). *The little community and peasant society and culture.* Chicago: University of Chicago Press.

Warren, M. (1997). *Seeing through the media: A religious view of communications and cultural analysis.* Harrisburg, PA: Trinity Press International.

Media and Transformations of Religion

KNUT LUNDBY

There are three flag-terms that stand out, states Birgit Meyer in the opening chapter of this book,[1] that, in her view, are 'central to the reconfiguration of the study of religion in general, and the trans-disciplinary conversation': *transformation, materiality, mediation*. I agree on the centrality of these three concepts to understand religion across media. However, I will confront this triangle of key terms with the concept of *mediatization* as developed and developing in media and communication studies. Meyer has asked, in Chapter 1, from her viewpoint in anthropology and religious studies, 'whether "mediatization" can at all be fruitfully extended into a broader, historical and global theory of the transformation of religion through "media"' (p. 15). The distinction between 'embedded' and 'disembedded' media introduced in the Introduction (pp. xiv–xv) is crucial to understand transformations of religion across media, I argue.

Mediation, Materiality—and Transformation

All contributors to this volume discuss forms of *mediation* of religion; this is what this anthology is about. The concept of mediation is central in my argument, as it is in the preceding chapters. The cases in this book cover a variety of religious practices within the long historical span from early antiquity to late modernity. The entries refer to mediation of religion in different geographical and textual spaces.

The *materiality* of all these mediations points to the quality or characteristics of the 'media' that are involved. These media have to be seen through their material forms, and the processes of mediation of which they are part. The preceding 11 chapters cover media with quite different properties, from the body to digital technologies.

Religions are in tension between traditions and transformations (Woodhead, Partridge & Kawanami, 2009). This final chapter aims at a further discussion of the *transformations* of religion that may take place in mediations with media of various materialities. My empirical material is cases and examples that are treated in the other chapters. Not all authors discuss transformation of religion explicitly. However, they all exemplify how the actual religious practices may vary with the material mediations. If such variations imply change in religious practice that last over time, this may be considered a transformation of the actual practice. Birgit Meyer does not offer a precise definition of the term, but she makes clear that one needs a historical perspective in order to conclude that religion is transforming (Chapter 1, p. 2). A transformation requires a significant change between 'before' and 'after.' Between the past and the present are the ongoing mediations of religion.

Transformations Through Mediations

Religion is seen as intertwined in its forms of mediation that may transform religious practices. Which forms of mediation and materiality of religion do my co-authors provide with their examples? To what extent do they consider that the material mediations they analyse involve transformations of religion?

Birgit Meyer (in Chapter 1) takes the reader to her research among Pentecostals in Ghana. She shows how images of the *Sacred Heart of Jesus*, which has an offspring in mystical experiences by a French nun in the second half of the 1600s, circulate in this African country today. A number of media, with physical as well as symbolic properties, are applied to conduct this interaction. Images of the Sacred Heart of Jesus are available on calendars, stickers, and posters, in framed pictures, paintings and Web resources. The devotees attribute power and protection, in short, religious meaning, to the interaction with these material media. These mediations keep up the devotion to the Sacred Heart. But to what extent is this particular religious practice transformed through the various material mediations? Meyer's answer is that this is 'a fascinating case for studying the circulation of a religious motif across media that, by virtue of technological mass-production, seem to fuel the concomitant reproduction *and* transformation of religion via the embracement of new media technologies' (p. 13). Meyer, in her other writings, offers sharper examples of how material mediation leads to transformation of religion, summed up as 'shifts of its position in relation to the state and the market, as well as the shape of the religious message,

structures of authority, and modes and moods of binding and belonging' (Meyer, 2009, p. 2). She adds that such changes in religion occur within broader processes, like the reconfiguration of a post-colonial nation in Ghana's case. Transformations of religion are never due to material media and mediation processes alone.

Terje Stordalen, in Chapter 2, does not focus on transformation of religion. His project is to demonstrate that a mediation perspective is productive in biblical studies. This perspective 'might well change the way we perceive ancient Hebrew religion,' he claims (p. 20). He wants to dig out the mediated religious practices that were there but have become hidden under the dominant textual (and archaeological) focus. Stordalen assumes that a rich repertoire of media was in use in this era of early antiquity. He is actually more concerned with the variety of media than with the processes of mediation they were part of, as those may no longer be accessible. Media, however, may be traced through archaeological memory and items. 'If various media of ancient Hebrew religion did generate specific social imaginaries through distinct aesthetic formations' (p. 24) they could not be reconstructed from written sources alone. Many of these media are documented as vehicles of communication in the archaeological record (as inscriptions, potsherds used as a writing surface, figurines, carvings, cultic spaces, etc.), Stordalen explains (p. 23). He draws attention 'to echoes of the plethora of ancient Hebrew religious media and symbolizations that are still available' (p. 27). He points to the *performative* media, especially dance and music. The 'material record' of rhythm would be things such as rattles, bells, body drumming, and small tambourines. Performative media invite performative religion. Stordalen is aware that various media 'activate distinct sensory registers' (p. 24) as Meyer (2011) has pointed out.

Stordalen observes 'multimediality' in ancient Hebrew religion by asking for the variety of religious practices within the totality of their 'religious media.' The record of these ancient practices is kept as part of *cultural media* ('the totality of a given group's cultural media' as historical documentation), *common media* (like pottery or clay figurines of the time), or *inscribed media* (that encompass both archive and canon, with the body that remembers the key heritage).

Peter Horsfield, in Chapter 3, takes us to the period when the oral stories from and about Jesus in early Christianity were about to be written down. This was a turn in mediation form from the materiality of the body in oral performance to the materiality of the body in handwriting. New materialities were added in the writings: pen and ink on skin or processed reeds. Horsfield looks at the contesting forms of mediation as a contrast in media cultures: an oral culture versus a written culture. A recent definition of 'media culture' by Nick Couldry (2012) is illuminating, confirming Horsfield's proposition that changes taking place with new media today were precedented by media that were 'new' (writing) in those days. By 'media culture' Couldry refers to 'collections of sense-making practices whose main re-

sources of meaning are media' (p. 159). Sense-making practices of the Jesus stories through the medium of writing were exactly what developed during the first five centuries of the Common Era.

This introduction of writing changed early Christianity, Horsfield argues, and the oral and the written existed side-by-side in an oral-literal movement. However, over time, the written record became dominant in the definition of the movement. Such media shifts play into the power struggles on religion. Horsfield's contention is that the adoption of writing transformed the authority structures within this young, diverse religious movement. Christianity was narrowed into one stream: Catholic-Orthodox Christianity that the Roman Emperor Constantine came to prioritize to serve his own political agenda. The 'Catholic Party used the media distribution systems of the empire to *transform* [emphasis added] Christianity into a global religious empire,' Horsfield argues (p. 48).

Rather than pointing out resemblances between new media of the twenty-first century and mediation with handwritten manuscripts, as Horsfield does, Liv Ingeborg Lied in Chapter 4 argues that mediation in manuscript culture should be understood on its own terms. Lied challenges media scholars, and I am among them, who indicate that 'the media' emerge with the printing press at the mid-1400s. To her, this is the 'myth of golden beginnings.' She researches handwritten manuscripts and argues that a manuscript culture is a media culture. The change from a pre-print media culture to a post-print media culture is a move from one complex situation of mediation to another. Lied's example is the manuscript culture among Christian monks in monasteries in the desert in the Northern part of Egypt. Due to a common liturgical practice and a shared language in an Aramaic dialect of Syriac, there was communication and exchange with Syriac Christians in the Eastern Mediterranean region and in Mesopotamia. Lied manages to demonstrate how their treasured manuscripts worked as media in ongoing mediations. Lied reports that some readers within this Syriac manuscript culture 'felt the urge to change' what they read in the manuscripts 'to express their reservation or disagreement' (p. 63). However, she does not apply the term *transformation* for such changes.

Ute Hüsken, in Chapter 5, is more explicit on transformations that go with the mediations in her study of Brahmin temple priests in South India. They 'are "media" in a literal and in an abstract sense' (p. 71). The priests do not have a high position in the society outside the temple but, when they act as media within this sacred context, they are 'invested with religious efficacy' (p. 71) that gives them transformative power. For example, they transform the offerings physically by certain ritual acts and also perform metaphysical transformations when the offerings are turned into the blessing of the god. Although the role of the Brahmin priests is contested, Hüsken concludes that they, as media, 'have the power to shape and transform what they mediate' (p. 82). Interestingly, their 'state of being a medium is not anchored in their

person, but is attributed, and the effects of this attribution clearly are very ambivalent and contradictory, which however is connected to their potential power the priestly role brings about' (p. 77). Hüsken sees these transformative ritual mediations within a larger picture of change in the South Indian Hindu society, where the temple traditions may trigger criticism and conflict. More often than not, these are situations of change. Hüsken makes visible an important distinction between changes in the power position or social function of a given medium in a society and the symbolic transformations that follow this medium at work.

Peter Simonson, in Chapter 6, also makes a distinction between transformations in media environments and processes of religious transformation (p. 88). He explores rhetoric as a vehicle for mediation or, more specifically, as 'pathways to thinking about religion and media.' He connects rhetoric as a means to 'transform mindsets' (p. 95) with Birgit Meyer's ideas of aesthetic mediation through sensational forms. Rhetorical mediation may thus trigger transformation of religious practices. Simonson brings his argument up to present digital forms of mediation with an idea of 'digital eloquence.' There is, in general, a 'rhetorical power of eloquence' (p. 93) that may solidify particular ways of life but that may also *create* culture, Simonson reminds us. By going to the digital media, Simonson points to 'the latest mediation of eloquence,' which has a 'culture-generating, culture-fixing potentiality' (p. 94), that is, a potential for transformations.

Kim Knott, in Chapter 7, outlines the spatial dimension of mediation. The materiality of mediation could always be located in space, be this in a geographical location, with the body as space, or the discursive space of a text. Similarly, transformations following processes of mediation could be located in space. Spaces are infused with power, she reminds us. Knott offers two examples from recent debates on the location of religion in secular contexts, namely the conflict over Salman Rushdie's book *The Satanic Verses* and the reception—or rather non-reception—of the Dutch anti-Islamist politician Geert Wilders in Britain. In the mediation of these cases, 'forceful articulation of ideological categories and positions' (p. 112) and the struggle between them was acted with reference to socio-spatial categories, of insides and outsides, inclusion and exclusion, 'us' and 'them.'

David Thurfjell (Chapter 8) does not consider transformation of religion when he writes about the mediation of gypsiness in the entrenched situation of the Romani people in Europe. Among them, he visits a group of Pentecostals. These charismatic Christians perform such spiritual practices as speaking in tongues. Thurfjell claims that these practices imply mediation 'through the Holy Spirit.' The Pentecostal Roma may use digital technology for their interaction and articulation of 'gypsiness' in a hostile environment when they could not come together to strengthen each other face-to-face. They could meet in chat rooms to 'talk, discuss, sing, and pray together,' Thurfjell reports (p. 122). New Internet media is added to

their mediation with former media, 'revivalist meetings, educational campaigns, novels, journals, pamphlets, broadcasted sermons' (p. 122) and the like. The new articulation of what it is to be Roma expressed by Romani Pentecostals serves as consolidating mediation within the group. Toward the 'discursive oppression' from the majority culture, it may serve as a mediation of resistance.

Nabil Echchaibi, in Chapter 9, explores mediations of Muslim modernities, that is, how conceptions of modernity that challenge traditional as well as secular views are mediated in Islamic media. A 'new generation of Muslims seeks alternative frames of political and cultural identification' (p. 138). Echchaibi researches this 'dialectic with modernity' in new forms of Islamic (satellite) television and Internet activity. The 'tele-Islamists' usually have a digital presence as well. Echchaibi particularly examines the programming by the initiator of Islamic Entertainment Television, Amr Khaled, and the young programme creator Moez Masood, who has a huge audience among young Muslims across the Arab world for his shows on faith and life. Echchaibi manages to show how complex these mediations of Islam are.

Mia Lövheim, in Chapter 10, identifies gender as a core dimension of religious change and studies how young women express and mediate religion and ethical challenges in blogging. Approaching religion as a practice of mediation, following Meyer's outline, Lövheim refers to research on how women's bodies have played a key role in mediation by Christian women in various new media across time. There is a 'transformative dynamic' among religion, media, gender, and commodification, she argues, with reference to Diane Winston's (2012) study of the Salvation Army. This also occurs in the female personal blogs that Lövheim analyses as a genre of new digital media. Her cases are highly popular young Swedish 'top-bloggers.' Lövheim observes how they use religious symbols and negotiate religious behaviour in their blogs as a new mode of mediation. These blogs become 'ethical spaces' (p. 165) and there is a gender dynamic at the heart of this mediation mode as to 'women's religious lives and positions' (p. 166). Lövheim finds that the 'characteristics of new actors and arenas for the mediation of religion emerging through new, digital media also pose questions about the transformation of religion in modern society' (p. 166). She points to how signs of religion become more of a personal matter and less confined to institutional spaces and, at the same time, how religion in late modern societies is more visible as existential questions of values, morals, and ethics that used to be considered private are now asked in public.

Stewart M. Hoover, in Chapter 11, takes the discussion into a more general assessment of 'evolving religion in the digital media.' With a broad definition of media and an expanded definition of religion beyond established structures and authorities, Hoover moves into the digital terrain. He gets close to Meyer's 'mediation of religion' thesis, 'that all religions have always been mediated, and that new forms of media simply introduce new forms through which religion is circulated'

(p. 173). Hoover finds it particularly helpful for a discussion of digital religion 'that the contemporary mediation of religion needs to be seen in terms of its aesthetic capacities, its "sensational forms,"' as Meyer has suggested. 'These aesthetic forms, and more particularly, their affordances, define the capacities of media today to mediate religion,' he concedes (p. 173).

Mediation Without Transformation

This is the crucial question: To what extent does material mediations of religion lead to lasting transformations? In several of the cases and chapters in this volume, as shown previously, no necessary link between mediation and transformation is established. The religious practices that are discussed definitely have to be understood through their forms of mediation. But ongoing mediations may just as well sustain or simply adjust established religious practices rather than change or transform them. However, according to Meyer, it is the third element in the tripod conceptualization, that of materiality, that may trigger mediations into transformations. Transformations may occur when new media are introduced into existing communication patterns. This is not a deterministic proposition, as media are socially embedded. Meyer explains:

> [M]edia are crucial factors for the formation and transformation of religion, both internally (regarding relations between leaders and followers) and externally (regarding religion's position in society). From the perspective of mediation, the incorporation of a new medium into established, longstanding religious sensational forms is not a simple transfer. My point here is that what a medium is and does is not fixed, but subject to negotiation and incorporation within a religious tradition, both on the level of theology and actual religious practice. What a medium is and does is constituted socially. (Chapter 1, p. 10)

While I agree with this approach, I find it necessary to bring the technological aspect of the media to the fore. I want to supplement Meyer's anthropological religious-studies perspective from my media sociological background.

The Issue of Technology

Religion and technology are entangled (Stolow, 2013). A technology is a technical tool or invention taken into social use. The actual use may not be what the inven-

tor envisaged but how people shape and adjust the invention to their needs. SMS messaging was not, for example, intended as a main cell phone activity but was developed as such by the mobile users (Ling, 2008, p. 15). A technology is socially shaped and embraced while a pure technical invention may not be. It then goes out of 'the market,' out of social and cultural circulation.

As noted in my Introduction, I make a distinction between 'embedded' and 'disembedded' media technologies. The former relies on the materiality of the body or on objects that are located in a certain geographical space, like the musical instruments in ancient Hebrew religion (Chapter 2) or the Brahmin priests in Hindu temples (Chapter 5). Disembedded media work over distance and may be based on print, broadcast, or digital technologies, for example.

The materiality of a medium gives certain possibilities but also implies some restrictions on the actual religious mediation. Each kind of medium offers some *affordances,* that is, constraining as well as enabling properties in the communication and interaction processes (Hutchby, 2001, 2003). The affordance of handwriting is different from the affordance of printed material in the communication of religious texts, and digital media offer affordances other than print. The affordances of the various media condition the mediation practices and, hence, the religious practices that are shaped in the mediations.

Digital media technologies may actually give an impression of being embedded media, more so than mass media. Newspapers, radio, and television are visibly external to the body, while 'smart' devices and Internet connections, with streamed music, social networking, e-mail, shopping services, and information gathering, become closer and closer to the body. However, when they do not work we are reminded how embedded this 'media life' (Deuze, 2012) is in advanced technical systems. Is the dynamics of digitalization qualitatively different from former media of mediation? I tend to say yes, due to the unlimited multimodality, interactivity, and hypertextuality of the digital media.

Mediation—Technology and Culture

This chapter is about mediation and possible transformations of religion or other cultural or social practices due to the material media or technologies that are involved. Let me examine briefly some perspectives on mediation and technology that may add to the discussion of mediation and transformation so far.

Bruno Latour (2005) makes a significant distinction between 'mediators' and 'intermediaries.' Mediators have the capacity to transform the cultural and social activities in which they are active while intermediaries only transport meaning without transformation (p. 39). In the context of this book, religious manuscripts are inter-

mediaries in a monastery culture (Lied in Chapter 4) while printed Bibles (Eisenstein, 1979) and missionary mass pamphlets (Morgan, 2011) become mediators.

A review of the chapters, as I have above, demonstrates that mediation of religion may not necessarily lead to transformations of the religious practices. The material mediations, then, work as intermediaries to confirm existing patterns. However, when the material mediations work as mediators, transformations of religion may occur. As Latour (2005) says, mediators 'transform, translate, distort, and modify the meaning or the elements they are supposed to carry' (p. 39).

Raymond Williams (1975) has taught us that media have to be treated as both technology and cultural form. In *Keywords* (1988, pp. 204–207) he identifies three different meanings of 'mediation' in current use. The first is to reconcile adversaries through acts of intermediation, but this meaning is not relevant here. However, the two other meanings are. One is mediation as form, where the form of the medium in itself may cause or stimulate transformation. The media form intervenes in the relationship between the 'producer' and the 'consumer' of the cultural content or practice. This applies to mediated communication where the form of the medium is a matter of technology. The third sense of 'mediation' is particularly relevant to disembedded media with their technology. In Sonia Livingstone's (2009) words, this is the sense of mediation where the 'media overcome (or *transform*) [emphasis added] distance, both physical and symbolic, time and space, and so connect otherwise separated parties' (p. 13).

Out of his experiences of struggles in Latin America, Jesús Martín-Barbero (1993) early advised the move from 'media' to 'mediations.' By the latter he meant 'the articulations between communication practices and social movements and the articulation of different tempos of development with the plurality of cultural matrices' (p. 187). This takes media technologies into the social and cultural landscape where religion usually is significant. This is a bottom-up view on mediations, which may imply transformations by challenging power and hegemonic structures. Martín-Barbero (2003) is concerned with how mediation sparks cultural transformations.

Pitirim A. Sorokin, the Russian scholar who became the first professor in sociology at Harvard University in the United States, may help us extend our understanding of mediation, materiality—and transformation. Some of his writings and examples look outdated today but the structure of sociocultural phenomena that he lays out in *Society, Culture and Personality: Their Structure and Dynamics* (1947) is valid and relevant for this particular discussion.

Sorokin (1947) introduces 'material vehicles' as a 'universal component of sociocultural phenomena' (p. 51). Religion is among them. His theorizing on material vehicles is about mediation, I will argue, although he does not use the term. Sorokin states: 'Since pure meanings, values, and norms are immaterial, spaceless, and timeless, they cannot be transmitted directly from mind to mind' (p. 51). Meanings have

to be externalized, objectified, and socialized through vehicles.[2] Such vehicles could be overt actions, material objects, or natural processes that are used in social interaction (p. 52). These 'vehicles' are the material part of 'media' as defined in this book. The vehicles work as 'conductors' of meaningful interaction or communication, that is, in processes of mediation. Sorokin acknowledges them as 'media,' stating that interaction across time and space is possible 'only through the media of vehicles as conductors' (p. 52).

Sorokin (1947) makes a distinction between physical and symbolic conductors, although the two aspects may be connected. Physical conductors work with quite a range of physical phenomena: in gestures and expressive movements of the body, in sound waves, light and colour, in thermal and mechanical forms of energy. There are chemical conductors where chemical properties are used for interaction. Sorokin also lists 'electrical and radio conductors' (pp. 52–53). If he had been around today he would surely have also mentioned digital conductors. Symbolic conductors, on their part, 'exert an influence not so much through their physical properties as by virtue of the symbolic meaning attached to them' (p. 53). Different vehicles may combine into chains of conductors in mediated communication (pp. 53–57).

Sorokin (1947) regards 'meaningful human interaction' as 'the generic social phenomenon' (p. 39). He does not stress the communicative aspect but is aware of communication as the flip-coin of human interaction (p. 578). This is visible in his explanation on transformation of cultural phenomena. Sorokin actually formulates 'The Laws of Transformation':

> When the difference between the culture of departure and that of infiltration remains constant, the extent of the transformation of the migrating phenomenon depends upon its own nature. The more complex, refined, and intricate the phenomenon, and the greater the training required for its use, the more profoundly it changes in the culture of infiltration. (p. 573)

Religion is a cultural phenomenon under these 'Laws of Transformation.' Most religions will have the inherent complexity that Sorokin points to, where transformation of the actual religion takes place in the mediation between cultural contexts. Since there are 'scarcely any individuals or groups with identical cultures, an overwhelming majority of migrating cultural phenomena undergo a transformation.' Transformations of cultural phenomena depend on the media ('conductors of interaction') that are at hand. If they are 'mechanically standardized, like the printing press, thousands of cultural meanings can be conveyed clearly to all who know and read the language' (p. 573). He observes that modern, technical media—what he termed '*a more developed system of communication and interaction*' (p. 578)—may reach

more people and thus accelerate the transformations, as they—like 'letters, telegrams, the radio, etc.' (p. 52)—make interaction possible across physical distance.

Sorokin, Latour, Williams, and Martín-Barbero show us how material mediations across cultural settings may transform the actual cultural practice. This applies to religion, and this is in accordance with Birgit Meyer's reasoning on material mediations.

However, when the mediation takes place by media that '*will reach a greater number of persons and groups*,' that is, by disembedded, modern media, the transformations take place with a broader scope and at a greater distance. I find the term *mediatization* more apt than *mediation* for transformations in such a media environment. This, however, is on the premise that the disembedded media are not to be found one by one but, rather, creating a context saturated by such technical means for communication and social interaction.

Mediatization as a Life Horizon

The transformations inherent in mediatization change the life horizon of people. Mediatization takes place in an environment saturated with disembedded media and the concept of mediatization is related to this evolving media environment. Disembedded media in use on a broad scale make people experience mediated communication as part of the normal social interaction across time and space.

Across time, cultural memory could be stored and restored in printed books. The difference from manuscript culture is in the availability, as books could be printed and sold in 'mass' numbers. Recordings captured live music and kept it for replay. Photography made it possible to store and retrieve images. Today, with digitalization and networked media, old tunes and popular films can be retrieved in streaming services, available to a growing number of people. Databases and digital libraries make it easy to trace past material with a broad scope.

These disembedded media working across time also make the content available across space, as they could be accessed from anywhere that has an outlet or a connection to the network. And it is about to work the other way around: Newspapers, radio, and television spread news and entertainment that disappeared as soon as they were aired or distributed. Today, mass media content can be recalled from digital archives.

Religion may be transformed in this disembedded media environment simply by the way religious symbolization is present or not present. We know that the printing 'revolution' made Bibles available to a reading public in their own language, thus helping the breakaway of Protestantism from the Catholic Church (Eisenstein, 1979). We do not know yet how the digital 'revolution' with its multitude of individual 'likes' and postings will transform contemporary religion, al-

though we have some indications from Heidi Campbell's (2012) review of recent research on 'networked religion.' It spans between the offline and the online and is characterized by 'networked community, storied identities, shifting authority, convergent practice, and a multisite reality' (Campbell, 2012, p. 1).

Mediatization moulds (Hepp, 2012) the life horizon of people living in media-saturated societies. Borrowing the term from Latour (2005, pp. 187–190) Andreas Hepp sees this horizon as a 'panorama' where the outlook through the media gives actors a sense of complete overview that may actually be distorted through the representations in these media. Hepp (2013, pp. 46–54) relates this mediated panorama to the idea of mediatization as a 'meta-process,' proposed by Friedrich Krotz (2007, 2009). He understands mediatization as being on par with globalization, individualization, and commercialization. These 'metaprocesses are panoramas of comprehensive processes of change' grasped as 'panoramas of scientific metatheory' (Hepp, 2013, p. 50) and as part of the life horizon of people in everyday life. Nick Couldry (2012) also sees mediatization as a metaprocess 'that is grounded in the modification of communication as the basic practice of how people construct the social and cultural world' (p. 136).

Mediatization manifests itself in daily interaction as 'mediatized worlds.' They are the small everyday life-worlds at work, in family and leisure time, in political parties, religious groups, and so on, where people to a large extent interact through media with the panorama they gather from the media. The concept of mediatized worlds is a concretization of mediatization. In mediatized worlds people interact beyond their territorial location through networked media. Mediatized worlds exist on various scales, from small to large, and they are nested or interlaced with each other (Krotz & Hepp, 2012).

This approach applies a social-constructivist approach to mediatization, with roots in symbolic interactionism and social phenomenology (Hepp, in press). The alternative is an institutional approach, championed by Stig Hjarvard, focusing how various institutions in society, and religious institutions among them, rely more and more on the media, and where the media themselves are gaining a stronger position in society (Hjarvard, 2008b, 2013). So far, an institutional approach has dominated the research on mediatization of religion (Hjarvard, 2008a, 2012; Hjarvard & Lövheim, 2012). Hepp (in press) observes the difference between a social-constructivist and an institutional approach to mediatization but thinks that they may be combined. I agree; they meet in a focus on social interaction (Hepp, 2012; Hjarvard, in press). Both perspectives are necessary and useful in studies of mediatization of religion. In this chapter, I get closer to the 'mediatized worlds' approach than I have done in former writings (Lundby, 2009) because this opens the panorama to all forms of mediatized religion.

I recognise mediatization when embedded and disembedded media impact people's life horizons and make a base for a significant part of the social interaction within a certain area, thus becoming a 'mediatized world.' This makes mediatization a modern phenomenon dependent on wide availability and use of disembedded media. I agree with David Morgan (2011) that mediatization theory needs to be 'strongly qualified by historical evidence' (p. 137). However, I cannot see that mediatization theory fits back in time beyond a mature print culture.

Mediatization of Religion in This Book

Following the previously mentioned, mediatization of religion is identified in the later part of the historical span covered in this book because this is the period saturated by disembedded media. The transformations then occur within a social and cultural environment where these technical media have become obvious in everyday interaction for individuals and institutions.

To what extent are transformations through mediatization, in this sense, coming to the fore in the contributions to this volume? This is clearly visible in the chapters that place a heavy emphasis on the disembedded media, particularly on digital mediation: Chapters 9, 10, and 11 and the main part of Chapter 6.

For me, the many characteristics and transformations that Stewart Hoover relates to digital media and digital technologies per se make them part of a broad context of mediatization. As he says, 'it appears that there is something entirely new about religion in relation to digital media' (p. 181). Peter Simonson takes rhetoric all the way into this digital realm. Digital eloquence may serve to solidify and confirm meanings and identifications, as is a main function of rhetoric. However, the multimodality of the digital makes transformations through rhetoric more likely (p. 97). Digital eloquence, then, implies mediatization in a context set by digitalization. Nabil Echchaibi does not use the term 'mediatization' but his explorations into the complex dialectic with modernity in new forms of Muslim media demonstrate what mediatization is: Within a rapidly growing environment of Islamic 24-hour channels, Web outlets, record companies, and 'clean cinema,' mediatization takes place when traditional Muslim authority is challenged and definitions of Muslim practices are reconfigured and transformed. Mia Lövheim asks how the new ethical spaces she identifies in young female top-blogs relate to transformation of religion in contemporary society. The new digital mediation forms, in the individualized societal context, transform gender roles and authority structures. These transformations are part of a disembedded media environment and, hence, related to processes of mediatization.

The chapters in the book that focus on old embedded media (Chapters 2, 3, 4, and 5) do not play with mediatization. The media they cover are directly involved in the religious practices and do not create a media environment for society as a whole. Terje Stordalen explores performative media through dance and music. These media in ancient Hebrew religion may have triggered transformations of the religious practice, but as mediations, not within a context of mediatization. Peter Horsfield explains transformation of early Christianity in the mediation shift from oral to handwritten communication. However, this transformation was not a mediatization process, as writing did not dominate fully and technical media were not applied. It was, rather, the Roman political order with its 'fast and effective empire-wide infrastructure of communication to support political, military, cultural, and trade activities' (p. 46) that made the dominant horizon, not writing as such. Later, the Catholic Party used the media distribution system of the political empire to transform Christianity into a global religious empire with censorship and control through the Latin language. However, these transformations, again, strengthened the Church as an institution rather than made a media environment as such. Liv Ingeborg Lied criticizes the tendency among media scholars to distinguish between a pre-print period where transformations are not really found to take place, and the post-print era where they do. The latter could be characterized by a concept of mediatization, as John B. Thompson does in his study of *The Media and Modernity* (1995).[3] Lied's example from Syriac monasteries proves that rich mediations were going on within this media culture, but not as mediatization in an all-encompassing media environment. The same goes for Ute Hüsken. There are particular transformations with the Brahmin temple priests when they mediate the rituals, but not as mediatization in an overall media environment. Rather, the priests have a marginal position in society.

Three chapters cover a mix of embedded and disembedded media (Chapters 1, 7, and 8). The transformations Birgit Meyer points to with her examples from Ghana are within the conceptual scope of mediation. Although some disembedded media are involved, these transformations do not occur on the base of broad saturation of such media. Hence, the concept of mediatization is out of scope. In the other chapter on Pentecostals, discussing the case on the Romani people, David Thurfjell talks about a group that has 'an experience of being different from the majority cultures in a very profound way' (p. 129). Media-wise they have no standardized language, no Bible translations, no books, no papers, and no written documents—just oral tradition and spoken folklore. They also have no common practice that would be recognised as religion, Thurfjell explains. However, when Roma people now gather as Romani Pentecostals, they apply a range of media including Internet spaces. This transforms the former mediations into a mediatization of being Roma. Kim Knott discusses transformations of religion in spatial

contexts through cases about the location of religion in secular environments. She concludes that we 'draw on our embodied cognitive and linguistic resources to mediate our religious identities, to represent others, and to produce innovative ideological and practical spaces' (p. 118). This, to me, turns into processes of mediatization when the transformations take place on the broad canvas created by mass media, supported by social media.

Mediation and Mediatization

Some of the authors in this volume have discussed the relation between mediation of religion and mediatization of religion (Birgit Meyer in Chapter 1, Kim Knott in Chapter 7, Mia Lövheim in Chapter 10, and Stewart Hoover in Chapter 11). I regard mediation and mediatization as complementary and not conflicting terms. In *Cultures of Mediatization* (2013) Andreas Hepp clarifies the distinction as far as media and communication studies goes:

> While mediation is suited to describing the general characteristics of any process of media communication, mediatization describes and theorizes something rather different, something that is *based on* the mediation of media communication: *mediatisation seeks to capture the nature of the inter-relationship between historical changes in media communication and other transformational processes.* Hence mediatization *presumes* mediation through media communication. (p. 38, his emphases)

Mediation is the broad concept. In media and communication studies this is the general process of mediated communication. As put by Stig Hjarvard (in press): 'By mediation we usually understand the use of a medium for communication and interaction.'[4] Still, mediation is restricted to modern, technical media. This volume applies a broader and more dynamic concept of 'mediation' with reference to Birgit Meyer's work on mediation of religion. Mediation in this sense encompasses the broad range of media discussed here based on Meyer's approach.

Mediatization is a more specific concept. That religion is defined by its practices of mediation does not imply that all religions are mediatized. A state or process of mediatization requires a context for the ongoing mediations: a media-saturated environment, as explained above. Mediatization could occur when various media provide a horizon for the communication and interaction between individuals, part of which is about religion. Mediatization, then, is characterized by the media-saturated context and, further, by the transformations this may imply—in our case, of religion. 'Through its electronic reproduction and circulation, religion is transformed

in ways that reflect the media of transmission and the economy and politics of media that shape its circulation' (Herbert, 2011, p. 640). Mediatization primarily relates to disembedded media, because they have the capacity to make the kind of media-saturated environment that moulds everyday interaction. This implies that studies of transformations through mediatization are more preoccupied with media technology than the general perspective on mediation in this book. My project is to find the best from both perspectives and to see how they match or diverge.

Varieties of Transformation

While transformations *may* follow mediations, but quite often do not, transformations are inherent in mediatization. In line with Latour (2005, p. 39), material mediations may be intermediaries while mediatization always require mediators. Transformations with mediation relate to the materiality of the media in question, and this shapes the actual religious practices. The material mediation is inherent to the religious practice.

The mediation perspective gives priority to the forms of *religion,* while the mediatization approach gives priority to the forms of *media.* Transformations with mediatization follow from the media-saturated context or environment within which religious practices and ideas are grown alongside other cultural and social expressions. A mediatization approach may thus be well fitted to grasp transformations of religion in individualized and fragmented settings.

The mediation of religion perspective, then, takes it point of departure in changing religious practices (and ideas) and points to the role of the material media in these transformations. The perspective of the mediatization of religion starts with the changes in media in a disembedded media landscape and observes transformations of religion within that context. In a mediation perspective, transformation of religion is seen from inside the mediation practices of the actual religion, while the mediatization perspective sees transformations of religion from outside, through the media-saturated environment.

Notes

1. I am grateful to Birgit Meyer for constructive comments on a draft of this chapter.
2. Berger and Luckmann (1966/1971) do not refer to Sorokin for their circle of externalization, objectivation, and internalization in the 'social construction of reality' but the resemblance is obvious. The same goes for Peter Berger's sociological theory of religion, *The Sacred Canopy* (1967/1969).

3. Although Thompson terms it 'mediazation.'
4. Within media and communication studies there has been a dispute about whether 'mediation' or 'mediatization' is the most apt term on long-term transformations (Couldry, 2008). This dispute is settled in favour of 'mediatization,' which Nick Couldry (2012, p. 134) acknowledges.

References

Berger, P. L. (1967/1969). *The sacred canopy: Elements of a sociological theory of religion (Later: The social reality of religion)*. Garden City, NY: Anchor Books.

Berger, P. L., & Luckmann, T. (1966/1971). *The social construction of reality*. Harmondsworth, Middlesex: Penguin.

Campbell, H. A. (2012). Understanding the relationship between religion online and offline in a networked society. *Journal of the American Academy of Religion, 80*(1), 64–93.

Couldry, N. (2008). Mediatization or mediation? Alternative understandings of the emergent space of digital storytelling. *New Media & Society, 10*(3), 373–391.

Couldry, N. (2012). *Media, society, world. Social theory and digital media practice*. Cambridge: Polity.

Deuze, M. (2012). *Media life*. Cambridge: Polity.

Eisenstein, E. L. (1979). *The printing press as an agent of change. Communication and cultural transformations in early-modern Europe* (Vol. I–II). Cambridge: Cambridge University Press.

Hepp, A. (2012). Mediatization and the 'molding force' of the media. *Communications: The European Journal of Communication Research, 37*(1), 1–28.

Hepp, A. (2013). *Cultures of mediatization*. Cambridge: Polity.

Hepp, A. (in press). Mediatization as a panorama in media and communication research. In J. Androutsopoulos (Ed.), *The media and sociolinguistic change*. Berlin: de Gruyter.

Herbert, D. E. J. (2011). Theorizing religion and media in contemporary societies: An account of religious 'publicization.' *European Journal of Cultural Studies, 14*(6), 626–648.

Hjarvard, S. (2008a). *The mediatization of religion. A theory of the media as agents of religious change. In S. Hjarvard (Ed.), The mediatization of religion. Northern Lights* (Vol. 6, pp. 9–26). Bristol: Intellect.

Hjarvard, S. (2008b). The mediatization of society. A theory of the media as agents of social and cultural change. *Nordicom Review, 29*(2), 105–134.

Hjarvard, S. (2012). Three forms of mediatized religion. Changing the public face of religion. In S. Hjarvard & M. Lövheim (Eds.), *Mediatization and religion. Nordic perspectives* (pp. 21–44). Gothenburg: NORDICOM.

Hjarvard, S. (2013). *The mediatization of culture and society*. London: Routledge.

Hjarvard, S. (in press). From mediation to mediatization: The institutionalization of new media. In F. Krotz & A. Hepp (Eds.), *Mediatized worlds: Culture and society in a media age*. Basingtoke: Palgrave.

Hjarvard, S., & Lövheim, M. (Eds.). (2012). *Mediatization and religion. Nordic perspectives*. Gothenburg: NORDICOM.

Hutchby, I. (2001). Technologies, texts and affordances. *Sociology, 35*(2), 441–456.

Hutchby, I. (2003). Affordances and the analysis of technologically mediated interaction. *Sociology, 37*(3), 581–589.

Krotz, F. (2007). *Mediatisierung: Fallstudien zum wandel von kommunikation.* Wiesbaden: VS Verlag für Sozialwissenschaften.

Krotz, F. (2009). Mediatization: A concept with which to grasp media and societal change. In K. Lundby (Ed.), *Mediatization: Concept, changes, consequences* (pp. 21–40). New York: Peter Lang.

Krotz, F., & Hepp, A. (2012). A concretization of mediatization: How mediatization works and why 'mediatized worlds' are a helpful concept for empirical mediatization research. *Empedocles—European Journal for the Philosophy of Communication, 3*(2), 119–134

Latour, B. (2005). *Reassembling the social. An introduction to Actor-Network-Theory.* Oxford: Oxford University Press.

Ling, R. (2008). *New tech, new ties. How mobile communication is reshaping social cohesion.* Cambridge, MA: MIT Press.

Livingstone, S. (2009). On the mediation of everything. *Journal of Communication, 59*(1), 1–18.

Lundby, K. (2009). *Mediatization: Concept, changes, consequences.* New York: Peter Lang.

Martín-Barbero, J. (1993). *Communication, culture and hegemony: From the media to the mediations.* London: Sage.

Martín-Barbero, J. (2003). Cultural change: The perception of the media and the mediation of its images. *Television & New Media, 4*(1), 85–106.

Meyer, B. (2009). From imagined communities to aesthetic formations: Religious mediations, sensational forms, and styles of binding. In B. Meyer (Ed.), *Aesthetic formations. Media, religion, and the senses* (pp. 1–28). New York: Palgrave Macmillan.

Meyer, B. (2011). Mediation and immediacy: Sensational forms, semiotic ideologies and the questions of the medium. *Social Anthropology, 19*(1), 23–39.

Morgan, D. (2011). Mediation or mediatisation: The history of media in the study of religion. *Culture and Religion, 12*(2), 137–152.

Sorokin, P. A. (1947). *Society, culture, and personality. Their structure and dynamics. A system of general sociology.* New York: Harper.

Stolow, J. (Ed.). (2013). *Deus in machina. Religion, technology, and the things in between.* New York: Fordham University Press.

Thompson, J. B. (1995). *The media and modernity.* Oxford: Polity Press.

Williams, R. (1975). *Television, technology and cultural form.* New York: Schocken Books.

Williams, R. (1988). *Keywords.* London: Fontana Press.

Winston, D. (2012). The angel of Broadway: The transformative dynamics of religion, media, gender, and commodification. In G. Lynch & J. Mitchell (Eds.), *Religion, media and culture: A reader* (pp. 122–130). Oxon: Routledge.

Woodhead, L., Partridge, C., & Kawanami, H. (2009). *Religions in the modern world. Traditions and transformations* (2nd ed.). London: Routledge.

Contributors

NABIL ECHCHAIBI is Assistant Professor and Associate Director of the Center for Media, Religion, and Culture at the University of Colorado Boulder, USA. His research focuses on religion and the role of media in shaping and reflecting modern religious subjectivities among Muslims in the Middle East and in diaspora. His work on diasporic media, Muslim media cultures, and Islamic alternative modernity has appeared in various international publications such as *Javnost, International Communication Gazette, Journal of Intercultural Studies, Nations and Nationalism, Journal of Arab and Muslim Media Research, Media Development,* and in many book publications. He is the author of *Voicing Diasporas: Ethnic Radio in Paris and Berlin Between Culture and Renewal* (Lexington Books, 2011) and the co-editor of *International Blogging: Identity, Politics and Networked Publics* (Peter Lang, 2009).

E-mail: nabil.echchaibi@colorado.edu

STEWART M. HOOVER is Professor of Media Studies and Religious Studies at the University of Colorado at Boulder (USA), where he directs the Center for Media, Religion, and Culture. His field of scholarship is in media audience research, media history, and the social and political impact of the media. Professor Hoover has studied and written about a diverse array of topics in this field, including televangelism, religion journalism, religion in secular and entertainment media, and religion in the Internet and digital media. He and his colleagues have studied the ways

audiences today find religious and spiritual meaning in the media: from books, television, and film to Facebook and other social media. He is author or editor of ten books, including *Media, Home, and Family* (with Lynn Schofield Clark and Diane F. Alters, Routledge, 2004), and *Religion in the Media Age* (Routledge, 2006).
E-mail: hoover@colorado.edu

PETER HORSFIELD is Professor of Communication and Associate Dean in the School of Media and Communication at RMIT University in Melbourne, Australia, where he also established and led the Media and Religion Research Project. He has written extensively and edited compilations on the interface of media and religion, including religious broadcasting, media and social religiosity, and media and the transformation of religious traditions. He is currently working on a history of media in the development of Christianity.
E-mail: peterhorsfield@optusnet.com.au

UTE HÜSKEN is Professor of Sanskrit at University of Oslo, Norway. She was educated as an Indian and Tibetan studies scholar and as a cultural anthropologist in Göttingen (Germany). She lectured at Göttingen and Heidelberg University. In Oslo she teaches courses on religion in South Asia, Sanskrit, Pali, ancient and contemporary Buddhism, Hinduism, and Jainism. Her major publications include the 2009 monograph with DVD *Visnu's Children. Prenatal Life-Cycle Rituals in South India* (Wiesbaden: Harrassowitz), and a volume on *Ritual, Media, and Conflict*, which she co-edited in 2011 with Ronald L. Grimes, Udo Simon, and Eric Venbrux (New York: Oxford University Press).
E-mail: ute.huesken@ikos.uio.no

KIM KNOTT is Professor of Religious and Secular Studies at Lancaster University in the UK. She works on religion, space and place, religion and media, and diaspora studies. Her recent publications include *The Location of Religion: A Spatial Analysis* (Equinox, 2005), *Diasporas: Concepts, Intersections, Identities* (Zed, 2010, with Seán McLoughlin) and the website www.movingpeoplechangingplaces.org. In recent years she developed a spatial methodology that she has used to examine the location of religious and non-religious beliefs and values in secular contexts. From 2008–2010, she directed a research project on *Media Portrayals of Religion and the Secular Sacred*, and she has recently completed a book by the same title (Ashgate, 2013).
E-mail: k.knott@lancaster.ac.uk

LIV INGEBORG LIED (Dr.art., 2007, University of Bergen) is Professor of Religious Studies at MF Norwegian School of Theology in Oslo, Norway. Lied has published on both contemporary and ancient media culture. She is the author of *The Other Lands of Israel: Imaginations of the Land in 2 Baruch* (2008), and *Det folk vil ha: religion og populærkultur* [What People Want: Religion and Popular Culture] (with Dag Øistein Endsjø, Universitetsforlaget, 2011).
E-mail: Liv.I.Lied@mf.no

KNUT LUNDBY is Professor of Media Studies at the Department of Media and Communication, University of Oslo, Norway. He wrote his doctoral dissertation in sociology of religion. Lundby was among the founding members of the international research community on Media, Religion, and Culture since 1993 and edited *Rethinking Media, Religion, and Culture* (Sage, 1997) with Stewart M. Hoover. He is co-editor of *Implications of the Sacred in (Post)Modern Media* (Nordicom, 2006). Lundby was founding director of the research centre InterMedia, University of Oslo, working on communication, learning, and design in digital environments. He has edited *Digital Storytelling, Mediatized Stories. Self-Representations in New Media* (2008) and *Mediatization: Concept, Changes, Consequences* (2009), both with Peter Lang.
E-mail: knut.lundby@media.uio.no

MIA LÖVHEIM is Professor in Sociology of Religion, Uppsala University, Sweden. Her current research focuses on performances of religious and gender identity among youth, particularly on the Internet, and on representations of religion in Swedish daily press. Her work has appeared in the journals *Nordicom Review; Information, Communication and Society; Feminist Media Studies; Culture and Religion;* and *Nordic Journal of Society and Religion.* She is the editor of *Media, Religion and Gender: Key Issues and Future Challenges* (Routledge, in press) and, with Stig Hjarvard, of *Mediatization and Religion: Nordic Perspectives* (Nordicom, 2012).
E-mail: mia.lovheim@teol.uu.se

BIRGIT MEYER is Professor of Religious Studies at the Department of Religious Studies and Theology at Utrecht University in the Netherlands. She is an anthropologist working on Africa (Ghana), with a strong thematic interest in Pentecostal movements, popular culture, religion and media, art and aesthetics, and post-secular publics. Her publications include *Translating the Devil. Religion and Modernity Among the Ewe in Ghana* (Edinburgh University Press, 1999), *Religion, Media and*

the Public Sphere (edited with Annelies Moors, Indiana University Press, 2006), *Aesthetic Formations. Media, Religion and the Senses* (Palgrave Macmillan, 2009), and *Things. Religion and the Question of Materiality* (edited with Dick Houtman, Fordham UP, 2012). She is vice-chair of the International African Institute (London), a member of the Royal Dutch Academy of Arts and Sciences, and one of the editors of *Material Religion*. In 2010–2011 she was a fellow at the Institute for Advanced Study (Wissenschafstkolleg), Berlin.

E-mail: B.Meyer@uu.nl

PETER SIMONSON is Associate Professor in the Department of Communication at the University of Colorado Boulder (USA). He has published on the intellectual history and theory of rhetoric and mass communication, the religious and normative horizons for thinking about them, and the history of the study of communication, among other subjects. He is the author of *Refiguring Mass Communication: A History* (Peter Lang, 2010) and editor or co-editor of *The Handbook of Communication History* (Routledge, 2013), *Politics, Social Networks, and the History of Mass Communications Research: Re-Reading* Personal Influence (The Annals, 2006), and *Mass Communication and American Social Thought: Key Texts* (Rowman & Littlefield, 2004).

E-mail: peter.simonson@colorado.edu

TERJE STORDALEN is a Professor of Theology (Hebrew Bible/Old Testament studies) at the Faculty of Theology, University of Oslo, Norway. His thesis from 1998— 'Echoes of Eden: Genesis 2–3 and Symbolism of the Eden Garden in Biblical Hebrew Literature'—explored garden symbolism across different ancient media. In recent years Terje Stordalen has worked and published on canonicity and canonical commentary in comparative sight, on memory perspectives in biblical studies, on the Book of Job, and on classical Hebrew religion and Old Testament theology. During the years 2008–2010 he coordinated the research network PluRel (Religion in Pluralist Societies) at the University of Oslo.

E-mail: terje.stordalen@teologi.uio.no

DAVID THURFJELL is Associate Professor and Research Fellow in Religious Studies at Södertörn University, Stockholm, Sweden. He received his doctoral degree in History of Religions from Uppsala University (2003) and has published widely within the fields of Islamic and Romani studies. His academic interests also include secularization and religious change, Iranian and Shi´ite studies, as well as rit-

ual and postcolonial theory. He is the author of *Living Shiʿism: Instances of Ritual-isation Among Islamist Men in Contemporary Iran* (Brill, 2006) and *Faith and Re-vivalism in a Nordic Romani Community: Pentecostalism Among the Kaale Roma of Sweden and Finland* (I. B. Tauris, 2013).

E-mail: david.thurfjell@sh.se

Index

(e) = Endnote
(sh) = Section head

A

Actor-network theory, 15, 31, 83, 195, 196
aesthetic formations, xx, 24, 88, 93, 95 (sh),
 97–98, 100–101, 187
Alacoque, Margaret Mary, 12–13
Ambrose, 46–47
ancient Hebrew religion/Israel, xiii, xvi, xviii, 10,
 20–32, 187, 192, 198
 case of, 21, 31
 Deuteronomic literature, 24
 Garden of Eden, 28
 grief and joy in, 26
 Israelite aniconism, 24
 religion in, 24, 29
 rhetoric in, 92
 symbolizations of, 30
anthropology, xi, xiv, 3, 5, 14, 88, 173, 185
 cultural, xii
 philosophical, 91
 of religion, xii

Arab Spring, xvii, xxi, 138, 143, 151 (e)
Aristotle, 89, 92
 Rhetoric, 92
Augustine of Hippo, 48, 92, 94, 95
 Confessions, 49, 92

B

Bhabha, Homi, 112
Bible (translations and canons)
 Greek Septuagint, 21
 King James Bible, 99
 Latin Vulgate, 21, 32 (e 5)
 Masoretic accentuation for chant, 28
 Qumran manuscripts, 28, 33 (e 21)
blogging
 Ana-Gina's blog, 161
 Bloggportalen.se, 159
 blogs as ethical spaces, 165, 190, 197
 Stina's blog, 160
Bourdieu, Pierre, 24, 33 (e 9), 38, 41,
 cultural products, 24
Brasher, Brenda, 174, 177
Braun, Joachim, 26, 33 (e 15)

Burke, Kenneth, 94, 98

C

Campbell, Heidi, 155, 175, 177, 196
Carrithers, Michael, 23–24
Chakrabarty, Dipesh, 139
Christianity
 Calvinist reformation theology, 12
 Catholicism, 12
 Catholic (brand), xix, 49–50
 Catholic piety, 12
 Church, 12, 43, 49, 160, 195
 Irish Catholics in Boston, 115
 post-Catholic media theory, 8
 Coptic Church, 62
 early Christianity
 Catholic-Orthodox Party, 43–46, 49, 51,
 188, 198
 Church Council Nicaea (325 AD), 44
 Gnostic Christianity, 43
 Logos Christianity, 43
 Marcionism, 43
 Montanism, 43
 Evangelism, 92, 125, 170
 Neo-evangelicalism, 171
 Pentecostalism, xiii, xx, 11, 125–127, 128, 132, 133,
 134, 171
 pentecostal in Ghana, xv, 9, 186
 pentecostal revivalism, 122–123, 125 (sh), 128
 pentecostal Roma, xv, 125, 127, 132, 134,
 189–190, 198
 Protestant, 2, 11
 ideas about God as the Wholly Other, 7
 Ulster Protestants in Boston, 115
 Reformation and Counter-Reformation, 90
 Syriac Christians, 59–61, 63, 188
Cicero, 89, 90, 95, 96
Clark, Lynn Schofield, 164
Clement of Alexandria, 39–40, 42, 46
 The Stromata, 39
Colbert, Stephen, 164
Constantine, 44, 188
Couldry, Nick, 201 (e 4)
 MediaSpace: Place, Scale and Culture in a
 Media Age, 105–106

cultural memory, xvi (culture's memory), 23, 195
 collective or distributed memory, 23
 non-inscribed memory (Paul Connerton), 23
Cyprian of Carthage, 46, 47–48

D

de Certeau, Michel, 27, 29, 105
 The Practice of Everyday Life, 27
democratization, 64, 66, 97
digital eloquence, xiii, xx, 94, 96–97, 189, 197
 digital religious eloquence, 88, 93, 95–101
digitalization, 192, 195, 197

E

Echchaibi, Nabil, vii, viii, xii, xiii, xv, xvii, xxi, 92,
 190, 197
 "The Third Spaces of Digital Religion", 181
Egypt
 Coptic, 62
 Islamist parties in, 138, 143
 secular film industry in, 148
 tele-Islamists/televangelism, xxi, 92
Eisenstein, Elizabeth, 51, 54
eloquence
 Christian, 94, 95
 ideal of eloquence, 89, 93
 "in an electronic age", 95
 material mediations of, 94
 Muslim, 94-95
 rhetorical power of eloquence, 93 (sh), 189
Emerson, Ralph Waldo, 89, 95
Enlightenment, the, 89, 145, 156
 post -Enlightenment, 2
 critique of religion, 156
Ethnicity Inc, 3
Eusebius, 45, 47, 49
 Ecclesiastical History, 45, 49
externalization, 81, 200 (e 2)

F

Facebook, 117, 153, 204

Farias, Paulo, 182
Finland
 Romani (Kaale) in, 121, 128
Foucault, Michel, 38, 105, 107, 109,
Friedson, Steven, 27, 29
Fundamentalist movement, 170

G

Geertz, Clifford, 31,
 description/definition of religion, 169, 182
Ghana, 198
 local video-film-industry in, 3
 mobile phone advertisement in, 6
 Pentecostals in, xv, 9, 186
 Sacred Heart of Jesus in, xvii, 11–13, 186
globalization, 3, 6, 107
 era of and study of, 3
 of religion, 178
Gutenberg, invention/revolution, xiv, 170

H

Hebrew Bible/Old Testament, xii, xviii, 26, 32 (e 3)
 Book of Job, 28
 Ecclesiastes 3: 14, 99
 Psalms, 63
 Psalms & Proverbs 99–100
 Psalm 118: 2–4, 28
 Psalm 136, xviii, 28–29, 32
 Proverbs 15: 17, 99
Helland, Christopher, 175, 178
Hepp, Andreas, 196, 199
 Cultures of Mediatization, 199
Hinduism
 Āgama schools, 77–79
 Brahmin Temple Priests, xvi, xix, 71, 77-78, 82, 188, 198
 devalaka, 76
 Hindu Religious and Charitable Endowment Department, 78
 Sanskrit texts, 78
 South India Arcaka Sangham, 78
 South Indian Vishnu and Shiva temples, 80
 Varadarāja temple in Kānchipuram, 78, 79, 81

Hirschkind, Charles, xxii (e), 98–99, 143
Hjarvard, Stig, vii, 15, 111, 173, 196, 199
Hoover, Stewart, viii, xii, xiii, xv, xvii, xxi–xxii, 55–57, 190-191, 197
 Religion in the Media Age, 55
 "The Third Spaces of Digital Religion", 181
Horsfield, Peter, vii, xii, xiii, xv, xvi, xvii, xviii. 32 (e 1), 33 (e 12, 24), 187–188, 198
Hüsken, Ute, viii, xii, xiii, xv, xvi, xvii, xix. 84 (e 11, 13), 188–189, 198

I

India
 ideas about speech, 92
 Salafi groups in, 142, 145
 Tamil Nadu (South Indian State), xvii, 77
industrialized communication, 170
Innis, Harold, 44, 48, 176
Innocence of Muslims, The, xvii, 137
Internet, xviii, 116–117, 122, 143, 145, 154, 158
Islam
 Islamification of Britain, 115
 Islamism (political), xxi, 138
 distinction political vs. culturalist form, 143–144
 Jamaat-e-Islami, 142
 Muslim Brotherhood, 142, 149
 Salafi groups, 142, 145

J

Jerome, 21

K

Kant, Immanuel, 107, 141
khuṭub, 98, 99
Knott, Kim, vii, xii, xiii, xv, xvi, xvii–xviii, xx, 118 (e 1), 189, 198–199
 The Location of Religion: A Spatial Analysis, 105
Krämer, Sybille, 4

L

Latour, Bruno, 4, 15, 31, 83, 192–193, 195, 196, 200
 Actor-network theory, 15, 31, 83, 195, 196
 mediator vs. intermediaries, 192–193, 200
le Cossec, Clément, 125, 127–128, 133, 134 (e 4)
Lefebvre, Henri, 105, 106, 107, 109, 117
 The Production of Space, 109, 117
Lied, Liv Ingeborg, viii, xii, xiii, xiv, xv, xvi, xvii,
 xix. 188, 198
Lövheim, Mia, vii, viii, xii, xiii, xv, xvii, xxi, 190,
 197, 199
Lundby, Knut, vii, xii, xiii, xxii

M

manuscript
 as intermediaries, 192
 Church as production house for Christian, 48
 colophons, 63
 culture, xiv, xvi, 55, 59, 60, 64, 65, 188, 195
 handwritten, xv, 58, 188
 Hexapla, the, 47
 pre-print manuscript culture, 56
 Qumran, 28
 Syriac manuscript culture, xvi, xvii, 60–63, 188
marginalization, 127, 128, 131
Martín-Barbero, Jesús, xv, 193, 195
 Communication, Culture and Hegemony, xv
Marxism, 105, 114, 140
 neo-Marxists, 174
Material Religion, 8
materiality, viii, xvii, xviii, xxii, 1, 2, 9, 24, 185-187,
 189, 191, 192, 193, 200
 body as material medium, 9
Maximus Daia (Roman emperor), 45
 The Memoirs of Pilate and the Savior, 45
McLuhan, Marshall, xvi, 174
media
 aesthetic properties and propensities of, 4, 23, 31
 affordances of, 155, 173, 191, 192
 digital media, 175, 176, 179, 180, 181, 192
 new media, 177
 bodily or performative media, xv, 24, 25, 30,
 187, 198
 body as material medium, 9

media, *cont.*
 common media, 23, 187
 cultural media, 23, 38, 187
 digital media, xiii, xv, xxi, 100, 145, 153–155, 156,
 158, 160, 163, 164–166, 171, 174–182, 189,
 190, 192, 197
 digital media spaces, xviii
 disembedded media, xiv–xv, xvii, xxii, 185, 192,
 193, 195, 197–198, 200
 embedded media, xv, 185, 192, 198
 inscribed media, 24, 187
 non-inscribed, 28
 Islamic media, xxi, 138, 145, 151, 190
 mass media, xv, xvii–xviii, 3, 4, 10, 13, 14, 37,
 128, 155, 163, 170, 172, 192, 195, 199
 impact of, 6
 new mass media technologies, xiii
 multimedial/multimediality, xviii, 58, 64, 65, 187
 new media spaces, 106, 110
 reificatory approach of, 15
 religious media, 20, 23, 30, 31, 51, 148, 187
 Ancient Hebrew religious media, 21, 23, 24,
 25, 27, 28, 187
 performative religious media, 30
 religious media theory, 11
 technical media, xiv, xvii, 194, 197, 198, 199
 technological media, xiii, xiv, xv, 191–193, 200
 textual media, 24–25
media culture, xvi, xix, 38, 51, 55, 58–61, 63–66,
 187–188, 198
mediation
 cultural mediations, 6
 digital mediations, 154, 197
 electronic mediations, 172
 mass mediations, 13, 170
 material mediation/materiality of, xiv, xvii,
 xviii, 3, 94, 186, 189, 191, 193, 195, 200
 mediation process, xviii, 187
 of religion, xx, 57–58, 72, 81, 82, 115, 117, 156, 159,
 165–166, 171, 172, 173, 175. 185, 190–191, 193,
 199–200
 of religion thesis, 173, 190
 religious mediation, xiii, 7–8, 9, 10, 11, 14, 58,
 82, 115, 156, 157, 163, 192
 re-mediation, xiii, 6, 7, 11, (symbolic) 181
 transmission (process), xiv, 4, 7, 115–116, 117,
 172

mediator vs. intermediaries, 192-193, 200
mediatization, 185, 195–197, 200
 Campbell's definition of, 155
 Clark's definition of, 155
 Hjarvard's theory/thesis, 14–15, 17 (e 13)
 mediation and mediatization, xxii, 2, 15, 17 (e
 13), 110–111, 195, 199–200
 mediatized religion, 196
 as metaprocess, 196
 of religion thesis/theory, 15, 155, 173, 199
Meyer, Birgit, viii, xii–xviii, xx, xxii, 22–23, 71, 72,
 82, 83 (e 2), 88, 97–98, 99, 100, 173–174. 175,
 179–180, 185, 186–187, 189, 190–191, 195, 198,
 199
 Aesthetic Formations, 72
modernity
 Islamic, 144
 secular (Western), 138, 144–145, 146, 151
 social modernization, 56

N

narrative
 meta-narrative, 56, 145
 primordial narrative of modernity, 145
 Western narratives of modernity, 144
Neda Agh-Soltan, 100, 179
Nietzsche, Friedrich, 90
 The Gay Science, 90
Nordic Network on the Mediatization of Reli-
 gion and Culture, viii, 2

O

Ong, Walter, J., 27, 44, 174
Origen, 46–47
 Hexapla, the, 47
Orsi, Robert, 7–8

P

Peirce, Charles Sanders, 90
 A Neglected Argument for the Reality of God, 90
 Evolutionary Love, 90

Penn, Michael Phillip, 62–63
Plato, 89
PostSecret (online site), 179
printing press, xiv, xix, 54, 55–56, 57–59, 64, 65, 157,
 188, 194
Protagoras, 88–89
Pussy Riot, 153, 164

R

recombination (Lievrouw and Livingstone),
 154
religion
 definition/description of religion
 Farias's, 182
 Geertz's, 169, 182
 Hoover's, 190
 Meyer's, 2
 digital religion, 173, 174, 175–176, 178, 179, 180,
 181, 182, 191
 privatization of, xxi, 156
rhetoric, xix, xx, 87–101, 112, 189, 197
 against the Roma, 123
 ancient Hebrew, xiii, 92
 by-product, 55
 Ciceronian rhetorical Humanism, 90
 in conjunction with sensational forms,
 97–98
 by early Christians, 38, 47, 92
 Greco-Roman, xvi, xvii, xx, 47, 87, 88–89, 91,
 92, 93
 Homo Rhetoricus, 91
 Indian, 92–93
 Islamic (Arabic), 92, 137, 142, 148
 macro-rhetoric, 93
 rhetorical pathways about religion and
 media, xvi, 91, 100, 189
 speculative rhetoric (Peirce), 90
 theory, 87, 92, 93, 100
 Western rhetorical concepts/traditions, 87, 88,
 91, 101 (e 1)
Rhetoric Culture Project, 94
ritual
 honors, 73, 74
 "ritual shares", 73, 74
 Sanskrit ritual texts, 78

Roma/Romani (Gypsies), xvii, xx, 121–134,
 189–190, 198
 antiziganism, 122–123, 126, 128
 gaje (non-gypsies), 123–124, 126, 127, 129–131, 134
 The Roma–gaje situation, 132–133
 Kaale, 121, 122, 127, 128
 Manouche travellers, 125, 127–128
Rushdie, Salman, 111–112
 The Satanic Verses, 111, 189

S

Sacred Heart of Jesus (by Pompeo Batoni), xvii,
 11–12, 186
Scetis desert, 59, 62
secularization, 1, 15, 17 (e 12), 56, 140
 academic narratives of, 66
 secularism's marginalization of faith, 144
 secularization theory, 56, 155, 156
sensational forms, 8, 10, 83 (e 2), 97–98, 100, 173,
 175, 179, 189, 191
Sikhism, xiii, 115–117,
 gurdwaras, 116
 gurmukhi, 116
 Guru Granth Sahib, 116
 Sikhitothemax.com, 116
 Sikhiwiki, 117
Singh, Jasjit, 116–117, 118 (e 2)
sociality (Carrithers), 23–24
Simonson, Peter, viii, xii, xiii, xv, xvi, xvii, xix,
 189, 197
SMS messages, 96, 192
Sorokin, Pitirim, A., 193–194, 195, 200(e 2)
 material vehicles, 193
 The Laws of Transformation, 194
 Society, Culture and Personality: Their Structure
 and Dynamics, 193
spatiality
 body's spatiality, 109
 mediation/mediatization as spatial, 109, 110,
 111, 189
 spatial analysis, 106, 110, 111
 spatial approach/methodology, xvii, xviii, xx,
 105, 107, 109, 111, 117
 spatial language, 110, 111, 112, 113, 118
 spatial metaphors, 108, 110, 115

spatiality, cont.
 spatial properties, 113
 spatial schemas, 108
 spatial and temporal frame of public rituals,
 75, 77, 82
Stolow, Jeremy, xxii (e 1), 55–56, 58–59, 60–61, 63
Stordalen, Terje, vii, viii, xii, xiii, xv–xvi, xvii,
 xviii, 10, 187, 198
 "Local Dynamics of Globalization in the
 Pre-modern Levant", viii
symbolizations, xvi, 23, 24, 25, 27, 28, 29–32, 187
Syriac monasteries, 62, 188, 198
Sweden
 bloggers in, xvii, 159, 161
 Romani in, xvii, 121

T

Tamil Nadu, xvii, 77
Taylor, Charles, 140
technological determinism, 4
Televangelism, 2
 Egyptian, 92
 Evangelical broadcasting, 172
 tele-Islamist, xxi, 138, 146, 148, 190
television
 CNN, 138
 Islamic /Egyptian satellite television, xxi,
 190
 4Shbab ("Islamic MTV"), 150
 halal soaps, 148
 Islamic Entertainment Televison, 148, 190
 Khaled, Amr, 148–149, 190
 Lifemakers, 149
 The Reformers (Mujaddidun), 150
 Masood, Moez, 146–147, 190
 Revolution on the Soul: The Journey to
 Certainty, 147
 The Right Path, 146
 SVT, 161
 as visual eloquence, 96
theological determinism, 139
Thompson, John B., xiv, 198, 201 (e)
 The Media and Modernity, xiv, 198
Thurfjell, David, vii, viii, xii, xiii, xv, xvii, xx, 189,
 198

transformation (of religion), xiii, xvii, xviii, xxii,
1–2, 3, 10, 13, 14. 15, 17 (n 12), 97, 111, 166, 185–
187, 189, 190, 192, 197–199, 200
"Laws of transformations", 194
metaphysical transformation, 188
symbolic transformations, 189
Tumblr, 178
Tunisia
Arab Spring revolution in, 137, 143
elections in, 138
Tweed, Thomas, A., 105
Crossing and Dwelling: A Theory of Religion, 105
Twitter, 96, 99, 178, 179

U

Uehlinger, Christoph, 28
United States
Congregations and networks in, 178
fight for African American equality in, 95

Upanishads, 93

W

Wilders, Geert, 113, 114, 115, 118 (e 1)
Fitna, 113, 118 (e 1)
Williams, Raymond, 193, 195
Keywords, 193
Winston, Diane, 158, 190
study of the Salvation Army, 158, 190
*Women and Religion in the West: Challenging
Secularization*, 156

Y

YouTube (videos), 96, 97, 98, 99, 100, 117, 118 (e
1), 146, 151 (e 1), 153, 178
khuṭub, 98, 99